**Natasha F. H. O'Hear** completed her DPhil
with Oxford University and held a Junior Research
Fellowship at Worcester College, Oxford, where
she also held a College Lectureship in Theology.
She is currently teaching English in an inner city
school in North London.

# OXFORD THEOLOGICAL MONOGRAPHS

*Editorial Committee*

# CONTRASTING IMAGES OF THE BOOK OF REVELATION IN LATE MEDIEVAL AND EARLY MODERN ART

# OXFORD THEOLOGICAL MONOGRAPHS

# CONTRASTING IMAGES OF THE BOOK OF REVELATION IN LATE MEDIEVAL AND EARLY MODERN ART

## A Case Study In Visual Exegesis

NATASHA F. H. O'HEAR

OXFORD
UNIVERSITY PRESS

# OXFORD
## UNIVERSITY PRESS

Great Clarendon Street, Oxford OX2 6DP

Oxford University Press is a department of the University of Oxford.
It furthers the University's objective of excellence in research, scholarship,
and education by publishing worldwide in

Oxford New York

Auckland Cape Town Dar es Salaam Hong Kong Karachi
Kuala Lumpur Madrid Melbourne Mexico City Nairobi
New Delhi Shanghai Taipei Toronto

With offices in

Argentina Austria Brazil Chile Czech Republic France Greece
Guatemala Hungary Italy Japan Poland Portugal Singapore
South Korea Switzerland Thailand Turkey Ukraine Vietnam

Oxford is a registered trade mark of Oxford University Press
in the UK and in certain other countries

Published in the United States
by Oxford University Press Inc., New York

© Natasha F. H. O'Hear 2011

British Library Cataloguing in Publication Data

Data available

Library of Congress Cataloging in Publication Data

Data available

Typeset by SPI Publisher Services, Pondicherry, India
Printed in Great Britain
on acid-free paper by
MPG Books Group, Bodmin and King's Lynn

ISBN 978–0–19–959010–0

1 3 5 7 9 10 8 6 4 2

# *Acknowledgements*

As I draw near to the end of the exhilarating, exhausting, and extremely long process, otherwise known as writing an academic book, there are many advisers, guides, and friends, to whom I am immensely grateful and to whom I would like to offer some words of thanks.

The first people that I would like to thank are my two book advisers. The first of these is Chris Rowland, to whom I owe an immeasurable debt of gratitude. Chris supervised the thesis from which this book grew from the outset in 2004 and has also been one of my book advisers since 2008. Since then, he has inspired me, challenged me, and enlightened me on an almost monthly basis. It has been an absolute privilege to work with Chris, whose towering and dynamic intellect is surpassed only by his profound kindness and generosity of spirit. Geraldine Johnson is my second book adviser and also supervised my thesis. With Geraldine I spent wonderful months discovering Albrecht Dürer and for that alone I am indebted to her. However, I am also indebted to her dynamic supervision sessions, her extremely detailed and helpful marking, and for her general energy and enthusiasm.

Cathy Oakes was my third thesis supervisor and her encyclopaedic knowledge of and enthusiasm for late medieval art served as a constant source of inspiration both while I was working on the thesis and beyond. Along with Chris Joynes of the Centre for the Reception History of the Bible, Cathy has continued to support me and take an interest in my work and for this I am very grateful.

Anthony O'Hear, my father, has taken an incredible interest in both my thesis and the book and it is no exaggeration to say that he has read every word of both, casting a philosophical eye over my arguments and helping me to tighten them up and, in some places, extend them. His enthusiasm for the project has also extended to accompanying me on many research trips, both in the UK and further afield, along with my mother Patricia. I am enormously grateful to both of them for their support, which has sustained me through the difficult times.

Sue Gillingham also deserves special mention. Under her tutelage (at Worcester College, Oxford since 2000) I learned to love not only Theology but also reception history and religious art. She has given me countless opportunities, from teaching to sabbatical cover to academic research. Sue has been a wonderful mentor to me as well as, in later years, a good friend.

Other people who have supported me academically and who have given me feedback include Ian Boxall, Ben Quash, Martin O'Kane, Nick King, and Jeremy Begbie. I am also grateful to Gervase Rosser and Judith Kovacs, my

D.Phil. examiners, who wrote me an excellent examiners' report and who have continued to support me. Thanks also to the anonymous reader at OUP, not only for recommending the thesis to OUP but also for their excellent report. The weekly New Testament Graduate Seminar in Oxford was a useful testing ground for ideas throughout the thesis. Bob Morgan of the Senior Seminar in Oxford has also taken an interest in the project from the outset. I am also very grateful to have been invited to give papers at the BNTC in Liverpool (2005), the 'D' Society in Cambridge (2006), the Oxbridge Biblical Studies Conference (2006), the Oxford–Zurich Religion Symposium (2006, 2007, 2009), the Institute for Theology, Imagination and the Arts in St Andrews (2007), the Bible in Art, Music and Literature Seminar (2009), the King's College London Religious Studies Seminar (2009), 'The Access Project', Highbury Grove School (2010), and 'Seeing the Scriptures', Rewley House, Oxford (2010). All of these occasions produced useful feedback, which helped with the development of first my thesis and then my book.

Academic support aside, the book would never have materialized at all were it not for the support of many people at OUP. Thank you first to Diarmaid MacCulloch of the Oxford Theological Monographs Committee for recommending the book to OUP. Thank you to Tom Perridge at OUP for taking the book on and to Elizabeth Robottam, Jenny Wagstaffe, and Tessa Eaton for all their hard work on the project. Special thanks to Heather Watson for her brilliant copy-editing and to Andrew Hawkey and Adam Ferner for their excellent proofreading. Any mistakes that remain are all my own. Thank you also to the AHRC and to Worcester College, Oxford for their generous financial support throughout the thesis stage of the project via my AHRC grant and the Worcester College Senior Martin Scholarship. Thank you also to the Provost of Worcester College, Oxford for my three-year Junior Research Fellowship, which allowed me to finish the thesis and turn it into this book, during which time I also enjoyed a Senior Lectureship at the same College.

And finally to the army of kind and generous souls who have made this book possible and who stood to gain nothing at all by helping me. Thank you to Roger Hausheer, Nicole Robertson, Moira Paulino, and Anne Bonavero for their generous help with translation. Thank you also to Hattie Miall, Gemma Craig, and Phil Bonavero for proof-reading earlier drafts. Their eye for detail was quite astonishing. Thank you also to Alan Coates in the Bodleian, Vicky Brown in the History of Art Slide Library, Clare Brown in the Lambeth Palace Library, Giulia Bartrum in the British Museum Print Room, the staff at the Sackler Library, and the staff at the British Library, particularly those in Humanities Reading Room One. Thank you more recently to the staff and students at Highbury Grove School, who have helped me to see not only the images in this book, but also the word itself, through new eyes.

Thank you to all my friends and family and especially to my wonderful sister and brother for their support and for making me laugh when it all got a

bit crazy. Thanks also to Yves and Anne Bonavero, my parents-in-law, for all their love and support.

And finally I turn to my husband Philippe. Thank you, Phil, from the bottom of my heart, for living with this book practically as I have for the last six years. Thank you for proof-reading, formatting, cutting out images with me at three in the morning, taking and picking up endless drafts from the printers, bouncing ideas around with me, and generally keeping me going with your love and unwavering support. It is to you and to my parents that I dedicate this book, with gratitude and with love.

# Contents

# List of Illustrations

# Abbreviations

| | |
|---|---|
| *Angers* | The *Angers Apocalypse Tapestry* |
| BR | Luther, M. 1930–85: *D. Martin Luther's Werke: Kritische Gesamtausgabe, Briefwechsel*, 18 vols. Weimar: Hermann Böhlaus Nachfolger |
| BW | The Burckhardt-Wildt Apocalypse |
| Koberger | The Koberger Bible |
| Lambeth | The *Lambeth Apocalypse* |
| *LW* | Luther, M. 1958–86: *Luther's Works*, American Edition, 55 vols. St Louis and Philadelphia: Concordia and Fortress Press |
| *WA* | Luther, M. 1883–1993: *D. Martin Luthers Werke: Kritische Gesamtausgabe [Schriften]*, 65 vols. Weimar: Hermann Böhlaus Nachfolger |

# Brief Summary Outline of the Book of Revelation

| Chapter reference | Brief description |
|---|---|
| 1: 1–3 | Introduction |
| 1: 4–11 | John's opening message to the Seven Churches of Asia |
| 1: 12–20 | The vision of the Seven Candlesticks and the One like the Son of Man |
| 2–3 | Messages to the Seven Churches of Ephesus, Smyrna, Pergamum, Thyatira, Sardis, Philadelphia, and Laodicea |
| 4: 1–11 | The vision of the Heavenly Throne-Room: the Twenty-Four Elders and the Four Living Creatures |
| 5: 1–14 | The Lamb appears and takes the scroll |
| 6: 2–8 | First Four Seals: the Four Horsemen |
| 6: 9–11 | Fifth Seal: the Martyrs |
| 6: 12–17 | Sixth Seal: the Earthquake |
| 7: 1 | The Four Angels hold back the winds |
| 7: 2–17 | The 144,000 sealed ones and the multitude from every nation |
| 8: 1 | Seventh Seal |
| 8: 2–5 | The Seven Trumpets given out; the Angel with the Golden Censer |
| 8: 7 | First Trumpet: hail and fire, a third of the earth burnt up |
| 8: 8 | Second Trumpet: mountain of fire thrown into the sea, a third of the sea becomes blood |
| 8: 10 | Third Trumpet: the Wormwood star poisons a third of the earth's water |
| 8: 12 | Fourth Trumpet: a third of the sun, moon, and stars darkened |
| 8: 13 | The crying Eagle |
| 9: 1 | Fifth Trumpet: the locust army |
| 9: 7 | The Locust Army rampage |
| 9: 13 | Sixth Trumpet: the four avenging angels and the myriad horsemen kill a third of mankind |
| 10: 1–11 | The Mighty Angel; John devours the scroll |
| 11: 1–3 | The Measuring of the Temple |
| 11: 4–13 | The Two Witnesses |
| 11: 15 | Seventh Trumpet: worship of God in heaven, destruction below |
| 12 | The Apocalyptic Woman or the Woman Clothed with the Sun: her battle with the Dragon, the War in Heaven |
| 13: 1–10 | The Sea-Beast |
| 13: 11–18 | The Earth-Beast or False Prophet |
| 14: 1–5 | Song of the 144,000 |
| 14: 6–12 | Three angels with messages |
| 14: 14 | One like the Son of Man appears in the clouds |
| 15: 1–4 | Angels with the last plagues appear |
| 15: 5–8 | Angels given their bowls/vials |
| 16: 2 | First Bowl: plague |
| 16: 3 | Second Bowl: all sea-life killed |
| 16: 4 | Third Bowl: all water poisoned |
| 16: 8 | Fourth Bowl: the earth burnt up |
| 16: 10 | Fifth Bowl: darkness, pain, and sores |
| 16: 12 | Sixth Bowl: foul spirits issue from the mouths of the Dragon, Sea-Beast, and false prophet/Earth-Beast |

# Introduction

Until now (and with the notable exception of the 2004 Blackwell Bible Commentary on the Book of Revelation), mainstream academic biblical exegesis has focused mainly on the textual interpretation of the Book of Revelation and indeed of other biblical texts. It is the contention of this study that this exclusive focus on the textual exegesis of this work is in danger of distorting the interpretation of this most visual of biblical books. Neglecting the contribution made by visual interpretations of the Book of Revelation to its reception history, a growing field within biblical studies, is to deny a key part of the data available to us.[1] Therefore this study is, firstly, a contribution to the history of interpretation of the Book of Revelation in the late medieval and early modern period in the form of seven case studies of visual interpretations ranging from *c*.1250 to *c*.1522. During this time the Book of Revelation, the most widely illustrated biblical book in Western Europe, was pictorialized across many different media, sometimes accompanied by text and sometimes without, for both 'elite' and 'popular' audiences. It is important to note that for the most part, this study is an investigation into the visual reception history of the Book of Revelation, a biblical text, and not one of the reception history of these seven visual interpretations of the text. This would constitute a different sort of study altogether.[2]

The Book of Revelation itself is written in a highly visual, often symbolic language with the word 'like' being used repeatedly throughout. In keeping with what one might expect from a text that purports to be a report of an apocalyptic vision (Rev. 1: 9–20, 4.1), there are over sixty references to 'seeing' (e.g. Rev. 1: 12–13: ' . . . and I *saw* ($\epsilon\hat{\iota}\delta o\nu$) seven golden lampstands and in the middle of the lampstands I *saw* ($\epsilon\hat{\iota}\delta o\nu$) one like the Son of Man'; Rev. 5: 1: 'Then I *saw* ($\epsilon\hat{\iota}\delta o\nu$) in the right hand of the one seated on the throne . . . '); frequent use of metaphors and

---

[1] For literature on biblical reception history see Luz 1994; Beuken and Freyne 1995; Müller and Tronier 2002; Kovacs and Rowland 2004; Nicholls 2005; Sawyer 2006.

[2] Indeed, a future study could focus on how, as with a biblical text, the original contexts of the works in question were often left behind as they found new functions and even new meanings in new contexts.

similes (e.g. Rev. 4: 3: 'And the one there looks *like* (ὅμοιος) jasper and cornelian, and around the throne is a rainbow that looks *like* (ὅμοιος) an emerald' or Rev. 13: 2: 'And the Beast that I saw was *like* (ὅμοιοsν) a leopard, its feet were *like* (ὡs) a bear's, and its mouth was like (ὡs) a lion's mouth'); as well as inconsistencies and abrupt changes of perspective and interruptions.[3] Sometimes the language even stretches the boundaries of sense, such as at Rev. 4: 6 when the four living creatures are said to be simultaneously both in the middle of the throne *and* around it or at Rev. 9: 7–10 where the locusts are described by piling simile upon simile with rather confusing effect.[4]

While it has been objected by some recent commentators that the complexity of John's literary imagery acts as a barrier to visual depiction, this did not, as shall be seen throughout this study, prevent widespread pictorialization of the Book of Revelation in the late medieval and early modern era.[5] As has been demonstrated by Carruthers, forms of 'visualization' were used extensively in late medieval biblical interpretation.[6] This was, in many ways, a very visual time, and although images did not proliferate in medieval society as they came to in later societies, it seems that as a rule, and for numerous reasons, people from various backgrounds were receptive to the role that images could play in helping to advance their understanding of biblical texts, particularly those such as the Book of Revelation, which, superficially at least, lends itself easily, indeed perhaps more easily, to visual than to textual interpretation.[7] Thus, while knowledge of the Book of Revelation itself would have been fairly widespread, some audiences would have had a direct relationship with the text (via the Vulgate and other editions) while others would have acquired their knowledge of it primarily (if not exclusively) through images, sermons, liturgy, and perhaps other texts such as *The Golden Legend*. The ways in which the text was experienced and particularly the level of detail in which it was known would therefore have differed substantially.

Seven examples from the vibrant, visual tradition of interpretations of the Book of Revelation have been selected as case studies for this inquiry: the *Lambeth Apocalypse*, the *Angers Apocalypse Tapestry*, the Van Eycks' *Ghent Altarpiece*, Memling's *St John Altarpiece*, Botticelli's *The Mystic Nativity*, and Dürer's and Cranach the Elder's respective woodcut series of the Book of

---

[3] In the Vulgate version of these verses, the normative version of the Bible up until the 15th cent., the word 'like' is denoted by the words *similis, tamquam*, and *sicut*. In the Koberger version, the normative German version after the 1470s, the word 'like' is denoted by the words *gleich* and *als*.

[4] See Boxall 2006: 87, 144–5. See Appendix 1 for a discussion of the apocalyptic and visionary character of the Book of Revelation.

[5] See Schüssler-Fiorenza 1993: 29, 51, for example. See Ch. 6 and Appendix 1 of this study for further discussion of this.

[6] Carruthers 1990: 122–257.

[7] See Luz (1994: 17–22) on how it is a legacy of the Reformation that art has *not* been regarded as a valid form of interpretation of biblical texts. See also Berdini 1997: 9–10.

Revelation. The images themselves, as well as related images pertinent to the discussion, appear in the plates section. Information on where to find the entire versions of the *Lambeth Apocalypse*, the *Angers Apocalypse Tapestry*, and the Dürer and Cranach series is given in the relevant chapters.

Analysis of these images, all of which are based on, or inspired by, the Book of Revelation, revealed the existence of different hermeneutical strategies towards the same biblical text. Parallels can be found between these visual strategies or approaches and the contrasting hermeneutical strategies that have been isolated during work on the textual history of the Book of Revelation.[8] Thus, while research into the visual history of the Book of Revelation is an end in itself, this study is, secondly, and perhaps more innovatively, an attempt to understand the different ways in which images themselves exhibit hermeneutical strategies akin to those found in textual exegesis, but with those peculiar properties of synchronicity of subject-matter and effect that differentiate them from the experience of reading a text. Thirdly, therefore, it investigates the character of visual exegesis and its relationship to textual exegesis, a relationship that was first explored in the seventeenth century by G. Lessing in his *Laocoön*.[9] He argued that painting deals in bodies and space while poetry (or text more generally) describes actions and chronologically occurring events, thus putting an end to the notion of *ut pictura poesis*.[10] Thus while temporality or narrative progression can be implied in an image, this, in fact, is an inference made by the viewer. Lessing's arguments regarding the distinctions between texts and images, which have been much discussed since then, by W. J. T Mitchell in particular, represent a useful starting point for the discussion of synchronicity (as a defining feature of the image) that runs through the study.[11]

# 1 RATIONALE BEHIND THE STUDY AND CHOICE OF VISUAL CASE STUDIES

Preparatory work undertaken on the visual reception of the Book of Revelation had highlighted the fact that very few commentators in the fields of either biblical studies or art history were interested in the concept of images as visual exegesis, the art historian Berdini and the theologian O'Kane being the main exceptions.[12] However, even in the case of Berdini and O'Kane, their definition of visual

---

[8] See McGinn 1987: 523–34 for a summary of the different hermeneutical trends within textual exegesis of the Book of Revelation. See also Kovacs and Rowland 2004: 7–11 for a different perspective.

[9] Lessing, tr. E. A. McCormick 1984: 7–158.

[10] Ibid. 3, 78–97.

[11] Mitchell 1986: 95–115.

[12] See O'Hear 2009. See also Berdini 1997, O'Kane 2005, 2007, and Pattison 2007.

exegesis—namely, that it is a process whereby an artist visualizes not a text but a *reading* of a text—serves in the end to render it subordinate to textual exegesis, whilst at the same time failing to capture its distinctive properties.[13] Thus there was an opening for an approach to the topic of visual exegesis via a more connected investigation of images of the Book of Revelation.

With regard to the chosen time period, in many ways this was the result of work already undertaken on Dürer's series of images on the Book of Revelation (*c.*1498). This seminal series represented a potential launching point from which to undertake further research into the visual history of the Book of Revelation. From here one can move backwards to visual predecessors and forwards to works influenced by the Dürer series. Close analysis of both the Dürer *Apocalypse* images and the wealth of scholarship on Dürer himself revealed a self-conscious positioning of his series as the culmination of the late medieval tradition of visualizations of the Book of Revelation, both reliant on and, at the same time, distinct from established iconographical practices. To understand fully the implications of the Dürer series on the history of the interpretation of the Book of Revelation, it seemed necessary to include a selection of late medieval visualizations of the Book of Revelation. Dürer's hermeneutics could then be compared with those of his European predecessors. In terms of later visualizations of the Book of Revelation, which invariably owe something to the Dürer series, some of these are discussed in brief in the Conclusion. So, while Bosch, Duvet, Velázquez, Blake, and the contemporary artist, Kip Gresham, who have, among others, all produced notable images of the Book of Revelation, are very much part of its visual history, a more in-depth study of these later figures will provide the basis for a future investigation.

In light of the above rationale, the present study begins in the late thirteenth century and centres on five specific media: illuminated manuscript, tapestry, altarpiece, painting, and woodcut. Each chapter analyses a different medium, although in some chapters more than one example of the medium is discussed. To an extent the media chosen reflect the 'elite' tastes of this period, although Dürer's and Cranach's woodcuts very probably had a broader audience.[14] There are, of course, a whole range of visualizations of the Book of Revelation, such as church frescoes, stained glass windows, and, in the fifteenth century, block-book *Apocalypses*, which could also be studied and which would tell us more about 'popular' understandings of the Book of Revelation.[15] But they are not the focus of this study. This was partly due to considerations of space and time, but also partly because 'popular' visualizations of the Book of Revelation

---

[13] See Berdini 1997: 1–35; O'Kane 2005: 340–8.

[14] I am aware that the terms 'elite' and 'popular' are much debated ones. While there is no further space to discuss them here, they will therefore be used with due caution.

[15] See articles by Klein, Christie, and Camille in Emmerson and McGinn (eds.) 1992: 159–99; 234–58; 276–92 for information on more 'popular' apocalyptic imagery in the late medieval period and for church art in particular.

tended to be of a more didactic than exegetical nature and are thus less relevant to the investigative aims of this study. Similarly, the huge number of images of the Last Judgement from the late medieval period have also been excluded from the scope of this study, due to the fact that the iconography found therein is mainly derived from Matthew 3, 13, and 25, rather than from the Book of Revelation itself. An analysis of Last Judgement images and their relationship with their source-texts would, however, be an interesting future study.

My final choice of images deliberately reflects different contexts, different media, and different kinds of juxtaposition of images with texts. Thus diverse (in both the temporal and topographical sense) visualizations of the Book of Revelation from the five chosen media are all considered within their temporal and place-specific backgrounds. While we cannot be sure what access to written texts the various featured artists and their patrons had, and are even less certain that their exegesis might be based on the original Greek, it is the contention of this study that the images discussed herein all demonstrate, to greater and smaller degrees, a grasp of the subject-matter or *Sache selbst* of the Book of Revelation. Analysis of these works, therefore, enables us to map different hermeneutical strategies, not only among the images themselves but also, in some cases, between the images and their corresponding texts. With the exception of Hans Memling's *St John Altarpiece*, the images discussed were accompanied by extracts from the Book of Revelation text or from a commentary on the text.[16] Thus, the text–image relationship varies from instances where the images are presented as an auxiliary feature of the text, to instances where the text is subordinate to the image, albeit in different ways.

## 2 BRIEF OUTLINE OF THE STUDY

The case studies therefore begin in Chapter 1 with the *Lambeth Apocalypse* (*c*.1260), an example from the thirteenth-century Anglo-Norman illustrated *Apocalypse* manuscript tradition. The iconography developed in this family of manuscripts influenced visualizations of the Book of Revelation until well into the fifteenth century. While the *Lambeth Apocalypse* might be described as normative in iconographic terms, the manuscript is 'however' unique in being bound with twenty-eight additional miniatures, images that serve to illuminate the hermeneutical approach of the manuscript's compilers and possibly of the (female) patron.

The chronological, episodic, and diachronic way of visualizing the Book of Revelation found in the *Lambeth Apocalypse* and related manuscripts was

---

[16] Note that the text of the *Angers Apocalypse Tapestry* has now been destroyed.

transposed from its small-scale manuscript format onto a huge-scale tapestry format in the late fourteenth century by the French designers of the *Angers Apocalypse Tapestry* (*c*.1373–80), the case study at the heart of Chapter 2 of this study. The huge size, lack of surviving text, and largely secular function of the tapestry combined with subtle, yet significant changes in the established Anglo-Norman iconography result in a unique hermeneutical approach to the visualization of the Book of Revelation.

Chapter 3 focuses on visualizations of the Book of Revelation in altarpiece format. This takes the form of two case studies, the first being the Van Eycks' *Ghent Altarpiece* (*c*.1432) and the second Memling's *St John Altarpiece* (*c*.1474–9). In contrast to the Anglo-Norman manuscript iconography, which adopts what might be called a 'holistic' approach to the Book of Revelation, in that it visualizes most of the text in chronological order (there will always be small parts of the text that are neglected, left out for artistic reasons or that are simply not able to be visualized), these two Flemish altarpieces offer a synchronic, selective approach to the text. In the case of the *Ghent Altarpiece*, parts of the text are visualized, in combination and juxtaposition with representations of other biblical texts, in what amounts to a giant visual explication of the Eucharist viewed through the lens of the Book of Revelation. In contrast, in Memling's *Apocalypse* panel (the right-hand panel of the altarpiece), events from the first thirteen chapters of the Book of Revelation have been visualized simultaneously as a series of visions appearing before the gaze of a life-size figure of St John. Both images therefore illuminate aspects of the Book of Revelation without attempting to depict it in its entirety.

This is also the case with Botticelli's painting, *The Mystic Nativity* (*c*.1500), as discussed in Chapter 4 of this study, although his approach is somewhat different in hermeneutical terms. On the face of it, *The Mystic Nativity*, painted in Florence shortly after the death of the influential Dominican preacher Savonarola, is a Nativity scene based on Luke 2: 8–20. However, the Greek inscription at the top of the painting relates the image to Rev. 11–12. Thus Botticelli not only provides the viewer with a hermeneutical key to his painting but also with an insight into his own process as a visual exegete. *The Mystic Nativity* is therefore a very useful case study in terms of the ensuing discussion of visual hermeneutical strategy and visual exegesis.

Chapter 5 considers the two last case studies, those of Dürer's and Cranach's *Apocalypse* cycles, of 1498 and 1522 respectively. Both artists present their woodcut images in a 'book format', and embody, in different ways, the end of the late medieval approach to the pictorialization of the Book of Revelation. Dürer's work represents the application of Renaissance artistry to the task of apocalyptic visualization, although his religious outlook remains broadly late medieval, not yet influenced by the polarization of thought that was to characterize the Reformation. Cranach, who was working during the early years of the Reformation, was on the one hand heavily dependent on the

Dürer series. However, due to the demands of his very specific context, he produced a woodcut series of the Book of Revelation that combined pre-Renaissance artistry with a simplified, literalistic, and, in parts, highly polemical approach to the text.

Chapter 6 provides hermeneutical reflection on the varying interpretative approaches witnessed in the seven case studies. The approaches are first clarified and comparisons and contrasts drawn. Following this, Gadamer's contrast between the visual strategies of *Darstellung* and *Vorstellung* and the hermeneutical contrast drawn by Kovacs and Rowland between 'decoding' and 'actualizing' or more metaphorical types of exegesis, are used as a complementary perspective through which to view the different approaches.[17] From these different analyses emerge two clear strands of visual exegesis, one which expresses the subject-matter of the Book of Revelation via images and another which engages primarily with the apocalyptic, visionary character of the text, which is itself dependent on 'something seen', also via a visual medium.[18] The nature of these two strands of visual exegesis are drawn out with reference both to the seven case studies that make up the current survey as well as to some later examples. The implications of the exegetical observations made in Chapter 6 are taken up in the Conclusion with reference to current work on visual exegesis as well as to the field of biblical studies more generally.

## 3 TOWARDS AN INTERDISCIPLINARY METHODOLOGY

The method used throughout the study is deliberately interdisciplinary. The interests of the art historian and the biblical exegete are brought together in an attempt to understand the hermeneutical and exegetical strategies at work in the images considered. Throughout a concerted effort has been made to balance the possibilities and limitations of both approaches. Thus, full attention is given to the artistic and historical context of all of the works in question, as well as to the relationship with the (textual) tradition of the interpretation of the Book of Revelation, a field in which I have undertaken sustained research. In terms of the latter, the main hermeneutical trends in late medieval exegesis of the Book of Revelation will be summarized in Chapter 1 and then discussed where necessary as points of comparison or contrast in the following chapters. Chapter 6 and the Conclusion provide an opportunity for more extended

---

[17] See Gadamer 1989: 144–59; Davey 1999: 3–26; Kovacs and Rowland 2004: 7–11.

[18] The visionary character of the text is discussed separately in Appendix 1.

engagement with the concept of visual exegesis, as well as its possible contri-
bution to the field of biblical theology.

On one level, the art historical and historical research that forms the major
part of this study, and has provided some new insights into the works under
discussion, has been undertaken as an end in itself in order to contribute to
our understanding of the images in question. On another level, the research
also allows for a novel investigation of the hermeneutical and exegetical
character of images based on or inspired by the Book of Revelation, which
has broader methodological implications. It is the contention of this study that
an intimate understanding of a work of art and its immediate context in terms
of sources and artistic and exegetical inspiration, as well as its intended
function and reception, are all necessary for a full understanding of both the
hermeneutical strategies at work within the image, as well as how it functions
as a piece of visual exegesis. Without such an understanding, hermeneutical
and exegetical judgements based on such images may be superficial, or even
miss the mark altogether. Likewise, an exegetical approach to images linked to
religious texts allows for a deeper understanding of the images themselves.
While I would maintain that such a dual approach remains valid to a certain
extent even when studying more recent apocalyptic works such as Turner's
and Blake's versions of *Death on a Pale Horse*, it is especially relevant in the
cases considered in the present study, which are all products of multi-layered
patronage and religious contexts.[19]

Thus, a systematic methodology has been employed throughout the study.
In each chapter, a small number of visualizations based on or inspired by the
Book of Revelation in the same medium are considered. Particular attention is
paid in each chapter to the cultural, artistic, and theological background of the
works, with a special focus on both the artist(s) and patron(s), if known. The
text–image relationship (where appropriate) and the probable functions (de-
votional, ceremonial, liturgical, private and/or polemical) of the visualizations
are also considered in order to understand the role they played in shaping the
type of visual exegesis devised. With these elements in place, sustained analysis
is undertaken of the hermeneutical perspective and exegetical emphases of the
visualizations, with a particular focus on how the format of the work (be it
synchronic or diachronic), as well as its nature (whether it adopts a holistic
visualization of the Book of Revelation or takes an inclusive approach),
contributes to the presumed effect of the visualization on the viewer. The
way in which contemporary viewers would have interacted with the images in
question, and in particular with their visual hermeneutics, is, therefore, also an
important consideration. While it is the visual reception history of the text of
the Book of Revelation and not of the images themselves that remains the clear

---

[19] W. Blake, *Death on a Pale Horse*, c.1800, Cambridge: Fitzwilliam Museum, Acc. no. 0765;
J. M. W. Turner, *Death on a Pale Horse*, 1825–30, London: Tate Britain.

focus of the study throughout, in some cases, where pertinent, the enduring exegetical effect of the image on the present-day viewer is also considered. Although comparisons and contrasts are drawn throughout the study between the different case studies, care has been taken not to make direct or detailed comparisons between works originating from diverse contexts. Thus the main evaluative judgements are made at a hermeneutical level in Chapter 6 and the Conclusion, rather than in the individual chapters.

# 1

---

## The *Lambeth Apocalypse*

### Reading, Viewing, and 'Internalizing' the Book of Revelation in the Thirteenth Century

## 1.1 INTRODUCTION

The thirteenth-century English illustrated Apocalypse was something of a cultural phenomenon. Around 1250, two distinctive illustrated Apocalypse cycles appeared in England, seemingly without clear antecedents. The fact that there are around twenty extant English Apocalypse manuscripts dating from the latter half of the thirteenth century suggests that there were in fact more that did not survive.[1] The first type of cycle, known as the 'Corpus-Lambeth' stem, consisted of an illustrated Apocalypse based around an anonymous French prose gloss. There are three extant manuscripts of this cycle from this period. This chapter will focus on the *Lambeth Apocalypse* (hereafter *Lambeth*), which belongs to the second of these cycles, the so-called 'Berengaudus' cycle of which there are fifteen extant manuscripts.[2] All the Apocalypse manuscripts in this 'family' are based around extracts from Berengaudus' commentary on the Book of Revelation, his *Expositio super septem visiones*. The manuscripts belonging to the Berengaudus cycle, which can be further subdivided into the Metz, Morgan, Westminster, and Trinity clusters, have in common several defining features that set them apart as a separate genre in terms of the visual interpretation that they offer of the Book of Revelation.

*Lambeth* is an excellent example of this genre while also possessing individual emphases and additions that render it a particularly interesting case study in terms of the interpretation that it offers of the Book of Revelation. Particular attention will be paid to a series of additional miniatures attached to *Lambeth* which both reflect and strengthen the visual hermeneutical strategies found

---

[1] See Lewis 1995: 337.

[2] Nine of the *Lambeth Apocalypse* miniatures have been reproduced in this study. For a full reproduction of the seventy-eight miniatures see Morgan 1990.

within the Apocalypse miniatures as well as some exegetical points made in the Berengaudus commentary extracts. The visual links and repetitions between the two sets of miniatures may have been more easily grasped by the thirteenth-century 'reader' who would have been well versed in the visual practices of the day.[3]

Illustrated Apocalypses belonging to the Berengaudus cycle followed quite a precise format. They tended to be medium-sized books that followed a standard page design.[4] The pages were designed in diachronic format with a rectangular, framed, tinted illustration set at the top of each page above a two-columned text made up of some verses from the Book of Revelation and followed by an extract in Latin from the Berengaudus commentary. On every page the reader is presented with a package of image, text, and gloss that they had to learn to 'read' (see Fig. 1, for example). There is also strong evidence that the Gothic Apocalypses were intended to be read or contemplated by silent readers as opposed to being read out loud in a more public setting.[5] The placing and prominence of up to one hundred images within these manuscripts suggests that the 'reading' of these works had become a very visual experience in which the images could condition how the text appearing underneath should be read. The Berengaudus commentary extracts may also have conditioned the reader's interpretation of both the biblical text and the images, but the relationship between all three components (two textual and one visual) and, in particular, the exact role of the Berengaudus commentary, remains somewhat obscure. The miniatures also had another function. They helped to make the reading/viewing experience a transformative one in that they offered a way for the 'reader' to move from 'the physical optical perception of the written and illustrated page to the intellectual realm of thought and idea, memory and association'.[6]

In terms of the demography of the readers there is evidence that at least some of the English Apocalypse manuscripts were owned by lay readers and secular Bishops as opposed to being restricted to monks. Lady Eleanor de Quincy, a thirteenth-century English noblewoman, probably owned *Lambeth*.[7] The manuscripts were prepared for their patrons by teams of artists and scribes working under the aegis of theologically skilled, probably clerical, compilers. Perhaps the same person was responsible for the compilation of the

---

[3] The word 'reader' will be used throughout to refer to someone who engaged with illustrated books on some level, either through actually reading them or through viewing their images.

[4] *Lambeth*, for example, measures 27.2 cm × 20.0 cm. The Trinity Apocalypse, by far the largest of these manuscripts, measures 43.0 cm × 30.4 cm.

[5] Carruthers 1990: 170–3.

[6] Lewis 1995: 10.

[7] See Carmi Parsons 1996: 175–201 and Lewis 1995: 240–1 on other secular owners such as Eleanor of Castile.

gloss as well.[8] They would certainly have been capable of doing so in theological terms if they were responsible for directing the layout and pictorial interpretations, both of which reveal an exegetical sophistication beyond that of a straightforward illustrative scheme. Thus the manuscripts were labour-intensive, luxurious, and sought-after items; status symbols as well as devotional objects.

## 1.2 THE ANGLO-NORMAN APOCALYPSE: GENRE, PATRONS, AND PURPOSE

Both literacy and literary output, particularly in the vernacular, increased in the thirteenth century in England and France, although mainly among the nobility.[9] The illustrated Apocalypse belongs to a class of literature that may be defined as one of religious instruction. Most other works of religious instruction, such as William of Waddington's *Manuel des Péchés* or Robert Grosseteste's *Château d'Amour*, were written in Anglo-Norman. The small family of illustrated English Apocalypses to which *Lambeth* belongs were all written in Latin. Since they are also all prominently illustrated, they find their closest parallel in contemporary illustrated Psalters, which also fulfilled an instructional, devotional function.[10] However, the illustrated Apocalypses, by virtue of their apocalyptic subject-matter, must have held a different appeal and served a slightly different purpose for their patrons than did the illustrated Psalters. Exactly why there was a demand for illustrated Apocalypses as opposed to illustrated manuscripts of other biblical texts remains, to an extent, unclear. The illustrative scope of the Book of Revelation, with its visual language of seeing and perceiving, would not have gone unnoticed by those wishing to own a lavishly illustrated biblical text, having been inspired perhaps by the earlier Beatus Apocalypse manuscripts.[11] Rivalry amongst the nobility over the ownership of the resulting manuscripts, known to be precious objects brought into existence by a set of trained professionals, may also account for their subsequent popularity.[12]

With regard to the timing of the popularity of the thirteenth-century illustrated Apocalypse, it may be noted that apocalyptic speculation had reached something of a climax in Europe in the thirteenth century due to

---

[8] Lewis 1995: 44, Morgan 1990: 26–8.

[9] See Auerbach 1965; Brownrigg (ed.) 1990; Bruce 1928 and Salter 1988 on the literary output of the Middle Ages.

[10] See Morgan 1990: 92 n. 9: 154 out of the 165 extant Psalters from 1100 to 1300 are in Latin.

[11] See Morgan 2005a: 5 on how Eleanor of Castile might have seen (and been inspired by) a Beatus Apocalypse (c.1220) at the court in Castile before moving to England in 1254.

[12] See Nichols 1996: xii.

the dissemination of the interpretative ideas of Joachim of Fiore. Freyham argues that the English illustrated Apocalypse was conceived of as a counter-balance to the more radical Joachite apocalyptic exegesis that had taken hold in Italy and, to an extent, France.[13] The conservative nature of the much earlier Berengaudus commentary, as well as the fact that potentially contro-versial apocalyptic details have been 'toned down' in *Lambeth* (see for instance the blank scroll symbolizing the 'eternal gospel' in fo. 22, itself a pictorializa-tion of Rev. 14: 6–8, the cause of a Joachite controversy surrounding the significance of the 'eternal gospel' in Joachim's 'third age'), support this theory.

The addition of illustrated 'lives of John' or *vitae* to a core of illustrated Apocalypse manuscripts, as well as two quires of additional miniatures in the case of *Lambeth*, imply that for some patrons the illustrated Apocalypse also provided scope for the fusion of popular literary genres. Support for this idea is found in the library records of Eleanor of Castile, who owned both the Douce and Trinity Apocalypses alongside the *Cambridge Life of St Edward*.[14]

That the thirteenth-century illustrated Apocalypses represent a 'mixed genre' is strengthened by the text–image format followed in the Berengaudus Apocalypse cycles in particular. In the fifteen Berengaudus Apocalypse cycles the image always appears at the top of the page, underneath which is a short segment of the Book of Revelation text (normally only a few verses) which in turn is followed by a section of commentary. The commentary selection varies from manuscript to manuscript. Six different arrangements of sections from the Berengaudus commentary are extant.[15] None of the Berengaudus Apoca-lypse manuscripts includes the full version of the Berengaudus commentary. The text is set out in two columns and distinguished from the commentary text in the following ways. In the Metz and *Lambeth* 209 versions, the headings *textus* and *expositio* are inserted, while in the Douce 180 and the Paris lat. 10474 the commentary text is half the size of that used for the Book of Revelation text. The Gulbenkian and Abingdon Apocalypses (which are close-ly related to the Metz and *Lambeth Apocalypse* manuscripts in other ways) are different again. They contain fully illustrated commentaries on separate pages alternating with pages of the illustrated text.

The complicated narrative structure of the Book of Revelation is to an extent eroded by the fragmentation and dispersion of the visionary events across many pages. The commentary, whose purpose it is to elucidate and explain the text of the Book of Revelation, often ends up intruding on the visionary experience and even obfuscating the point of the textual fragment with confusing allegorical interpretation. However, Lewis, in her influential study of the multi-layered relationships between the text, image, and its

---

[13] Freyham 1955: 211–44.
[14] See Carmi Parsons 1996: 177–88 for further details on the library of Eleanor of Castile.
[15] Lewis 1992: 261.

reader/viewer in Apocalypse manuscripts produced in England during the thirteenth century, stresses that the central structural unit in the medieval narrative was not plot but episode, thus accounting for the apparent popularity of this fragmented approach to narrative. Each page of the Berengaudus cycles constitutes a definite 'episode' even if the separate episodes relate to each other rather awkwardly.[16] She also suggests that the John figure provides the continuity between these 'episodes' in the consciousness of the reader.[17] Thus, the Berengaudus cycles represent a 'peculiar merger of hagiographical *vita* and apocalyptic *visio*'.[18]

It has additionally been argued that the presentational (and in particular visual) similarities between the Berengaudus Apocalypse cycles and contemporary theological romances might account for their popularity in the thirteenth and fourteenth centuries.[19] So, for instance, the illustrations of the wedding feast of the Lamb (Rev. 19) in the Trinity and British Library Apocalypses include 'courtly details' such as cupbearers and musicians.[20] Similarly the Theophilus and Mercurius miniatures in *Lambeth* demonstrate a real link with the pervading chivalric culture (see Figs. 2 and 7). On a more general level, Lewis demonstrates that both genres (the 'romance' and the Berengaudus Apocalypse genre) share an exemplary hero figure who is open to instruction from a higher power.[21] She also cites the presence of books in the miniatures of the Berengaudus cycles and in particular of John holding his 'note-book' (see *Lambeth* fo. 1 (Fig. 1), fo. 2$^v$, fo. 4$^v$ and ff.) as evidence of this appropriation of the romance genre.[22]

Henderson suggests that the Book of Revelation appealed to aristocratic patrons who saw it as a biblical counterpart to their own chivalric culture.[23] Visser specifically links the particular popularity of the Berengaudus Apocalypse cycles to the optimistic tone of the Berengaudus *Expositio super septem visiones* (hereafter the *Expositio*). He sees parallels between the thirteenth-century Arthurian ideal and 'utopian Camelot tradition' and the *Expositio*'s stress on the positive outcomes of the battles described in the Book of Revelation (such as that in Rev. 19: 11–16) as well as on the New Jerusalem (Rev. 21–2).[24] He has even found thirteenth-century evidence of editions of the *Expositio* having been bound together with Arthurian materials.[25] Visser concludes that the verbal images found in the *Expositio* must have been seen (by the compilers

---

[16] Lewis 1995: 51; Evans 1986: 126–41.          [17] Ibid. 49–50.          [18] Ibid. 50.
[19] See Henderson 1967: 115–17; 1968: 136; Klein 1983: 171 ff.; Morgan 1990: 12–13; Lewis 1995: 50–3.
[20] Trinity R. 16.2, fo. 22$^r$ and Brit. Libr. Add. 35166 fo. 23$^r$.
[21] Lewis 1995: 50.          [22] Ibid. 52.
[23] Visser 1996: 22; Henderson 1967: 115–17.
[24] Visser 1996: 22–3.          [25] Ibid. 23, 211.

as well as the patrons perhaps) as a useful companion to the Apocalypse miniatures.[26]

Morgan, in his scholarly study on *Lambeth*, makes the interesting point that the 'chivalric overtones' of the miniatures in the Berengaudus cycles may have served to capture the imagination of the reader/viewer who would then be 'drawn in' to the more serious theological concerns of the text and commentary.[27] The miniatures provide the 'exterior aspect' which appealed to the senses and the text and commentary provide the 'interior aspect' that appealed to reason and to the soul.[28]

## 1.3 THE BERENGAUDUS COMMENTARY AND THE DEVELOPMENT OF APOCALYPTIC EXEGESIS

Apocalypse manuscripts that share the same or very similar versions of the Berengaudus commentary also tend to share a similar iconography.[29] Thus, the fifteen thirteenth-century illustrated Berengaudus cycles have a very different overall feel from those contemporary Apocalypses in the Corpus-Lambeth stem, which are arranged around the French prose gloss. While the Berengaudus commentary can be said to invite spiritual meditation, the French prose gloss interprets the Book of Revelation as a series of remedies to practical problems, and this is reflected in the types of illustrations present in these cycles.[30] The choice of commentary in such Apocalypse manuscripts was therefore crucial and was probably also (as suggested by Freyham) polemically or ecclesiastically motivated.[31] The commentary not only dominated the page (by virtue of the size of the extracts) but appears on one level to have been included to control the 'reader's' exegetical response to the Book of Revelation itself. It is therefore necessary briefly to consider the emphases of Berengaudus' *Expositio* as well as the probable reasons for its continued popularity in thirteenth-century England.[32] On another level, however, the lack of care with which the commentary extracts have been compiled in *Lambeth* and its related manuscripts suggests that it did not, *in reality*, play a key role in the experience of the 'reader', a point that will be returned to below.

---

[26] Visser 1996: 23.
[27] Morgan 1990: 13.
[28] Ibid.
[29] See for instance the 'Metz' group comprising the Metz, *Lambeth*, Gulbenkian, and Abingdon Apocalypses.
[30] Lewis 1992: 264; Visser disagrees with this claim: Visser 1996: 39 n. 53.
[31] Freyham 1955: 211–44.
[32] See Visser 1996 for a comprehensive study of the *Expositio* and its influence.

A brief overview of the history of exegesis of the Book of Revelation in the late medieval era is necessary for understanding how the Berengaudus commentary fits into this picture. The main trends in textual interpretation will also be referred to throughout this study. Although ignored by some commentators, exegetes since Victorinus (d. 304) have written commentaries on the Book of Revelation.[33] McGinn has isolated three main tendencies within the interpretation of the Book of Revelation: those typified by the Tyconian, the Joachite, and the 'linear-historical' approach.[34] It can successfully be argued, however, that McGinn's three categories should be collapsed into two, as there is no essential difference between his second and third categories, both of which embody an allegorical approach to the text. Thus one is left, broadly, as was suggested within the Introduction, with two contrasting exegetical approaches to the Book of Revelation, the metaphorical approach and the decoding approach.

The first approach, the metaphorical, is typified by Tyconius (d. *c.*400). It is described as being recapitulative, moral, ecclesiological, ahistorical, and anti-millenarian.[35] Tyconius' distinctive reading of the Book of Revelation was taken up and extended by Augustine (354–430), and such was Augustine's legacy within the Western Church that this way of reading the text went virtually unchallenged until the twelfth century when its ahistorical aspect was questioned by Rupert of Deutz.[36] Although challenged, it remained important, normative even, throughout the fifteenth century, although the enduring popularity of Nicholas of Lyra's fourteenth-century linear-historical commentary on the Book of Revelation suggests that its influence was waning.

The Tyconian interpretation is recapitulative in that it reads the Book of Revelation as a cyclical presentation of visions recapitulating the history of the Church and its struggle against the world. Thus the history of the Church is repeated several times throughout the Book of Revelation, using different imagery and characters. In the Tyconian reading the Book of Revelation is not read as a complete history of the Church (i.e. from Rev. 1 through to Rev. 22) or of salvation history. The contents of the seven visions are interpreted as enduring problems that have faced the Church from within, such as the presence of heretics, for example.[37] Thus the Book of Revelation is understood as a means of ethical challenge and guidance rather than an allegory in which all its symbols can be precisely interpreted. Finally, it is anti-millenarian in that Augustine, who took up the interpretation, categorically rejected any literal readings of the

---

[33] See Boxall 200–6: 146–50 for a survey of negative attitudes towards the Book of Revelation.
[34] See McGinn 1987: 523–34.
[35] See Tyconius' *Book of Rules*, tr. Babcock 1989; McGinn 1987: 534.
[36] McGinn 1987: 532.
[37] Krey 1995: 187.

millennium described in Rev. 20.[38] The millennium was to be understood symbolically and not as a future event.

The decoding model, by contrast, attempts to 'decode' the Book of Revelation with reference to specific historical events. However, this decoding enterprise can take different forms. The first is espoused by what might be called the Joachite approach and the second by the linear-historical method. Joachim (*c*.1135–1202) showed in detail how the symbols of the Book of Revelation related to major and specific events in Church history and also how it pointed to what was to come.[39] Using his Trinitarian understanding of history as divided into three ages (*stati*) or symbolic trees, those of the Father, the Son, and the Holy Spirit, he located himself near to the end of the second age on the brink of the sixth seal (Rev. 6: 12–17), the dawning of the age of Antichrist, which in turn corresponded to the sixth and seventh heads of the Dragon in Rev. 12.[40] By interpreting around two-thirds of the Book of Revelation as future prophecy, Joachim helped to reintroduce a millennial interpretation of Rev. 20 into the exegetical tradition as well as into Christianity itself.[41] Importantly, Joachim also viewed the Book of Revelation not only as the inner key to the meaning of general history and to the historical books of the Old Testament, thus rendering it not an addendum to the New Testament, as previous exegetes had been inclined to view it, but rather as the 'culmination and summary of the entire course of history'.[42] Thus the Book of Revelation also takes on a positive dimension, whereas for exegetes in the Augustinian mould it had represented the final climax of evil.[43] Joachim had many followers within the radical Franciscan movement, his influence reaching well into the sixteenth century, and beyond. Importantly, Peter Olivi built on Joachim's writings at the end of the thirteenth century in order to implicate the Papacy in both positive and negative ways in the coming eschatological transition.[44]

Other commentators, such as Alexander Minorita (d. 1271), Peter Aureol (d. *c*.1322), and Nicholas of Lyra (d. 1349), while rejecting the more radical implications of a Joachite interpretation, nevertheless continued to embrace the fundamental tenets of his decoding method. Thus the second branch of the 'decoding' commentators are known as the linear-historical interpreters. The

---

[38] See Augustine, tr. H. Bettinson 1984: book 20.
[39] See McGinn 1987 and Reeves 1969 on Joachim.
[40] Daniel 1992: 85.
[41] McGinn 1987: 532. Although the third *status* should not be seen as a new beginning exactly but as a culmination of a process that began with Adam (see *Lib. conc. (Dan)* 2.1.25, pp. 107–11; *Lib. Conc. (Ven)* 2.1.21–2, fos. 13ᵛa–14ʳb: see in McGinn). Note also the millennial elements in Bede's 8th-cent. interpretation of the Book of Revelation.
[42] Daniel 1992: 87 (see Joachim, *Expositio in Apocalipsim*, fo. 3ʳ).
[43] Ibid. 77.
[44] For further information about the influence of Joachite thought in the Late Medieval period see Bauckham 1978: 20, Burr 1993: 118–78, Potesta 1999: 117–36 and bibliography, Lerner 1999: 351–4.

Franciscan Alexander Minorita, for example, argued that the Book of Revelation should be interpreted as a continuous reading of Church history from the primitive church in Rev. 1 through to the eschaton in Rev. 22. Accordingly, his commentary is allegorizing and historical and includes many specific identifications made between characters in the Book of Revelation and actual historical figures and dates, apparently gleaned from a variety of sources including patristic sources, histories, Joachim's commentary on the Book of Revelation, the *Super Hieremiam* of pseudo-Joachim, and contemporary German chronicles.[45] For example, Rev. 7: 2 is related to the time of Constantine and Rev. 20: 2 to the time of the Emperor Henry V. The New Jerusalem is interpreted as a prediction of the Franciscan and Dominican orders.[46] Alexander's approach found two important followers in the fourteenth century, Peter Aureol and Nicholas of Lyra, also both Franciscans.[47] Importantly, Lyra differs from Alexander Minorita and Peter Aureol in ending his commentary of the Book of Revelation at Rev. 16, which he believed corresponded to the twelfth century, as he did not feel able to make prophecies either about his own time or the future.[48]

Returning now to Berengaudus' *Expositio*, there is a certain amount of scholarly disagreement over when it was actually written. However, most (including Klein, Lewis, Lobrichon, and Morgan) agree that it originates from the eleventh century, perhaps written by a Benedictine contemporary of Rupert of Deutz and Bruno of Segni.[49] The eschatological ideology of Berengaudus can be linked with the institutional and moral reform inspired by the Gregorian initiative at the end of the eleventh century, a reforming context that may have been pertinent to the concerns of the thirteenth-century compilers of *Lambeth* who were operating in the wake of Lateran IV. Certainly, the *Expositio* seems to have had a 'popular', rather than an academic, appeal, with frequent use also being made of it in non-academic circles, such as English monasteries, after 1100.[50] The *Expositio* also has an optimistic rather than a pessimistic focus and can therefore be distinguished from other medieval apocalyptic tracts, such as Bishop Adso's *De ortu et tempore Antichristi* (*c.*954), which emphasize the rule of Antichrist and the horrors of hell.[51] By the thirteenth century, thinkers in the Joachite tradition had begun to speculate more specifically both about the dangers closing in on the Church

---

[45] Burr 1993: 99.

[46] Ibid. (see also Alexander Minorita, *Expositio in Apocalypsim* 469–501).

[47] See Peter Aureol, *Compendium sensus literalis totius divinae scripturae* (Quaracchi, 1896) and see Krey 1995 and 1997: 80–99 on both Peter Aureol and Lyra.

[48] Krey 1997: 216.

[49] Lewis 1995: 42; Klein 1983; Lobrichon 1988: 221–41; and Morgan 1990: 20. Visser argues (1996: 12–103) for a 9th-cent. date.

[50] Visser 1996: 4–26.    [51] Ibid. 2.

and the fact that the world was moving into its last age which would be directly preceded by the reign of Antichrist.[52]

Whilst reflecting elements of the Tyconian interpretation, as well as standing in part in the historicizing, decoding tradition, overall Berengaudus seems to interpret the events contained in the Book of Revelation, somewhat uniquely, as already having been accomplished.[53] Thus, the New Jerusalem is already a reality even while the battles and plagues take place. The other battles of the Book of Revelation are seen as reiterations of the final battle and victory of Rev. 19–20.[54] He also saw the Kingdom of God as identical with, or at the very least strongly reflected in, the present Church (see his commentary to Rev. 1: 12–20). This way of interpreting the Book of Revelation is original to Berengaudus and has a direct bearing on his other exegetical emphases, which include, among other things, an interest in predestination and Christology.[55]

With regard to the issue of predestination, Berengaudus contrasts the 'elect' with the 'reprobates' arguing with reference to Rev. 20: 14–15, for example, that the judgement of Rev. 17: 1 applies to all the *reprobi* (PL 17: 910) or that all those whose names are not in the 'Book of Life' will be sent to the 'burning oven' (PL 17: 936).[56] The distinction between the 'elect' and the 'reprobates' was made formal at Lateran IV in 1215, thus rendering Berengaudus' thinking on the topic particularly relevant for a thirteenth-century compiler.

Berengaudus also has a tendency to interpret many of the symbols in the Book of Revelation in Christological terms. Thus the door in heaven in Rev. 4: 1 is interpreted in terms of John 10: 9 as referring to Christ. Additionally the angel with the censer (Rev. 8: 2–4), the angel Michael (Rev. 12: 7–12), the eagle (12: 13–14), the earth (Rev. 12: 15–16), the Lamb (Rev. 14: 1–4), the angel like the Son of Man (Rev. 14: 14–16), the angel with the millstone (Rev. 18: 21–4), the rider on the white horse (Rev. 19: 11–16), the angel with the key to the bottomless pit (Rev. 20: 1–3), and the tree of life (Rev. 22: 1–7) are all interpreted by Berengaudus as Christ. His interpretation of the riders and the horses of Rev. 6: 1–8 also reflect his Christological emphasis. The second, third, and fourth riders had traditionally been seen as variations on the devil (see for example Caesarius of Arles, PL 35: 2426). Possibly influenced by Hrabanus' positive interpretation of the horses in Zechariah 1.8 ff., Berengaudus argues that the riders and their horses actually represent the 'Lord and the Church' (PL 17: 837). Thus the first horse 'stands guard over the saints' (PL 17: 813) and the second horse 'lives in the saints' (PL 17: 822). The scales of the third rider 'demonstrate the equitable judgement of Mosaic law' (PL 17: 831) and the fourth horse 'lives in his prophets' (PL 17: 838).[57] This positive interpretation of

---

[52] See for instance Matthew Paris's *Chronica majora* in which he intimated that the world would end in 1250.

[53] See Kovacs and Rowland 2004: 16 for a summary of Tyconius' interpretative hermeneutics.

[54] Visser 1996: 104.      [55] Ibid. 104.      [56] Ibid. 49.      [57] Ibid. 112.

the last horse and rider is reflected in the illustration for the Douce Apocalypse in which the rider on the pale horse has the face of Christ and is wearing a nimbus.[58]

In his understanding of the Hebrew Bible Berengaudus is fairly orthodox, as he is in his interpretation of the millennium (Rev. 20: 1–3), in which he follows the Augustinian position that the millennium is a symbolic and not a literal event.[59] As will be discussed below, Berengaudus also adopted a stridently anti-Jewish line of interpretation throughout his *Expositio*, a fact that may have appealed to the compilers of the thirteenth-century illustrated Apocalypses, who were operating in a climate of increased hostility towards Jews.

Thus Berengaudus' *Expositio* represents neither a straightforward application of the Book of Revelation to the status of the present Church nor a complete sacred history of the Church. This is in contrast to the twelfth-century *Glossa Ordinaria* and Joachite readings of the Book of Revelation. It seems that the *Expositio* had a 'popular', 'utopian' appeal that led to its repeated use in the thirteenth-century illuminated Apocalypses and beyond. As Nolan argues, the *Expositio* served both to intensify and to systematize the reading of the Book of Revelation 'as a linear narrative pertinent to the temporal lives of contemporary Christians'.[60]

However, the fragmentary use of the *Expositio* in the thirteenth-century Anglo-Norman Apocalypse manuscripts must also be addressed. In some ways these commentary extracts made up completely new commentaries in their own right, presenting only a fragment of the views expressed in the real commentary.[61] Indeed, sometimes the compiling is somewhat careless and references are made back to details in the original commentary that have not been included in the extracts.[62] The commentary passage on Rev. 20: 1–3 on fo. 35 of *Lambeth*, for example, refers the reader back to an earlier commentary on the meaning of the 'abyss' with the words *superius diximus* ('as said above'). However, in actual fact this earlier exposition of the abyss, while present in the original Berengaudus commentary, has been omitted from the *Lambeth* commentary extracts. Conversely, there is also an occasion at *Lambeth* fo. 8ᵛ where Berengaudus' commentary on Rev. 8: 1 is included in the commentary extract despite the fact that Rev. 8: 1 has been left out of the actual *Lambeth* text.

Certainly, the careless nature of the commentary compilation is perplexing and may reveal something about how the manuscripts were used. If the

---

[58] MS Douce 180: 16.    [59] See Augustine, *City of God* xx. 7–8.

[60] Nolan 1977: 9–12, 68–83.    [61] See Morgan 1990: 25.

[62] Nolan (1977: 69–83) contrasts the somewhat careless, briefer commentary extracts found in the Morgan family of manuscripts with the more considered approach to compilation of commentary extracts found in the Trinity Apocalypse.

owners of the thirteenth-century Apocalypse manuscripts had viewed the Latin extracts from the Berengaudus commentary as important, then the sort of errors that one finds in *Lambeth* would have been corrected or 'ironed out'. In actual fact, later Apocalypses in the same family, such as the Gulbenkian Apocalypse, carry many of the same errors. This implies that the commentary extracts were not the most important feature of the thirteenth-century manuscripts and that they may actually have been included for reasons other than providing elucidation of the Book of Revelation. Additionally, in the case of *Lambeth* at least, the main emphases of the Berengaudus commentary do not appear to have pervaded or guided the compositions of the accompanying images in any meaningful way.[63] Could the Latin Berengaudus commentary extracts have been included in order to add *gravitas* to the project as a whole? There are some interesting, roughly contemporary examples of Latin text being used in a similar way in French Romanesque architecture. There are incised Latin inscriptions on the historiated capitols of the twelfth-century church of S. Pierre at Chauvigny, for example, which may never have been read.[64] Similarly, there is a Latin inscription attached to a twelfth-century wall-painting of the Annunciation at Hardham in Sussex, while the altar cross from Bury St Edmunds has been carved with propagandist Latin inscriptions.[65] In such cases, the Latin text is thought to have been used in order to awe a non-intellectual audience.[66] Is it possible that the same idea (i.e. of adding *faux gravitas* to something) lay behind the inclusion of the carelessly compiled commentary extracts in the thirteenth-century illustrated Apocalypse manuscripts? If this is the case then it was the images in these manuscripts which held a position of primacy in practical terms, even if this was not the original intention of the first (probably monastic) compilers of the thirteenth-century illustrated Apocalypse manuscripts.[67]

## 1.4 THE *LAMBETH APOCALYPSE*

### 1.4.1 Questions of date, provenance, and patron

Morgan tentatively asserts that *Lambeth* is the earliest product of a group of artists working during the period 1260–75 and whose latest works are the

---

[63] Although Lewis argues (1992: 264–9) that the Berengaudus commentary did exert a considerable influence over the choice, conception, and design of the illustrations for other Apocalypse manuscripts in the same family.

[64] Costen and Oakes 2000: 119.

[65] Ibid. 186 n. 18.

[66] See further Leclerq-Marx 1997: 91–102.

[67] See Lewis 1992: 262 and Klein 1983: 177 on the probable monastic genesis of the genre.

miniatures in the Abingdon Apocalypse.[68] This seems to be a reasonable assertion given the available evidence. Although this group of artists might have worked in St Albans or at a monastery in Canterbury (as suggested by M. R. James) no firm conclusions have been reached on the location of their workshop.[69] In fact, Morgan argues that *Lambeth* may actually have been produced in London due to ornamental and iconographical similarities with Psalters and other Apocalypses also thought to have been produced there, but once again the evidence is not firm.[70] What we are certain of is that *Lambeth* was produced in England for an aristocratic female patron, called either Eleanor de Quincy or Margaret Ferrers, and who is depicted at fo. 48 kneeling with a book before a painting of the Virgin and Child and wearing the De Quincy and Ferrars heraldic arms.[71] There exists further evidence in the form of sketched plans by Matthew Paris for an illustrated book for the Duchess of Winchester (Eleanor de Quincy) on the flyleaf of another manuscript, Trinity College MSE 1.40. The sketch is thought to refer to *Lambeth* itself.[72]

That the patron of *Lambeth* was a woman is an interesting but not an isolated occurrence, book patronage being one of the few public activities in which (aristocratic) women could participate in the late medieval era.[73] Indeed, a sizeable number of thirteenth-century instructional texts (such as the *Ancrene Riwle*) were owned by both cloistered and laywomen, a precedent having been set regarding female book patronage by Queen Eleanor of Aquitaine (1122–1204).[74] In the thirteenth century, the Plantagenet Queens, Eleanor of Provence (d. 1291) and the aforementioned Eleanor of Castile (d. 1290), were the most prominent lay female book patrons. Eleanor of Castile even maintained a personal scriptorium in the latter years of her life.[75] On the specific subject of Apocalypse manuscripts, Morgan notes that twelve of the extant thirteenth-century illustrated Apocalypse manuscripts (not all from the Berengaudus cycle) had female patrons (even if they were not specifically created for them).[76] While women are noted to have been behind the proliferation of books in the vernacular, the commentary selections and

---

[68] See Morgan 1990: 90 on the problems with dating the Abingdon Apocalypse.

[69] James 1903: 89–90; 1927: 29–32.

[70] Morgan 1990: 82.

[71] Attempts to uncover a more precise date for the *Lambeth Apocalypse* have been detailed by Morgan 1990: 72–82.

[72] Jambeck 1996: 243.

[73] McCash (ed.) 1996: 1.

[74] Ibid. 6–8, 15, 33, 127–31, 202–3; Morgan 1990: 96.

[75] Carmi Parsons 1996: 175–201.

[76] These include the Trinity Apocalypse (MS R. 16.2); *Lambeth* (MS 209); the Abingdon Apocalypse (Add. MS 42555); the Douce Apocalypse (Paris BN fe. 9574); Cambridge Fitzwilliam (Mus. Mclean 123); Oxford New College (MS 65), London BL (Royal 15. D.II), Cambridge Corpus Christi College MS 20, Oxford Bodl. (Selden Sup. 38), and the Burckhardt-Wildt Apocalypse. (See Morgan 1990: 96.)

language in these illustrated Apocalypses do not seem to differ according to whether they had a female patron or not.[77] It is probable that while they might have understood some Latin, Anglo-Norman French would have been the language spoken and read in aristocratic circles in the thirteenth century.[78] Even well-educated women would have been excluded from a Latin education.[79] For example, Christine de Pisan (1364–1430), the writer, whilst very well-educated, did not know any Latin at all.[80] Thus, Anglo-Norman was favoured for written texts commissioned by both men and women. Works of religious instruction such as William of Waddington's *Manuel des Péchés* or R. Grosseteste's *Château d'Amour* were normally written in Anglo-Norman, as were the 'popular' *Lives of the Saints*.[81] However, this does not necessarily imply that the Berengaudus Apocalypse cycles (written in Latin) were not intended for a lay audience. The rich illustrations in *Lambeth*, for instance, as well as the inclusion of twenty-eight devotional miniatures, one of which, fo. 48, depicts the patron in prayer, strongly imply an aristocratic lay patron.[82] The pictorial schema, particularly of the standard seen in the *Lambeth* miniatures, added considerably to the cost of the manuscript, their presence in very large numbers supporting the above claim that they took primacy (in practical terms) over the Latin text and commentary extracts.[83]

Some suggestion therefore needs to be made as to how Eleanor de Quincy or Margaret Ferrers, who would very likely only have been literate in Anglo-Norman French, would have interacted with *Lambeth*. Morgan ventures that for the most part she would have sat alone in her chamber with the book. Since she might not have been able to understand the Latin text, one assumes that the images were the primary focus. Perhaps, as Henderson suggests, she would also have had access to a version of the Book of Revelation (and/or a commentary) in the vernacular. Her chaplain or spiritual adviser might also at times have translated and explained parts of the book.[84] This is interesting in exegetical terms as the presence of such an adviser serves to interpolate another layer of interpretation between the text and the 'reader'. Following such explanations by the advisory figure, the pictures would then serve as a visual reminder of the complex theological issues that she had read/heard about in the text and commentary of the Book of Revelation.[85]

---

[77] See Carmi Parsons 1996: 177–8, Wogan-Browne 1993: 61–87; Morgan 1990: 97.

[78] Morgan 1990: 91. See also Wilson 1942: 37–60; Rothwell 1975–6, 1978.

[79] Carmi Parsons 1996: 187; Shahar 1983: 154–65; Wogan-Browne 1993: 62.

[80] Shahar 1983: 155–6.

[81] Morgan 1990: 91; Wogan-Browne 1993: 62–3.

[82] Lewis (1995: 272) also suggests that the lines between clerical and lay readership were becoming blurred in the second half of the 13th cent.

[83] Morgan 1990: 96.      [84] Ibid. 94.      [85] Ibid. 95; Lewis 1995: 296.

The notion that the miniatures in these manuscripts served as memory aids, or perhaps even as the primary point of contact between the patrons and their books, fits well with Carruthers' findings on memory in medieval culture. She argues that images were often included in books in order to 'fix' ideas in the memory and that great attention was given to the design of the whole page, including the text layout, in an effort to respond to the memorial needs of readers.[86] Understanding these 'memorial needs' helps us in turn to understand some of the features of the medieval manuscript such as the use of text scroll within miniatures and marginalia or 'bas-de-page' surrounding the text columns (see Fig. 1 for example, *Lambeth* fo. 1).[87] The latter have a particularly interesting function. They generally do not help to explain the content of a particular section of text. Rather they serve to make each page memorable and also to remind readers of the higher purpose of books, 'that they contain matter to be laid away in their memorial storehouse'.[88] Carruthers also emphasizes the role of emotion in stimulating the memory. Thus all images needed to create strong responses in order to 'surprise and delight' the memory and thus trigger the recollective chain.[89]

By way of conclusion to this section, I suggest that *Lambeth* perhaps marks something of a transitional phase in the production of Apocalypse manuscripts. The later Gulbenkian and Abingdon Apocalypses illustrated the commentary text as well as the text of the Book of Revelation, so although the lay reader might not have been able to understand the text of the Gulbenkian Apocalypse (the Abingdon is in Anglo-Norman) they would have also had the commentary elucidated through the images.[90] The 'reader' of *Lambeth* by contrast probably relied on the miniatures and their clerical adviser for their understanding of the Book of Revelation. They would then have relied on memory and the 'inbuilt' memory aids contained in the manuscript itself, the Latin text and commentary perhaps only serving to add perceived *gravitas* to the production.

## 1.4.2 Questions of style and unity in *Lambeth*

Morgan labels fos. 1–39$^v$ of *Lambeth* Style 1, and fos. ii$^v$, 40–53$^v$ and the marginal scenes on fos. 11$^v$–13 Style 2.[91] Thus the twenty-eight additional miniatures have all been executed in Style 2. In Style 1 full painting is combined with tinted drawing. In Style 2, with the exception of the Benedictine monk on fo. ii$^v$, all the work is in tinted drawing. However, there is enough similarity between the two styles to posit either that one artist changed

---

[86] Carruthers 1990: 9, 14.  [87] Ibid. 229, 242 ff.
[88] Ibid. 247.  [89] Ibid. 257.
[90] See also Lewis 1995: 296.  [91] Morgan 1990: 83.

his style during the course of the *Lambeth* illustrations or that a younger artist from the same workshop was responsible for the miniatures in Style 2.[92]

*Lambeth* consists of seventy-eight Apocalypse miniatures accompanied by the text of the Book of Revelation and extracts from the Berengaudus commentary, as well as twenty-eight additional miniatures of devotional content.[93] This is despite the command in Rev. 22: 18–19 that nothing should be added to or taken away from the apocalyptic revelation that had been shown to John. Such additional miniatures were normally found in Psalters and Gothic picture books. Psalters were often bound with extended series of Old and New Testament scenes unaccompanied by text.[94]

The additional miniatures are bound in two separate quires. The first quire consists of a full-page representation of St Christopher, John's illustrated *vita* (here consisting of twenty miniatures in double-registered scenes), and two miracles of the Virgin, the Mercurius and Theophilus legends (which run across eight double-registered scenes). The two miniatures of the Mercurius Legend (fo. 45[v]), derived from the Life of St Basil, are its earliest representations in English art.[95] The saint has a dream in which he sees a Roman soldier called Mercurius restored to life and armed by the Virgin. Mercurius then successfully defeats the Emperor Julian the Apostate in battle.

The Theophilus miracle (fo. 46, fo. 46[v] (Fig. 2), fo. 47), of Eastern origin, was the most commonly represented of all the Miracles of the Virgin, having received a place in the liturgy of the Church by the eleventh century.[96] There existed a strong tradition of artistic representation of the Theophilus story from the twelfth century onwards (see for instance the Psalter made for Queen Ingebruge in 1200).[97] The legend tells of how Theophilus, a priest, made a pact with the devil after suddenly losing his job and his friends. Theophilus' fortunes are restored in return for his soul which he pledges in a bond signed in blood. Afterwards, racked with guilt, Theophilus begs the Virgin to intercede on his behalf and procure his soul back. The Virgin agrees to intercede and returns the bond to Theophilus who receives absolution but dies three days later (a detail which is omitted from the *Lambeth* miniatures).

---

[92] For more information on the two styles evidenced in *Lambeth* see Ibid. 83–7. See also Morgan 1990: 87–8 on the stylistic similarities between *Lambeth* and other contemporary Book of Revelation manuscripts and Bestiaries.

[93] Two other contemporary Book of Revelations have been bound with additional miniatures: the Burckhardt-Wildt Apocalypse and Eton 177 (Lewis 1995: 272).

[94] Lewis 1995: 272.

[95] Ibid. 276. The legend originated in the East and was translated from Greek into Latin in the 9th cent. It occurs in collections of the Miracles of Virgin from the 12th cent. onwards in England. See Binon 1937.

[96] See Gautier de Coinci in König vol. IV, pp 1–30, lines 203–19, 233–9, 547–9 for a popular version.

[97] Fryer 1935: 287 ff.

The second quire of additional miniatures consists of twelve full-page devotional and allegorical illustrations, including images of the Virgin and Child with Eleanor de Quincy, St Margaret and St Catherine, an allegorical scene of faith and penitence and an image of a 'Veronica Head of Christ'.[98]

Lewis suggests that *Lambeth* may originally have been commissioned by an ecclesiastical reader and then taken over by Eleanor de Quincy, for whom the Apocalypse miniatures and the devotional miniatures would have served as a series of mnemonic reminders of the text and its meanings.[99] Thus both she and Morgan agree that while the additional miniatures may not have originally been intended as part of the Apocalypse manuscript, all the miniatures should now be understood (both stylistically and thematically) as part of an over-arching whole. That there are stylistic links has already been demonstrated. The thematic links will be demonstrated below. Lewis makes the interesting suggestion that the first quire of additional miniatures was probably intended to form a prefatory section before the beginning of the Book of Revelation text and miniatures.[100] The second quire would therefore have formed the epilogue. It would certainly have been more traditional for John's *vita* to have been placed before the text of the Book of Revelation. *Lambeth* is the only manuscript in which it appears after the text. In interpretative terms, placing the first quire of additional miniatures before the text of the Book of Revelation and the illustrative miniatures would certainly draw out some of the visual themes (particularly those relating to the John figure) in a more forceful way.

### 1.4.3 The reading/viewing experience

It was suggested above that the non-Latinate patrons of *Lambeth*, and Apocalypse manuscripts in the same family, might have used them primarily as 'visual Apocalypses'. The images provided the 'reader' with a means of learning and internalizing the Book of Revelation narrative.[101] Lewis argues that the illustrated Apocalypse lends itself above all other biblical books to the art of 'internalization' due to its sequences of seven (churches (Rev. 2: 1–3: 22), seals (Rev. 6–8: 1), trumpets (Rev. 8: 2–11: 18), and bowls (Rev. 16)), its frequently recurring figures (such as the Twenty-Four Elders in Rev. 4: 4; 5: 8, 11–12; 11: 16; 14: 3) and the vivid imagery such as that of the hell-mouth in

---

[98] See Lewis 1995: 281–96 and Morgan 1990: 58–71 for more on the second quire of miniatures.

[99] Lewis 1995: 296.

[100] Ibid. 274.

[101] See further Carruthers 1990: 222 and 1998: 7–220 on the process of medieval internalization and meditation.

which Satan is tormented (cf. Rev. 19: 9–10).[102] These long cycles of images, on the surface mimetic, repetitive illustrations of the text, were in fact part of a much more complicated process of visual exegesis in which the image (and perhaps the text) were 'read' and then (ideally) memorized or internalized.

The distinctive (and seemingly unprecedented) features of the image cycles in the thirteenth-century illustrated Apocalypses were their length and comprehensive, highly detailed nature. Lewis argues that they represent 'every episode, moment and gesture' of the Book of Revelation, thus constituting a 'complete visual replication of the text'.[103] This claim can clearly be contested. Rev. 2 and 3, are, for example, heavily edited in the Berengaudus cycles and not illustrated at all. However, it is undeniable that John's visions *are* comprehensively illustrated in these cycles, thus allowing the viewer to share in a representation of his overall experience 'blow by blow', something that they had not been able to do previously.

While it cannot be known for certain how the Anglo-Norman Apocalypse manuscripts would have been used, any analysis should start with the manuscript as a whole, as opposed to just focusing on the images, as this can give clues to artistic intention. All too often the images from Apocalypse manuscripts and books are reproduced without the text in a sort of vacuum and with no regard to order and so forth so that the combined effect of text and image as well as the cumulative effect of the entire manuscript is completely lost. Analysing the different components of a manuscript 'opening' also serves to highlight the time it would have taken to 'read' such a manuscript.

The first opening of *Lambeth* provides rich material for analysis. Visual themes introduced in these initial miniatures unfold throughout the entire manuscript. On the left-hand side of the 'opening' is a frontispiece in which a Benedictine monk paints a statue of the Virgin and Child that appears to have come alive (Fig. 3, fo. ii$^v$). The Virgin offers the monk an object, which resembles an apple, perhaps a reference to the fruit of her womb.[104] The visual parallel with the third Theophilus miniature (Fig. 2, fo. 46$^v$, top) that depicts Theophilus praying to the Virgin is striking. The statue that he is praying to also looks remarkably similar to the statue being painted in the frontispiece image. Both statues are distinctive for their 'standing Christs' (unusual in iconographic terms) and the presence of a fruit in the Virgin's right hand.[105]

Morgan argues that the frontispiece image is a representation of a thirteenth-century miracle of the Virgin in which the Virgin intercedes on behalf of an artist-monk who is attacked by the devil.[106] This explanation would

---

[102] Lewis 1995: 14; 242–59.     [103] Ibid. 15, 235.     [104] Ibid. 237.
[105] The standing Christ-Child also appears in fo. 48 (Eleanor de Quincy kneeling before a statue of the Virgin). Here the Virgin holds a bird in her right hand and not an apple.
[106] Morgan 1990: 50 (see Warner 1885: xxxiv–xxxv and Morgan 1982: no. 80 for a discussion of some of the different versions of this story).

constitute an interesting preface to the Book of Revelation, in which the devil and his ministers are let loose on earth and eventually defeated. Indeed, most medieval commentators saw Rev. 12 as an attack on the Virgin who herself had to be protected by the angel Michael.[107] The frontispiece therefore functions as a visual *exemplum* for the reader of the kind commonly used by contemporary preachers.[108] However, Lewis suggests that the frontispiece is based on one of the *Miracles of the Virgin* by Gautier de Coinci in which the Virgin appears to a devout monk in a dream.[109] By placing this image opposite fo. 1 (John sleeping on Patmos) the compiler was sending a message to the 'reader' that the experience of reading/viewing *Lambeth* would provide 'visual access to the invisible through art as well as miracles and visionary prophecy' (Fig. 1).[110] The devout 'reader' may, like John or the monk, experience the Divine. Both explanations of the frontispiece are plausible with both serving to underline the allegorical import that would very likely have been 'read in to' it in the thirteenth century.

On the right-hand side of the opening is fo. 1 (Fig. 1). At the top of the page, taking up around one-third of the page space, is a miniature depicting John asleep on Patmos, his body almost covering the island. This detail is an immediate indication of the non-naturalistic style of the miniatures. The boat, which might have brought John to Patmos, sits at anchor on the left and the four surrounding islands have been labelled with their names. Morgan suggests that the bird on Sardis can be linked to a bird that keeps watch in the Bestiary.[111] Interestingly, although he is clutching his book, his constant companion throughout the miniatures, John appears to be asleep. This is at odds with the message to John on the angel's scroll which reads, 'What thou seest write in a book and send to the seven churches who are in Asia'.[112] The angel's command for John to record what he sees is recapitulated visually (as well as textually) in fo. 12 (Rev. 10: 1–10) where once again the angel leans out of the sky motioning to John, and at fo. 32$^v$ (Rev. 19: 9–10) where John is once again instructed to write by the angel, who looms over him pointing at his book.

John's closed eyes in fo. 1 form a visual contrast with his alert expression and pose in fo. 39$^v$, the final miniature in which he has an unmediated vision of Christ (Rev. 22: 10–21), a moment which represents the end-point and climax of his visionary journey (Fig. 4). Lewis correctly stresses the fact that this final miniature was a new and important addition to the Berengaudus cycles. Previous Apocalypse manuscripts had ended with an image of John

---

[107] See the *Lambeth* commentary extract on fo. 15 for example: 'by the woman in this case we are able to understand the blessed Mary' (tr. Morgan 1990: 175).
[108] Morgan 1990: 51.
[109] Lewis 1995: 237; See Mussafia 1896: 24–5 for the de Coinci text.
[110] Ibid.     [111] Morgan 1990: 127.     [112] Ibid.

with the angel (Rev. 22: 8–9).[113] This unmediated view of Christ, a sign that John has attained a higher status of understanding (something that he did not possess at Rev. 10: 8–11 where the angel prevents him from writing), is echoed in the last image of the additional miniatures, the 'Veronica portrait' (fo. 53ᵛ). Here too Christ's face appears, this time to the 'reader', unmediated and striking. Thus the 'reader's' experience parallels John's to the last.

John's closed eyes also have a visual contrast within fo. 1 itself. In the historicized initial embedded in the left-hand column of text, John is seen at a writing desk, receiving instruction from an angel. This image of John writing is also recapitulated in one of the additional miniatures, fo. 47ᵛ, where he is depicted writing in an open codex, his Gothic chair surrounded by sea. The label in the upper margin reads: *His scribit sanctus Johannes apocalipsim post exilium suum*. The visible words on the scroll are clearly those of John's Gospel, however (*In principio erat verbum*), a visual reminder of the conflation of the two Johns that existed in medieval exegesis.[114]

The two columns of text on fo. 1 reproduce Rev. 1: 1–12. There is no commentary text on this page but a short prologue has been included at the top of the page referring to the 'mysterious' and multivalent nature of the Book of Revelation.[115] Around the text there are ornamental border bars and at the bottom of the page is a peacock, a symbol not only of immortality but also of omnivoyance and which may have been included as a striking mnemonic device intended to fix the page in the reader's memory.[116] In other instances (such as at fo. 7ᵛ where a beaver is depicted) animal marginalia seem to have been included in *Lambeth* in order to parody the main miniature and thus aid the memory, but this does not seem to be the case here.[117] In terms of how the text and image actually relate to each other, it should be noted that the image only pictorializes the last two verses of the given text (Rev. 1: 10–12). This shows (*pace* Lewis) that even when artists had around eighty miniatures at their disposal, clear interpretative decisions had to be taken over which sections of the text to pictorialize and which to leave out.

[113] See, for example, the Beatus de Saint Server MS Lat. 8878, Bibliotheque Nationale, Paris, fo. 215 where John stands with the angel transmitting the message of the Book of Revelation to the Seven Churches below him. Christ remains differentiated in the upper tier of the image sitting on a throne.

[114] See Berengaudus (PL 17: 844), for an example of this conflation, but note that this piece of commentary is not reproduced in *Lambeth*.

[115] Seven pages in *Lambeth* have intentionally been designed without commentary extracts. See Morgan 1990: 127 for the full Prologue text.

[116] Lewis 1995: 253. A peacock also appears in London, British Library MS Add. 42555, fo. 5 and Lisbon, Museu Calouste Gulbenkian MS L. 139, fo. 1. See Apostolos-Cappadona 1994: 274 on the symbolism of the peacock.

[117] In fo. 8 it seems as if the hedgehog in the margin is a parody of the Lamb.

### 1.4.4  The role of John in the *Lambeth Apocalypse*

John is in many ways the most important figure in the images of the thirteenth-century illustrated Apocalypse manuscripts. Significantly, this is at odds with his presentation in the *Expositio* where, as Nolan argues, he is characterized as a minor figure, 'the transparent instrument through whom the vision is presented'.[118] By contrast, John appears in around two-thirds of the images in most of the illustrated Berengaudus cycles, including *Lambeth*. He functions as author, protagonist, voyeur, and guide. In *Lambeth* he also performs a unifying function between the Apocalypse miniatures and the additional miniatures.

#### (a) John as author

John's role as author has been discussed in detail in relation to fo. 1 (John on Patmos, Rev. 1: 1–12), fo. 32^v (John commanded to write about the marriage of the bride and the Lamb, Rev. 19: 5–10), fo. 12 (the Mighty Angel appears to John, Rev. 10: 1–11), and fo. 47^v (additional miniature depicting John at his writing desk). However, John is actually rarely characterized in this role in the other miniatures. In fact in *Lambeth* fo. 12, for example, John is actually prevented from writing by the angel. However, his ever-present book plays a large role in implicitly emphasizing his position as the author of the Book of Revelation throughout the miniatures. Thus throughout the miniatures John's book is nearly always visible in his hands, a symbol of his role as an obedient scribe.[119]

#### (b) John as protagonist and voyeur

When John is visualized in the *Lambeth* miniatures, several features indicate his special position as both protagonist and voyeur. First, the illustrations normally respond to textual cues referring to John's actions. So for instance *Lambeth* fo. 1^v constitutes a visual response to the description given by the text in Rev. 1: 12 of John physically reacting to the angel who delivers the first vision: 'Then I turned to see whose voice it was that spoke to me, and on turning I saw seven golden lamp stands . . .'. In the image John is kneeling in prayer at the feet of the 'One like the Son of Man'. Similarly, *Lambeth* fo. 4 takes its cue from the following textual marker: 'Then I looked, and I heard the voice of many angels surrounding the throne and the living creatures and the Elders . . .' (Rev. 5: 11). Thus the image, in this instance, depicts a face-on

---

[118] Nolan 1977: 12.
[119] See fos. 6^v, 7, 7^v, 8^v, 10^v and so forth. Note also fo. 8 where John holds a scroll instead.

view of the throne room scene that John would have seen. When not respond-
ing to textual cues, John's actions and demeanour can serve as clues to the
reader/viewer regarding how *they* might interpret the scene that they are
viewing. Thus in *Lambeth* fo. 7 for instance, John's face has been tinged
with green as he witnesses the earthquake of Rev. 6: 12–17. Similarly, in
*Lambeth* fo. 11ᵛ John shelters behind a rock from the Locust Army (Rev. 9:
16–21).

Secondly, when not a participant in the narrative, as defined by the text,
John appears very much at the edge of the action, as someone 'looking in'.
Indeed, he sometimes appears outside the picture frames altogether, peering
into the action contained within as in *Lambeth* fo. 2. John occupies a position
outside the picture frame in fos. 2, 3, 6, 8, 8ᵛ, 10ᵛ and 27. This has the effect of
distancing him from the action within the frames, whilst also reminding the
viewer of his unique role within the unfolding pictorial sequence. The posi-
tioning of John between the viewer and the main image on these occasions
may also indicate that John is being presented as a 'stand-in' for the viewer
who is also outside the main scene looking in. Inherent within this visual
strategy is the idea that by entering into the apocalyptic experience through
the miniatures (themselves re-creations of John's original visionary experi-
ence) the viewer could potentially undergo a similar transformative experience
to that undergone by John himself.

### (c) John as guide

The reason why the 'reader' feels able to empathize with John has much to do
with the inclusion of a pictorial version of John's *vita* in *Lambeth*. The *vita*
miniatures detail episodes from John's life, from his time preaching in Ephesus
prior to his visionary experience on Patmos right up until his death in Ephesus
after his return from Patmos. They are based on the second-century apocry-
phal Acts of St John which had been known in England since the eleventh
century in Aelfric of Aynsham's version.[120] *The Golden Legend*, which includ-
ed a *vita* of John, was also circulating around Europe from 1266 onwards.[121]
Generally the illustrations preceding John's experience on Patmos appeared
before the Book of Revelation itself and those detailing his life after Patmos
came after. In *Lambeth* the entire *vita* appears after the Apocalypse minia-
tures, although Lewis's suggestion that the first quire of additional miniatures
were intended to precede the Apocalypse miniatures is an attractive one.[122]
See Appendix 3, Table 1, for an outline of the content of the *Lambeth vita*.

---

[120] Morgan 1990: 53–5. See James 1924: 228–70 and Hennecke 1974, vol. 2: 188–259 for the
text of the Acts of St John.
[121] De Voragine, tr. Stace 1998: xvi–xxix.
[122] Lewis 1995: 274.

There are several noteworthy iconographical or thematic links between the Apocalypse miniatures and the *vita* miniatures, which strengthen the argument that the whole manuscript was intended to be experienced as a unity. First, Domitian's use of the sceptre and sword (fo. 41ᵛ) mirrors their 'mis-use' by the Satanic trinity of the Dragon, Beast, and False Prophet in the main Apocalypse images miniatures (see fos. 17ᵛ, 18, 18ᵛ, 19, 19ᵛ, 20, and 20ᵛ). The astute viewer knows that the sword of Judgement belongs to Christ (see fo. 1ᵛ, in which Christ/the 'One like the Son of Man' holds the sword in his mouth in accordance with Rev. 1: 16) and that the sceptre belongs to God (see fo. 2, in which God sits on the throne holding the sceptre). This iconographic link perhaps also indicates that Domitian is to be identified with Antichrist. Secondly, John's soul is taken up to heaven in a 'hammock' (fo. 45), which mirrors exactly the 'soul-hammock' used in fo. 23ᵛ to take the souls of the righteous up to heaven.[123] This miniature thus visually reiterates (or asserts them if it was originally intended to appear before the Apocalypse miniatures as Lewis suggests) John's 'saintly' credentials.

Lewis argues convincingly that in the *vitae* of the Berengaudus Apocalypse cycles the person of John took on a moral significance and that he 'spoke' to the reader in a number of different moral and paradigmatic guises.[124] First John could be viewed as a sort of spiritual pilgrim. He was travelling not to Jerusalem or some holy place, but rather made a journey into the future beyond time and space. On his return to Ephesus he resumes his life as teacher and miracle worker (although his powers seem to have escalated, managing as he does to raise Drusiana from the dead: *Lambeth* fo. 43). John's status as a pilgrim is signified by his staff (see for instance *Lambeth* 28ᵛ, 29ᵛ, 31ᵛ, 32, 35ᵛ, 38, 38ᵛ, and so forth). In this way John acts as a model of contemplative, as well as active, piety.

The John of the Berengaudus *vitae* also serves as a model for priestly ministry. His actions as wandering preacher, teacher, miracle worker, and political exile do not find many parallels in the lives of the orders of cloistered monks. The public ministry of the new mendicant orders had far more in common with John's ministry as it is recorded in these thirteenth-century illustrated *vitae*. He is for instance shown converting a group of Jews (fo. 40ᵛ top) and even baptizing one of them (also fo. 40ᵛ bottom). The way in which John is presented is thought in part to be a response to the goals of clerical reform that were set down at the Fourth Lateran Council of 1215 and extended well into the thirteenth century by figures such as Robert Grosseteste.[125] The

---

[123] The carrying of souls up to heaven in a hammock was a common iconographic feature during this period. See for instance *The Trinity Panel* (see Cheetham (ed.) 1984: no. 228) or the detail of Abraham holding souls in a hammock on the tympanum of the north transept portal of the Cathedral of Notre-Dame at Reims. See also Mâle 2000: 384.

[124] Lewis 1995: 32.

[125] Ibid. 208–15; Southern 1986: 237–44.

correct procedure for priests conducting the Eucharist, for example, was stressed in several injunctions.[126] These injunctions covered the instruments used and the conduct of the priest. In the *Lambeth vita* miniatures, which reflect these concerns, emphasis is subtly placed on the importance of the sacraments in fo. 43 where the sacramental materials left by Drusiana's bed indicate that the last rites have been adequately performed. This theme is further underlined in fo. 45 where a group of figures are depicted attending and participating in the last mass celebrated by John before his death. Here John is assisted by a cleric holding the missal as the Divine Hand reaches down from the sky.

Thus John, in all his guises as spiritual pilgrim, 'reformer', and apostle to the Jews represents an embodiment of the 'new', post-Lateran IV, clerical ideal.

## 1.5 CONTEMPORARY THEOLOGICAL ISSUES AND THE *LAMBETH APOCALYPSE*

### 1.5.1 The 'elect' and the 'reprobates'

The importance and special role of the earthly and heavenly Church is a theme that is heavily stressed in Berengaudus' *Expositio*. This may partly account for its renewed popularity in the thirteenth century. The commentary extracts in the Berengaudus Apocalypse cycles emphasize the role of the Church and the 'elect' as opposed to the 'reprobates' who are destined for hell. The 'elect' or Holy Church and the 'reprobates' are contrasted as early as fo. 2 (commentary to Rev. 4: 1–9), and these identifications continue throughout the commentary extracts in *Lambeth*. So, for instance, at fo. 11ᵛ the breastplates of the demonic horsemen of Rev. 9: 16–21 are interpreted by Berengaudus as symbolizing the hardness of the hearts of the reprobates. Likewise, at fo. 17ᵛ the sea from which the first Beast arises (Rev. 13: 1–3) is interpreted by Berengaudus as representing the 'multitude of the reprobates'.[127] As stressed above, the contrast drawn between the 'elect' and the 'reprobates' by Berengaudus foreshadows one of the dogmatic pronouncements of the Fourth Lateran Council in which the 'reprobates' were contrasted with the 'elect' in the context of the final judgement.[128] Thomas Aquinas went on to define a reprobate as one who cannot be saved (see Matt. 25: 41).[129]

---

[126] See Powicke and Cheney 1964: 29, 82, 142, 171, 296; Moorman 1946: 226, 230.
[127] Translation by Morgan 1990: 181.
[128] Morgan 1990: 27; see Denzinger 1965: 429/801 for the Lateran IV reference.
[129] Morgan 1990: 27; Aquinas, *Summa Theologiae* 1.19.4 and 1.23.

The 'reprobates' and the 'elect' are rarely represented explicitly in the *Lambeth* miniatures, with fo. 37 being a notable exception (Fig. 5). Here the 'books' of those who have done evil are being cast into the fire while they are devoured by the hell-mouth. On the opposite side of the image the righteous in turn hold their 'books', which will allow them entry into the New Jerusalem (Rev. 20: 12–15). At this late stage the viewer is therefore presented with a visual dichotomy to mirror the dichotomy that is frequently made in the commentary extracts between the 'elect' and the 'reprobates'. Although this is the first explicit example of a visual mirroring of the commentary on this prominent topic, there are prior visual hints. At fo. 6, for instance, 'death and Hades', which follow the fourth rider (Rev. 6: 7–8), are interpreted by Berengaudus as 'that which swallows up all who despised the threats of the prophets' (i.e. 'reprobates').[130] 'Death and Hades' are here visually depicted as the hell-mouth from fo. 37, which is devouring a crowd of 'reprobates'. Mâle argued that exegetical impetus for representing Hades as a hell-mouth, which remained fairly constant throughout the late medieval era, came from the identification of the Leviathan from Job 41: 19–21 as an agent of Satan. This identification had first been made by Gregory the Great and then later by Bruno of Asti and Honorious of Autun. This exegetical identification was given visual form in the twelfth-century *Hortus Deliciarum* (Add. 144, fo. 84r) where Hades is depicted in terms of a 'Leviathan-esque' hell-mouth.[131]

Once again in fo. 34v of *Lambeth* some 'reprobates' are visible at the top of the hell-mouth, which the false prophet and the Beast are being cast into. Meanwhile fo. 36 represents Rev. 20: 7–9, in which Satan and his army attack the 'holy city'. The commentary text identifies Satan and his army with the 'reprobates' and the saints with the 'elect'. This dichotomy is visualized for the 'reader' by once again placing the hell-mouth in the bottom left-hand corner of the picture frame. The soldiers of Satan's army rise up out of the hell-mouth while the 'elect' shelter in the castle on the right-hand side of the image. Finally, in fo. 28v the 'unclean spirits *like* frogs' that come out of the mouths of the Dragon, the Beast, and the false prophet (Rev. 16: 13–16) are represented as actual frogs. An identical frog appears in another representation of the hell-mouth in fo. 36v despite the fact that they are not mentioned again in the text of the Book of Revelation. Morgan suggests that the frog may be a visual reference to the 'reprobates'.[132]

In addition to the frog detail, in fo. 36v (Fig. 6) and fo. 47 (the fifth Theophilus miniature) there is a butterfly near the edge of the hell-mouth, an iconographic feature that scholars have found hard to explain. Butterflies were associated with death and the flight of the soul in Roman culture.[133]

---

[130] Translation from Morgan 1990: 146.   [131] Mâle 2000: 179–81.
[132] Morgan 1990: 235.
[133] Deonna 1920, 1954; Charbonneau-Lassay 1940: 850–2.

However, why they came also to be associated with hell is somewhat mysteri-
ous. Morgan suggests that it is possible that the butterflies represent the souls
of repentant sinners destined for purgatory after having narrowly escaped the
jaws of hell.[134] It is noteworthy that the butterfly does not appear in the earlier
Metz fo. 29$^v$ (the parallel image to *Lambeth* fo. 36$^v$) but that it does appear in
the later Gulbenkian Apocalypse fo. 71 (again the parallel image), an indica-
tion that the butterfly motif originated with *Lambeth*. Neither does it appear in
other 'families' of the Berengaudus Apocalypse cycles.

The preceding analysis has shown that while Morgan is on the whole
correct to suggest that the *Lambeth* miniatures illustrate the text of the Book
of Revelation only and not the commentary text, it seems that there *is* in fact
some subtle, visual 'mirroring' or elucidation of the commentary in the
Apocalypse miniatures, which is sometimes further echoed in some of the
additional miniatures.[135] The newly formalized category of the 'reprobates'
was clearly a matter of contemporary interest. Perhaps in a reflection of this,
the battle between Satan and Christ, the symbolic representatives of the
'reprobates' and the 'elect' according to the commentary, is recapitulated
vividly in the two Mercurius miniatures in fo. 45$^v$ (Fig. 7).

The first miniature shows the Virgin rousing the sleeping soldier from his
tomb and arming him with chain-mail armour. The shield given to Mercurius
by the angel, which he uses in the fight against Julian, provides a parallel with
the shield of faith that the woman holds out against the devil in the allegorical
picture on fo. 53. In both images the shield, which has been painted with a
cross, symbolizes protection against evil. In the bottom image, Mercurius is
now attired as a traditional crusader knight. The Virgin holds his right arm
and an outstretched hand reaches down from heaven and touches him on
the shoulder. The similarity with fo. 34 (Fig. 8) which depicts the rider on the
white horse battling with the army of the Beast (Rev. 19: 19) is striking.[136]
Although not attired as a knight, the posture and spear position of the rider on
the white horse (Rev. 19) and Mercurius are almost identical. Both thrust their
long spears into their victims with such force that the spear protrudes out
of the frame. In the case of the Mercurius miniature, Julian actually falls out of
the frame himself, his sword, his symbol of authority, falling down into the
void of the white border. The Mercurius legend is thus being presented as a
recapitulation of the battle between good and evil that was played out across
the seventy-eight miniatures depicting the Book of Revelation. Julian, the
tyrannical ruler and apostate, is presented as a manifestation of the Beast.
Interestingly the position occupied by the Virgin at the top left hand of fo. 45$^v$
(Fig. 7) is the same as that occupied by John in fo. 34 (Fig. 8). This 'mirroring'

---

[134] Morgan 1990: 56.      [135] Ibid. 94.
[136] See also fo. 15$^v$ (St Michael fighting the Dragon) and fo. 19 (the Beast making war on the
Saints).

of the Virgin's position would seem to indicate that John was seen, in his role as intermediary, to embody something of the two realms, human and Divine.

The 'thrusting of the spear' is also echoed in fo. 46ᵛ (Fig. 2) and fo. 47, two of the Theophilus miniatures. In fo. 46ᵛ (top), the saint/statue on the left-hand side of the image drives back a little devil with a long spear as Theophilus prays to the Virgin. The type of spear and the angle it is being held at recall the spear used in fo. 34 (Fig. 8) and fo. 45ᵛ (Fig. 7), discussed above. It also foreshadows the use of the spear by Michael in fo. 47, the fifth Theophilus miniature which depicts the Virgin and Michael as they descend into hell. The use of the spear by Michael to thrust one of the devils into the hell-mouth recalls fos. 34, 45ᵛ, and 46ᵛ. The same battle against evil, fought across the Apocalypse miniatures, is thus recapitulated visually for the viewer. The fact that the Virgin is accompanied by Michael, who actually engages in combat with the Satanic forces, is also significant and recalls the images used to illustrate Rev. 12 (fos. 15ᵛ–17). Here, the Woman Clothed with the Sun (in accordance with the text of Rev. 12: 1–14) is presented as a fairly passive figure. She is literally rescued by Michael and his angels, who spear the Dragon and his devils as she looks on from afar, or as in the case of fo. 17, is not depicted at all. The Virgin had long been associated with the Woman Clothed with the Sun by exegetes.[137]

### 1.5.2 Anti-Judaism, Antichrist, and the future in the *Lambeth Apocalypse*

The exegetical and visual presentation of Judaism in the thirteenth-century illustrated Apocalypses reflects the fact that the Jews in England were subjected to increasing prejudice and discrimination during this century. The synods from 1240 to 1261 adopted increasingly stronger measures against Jews.[138] From the 1260s up until the eventual expulsion in 1290 the Jewish people lived in fear of attacks and evictions.[139] Although previous commentators on the Book of Revelation such as Richard of St Victor and Bruno of Sergei had included Jews among the groups (along with pagan heretics, false Christians, and so forth) destined to be destroyed in the visions of the seven seals, trumpets, and bowls, they rarely singled out the Jews for special

---

[137] An unambiguous exegetical link between the Woman Clothed with the Sun and the Virgin Mary had been made as early as the 5th cent. (see Quodvultdeus in *De Symbolo* 3, PL 40: 661). In terms of artistic representations unambiguous examples of Mary as the Woman Clothed with the Sun start in the 14th cent. (see BL, MS Royal 6. E. VI. fo. 479). However, earlier, more ambiguous examples abound. See, for instance, the Beatus Manuscripts (Spain, 10th–11th cent.) and the 13th-cent. *Lambeth* and Trinity Apocalypses. See Oakes 1997: 272 ff.; Kovacs and Rowland 2004: 137 for further information.

[138] Watt 1988: 137–47.     [139] Lewis 1995: 216; Baron 1965, vol. 10: 101.

attack.[140] This was not the case with the Berengaudus commentary, which is to
be distinguished from these other commentaries in both the number and
violence of its anti-Jewish assaults. The Jews are condemned (among other
things) for the harshness of the Jewish law, for being disciples of Antichrist,
and for being persecutors of the Church.[141] The commentary also dwells on
the eventual rejection and destruction of the Jews that Berengaudus envisages
as a vindication for the blood of Christ.[142] The extracts from Berengaudus'
*Expositio* chosen for *Lambeth* certainly reflect this, with at least seven passages
referring to the rejection and destruction of the Jews.[143] Lewis argues that the
use of the Berengaudus commentary in the thirteenth-century illustrated
Apocalypse provided 'a framework of justification for abuses against the
Jews'.[144]

Interestingly the anti-Jewish overtones of the Berengaudus commentary are
rarely reflected in the illustrations for the actual text of the Book of Revelation.
Only a few details stand out. In *Lambeth* fo. 5ᵛ, the third horseman from Rev.
6: 6 is depicted as wearing a hood in order to symbolize the inability of the
Jews to see or understand scripture in the spiritual sense in which it was
revealed to John. This may be in response to the commentary passage which
claims that the black horse signifies the doctors of the law and that the
blackness of the horse signifies the obscurity of the law that they taught as
well as its harshness. Similarly in some of the illustrations to Rev. 13 some of
the followers of the Beast are characterized as Jews. Folio 20ᵛ, for example,
depicts some of the followers with exaggerated 'Jewish' features and wearing
Jewish caps.

However, the anti-Jewish sentiment that is so virulent in the Berengaudus
commentary is found in a more sustained way in the illustrations for John's
*vita*, as well as in the additional miniatures in *Lambeth*. Included under the
heading of 'additional miniatures' are three marginal inserts (fo. 12 (Fig. 9),
fos. 12ᵛ and 13) of scenes from the life of Antichrist.[145] These additional
miniatures accompany the standard miniatures to Rev. 10: 11–11.8. In the
first two scenes (see fo. 12), Antichrist and his followers are depicted as
wearing pointed 'Jewish' hats, perhaps a visual reference to Berengaudus'
interpretation of Rev. 13: 11–14 that 'although many of the Jews believed in
Christ through the preaching of Elijah, the greatest of them shall follow

---

[140] Lewis 1995: 216.
[141] See Berengaudus extract on *Lambeth* fo. 12, for example, which claims that most of the
Jews follow Antichrist.
[142] See Berengaudus commentary extract on *Lambeth* fo. 27ᵛ.
[143] See *Lambeth* fos. 5ᵛ, 7, 7ᵛ, 11ᵛ, 12, 19ᵛ, 27ᵛ.
[144] Lewis 1995: 216.
[145] Antichrist miniatures also appear in New York Pierpoint Morgan M. 524, Oxford
Bodleian Library Auct. D. 4.17, and London, British Library MS Add. 42555.

Antichrist'.[146] That the devil's agents were to be thought of as Jewish is visually reiterated in the Theophilus story. Here the Jewish 'friend' is portrayed as an agent of the devil in the first miniature and the devil himself is depicted as wearing the pointed Jewish cap.

Throughout the *vita*, John is also characterized as an apostle to the Jews. Many of the people John preaches to and converts are characterized as Jewish. So in fo. 41 (top), for instance, the three men that John is addressing wear exaggerated pointed Jewish caps and have exaggerated 'Jewish' features such as large noses. Many of the pagans, soldiers, and Roman officials have also been recast as Jews with pointed Jewish hats and exaggerated 'Jewish' features.[147] This is a polemical example of how the text of the Book of Revelation can be (and repeatedly has been) 'actualized' in different contemporary situations. 'Actualizing', as defined by Kovacs and Rowland, refers to an interpretation of the Book of Revelation whereby the text is juxtaposed with the interpreter's own circumstances, 'so as to allow the images to inform understanding of contemporary persons and events and to serve as a guide to actions'.[148] Thus actualizing interpretations belong to the 'metaphorical' strand of exegesis discussed above and not to the 'decoding' strand.

The interpolation of miniatures depicting scenes from the Antichrist legend into the body of the Apocalypse miniatures is not unique to *Lambeth*. Morgan 524, the Gulbenkian Apocalypse, and the Abingdon Apocalypse all interpolate series of miniatures detailing the Antichrist legend into their Apocalypse cycles. This represents a clear divergence from the emphases of Berengaudus' *Expositio*. Berengaudus had on the whole avoided speculation regarding Antichrist and when he was likely to appear. Neither did he engage with the medieval 'Antichrist legend', which represents Antichrist as a diabolical human figure whose life mirrors that of Christ.[149] Thus, his commentary on Rev. 14: 13–16 (see *Lambeth* fo. 28ᵛ) identifies the 'frog-like' unclean spirits with a general 'Antichrist' figure through whose mouth the devil speaks. The frogs spouting out of the mouths of the Beasts in the accompanying image are a good visual reminder of the commentary passage here.

By the thirteenth century, perhaps as a result of the proliferation of Joachite ideas, speculation had become more fevered. Twelve extant copies of Bishop Adso's *De ortu et tempore Antichristi* date from thirteenth-century England.[150] Opinions differed as to the form Antichrist's appearance would take. Joachim himself had regarded Antichrist as an inevitable part of the Divine plan

---

[146] See *Lambeth* fo. 19ᵛ.

[147] See *Lambeth* fos. 40ᵛ top and bottom, 41 top and bottom, 41ᵛ top, 42 bottom, 42ᵛ, 44 top. See also fo. 45ᵛ on the same theme where Julian the Apostate's army appears to be wearing pointed Jewish hats.

[148] Kovacs and Rowland 2004: 9.

[149] McGinn 1988: 13–18.

[150] Freyham 1955: 229 nn. 1–2.

regarding the eschaton. R. Grosseteste and others argued that the advent of Antichrist was directly linked to the corruption present in the Church and that his advent could be averted through ecclesiastical reform.[151] While the addition of the Antichrist miniatures to fo. 12 (Fig. 9), fos. 12$^v$ and 13 may have been an attempt on the part of the designers to engage on a visual level with the thirteenth-century interest in Antichrist, the commentary extracts themselves were not updated to fit with this particular contemporary concern. Instead, the future focus of *Lambeth* is directed towards a Judgement theme. This is particularly clearly brought out in *Lambeth* fo. 35$^v$, which illustrates Rev. 20: 4–6 (the first resurrection). Instead of presenting this as the initiation of a future kingdom of Christ on earth, the composition is dominated by three judges presiding over the souls of the first resurrection in the left-hand corner of the image as if engaged in a philosophical debate. Certainly there is no intimation here of the more usual thirteenth-century view, that the first resurrection would be a joyous age of the saints during which the Church would be returned to a state of perfection and Jews and pagans would be converted.[152]

## 1.6 CONCLUSION

*Lambeth* was produced for an aristocratic female patron (either Eleanor de Quincy or Margaret Ferrers) in the mid- to late decades of the thirteenth century (but certainly not after 1281). It stands within the Berengaudus branch of the English illustrated Apocalypse, a thirteenth-century manuscript phenomenon. All the manuscripts in this family follow the same page layout and thus present the reader with the same package of image, biblical text, and gloss on each opening, a way of representing the Book of Revelation that breaks it down into a series of 'episodes' as opposed to a more free-flowing narrative. It was suggested that this visual, 'episodic' approach appealed to the thirteenth-century lay-'reader'. 'Readers' may have used these Apocalypse manuscripts, and in particular the miniatures, both as a perceptual way into spiritual and theological contemplation and as a mnemonic device for internalizing the narrative of the Book of Revelation. It was remarked upon that the Book of Revelation lends itself particularly well to mnemonic visualization on account of its sequential structure and vivid, symbolic language.

It was also suggested that despite the fact that on the whole the Apocalypse miniatures in the Berengaudus manuscripts pictorialize the text of the Book of Revelation (and hardly ever the commentary) in a fairly literal way, they also, at times, have a deeper exegetical function. This is particularly evident in the

[151] Southern 1986: 281–4: Lewis 1995: 229.   [152] Lewis 1995: 186.

case of *Lambeth*, which contains an additional set of miniatures as well as various marginalia, such as the visualization of the Antichrist legend on fos. 12–13, which draw out and even extend the themes inherent in both the Book of Revelation itself and, in some cases, the Berengaudus commentary extracts. The relationship between the two quires of additional miniatures and the Apocalypse miniatures is not immediately clear. However, analysis of the key visual themes in both sets of miniatures has revealed hints of a sophisticated visual thread running throughout the entire manuscript. For this reason, as well as the presence of numerous iconographical similarities, it has been argued throughout that *Lambeth* should be viewed as a whole, with no essential distinction made between the Apocalypse miniatures and the additional miniatures.

The figure of John provides the most obvious visual link between the two sets of miniatures as well as between the Apocalypse miniatures themselves. Throughout the miniatures he is portrayed alternately as author of the visions, protagonist, voyeur, and guide, a presentation that contrasts with his minimal portrayal in Berengaudus' *Expositio*. The viewer is thus forced to attend to John and his role in the visions in an unprecedented way, the visual implication being that they are dependent on John for their existence and even their veracity.[153] John's power as mediator between the viewer and the visionary world is also emphasized through this new, almost 'John-centric' presentation. His role as protagonist reaches its climax in the last Book of Revelation miniature where he faces Christ (fo. 39$^v$, Fig. 4), unmediated and with open eyes, having passed from incomprehension to understanding. Christ's face appears again in the very last additional miniature, thus reminding the viewer of the climax of the Book of Revelation itself. John's role as spiritual guide is extended in the *vita* miniatures where he is also characterized as a pilgrim, a teacher/healer, and a priest, in a reflection of contemporary ecclesiastical concerns.

Just as John's role is 'extended' in the *Lambeth* miniatures, so are other theological and apocalyptic themes. Thus the commentary's preoccupation with the division between the 'elect' and the 'reprobates' is reflected in the frequent visual portrayal of the damned of the Book of Revelation in the menacing hell-mouth, which becomes, in the miniatures, a visual symbol for both Hades and the 'eternal lake of fire' (Rev. 20: 10). This seems to me to indicate that some of the concerns of the commentary *are* (*pace* Morgan and Henderson) subtly reflected in the Apocalypse miniatures themselves, despite the fact that the patron would very probably not have been able to discern this without help from an expert figure. This also applies to the anti-Jewish iconography that has been interpolated into the Apocalypse miniatures as

---

[153] See Camille 1992: 287–8.

well as into the additional miniatures in a reflection both of the anti-Jewish tone of the commentary as well as contemporary anti-Jewish sentiment. Finally, the interpolation of the Antichrist miniatures at the bottom of fos. 12–13 represents an interesting subversion (or perhaps an 'updating') of the Berengaudus commentary, which does not speculate about a human Antichrist figure. However, the inclusion of the miniatures at the bottom of fos. 12–13 strongly encourages the 'reader' to interpret those folios in terms of the Antichrist legend, thus effectively overriding the interpretation given in the commentary extracts. Therefore it seems that whilst on the whole the *Lambeth* images embody a literalistic form of representation with an emphasis on comprehensibility, there are also fleeting attempts to engage with the spirit and not the letter of the Book of Revelation.

However, while it has been possible to trace several visual themes through *Lambeth*, it cannot be denied that in exegetical terms 'reading/viewing' such a manuscript in its entirety is a multi-layered, complex experience, only able to enlighten the most dedicated and observant of readers. Lewis seems correct in maintaining that one had to develop a completely different way of reading before one could even think about using such a manuscript to maximum advantage. However, the determinedly visual approach to the Apocalypse espoused by the *Lambeth* miniatures meant that even viewers, perhaps such as de Quincy or Ferrars, who were unable to understand the Latin text and commentary, could gain an understanding not only of the content of the Book of Revelation but also of its visionary character. John's visionary journey is traced out for them, step by step, mainly through the figure of John himself, across the seventy-eight Apocalypse miniatures. Key visual themes are then reiterated in the subsequent miniatures. The thoroughness of the simplistic images meant that one could understand the text without ever reading it. Thus, in this important way, illustrated Apocalypse manuscripts such as *Lambeth* foreshadowed the 'de-throning' of the biblical text suggested in Dürer's late-fifteenth-century Apocalypse images, which will be discussed in Chapter 5.

This sense of transformation, of entering the world of the text almost as a participant rather than an observer or 'reader', also pervades the *Angers Apocalypse Tapestry*, the subject of the next chapter. The tapestry has close iconographical links with the thirteenth-century Berengaudus Apocalypse manuscripts. The transposition of this iconography onto a huge, life-size scale, and the removal of both the manuscript layout and most of the biblical text, renders the *Angers Apocalypse Tapestry* an interesting counterpart to its manuscript relations.

# 2

## The *Angers Apocalypse Tapestry*

### A Fourteenth-Century Walking Tour
### of the Book of Revelation

## 2.1 INTRODUCTION

In 1373 work commenced on the *Angers Apocalypse Tapestry* (hereafter *Angers*), the largest surviving narrative representation of the Book of Revelation.[1] Intended, as far as is known, as a display piece at ceremonies and weddings for its owner Louis I of Anjou (1339–84), second son of Jean II of France, in its original state the tapestry measured around 130 m long (across two tiers) and around 4.5 m high (on average). *Angers* served as the inspiration for several other large-scale Apocalypse tapestries commissioned in France around the same time and thus is the most important example of a key moment in the artistic reception of the Book of Revelation, as well as in the wider history of tapestry as a whole. As exhibited today (in a special display centre at the Château d'Angers) *Angers* measures a still monumental 103 m long by 4.5 m high.

As well as being part of a unique moment in the artistic reception of the Book of Revelation, *Angers* has been included in this study for several additional, and key, reasons. As discussed in Chapter 1, *Angers* represents a transposition of the thirteenth-century, Anglo-Norman Apocalypse iconography onto a huge and very physical scale. In order to follow the narrative of the Book of Revelation the viewer must literally walk alongside the tapestry, which is subdivided into six sections (each about twenty metres long) following first the top tier and then returning to the beginning of said section to follow the second, lower tier before moving on to the next section and so on. It is just about possible to 'take in' one section at a time by standing back against the

---

[1] Ten images from the *Angers Apocalypse Tapestry* have been reproduced here. For full colour reproductions of all extant images in the series, see Muel 1996 or http://www. johannesoffenbarung.ch/bilderzyklen/angers.php.

museum wall and looking out at the tapestry, but to fully grasp the narrative of the Book of Revelation, let alone the interpretative nuances of the tapestry, one needs to walk along it. Thus the viewer controls, through their own walking speed, the speed at which he/she views the tapestry and therefore the speed at which the visual narrative unfolds. The sheer size of the work in combination with the very balanced, simple compositions of the individual scenes, which are all enclosed by a *faux* architectural, almost three-dimensional frame and of which there are fourteen in each section, also make *Angers* very legible as a representation of the Book of Revelation, even if the overall effect, like Lambeth, is somewhat repetitive.[2]

The experience of viewing *Angers* is a very temporal, physical, and inclusive one. For those who do not know the text of the Book of Revelation very well, no better introduction could be imagined. It was argued in the previous chapter that *Lambeth* too was intended to help the 'reader' to memorize and internalize the Book of Revelation. However, the ways in which these two different artefacts achieve some of the same ends are markedly different. Where 'reading' *Lambeth* was a private, devotional experience, the original viewers of *Angers* would have been exposed to the tapestry at public functions such as the marriage of Louis' son, King René of Anjou, at Arles in 1400. Although *Lambeth* is determinedly visual, the images are framed by both extracts from the Book of Revelation and a commentary. There was originally a tier of (woven) text running through the middle of the upper and lower tiers of *Angers*. Some traces of these sections were discovered in the lining in three different parts of the tapestry when the lining was removed in 1982. These very small fragments consist of parts of letters woven in red or beige wool on a brown background. Examination of these fragments has led to the suggestion that this middle panel would have been about 58 cm in height.[3] Nowhere has this text been precisely recorded. It may have comprised extracts from the text of the Book of Revelation, or a gloss or commentary extract. On some level then, the presence of a text was important. However, the room allowed for the text was relatively small (in comparison with the tapestry scenes themselves, which measure around 1.8 m in height) and in this sense one witnesses a move away from the highly 'text-conditioned' Anglo-Norman Apocalypse manuscripts of the thirteenth and fourteenth centuries. As Camille points out, the fact that the images would have dominated the (perhaps illegible) text, to the point where the images are almost autonomous, is proof of how well-known the Book of Revelation text was by this time.[4] It also points to the fact that it had begun to enter the public consciousness as primarily a visual rather than a textual entity.

---

[2]  Muel 1996: 14; Van der Meer 1978: 180.
[3]  Muel 1996: 14.
[4]  Camille 1992: 280.

Despite the lack of text in the tapestry, *Angers* has, for the most part, followed the narrative progression of what I have called the Metz–Lambeth Apocalypse iconography. However, there are important flashes of exegetical complexity in *Angers* which reveal a deep understanding of the Book of Revelation and its developing interpretative tradition. These points of exegetical insight occur at moments where *Angers* deviates from the Metz–Lambeth iconography. In conjunction with these developments, there is no doubt that, owing to its monumental scale and unique presentational format, *Angers* provides the viewer with a new sort of encounter with the Book of Revelation.

## 2.2 PATRON AND POSSIBLE PURPOSE OF THE *ANGERS APOCALYPSE TAPESTRY*

As stated above, the patron and commissioner of *Angers* was Louis I of Anjou.[5] By the mid-1360s Louis had started to build up an impressive collection of both 'narrative' and more decorative tapestries. At this stage France was still the leading expert in the art of tapestry, and expert workshops existed in Paris and Arras.[6] Louis and his brothers, Charles V, Philip le Hardi (Duke of Burgundy), Jean (Duke of Berry), and Louis II (Duke of Bourbon), had a collection of hundreds between them, their patronage functioning as the major economic force behind the French tapestry industry. Weigert argues that by the fifteenth century, and precipitated by the commission of *Angers*, the commission and public display of tapestries had become very important for French royalty and nobility. The large scale of such works as well as the size of their overall tapestry collections attested to the wealth of their owners.[7] Whereas previously tapestries functioned as mobile frescoes for decorating castles and homes, they were now displayed at important ceremonies. In the January miniature of the *Tres Riches Heures du Duc de Berry*, for example, an elaborate tapestry, thought to be a medieval interpretation of the Trojan War, complete with poetry inscriptions and heraldic detail, provides the impressive courtly backdrop for the Duke's epiphany celebrations in the foreground.[8] Weigert argues that in late thirteenth-century France, tapestries had become a key part of the mise en scène of the ruler's authority.[9]

---

[5] For information on the life of Louis I of Anjou see: Delachenal 1910; de La Marche 1892, vol. 2: 175–264; Gaborit-Chopin 1985: 157–78.

[6] Elek 1946: 32; Weigert 2004: 7.

[7] Weigert 2004: 8.

[8] *Les Tres Riches Heures du Duc de Berry*, 1411–16, Chantilly, Musée Condé, MS 65, fo. 1ᵛ. See also Longnon and Cazelles (eds.) 1989: 2, 173.

[9] Weigert 2004: 8.

Tellingly, it was during the 1370s that Louis I of Anjou began to harbour ambitions to be crowned Emperor, ambitions which manifested themselves through his defence of the Pope in Italy.[10] In the mid-1370s he commissioned *Angers*, the scale and scope of which mirrored his imperial ambitions. Louis' choice of the Book of Revelation as the subject-matter for his most monumental tapestry has been much discussed. Ruais suggests that Louis might have seen hope for his own salvation in the Book of Revelation in spite of the unethical life that he had lived.[11] It is certainly true that *Angers*, like the Anglo-Norman Apocalypse manuscripts from which it takes its compositional and iconographical shape, places emphatic visual emphasis on scenes of heavenly liturgy and the New Jerusalem, thus ultimately emphasizing the positive side of the Book of Revelation over and above the negative cycles of destruction. Similarly, as was the case with Lambeth, the vivid, visual language of the Book of Revelation that unfolds within a structure of clearly defined sequences, lends itself easily to, perhaps even demands, visualization in a way that the Pauline Epistles, for example, do not. Conversely, the impact of the Black Death, which peaked in Europe between 1348 and 1350 and left a legacy of fear and morbidity should perhaps not be discounted when considering Louis' choice of subject-matter. This far-reaching historical disaster finds many echoes in the Book of Revelation which is replete with vivid descriptions of terrible plagues and pestilence (Rev. 6: 8; 9: 4–6, 18; 16).

Whatever the philosophy behind *Angers*, in 1373 Louis was lent an Apocalypse manuscript by his brother Charles V ('une Apocalipse en francois toute figurée et ystoriée'), the lending of which was entered in the King's library records and which has allowed historians to identify it with Paris BN fr. 403.[12] The 1380 entry next to the Apocalypse manuscript in question in the posthumous inventory of the King's library reads as follows: 'Le Roy l'a baillée a mons. D'Anjou, pour faire son beau tappis.'[13] It may therefore be surmised that the lending of the book in 1373 marked the beginning of the whole enterprise.[14]

Louis' ambitions to be crowned Emperor also coincided with his founding of the 'Order of the Cross', a society based around a relic, which he had stolen from the Boissière Abbey in Nantes, in the form of a cross with a double horizontal bar.[15] It was believed to have come from Christ's own cross and then later carried by an Emperor of Constantinople. Louis made the cross the symbol of his kingdom and founded the Order of the Cross in its honour. The

---

[10] Ruais 1986: 32.

[11] Ibid. 33.

[12] For the full entry see MS fr. 2700, fos. 5 and 42, Bibliothèque Nationale, Paris; See also Avril 1982: no. 291.

[13] King 1977: 160; Delisle 1907, vol. 1: 147; vol. 2: 19; Avril 1982: no. 285.

[14] For information on the design, manufacture, and financing of *Angers* see Archives Nationales, Paris, KK. 242, fos. 66$^r$ and $^v$, 92$^r$ and $^v$, 93$^r$; Lestocquoy 1978: 20–7; Ruais 1986: 33–5; and De Merindol 1987: 32.

[15] Gaborit-Chopin 1985: 171–2.

symbol can be seen on the flags being held by angels at the top of the four remaining 'opening scenes' to sections one, three, four, and five of *Angers* (see the flag on the right at the top left-hand corner of 1.1, Fig. 10). In each case the flag bearing the cross of Anjou actually overlaps with the upper border above the first scene of that section. This has the effect of linking Louis and the symbol of the Order of the Cross with the visions of the Book of Revelation. Gaborit-Chopin emphasizes the links between the symbol and the tapestry and argues that *Angers* may have been specifically made to be used in ceremonies related to Louis' Order of the Cross.[16] As will be discussed below, Louis' interest in this relic and the Order of the Cross is reflected in *Angers*' visual emphasis on the sacrifice of the Lamb (see *Angers* 1.7 and 4.47).

Between 1380 and 1382 Louis acted as Regent for the young Charles VI. This may prove significant for the interpretation of *Angers* 4.53, which seems to draw a visual comparison between the two angels of Rev. 14: 14–16 and Louis and his nephew, Charles VI, one of whom is depicted as an old man wearing a crown and the other as a young man wearing a smaller crown. Louis died in 1384 and curiously may never have seen *Angers* permanently displayed, as he did not have a room big enough in the Château d'Angers to accommodate the full length and height of the tapestry. Indeed a later inventory of the Château of Angers reveals that most of the time *Angers* was kept in a cupboard and sometimes laid out on a table.[17]

Perhaps the tapestry was primarily hung outside at special ceremonies, as was the case in the next recorded mention of it, in 1400. *Angers* can almost certainly be identified with the wall hangings referred to by Betrand Boisset at the marriage of Louis II (son of Louis I) to Yolande of Aragon in Arles. Boisset described the hangings as follows:

> Item tout à l'entour fut encourtinée et parée de draps nobles et beaux surlesquels draps était historiée tout l'Apocalypse. Et il n'est homme qui puisse écrire ni raconter la valeur, la beauté, la noblesse de ces draps, desquels l'hotel de l'archevêche était décoré tant aval qu'amont, car toutes les salles, chambres et corridors et la chapelle étaient très noblement parés.[18]

This quotation gives one a sense of the tapestry being hung all around the Archbishop's palace as decoration, but also as something to be walked around and experienced in a chronological fashion. There are also some indications that *Angers* went on to be used as background tapestries or scenery in mystery plays in Angers itself, as well as in Arles in the fifteenth century.[19] Others have

---

[16] Ibid. 171–88.

[17] See Godard-Faultrier 1866: 68 ('En la chambre de la Tappicerie:... unes armoires à deux guischez farmans à clef... item une grant table sur quoy on dresse la tappicerie, soubs laquelle sont quatre tréteaux...').

[18] See Planchenault 1941: 136–7.

[19] See Michel 1959: XL–LI.

argued that *Angers* was used as scenery for a repertory mystery play in Angers as early as the late fourteenth century. Mystery plays were 'popular' street narratives that recounted biblical stories over a number of days and nights.[20] However, I have not been able to find any further evidence for this claim of fourteenth-century 'popular' usage made in the Angers Museum audio guide.

For Louis I of Anjou then, *Angers* was primarily a status symbol, a sign of wealth and power, to be displayed at special ceremonies and perhaps particularly at the ceremonies of the Order of the Cross. The House of Anjou is certainly promoted through the heraldry present in the tapestry. Angels bearing the arms of Anjou on trumpets are found (facing each other) above the first two sections of the tapestry (see *Angers* 1.6 and 2.17). Above the other four sections, angels hold shields with the arms on. The fact that some of these angels hold shields and banners decorated with the arms of Anjou (see 2.17, 3.30, 3.31, 3.33, 4.44, 5.62 and especially the flags above the first, third, fourth, and fifth 'large figures') also serves to link the House of Anjou with the heavenly realm represented by this upper border. Outside the canopies of the 'large figures' in scenes 1.1 (Fig. 10), 4.41, and 5.56 are butterflies with coats of arms on their wings. The coats of arms alternate between those of Louis I of Anjou and those of Marie de Blois (his wife, d. 1404). In 1.1 and 4.41 the butterflies are represented only on the left of the canopy, but in 5.56 their number has been doubled and they fly around the whole monument. The use of butterflies in *Angers* as a visual vehicle for promoting the arms of the House of Anjou is interesting in light of the fact that in Lambeth the butterfly motif appeared only in connection with depictions of hell (see Lambeth MS 209, fo. 36$^v$ (Fig. 6) and fo. 37). Whilst this negative appropriation of the butterfly motif was echoed in the later Gulbenkian Apocalypse manuscript, clearly the butterfly symbol enjoyed more positive iconographic connotations in France in the late fourteenth century.

Louis' Apocalypse tapestry quickly became popular and sought-after, as emphasized by King in his article entitled, 'How many Apocalypse Tapestries?'[21] The accounts of Philip le Hardi, Louis' younger brother, record the commissioning of another set of six Apocalypse tapestries in 1386 from Robert Poinçon, the head weaver of *Angers*.[22] Jean, Duke of Berry, also owned a single Apocalypse Tapestry recorded in a posthumous inventory of 1416, and in 1490 a single Apocalypse tapestry was donated by a later Duchess of Bourbon to the chapter of Angers Cathedral.[23] Although *Angers* is the only extant Apocalypse tapestry from this period, it is clear from the evidence in the various accounts cited that among this family at least, an 'Apocalypse tapestry'

[20] Angers Tapestry Museum audio guide, 2006.
[21] King 1977: 160–7.
[22] Ibid. 161–2; see Dehaisnes 1886 : 639, 646, 666, and 697 for the original accounts.
[23] Ibid. 162.

was a popular and desirable item. There may of course have been many more Apocalypse tapestries commissioned that have not been recorded in accounts or that were recorded in accounts that were later lost. This was therefore an important moment in the artistic history of the Book of Revelation.

## 2.3  JEAN DE BONDOL AND THE MANUSCRIPT MODELS FOR *ANGERS*

Jean de Bondol or Hannequin of Bruges, one of the best-known artists working in France towards the end of the fourteenth century, is credited with artistic responsibility for *Angers*, either through drawing the miniatures from which the cartoons were prepared or through actually designing the cartoons himself.[24] *Angers* could not simply have been prepared by transposing the miniatures from a manuscript such as BN fr. 403 into tapestry form. A skilled artist was required to translate the miniature models onto a much larger scale. Once commissioned by Louis, de Bondol executed cartoons of small dimensions, probably the 'pourtraitures et patrons' (designs and patterns) for which he was paid in 1377.[25] The artists or cartoon drawers who realized the cartoons on the large scale now evident in *Angers* are not known to us. Joubert has suggested that it was perhaps the weavers themselves who did this, on account of the number of repeats of the same figures and buildings near the end of the tapestry. These repetitions seem to indicate that some of the cartoons were missing or incomplete, especially towards the end where the repetitions are more frequent.[26] There is also evidence of far greater suppleness and nuance in the figures of the first two sections and in those at the start of the third than in the remaining sections.

There has been a great deal of research done on de Bondol's use of existing, and in particular thirteenth-century, Apocalypse manuscripts. Henderson has written an influential article on the subject and his findings will be briefly summarized here.[27] As noted above, there exists documentary evidence that Louis I borrowed what is now known as Paris BN fr. 403 from the library of Charles V in 1373.[28] It was naturally assumed, for a while, that this was the manuscript used by de Bondol in his preparation of the cartoons.[29] However,

---

[24] For more information on Jean de Bondol see Erlande-Brandenberg 1993: 283–9. See also Muel 1996: 6.

[25] Ruais 1986: 33.

[26] Joubert 1981: 135.

[27] Henderson 1985: 209–18.

[28] See the entry in Charles V's library inventory from 1373 in BN Paris: MS fr. 2700f 5 and 42 cited by Avril 1982: no. 291.

[29] Delisle and Meyer 1901: clxxvi–cxci.

it was soon realized that BN fr. 403 belongs to what is commonly known as the first family of Anglo-Norman Apocalypse manuscripts, while the *Angers* images seem to have more in common with the second family, which includes the Metz–Lambeth cycles. One example of this is the fact that in *Angers* the Two Witnesses are killed by the figure of Abaddon (3.31), rather than by the henchmen of Antichrist, as is the case with manuscripts belonging to the first family such as Paris BN Fr. 403.[30] Henderson suggests that the Apocalypse images in what are known as the Burckhardt–Wildt cuttings (hereafter BW), themselves close descendants of Metz–Lambeth, constitute a much closer match to the overall scheme of *Angers*. The similarities in the 'selection and combination, or segregation of incidents' in the two works suggest a close connection.[31]

For Henderson it is the similarities in *how* the text of the Book of Revelation has been represented across the images in *Angers* and BW that is most telling. The same timing and emphases are found in their representations of Rev. 8: 1–6, for example. Metz–Lambeth and BN Lat. 14410 both represent this section of text in two images. *Angers* and BW, however, linger over their interpretations of the beginning of Rev. 8. While the first family of manuscripts tend to combine Rev. 8: 2 (the seven angels before God) and Rev. 8: 3–4 (the angel with the censer), in *Angers* 2.18, the angel with the censer is the subject of its own scene thus emphasizing the heavenly liturgy and worship. The other manuscripts in this group also combine the giving of the censer with its spilling. However the spilling of the censer is depicted separately in *Angers* 2.19. BW 41ᵛ and 42 form an absolute parallel to these two *Angers* scenes. In terms of detail, the stationary angels placed in two symmetrical groups either side of God in the first images in this sequence (*Angers* 2.17 and BW 41) are also strikingly similar. Later on in the sequence (Rev. 8: 12–13) BW and *Angers* both separate (within the same composition) the blowing of the fourth trumpet from the eagle of woe (BW 44: *Angers* 2.23). BN Lat. 14410 combines them while Lambeth, Cambrai, Tanner, and Canonici combine the eagle of woe with the fifth trumpet.

On the level of similarities in iconographic detail between *Angers* and BW there are numerous comparisons that can be made. BW 35ᵛ and *Angers* 1.6 (see Rev. 5: 4 f.), for example, both depict John weeping (see Fig. 11: *Angers* 1.6). In both images John is being led away to his right of the frame by an Elder holding a glove in his left hand, a detail that appears in no other known Apocalypse manuscript. Similarly, in *Angers* 2.22 and BW 43, the principal victim of the wormwood plague holds his left arm in the air. Both cycles also

---

[30]　Henderson 1985: 209.

[31]　Ibid. 210. See *Sotheby's Sale Catalogue 25th April 1983*: 35–121 for images of the Burckhardt–Wildt cuttings. Please note that I am using the BW folio references from the Sotheby sale catalogue and *not* Henderson's references.

depict the passing of authority from the Dragon to the Sea-Beast as the passing of a royal sceptre topped with a fleur-de-lis (*Angers* 3.40: BW 52$^v$).

Henderson concludes that in many places the two Apocalypse cycles are so similar that the small differences that exist between them become very striking, leaving the viewer in no doubt that de Bondol had access to a BW manuscript or a very similar one.[32] However, neither are the two cycles identical, particularly on a stylistic level. As Henderson puts it, 'there is a vehemence and monumentality in the *Angers* designs and the *dramatis personae* not always apparent in the miniatures', although the monumentality may of course be a consequence of the larger scale of *Angers*.[33] He argues that one finds precedents for the style, grace, and 'enquiring attitude' witnessed in the *Angers* scenes in the Douce 180 and BN Paris 10474 manuscripts. He cites, in particular, Douce 180, p. 44, a depiction of the war in heaven (see *Angers* 3.36) and Douce 180, p. 28, which pictorializes the fifth trumpet and the locust army (see *Angers* 2.24). He ends the article by emphasizing both the iconographic and compositional proximity of *Angers* to Lambeth, the 'parent manuscript' to BW and a close relation of Douce 180.[34] This supports the claim made at the beginning of this chapter that in many ways *Angers* represents a realization of the *Lambeth* iconography on a huge and contrasting presentational scale. However, Henderson also mentions, almost in passing, the fact that there are signs within *Angers* of the artist responding to extra items of imagery from within the Book of Revelation.[35] While Henderson does not expand on this comment, these original responses are discussed below.

## 2.4 THE *ANGERS APOCALYPSE TAPESTRY*: FORM AND COMPOSITION

In its original state the tapestry would have measured around 130 m in length and stood at around 4.5 m high on average. It originally comprised six equally sized individual sections. Each section began with one large panel the height of the whole tapestry, which was then followed by fourteen smaller narrative panels each measuring around 2.8 m in length and arranged across two tiers. Each scene was housed in a *faux* architectural, moulded frame, which helped to create the sensation of a theatrical pageant unfolding before the eyes, one that it would perhaps be possible to imagine oneself stepping into. De Farcy designed a helpful reconstruction of how the original tapestry would have

---

[32] Henderson 1985: 213.
[33] Ibid. 214.
[34] Ibid. 218.
[35] Ibid. 218.

looked which usefully captures the dramatic effect of these architectural frames (Fig. 10).[36] In total then, *Angers* depicted the 405 verses of the Book of Revelation across 84 individually framed scenes, of which twelve have been completely destroyed and five now remain only in fragmentary form.

Of the six original opening panels which depict 'large figures' reading at lecterns inside high canopies, four now remain, those corresponding to section numbers one (1.1, Fig. 10), three (3.26), four (4.41), and five (5.56). It has been discerned from the stitching that 5.56 has never been separated from its neighbouring panels. Similarly, all of the 'large figure' panels also clearly fit within the overall colour scheme of *Angers* in which neighbouring scenes have backgrounds of contrasting colours, a feature which contributes to the legibility of the compositions as the figures, buildings, and other features of the composition stand out against these strong background colours. Both these observations indicate that the 'large figures' are indeed displayed in their original places today, at the head of each section.[37] On an interpretative level the 'large figures' serve as an introduction to the visions that unfold to their right. They all read texts, possibly of the Book of Revelation, while their eyes rest on the intermediate level between the two registers, thus linking the text with the apocalyptic visions.[38]

As alluded to above, depictions of individual 'scenes' or images from the Book of Revelation move the visual narrative along at varying speeds, sometimes covering nearly a whole chapter in one image (see 5.66, the destruction of Babylon, for example, in which most of Rev. 18 is depicted) and sometimes only one verse (see 1.7, Fig. 12, the worship of the Lamb). There are also two instances where the order of the scenes has become confused. The first instance occurs in scenes 1.5 (the Elder worship God) and 1.6 (the tears of John, Fig. 11). 1.5 pertains to Rev. 4: 9–11 and 5.1 and 1.6 to Rev. 5: 2–5, but in the *Angers* 1.6 appears before 1.5. Similarly, 4.54 (the harvest of the damned: Rev. 14: 17–18) and 4.55 (the winepress overflows: Rev. 14: 19–20) have been mixed up so that the former appears after the latter. These apparent (or potentially deliberate) errors could not have taken place during restoration work, as analysis of the back of the tapestry in both cases reveals that the panels have never been separated: the original stitching remains and the colour scheme is uninterrupted.[39] It has been suggested in the second case (scenes 4.54 and 4.55) that the fact that these scenes were often amalgamated into one scene in some of the related manuscripts (see BN Lat. 10474 and

---

[36] De Farcy 1889 in Muel 1986: 60.

[37] *Contra* Farcy 1889 in Muel 1986: 24–34 and Planchenault 1966: 30 n. 1.

[38] Muel 1986: 75. Note also the debate regarding whether the large figures were intended to be the Seven Bishops of the Churches of Asia (i.e. when it was believed that *Angers* was made up of seven and not six sections (King 1977: 166)).

[39] Muel 1986: 212.

Douce 180) might have confused the artist as to the correct order in the text.[40] In the case of the 1.5 and 1.6, several of the Anglo-Norman manuscripts have also confused the order (Cambrai 482, Metz 38, and BN MS Lat 688).

These two instances of the order of the narrative becoming confused lead one to question how closely the designer of the tapestry knew or was working with the text of the Book of Revelation.[41] In fact, the designer of the *Angers* images must have either known the text of the Book of Revelation very well or have been working with a theological adviser. For the tapestry not only offers an occasionally *more* literal rendering of the Book of Revelation than its presumed manuscript models, but also offers some examples of penetrating visual exegesis on the original text. There is also some evidence of the influence of contemporary commentaries. Both of these interpretative innovations will be discussed where appropriate below.

## 2.5　ISSUES OF STYLE, PHYSICALITY, AND TEMPORALITY IN THE *ANGERS APOCALYPSE TAPESTRY*

The visual impact of *Angers* is due to the monumental scale of the tapestry and consequently to the physical dimension demanded by the viewing experience. There is undeniably a significant difference between walking around a monumental tapestry and turning the pages of a book such as *Lambeth*. Although one has power over when to turn the page, each page is still conditioned by or at least mediated through the text. When one has finished reading the text (provided one could read), that would be the natural time to move on. When viewing *Angers*, the viewer controls the entire experience, from the pace to how far away or how close to stand, and consequently how much of the narrative to 'take in' at any one time, although this latter point is also dependent on, to an extent, the interpretative choices of the designers. Thus while *Angers* is still episodic, the fact that the scenes are presented not in a double-page manuscript but in groups of fourteen scenes means that the viewer gains a greater awareness of the progression of the narrative of the Book of Revelation than the 'reader' of a manuscript.

This is despite the fact that there was very little textual narrative available to the viewer of *Angers*. The images were thus the main point of contact with the viewer and it is through them that the narrative and nuances of the Book of Revelation are conveyed. Although viewing *Angers* was by no means an un-

---

[40] Ibid. 290, n. 310.
[41] Planchenault 1966: 25–30.

intellectual experience, the primacy of the huge images meant that the viewing experience was a very physical one. A temporal narrative is implied through the viewing process because the tapestry images remain static while the viewer moves through time, rendering their movements integral to the overall experience. Thus the physicality of the initial viewing experience could lead to a heightened, very personal form of intellectual engagement with the images and thus with the narrative itself.

*Angers'* huge compositions are silhouetted against the alternate red and blue backgrounds, providing a legibility that could sometimes get lost in the much smaller scale of the miniatures. The fact that there was little visible text to engage with meant that the compositions had to be particularly comprehensible and unambiguous. De Bondol has thus simplified many of the manuscript scenes in order to make them more legible to the viewer. Some of the best examples of this are the battle scenes, where the multitude of soldiers described in the text are pared down to a handful of figures. Thus in *Angers* 2.26 (the myriad horsemen, Fig. 19) the 'twice ten thousand times ten thousand' (Rev. 9: 16) troops of the cavalry have become six and there are seven victims. Similarly, the great battle described in Rev. 19: 19–20, where the armies of the Beast fight the armies of the rider on the white horse, is depicted in 6.73 with a mere six figures. Finally, in 3.33 the seven thousand victims of the great earthquake of Rev. 11: 13 that occurs after the resurrection of the Witnesses are depicted with just five heads.

The same treatment is applied to depictions of natural phenomena and buildings. In 2.23 (the fourth trumpet), for example, the destroyed city has the air of a shattered building game.[42] In 5.64 the 'many waters' upon which the Whore of Babylon is seated (Rev. 17: 1) have been reduced to four streams flowing round the hill on which she is seated. It would perhaps be fair to say that although these are figurative depictions, they are not, indeed cannot be, completely literalistic, such is the extent of John's hyperbolic descriptions. Thus the *Angers* images *evoke* the text rather than merely transposing it into a visual medium.

Such scenes, as well as being bordered by *faux* architectural frames, are also surrounded by occasionally striking upper and lower borders. The upper and lower borders depicting heaven, or simply the sky, and the earth respectively are, like the 'large figures', unique to *Angers*. Although neither border is complete, Muel argues that the upper border originally made up a kind of 'heavenly tier' measuring around 60 cm high.[43] The lower border now only runs along the third, fourth, and fifth sections and only reaches its maximum height of 18 cm in some places. Again Muel contends that originally it would have run along the bottom of all six sections.[44] The upper tier consists mainly

---

[42]  Muel 1986: 84.
[43]  Muel 1990: 14.
[44]  Ibid.

of angels playing a range of musical instruments and occasionally bearing the arms of Louis of Anjou against a background of rather stylized clouds (see 2.17, for example). The lower tier consists of vegetation but also contains the odd vignette from everyday life, such as the dog chasing a rabbit down a hole under 3.39 (the Dragon fighting the servants of God). The rabbit can be seen surfacing under 4.52 (the sleep of the just). The purpose of these upper and lower borders can only be guessed at. It seems likely that they may have a similar function to that of the marginalia in *Lambeth*. There, the small drawings of animals and figures served to engage the imagination of the 'reader' and thus make the page more memorable. It is possible that the 'rabbit vignette' may also form an *inclusio* around the section of narrative underneath which it appears. The upper border perhaps also has an interpretative function. The presence of the angels signifies that the border is meant to represent a heavenly realm. In some cases the angels even appear to be directing the action below by blowing trumpets or holding scrolls in the direction of the visions (see 1.5, 1.7, and 4.44, for example). Thus the angels in the upper borders remind the viewer that even when there is no angelic or Divine presence in the scenes themselves, the narrative action is still being directed and controlled from heaven. Within the framed scenes themselves the sky also plays an important role. The sky is always represented when it is mentioned in the text of the Book of Revelation (see Rev. 6: 14; 8: 1; 8: 13; 14: 6; and 14: 16, for example) and is sometimes represented more than once in the same scene. This is the case in scenes 2.27 (the angel with the book, Rev. 10) and 3.33 (the Two Witnesses resurrected). In cases where the sky is specifically mentioned, it is depicted in a stylized manner as a patch of blue enclosed in a border of clouds with serrated edges. This helps to maintain a visual distinction between the heavenly and earthly realms.

## 2.6 THE ROLE OF JOHN

The way in which and the frequency with which John is visualized in artistic representations of the Book of Revelation is an important key to the *type* of representation one is analysing. Multiple appearances of the John figure, as is the case in *Lambeth* and *Angers*, usually coincide with a narrative or chronological visualization of the Book of Revelation. In more 'synchronic' visual approaches to the text of the Book of Revelation, such as Memling's *St John Altarpiece* or the Van Eycks' *Ghent Altarpiece* (to be discussed in the next chapter), John tends to appear only once or not at all.

Camille suggests that the reason that John was included in nearly every illustration in the medieval period was because contemporary devotees believed that visionary perception issued from the intellect of the visionary: 'John

is present [in the medieval Apocalypses] as the percipient—as witness, not author, of these events. His authority is vested not so much in his having written down what he saw as in his having seen it ... For the medieval visualisers, the Apocalypse had been not so much a text but a series of experiences, all of which were witnessed, felt and understood by the saint.'[45]

In the Lambeth–Metz iconography John was presented variously as author, protagonist, voyeur, and guide. Where he appeared as author or protagonist this was usually in response to textual cues from the Book of Revelation. However, the John figure also provides the visual link between the Apocalypse miniatures and *vita* illustrations which frequently appeared in the additional miniatures to the thirteenth-century Apocalypse manuscripts, and where he was also characterized more freely as a pilgrim, a reformer, and an apostle to the Jews. John traditionally appeared in around two-thirds of the miniatures in the Berengaudus Apocalypse cycles. While there is little or no evidence to suggest that John is being depicted as a 'reformer' or an apostle to the Jews in *Angers*, his role as guide and 'model' for the viewer is indisputable. We also see a greater emphasis on John's prophetic function in *Angers* (see discussion of *Angers* 1.2, 2.27–8, and 5.70 below). John's function as model and guide to the viewer in *Angers* is largely tied to the fact that he appears in every surviving scene of the tapestry, which leads to the not unreasonable assumption that he originally appeared in all eighty-four scenes. This may reflect the influence of the French prose gloss, found in Paris BN fr. 403, for example. In the fourteenth-century French prose gloss, 'John's role as the focus of visionary consciousness is more crucial to the unfolding moralisations'.[46]

Joubert has argued that John's features are sometimes different in different scenes, perhaps owing to the use of different models at different times during the production of the tapestry.[47] However, Muel rightly argues that despite the slight variation in his features, it is always possible to tell which figure is John, due to his prominent position in each scene.[48] His distinctive red cloak with a blue lining, his halo, and the fact that he is always holding a book with prominent clasps, also helps the viewer to locate John.[49] Thus it is fair to speak of John as a constant and recognizable presence within *Angers*. John's unwavering presence also allows him to function as an interpretative guide to the viewer in some cases. In 3.31, for example (the death of the Two Witnesses), John's fear and wonder at the scene unfolding before him are emphasized by his open mouth and incredulous expression. Similarly, in 2.24 (the fifth trumpet) John throws up his hands in horror as he watches the locust army led by Abaddon arise from the bottomless

---

[45] Camille 1992: 287–8.
[46] Ibid. 287.
[47] Joubert 1981: 134–5.
[48] Muel 1986: 78.
[49] *Angers* 3.42 is the only scene where John wears a different coloured (orange) cloak.

pit. In 3.36 (St Michael fights the Dragon) John covers his mouth with his hand thus perhaps intimating his anxiety as to the outcome of the battle.[50]

In contrast to the John of the miniatures, who was sometimes depicted outside the frame, the John of *Angers* is always inside the frame, usually but not always standing in a carefully constructed shelter, itself a commonplace iconographic device in tapestries and beyond. In the *Tenture des Preux: Arthur* (*c*.1400), for example, a large, very elaborate shelter is used in much the same way in order to give the tapestry an architectural, three-dimensional texture, something that is also achieved in *Angers* through the use of the *faux* architectural borders.[51]

John stands outside the shelter in 22 of the 84 scenes, usually in a response to textual cues regarding him seeing, hearing, or doing something. This shelter is one of the most distinctive features of *Angers* and is without precedent in the known manuscript models. Considerable care has gone into its design, to the extent that the same design features rarely appear twice. Thus, for instance, to take some contrasting examples, while in 4.51 John's shelter has a pointed roof with slates decorated with stone foliage, in 5.70 the shelter has a flat, turreted roof with more abstract details. Similarly, while in 5.66 the shelter has an open window for John to lean on or possibly to hide behind, in 6.80 (the New Jerusalem) the shelter is completely open, allowing John to step out of it towards the celestial city. Although there are some cases where it appears that the same shelter has been reused (see 4.45 and 4.53, for example), in general each shelter has a few distinguishing details, leading us to assume that it was considered a very important, balancing feature of the composition.

In the concluding compositions, John's shelter takes on an overtly symbolic function. Whereas previously (as in 5.66, 2.22, 2.26) John had used the shelter to hide behind or indeed had had to be carried out from it by the angel in 5.64, in 6.80 ff. John leaves the shelter permanently and of his own volition. In 6.80 he takes his first tentative steps towards the vision of the New Jerusalem, pointing the way with his hand, his foot purposefully poised over the edge of the base of the shelter, implying motion. In 6.81 John kneels at the feet of the angel with the measuring rod, his back to the shelter, which he no longer requires. Similarly, in 6.82 the eye is drawn away from the empty shelter by the vibrant, matching reds of John's cloak and the Divine mandorla (Fig. 13). Although John has appeared before without the shelter, in these cases the shelter itself is absent from the compositions.[52] Similarly, although *Angers* shares much with the Lambeth–Metz and BW compositions here in all other

---

[50] Although Muel 1986: 84 says that John is here covering his mouth in expectation of a victory.

[51] *Tenture des Preux: Arthur*, New York, Metropolitan Museum of Art, Cloisters Collection, Inv. 32.130.3 a, b (see also Taburet-Delahaye (ed.) 2004: 224–5).

[52] Except in 5.70 where John is receiving instructions from the angel to write down everything that he has seen (Rev. 19: 9–10), which represents another climax in the prophetic mission.

respects, the addition of the empty shelter to the compositions adds something on an interpretative level. Firstly, it underlines the climax of John's prophetic mission, which is emphasized in the text at Rev. 22: 8 when John reveals his prophetic self-understanding ('I, John, am the one who hears and sees these things'). Secondly, the presence of the empty shelter can also be seen to function metaphorically. For the redundancy of the shelter in *Angers* at the end of the vision seems to echo the conviction of Rev. 21: 2–8 that the barrier between the Divine and the human has been successfully removed: 'Look! God's tabernacle is among human beings and he will pitch his tent with them' (Rev. 21: 3). The need for a barrier or mediation between heaven and earth, perhaps symbolized by the shelter, has been removed.

The presence of John (usually in his shelter) in every scene performs an important unifying function across the *Angers* images. In the manuscript models the narrative cohesion is provided, to an extent, by the presence of the text and commentary. In *Angers* (although there was originally some text, the content of which is unknown) it is the figure of John alone who provides the narrative link or thread between the images. As Camille argued, his constant presence serves to emphasize the perceptual validity of the unfolding visionary episodes to the viewer, particularly in the absence of any authoritative text. His prominent visual role as prophetic intermediary between our world and the transcendent may also prompt the viewer to consider the visionary 'chain of transmission' that the Book of Revelation has gone through from source to (in this case) viewer.

## 2.7 EXEGETICAL EMPHASES OF THE *ANGERS APOCALYPSE TAPESTRY*

The overall hermeneutical impact of the distinctive format, size, and visual layout of *Angers* is the main focus of this chapter. It would, however, be a mistake to pass over *Angers'* smaller-scale iconographic, compositional, and exegetical innovations. Such details not only help to distinguish *Angers* from its manuscript models, but also contribute to its overall hermeneutical strategy.

Firstly, there are several occasions where *Angers* changes the established iconography of some of the key figures. In 1.12, for example, the hell-mouth, which was so prominent in Lambeth (see Fig. 6), has been converted from a mythical monstrous head to a more 'canine' head enclosed in a tower. A small devil has also been added at the top of the tower and the horseman is now a skeleton instead of a human 'rider'. Some of these iconographical developments can be attributed to BW, which also has a skeletal rider and a more vertical hell-mouth (BW 38$^v$). However, the canine mouth and the building

enclosing it are unique to *Angers* and may signal a desire on the part of the designers to enclose and tone down the horror of the earlier hell-mouths.

Secondly, *Angers* has altered the iconography of the three main Beasts of the Book of Revelation (the Dragon, the Sea-Beast, and the Earth-Beast/False Prophet). The Dragon has reptilian wings instead of birds' wings and one of its necks is broken in 3.35–3.38, perhaps in a mistaken reference to the Sea-Beast of Rev. 13: 3 (see 3.37, for example). Unusually the Sea-Beast itself resembles a lion. The earlier manuscript miniatures, including BW, all portray the Sea-Beast as a leopard, as is specified in Rev. 13: 2 (BW 52$^v$). This change in iconography may signify a subtle play on the messianic expectation inherent in Rev. 5, where John is told that he is about to see the 'lion of the tribe of Judah, offspring of David' who, on account of his victory, is the only one worthy to open the scroll (Rev. 5: 5). What John actually sees is the slaughtered Lamb (Rev. 5: 6). Here and in other places the Book of Revelation is therefore concerned with subverting traditionally held opinions about power and greatness.[53] It is quite possible that *Angers* is reflecting this textual longing for the lion of Judah. Other iconographical changes include the altering of the Earth-Beast's horns from seven to two (4.44) and the fact that the Whore of Babylon's Beast is not depicted in red (5.65). This latter amendment may have been the result of practical concerns, since the background of this image is also red.

Thirdly, there are several instances where *Angers* has made compositional and detailed changes in order to reflect the text more accurately. The first significant occurrence of this theme appears at 2.21, where *Angers* devotes an entire image to the events following the Second Trumpet of Rev. 8: 8. *Angers* focuses particularly here on the shipwreck that the trumpet blast causes. This composition is not found in Lambeth–Metz but is found in BW 42$^v$. *Angers* also devoted 2.20 to the first trumpet blast, an event that BW combines in a single image with the emptying of the Angel's Censer (Rev. 8: 5–7). However, this *Angers* composition has been destroyed, with only a fragment remaining. The number of images that *Angers* devoted to the sequence of seven trumpets (Rev. 8: 6–9.20; 11: 15–19) is, however, high and, consequently, exceedingly rare. This may be a result of the fact that *Angers* is primarily a visual medium, where all the detail had to be conveyed clearly in the images.

This attention to textual detail continues in *Angers* 2.23, where the number of angels with trumpets has been increased from the usual one (see Lambeth fo. 10 and BW 44$^v$) to three. The three angels in *Angers* are a visual response to Rev. 8: 13, which explains that the reason that the eagle cries 'Woe, woe, woe' is to signify the voices of the three angels who are yet to sound their trumpets.[54] In exegetical terms the presence of the three angels here also reminds

[53] See Bauckham 1993*a*: 7–17; Boxall 2006: 14–15.
[54] Henderson 1985: 213.

the viewer of where they are in the sequence of seven trumpets (i.e. that they have witnessed four and that there are three left to come). The next *Angers* scene, 2.24, also includes unique details that constitute a very literal response to the text. Here five actual locusts have been added to the composition to add to the effect of the locust army described in Rev. 9: 1–12, and also perhaps to clarify the subject-matter of the scene, in light of the fact that the army as described in the text does not visually resemble locusts at all. The falling star and key from 9: 1 have also been added to the *Angers* composition, having been conspicuously absent from both *Lambeth* and BW. The unusually wide expanse of fairly vivid green grass and the large tree in the right-hand corner may also be a visual response to the command in Rev. 9: 4 that the army was not to harm 'the grass of the earth, nor any green thing, nor any tree . . .'.

Another cluster of literal details occurs in *Angers* 3.30–3.33, a series of images depicting the ministry, death, and resurrection of the Two Witnesses. In 3.30 one of the Witnesses reaches up to a building in heaven, itself enclosed in the familiar 'cloud-border', and appears to be shutting a door. This is a unique visual response to the claim in Rev. 11: 6 that the Witnesses had the power to shut up the sky and one that is lacking from the corresponding Lambeth–Metz image (fo. 13) and BW image 47ᵛ. Similarly, in 3.31 it is Abaddon's own locust-horse who kills the Witnesses, not one of his henchmen as in *Lambeth* fo. 13ᵛ. Here BW fo. 48 agrees with *Angers* and is likely to have influenced the *Angers* composition. This reflects the text (Rev. 11: 7–8) more accurately and also reflects the Berengaudus commentary more accurately too. Berengaudus associates the Beast from the Abyss with Antichrist, who could not overcome the Witnesses with words but could only conquer them through killing them.[55]

*Angers* 3.32 (Fig. 14) is a composition that *Angers* and BW have interpolated into the more established manuscript series. It is a visual response to Rev. 11: 8–10 and shows the people of the city rejoicing at the death of the Witnesses. In BW 48ᵛ two men are exchanging a gift of a ring and in *Angers* 3.32 the two groups of bystanders are also exchanging gifts. This in turn is a visual response to Rev. 11: 10. Similarly *Angers* 3.33 retains the detail included in BW 49 of the angel in the top right-hand corner of the composition, a visualization of the loud voice of 11. 12. *Angers* also includes some witnesses to the destruction of some of the city, a visualization of the survivors of the earthquake who turn to God as a consequence of what they have seen (11. 13).

Other compositions within *Angers* are not more literal than their manuscript predecessors but rather more exegetically complex. Some of these exegetical responses are based on the BW compositions and iconography but some appear to be without precedent in the known manuscript models,

---

[55] See Lambeth fo. 13ᵛ for the Berengaudus commentary on Rev. 11: 7–8.

an indication that de Bondol made innovations of his own or that he was working with a theological adviser, rather as the artists of the thirteenth- and fourteenth-century manuscripts were known to have done.

One such response is the inclusion at *Angers* 1.2 of an image of the Seven Churches, an image that does not appear in the Lambeth–Metz cycles but which does appear in BW (fo. 33ᵛ), although John is not present in this image as he is in *Angers*. The inclusion of this initial image reminds the viewer of the character of the Book of Revelation as a prophetic message to the Seven Churches of Asia. Similarly, it provides a subtle introduction to the importance of the number seven throughout the Book of Revelation, a fact that takes on a particular resonance in visual interpretations (see for instance the seven angels with seven trumpets gathered together in *Angers* 2.17) and similarly the seven angels with the seven bowls at *Angers* 5.56 and 5.57 or the various Beasts with seven heads from 3.35 to 5.65). In this initial image (1.2) we also see John speaking his message to the churches (see his open mouth and cupped hand) instead of writing to them as he is ordered to do at Rev. 1: 11. By converting John's message from a written to an oral medium the artist reminds the viewer of the experiential nature of the original apocalyptic visions.

The presentation of the Lamb in *Angers* 1.7 (Fig. 12) and 4.47 (Fig. 15) is also striking and exegetically important. In Lambeth–Metz the Lamb is depicted as standing upright, alert and proud with its head held up, its right front leg supporting a flag-pole with a flag with a cross on it (see Lambeth fo. 3ᵛ and BW 36). In *Angers* 1.7, however, the Lamb is visibly slaughtered, with blood pouring from its neck and from holes in its feet, presumably in an evocation of stigmata. It almost looks as if it has been speared on the flagpole, which is suspended behind the Lamb. This visualization is a more textually accurate depiction of Rev. 5: 6 (which describes the Lamb as standing 'as if it were slain'). In portraying the Lamb as slain rather than visibly victorious *Angers* engages with the transcendent perspective revealed in the Book of Revelation that contrasts with the 'worldly' perspective held by some members of the seven churches and those who worship the Beast. As alluded to above, in Rev. 5: 5 John is told that he is about to see the 'lion of the tribe of Judah, offspring of David', who, on account of his victory, is the only one worthy to open the scroll. What John actually sees is the slaughtered Lamb (Rev. 5: 6), whose sacrificial death has redeemed people from all nations (5: 9–10). Bauckham writes that 'by juxtaposing two contrasting images, John has forged a new symbol of conquest by sacrificial death'.[56] By visualizing the marks of the sacrificial death of the Lamb, *Angers* 1.7 emphasizes for the viewer the crucial fact that the victory over evil has already been achieved through that submissive act.

---

[56] Bauckham 1993*a*: 75.

The signs of the crucifixion are also visible on the Lamb in *Angers* 4.47 (Fig. 15), which depicts the Lamb on Mount Zion surrounded by the 144,000 worshippers who are said to have his name and the name of the Father on their foreheads (Rev. 14: 1). Again, this textual detail regarding the marks of the Father and the Lamb is picked up in an interesting way in the *Angers* image, where the mark is interpreted as the Greek letter *tau*. St Francis adopted the *tau* symbol as his coat of arms after Lateran IV in 1215, on account of the fact that it had the same form as Christ's cross.[57] Thus, once again at a seemingly triumphant moment within the narrative, *Angers* reminds the viewer of the cross and also the way in which the 'victory' was achieved. The link to the Franciscans is also reflected in 3.39 where one of those fighting the Dragon is represented as a Cordelier or Franciscan monk.

The slaughtered Lamb 'theme' may also find an echo in the prevalence of Eucharistic imagery within *Angers*. In 1.13, for example, the prominent altar under which the souls of the martyrs are gathered (Rev. 6: 9) has a Eucharistic cup placed on top of it. Images 2.17–19 are also composed in such a way as to emphasize strongly the heavenly liturgy. *Angers* 2.17, which depicts the seven angels arranged around God and the Lamb, holding but not blowing their trumpets, follows BW 41 in representing only Rev. 8: 1–2, thus capturing a sense of the 'silence in heaven for half an hour' that precedes the sequence of seven trumpets. In 2.18, a composition original to BW and *Angers*, the angel with the censer wears a Bishop's cloak and holds a Eucharistic cup whilst shaking the censer over the altar, on top of which we find God/Christ in a mandorla, perhaps a visualization of the Divine presence at the Eucharist.

The Eucharistic cup reappears in 4.51, perched on top of the small hill above the Lamb, this time a symbol of the 'wine of God's wrath, poured unmixed into the cup of his anger' (Rev. 14: 10), reserved for anyone who had worshipped the Beast and received his mark. It is interesting that the Eucharistic cup, a symbol of hope, is here being linked with God's wrath instead of his redemption. In 4.54 the angel of the altar gestures to the grapes with his right hand and to a ciborium on the altar with his left. The same style of ciborium appears in the hand of the Whore of Babylon in 5.65.

There is one final interpretative point of interest arising from *Angers* 1.7. The background behind the Twenty-Four Elders in this composition is decorated with a recurring 'Y' motif. This 'Y' motif appears at 1.1 (Fig. 10) and 4.41, where the dais behind the 'large figures' is decorated with a foliated pattern, with 'Y's encased in mandorla-like shapes. It also appears in the background of 5.64, which depicts the Whore of Babylon seated on the waters (Rev. 17: 1–2). It is possible that the 'Y's refer to Yolande of Aragon who married Louis II, the son of Louis I, in 1400. However, Graham argues that the 'Y' motif is the sign

---

[57]  http://www.franciscanfriarstor.com/stfrancis/stf_the_tau_cross

known as the 'Pythagorean letter', a symbol for the divergent paths of virtue and vice.[58] One arm of the letter 'Y' corresponds to the path of virtue and the other to that of vice. She gives two roughly contemporary examples of the letter being used in this way. The first is in the windows of the chapel of St Nicholas in the priory Church of St Martin des Champs in Paris. Here the 'Y' with a harrow attached by a chain is depicted several times. The chapel was appropriated as the burial place of Philip de Morvilliers in 1426, who then had the symbol incised on his tomb. The symbol 'Y', which represents the divergence between virtue and vice, is certainly appropriate to the subject-matter of the Book of Revelation as well as to the trajectory of the life of Louis I. In 1.7 the slaughtered Lamb is a victim but also the conqueror of vice and death, and thus a source of life and virtue. In 5.64, the Whore has the appearance of something wonderful (Rev. 17: 4) but in fact is 'Babylon the great, mother of harlots and of earth's abominations' (Rev. 17: 5).[59] Thus the 'Y' symbol would seem to be another subtle reminder of the two contrasting 'systems' (the transcendent and the earthly) that oppose each other throughout the Book of Revelation.

Another overarching theological theme, that of John's prophetic mission and its various stages and permeations, finds powerful visual expression in *Angers'* treatment of Rev. 10. While Lambeth–Metz only devotes one image to Rev. 10, BW (fo. 46$^{r-v}$) and *Angers* visualize the chapter over two images, thus emphasizing its importance. These two images (2.27, Fig. 16 and 2.28, Fig. 17) also represent another instance of *Angers* 'slowing down' or drawing out the narrative, as was the case at 2.17–19. *Angers* 2.27 visualizes Rev. 10: 1–7 (the appearance of the Mighty Angel with the book) while 2.28 visualizes Rev. 10: 8–11 (the command for John to prophesy). The visual emphasis on this key passage found here in *Angers* and BW foreshadows Dürer's preoccupation with Rev. 10 (see Chapter 5).

In terms of John's mission, Rev. 10 marks the moment at which his prophetic commission is renewed but not yet fulfilled. Thus it marks a midway point between the start of the commission in Rev. 1: 9–20 and its fulfilment in Rev. 22, where, as discussed in the previous chapter, Christ speaks to John directly and instructs him to report what he has seen (Rev. 22: 10–21). *Angers* 5.70 provides another visual recapitulation of John's prophetic mission where we see him writing in his book at the command of the angel (Rev. 19: 9).

One of the ways in which *Angers* links the commission in Rev. 1 with Rev. 10 is through its treatment of the angels. In 1.3 the One like the Son of Man is depicted as having red feet, perhaps a visual response to the textual detail in Rev. 1: 15 that his feet were like 'burnished bronze'. Similarly, in 2.27, the red

---

[58] Graham 1947: 227.
[59] See also Muel 1986: 106.

foot of the angel (here a response to the textual description of the Mighty Angel having 'legs like pillars of fire', Rev. 10: 1) is clearly visible. It would seem that the traditional exegetical interpretation of the Mighty Angel as Christ himself has not been invoked by *Angers*, as the angel does not share any of the usual visual motifs used to depict Christ in the tapestry.

John himself is prominent in both 2.27 and 2.28, having moved, somewhat unusually, out of his shelter. As in *Lambeth* (fos. 12, 9), in 2.27 the viewer can clearly see that John is being prevented from writing by the angel (Rev. 10: 4). Especially prominent are the seven thunders of Rev. 10: 4 that have been personified as animal heads protruding out of the clouds. The presence of these heads usually signifies judgement in *Angers*.[60] However, as Bauckham argues, throughout the Book of Revelation, God's judgements are 'depicted as the manifestation of the same holiness which is revealed in the theophany in Rev. 4. 5'.[61] Here too the seven thunders of *Angers* 2.27 seem to represent not judgement but another manifestation of God's holiness.

In both 2.27 and 2.28 the 'little scroll' of Rev. 10: 8–10, here depicted as a book, plays a very prominent role (Figs. 16 and 17). The scroll or book itself is seen three times, once in the hand of the Mighty Angel in 2.27 and then at two different stages in 2.28, the moment when John receives it and secondly the moment of his eating it. The composition of these two images, when viewed side by side in the tapestry format, captures the notion of a chain of chrono-logically unfolding events effectively. The Mighty Angel, who is depicted in the same pose in both images, provides the link within the visual chain. The detail of the angel behind John, firmly supporting him as he eats the book (also seen in BW 46$^v$), is a powerful visual evocation both of the urgency described in Rev. 10: 6 ('there should be no more delay') and of the anticipated bitterness of the scroll (Rev. 10: 10). The visual presence of the scroll recalls the scroll of Rev. 5: 1 ff. (which corresponds to missing *Angers* image 1.8) and so provides another link with the earlier key chapters in which John is both given his prophetic commission and exposed to the secrets of the heavenly throne-room.

Finally, there are two images of the Beasts which are both unique to *Angers* and exegetically interesting. *Angers* 4.44 depicts Rev. 13: 11–13, the Earth-Beast causing fire to fall from heaven. Since Tyconius, the Earth-Beast of Rev. 13 had been associated with evil within the Church. The reference in Rev. 13: 13 to his ability to cause fire to fall from the sky was thought to refer to the deeds of wicked priests.[62] This interpretation was later adopted in the *Beatus* commentaries and by Bede (see Bede, *Explanatio Apocalypsis*, PL 93: 169.21–6). One of

---

[60]  See *Angers* 2.19 (the third trumpet: Wormwood); 3.34 (the seventh trumpet); 5.63 (the seventh bowl poured into the air).

[61]  Bauckham 1993*a*: 42.

[62]  Beatus, *Preface* 17–20; *Comm* vi. 3. 1–6, 15–19; Kovacs and Rowland 2004: 149.

the spectators, the kneeling man with his hands clasped in prayer, seems to be depicted in *Angers* 4.44 as a Bishop.[63] This may well be a visual reflection of the Tyconian interpretation of this verse. However, it also seems possible, on account of this figure's exaggerated facial characteristics, that he has been depicted in *Angers* as a Jew. This would reflect the 'Berengaudian' line of interpretation of Rev. 13: 11–14 in which he argues that the Earth-Beast will deceive both Jews and Christians, the figures in the background being Christians and the kneeling figure at the front representing a Jew.[64]

*Angers* 5.61 depicts the pouring of the Fifth and Sixth Bowls on the throne of the Beast and on the Euphrates respectively (Rev. 16: 10–12). The corresponding BW image has not survived. In contrast to the corresponding Lambeth–Metz compositions and related manuscript versions, *Angers* depicts the throne of the Beast as an altar. This is interesting in exegetical terms as the placement of an altar in the scene recalls not only the prominent placement of altars in a positive context in 1.13, 1.18, 2.25, 2.29, 3.35, 4.54, and 5.59 but also the placement of the 'image of the Beast' on top of an altar at 4.45 (cf. Rev. 13: 14–15). Thus the viewer is reminded visually of the contrast between true and false worship that pervades the Book of Revelation. The worship theme begins in Rev. 4–5 where 'true' worship is defined as the constant worship given to God and the Lamb in the heavenly throne-room. Subsequently, some form of heavenly worship accompanies every stage of God's victory up to Rev. 19.[65] After this, heaven and earth are merged in the creation of the New Jerusalem and false worship exposed for what it is. The worship given to (indeed demanded by) the Beasts and the Whore of Babylon is set up in opposition to the 'true worship' that has been revealed to John in the earlier vision of the heavenly throne-room. The Satanic Trinity of the Dragon and the two Beasts attain worship through force (see Rev. 13: 7–8) but also through deception and seduction (see Rev. 13: 14 and 17: 3–5).

The use of the altar in *Angers* 4.45 (the worship of the image of the Beast) and 5.61 (the pouring of the Fifth Bowl on the throne of the Beast) reflects this theme of deception and false worship in a visually effective and memorable way. In 5.61 in particular the altar represents the Beast's appropriation of the symbols of Christianity for his purposes, whilst also serving as a reminder that Christians and non-Christians alike are susceptible to his seductive allure, a point made in the Berengaudus commentary to Rev. 13: 11–14 with particular reference to Antichrist.[66] In another compositional addition not found in the manuscript models, *Angers* has also added a horseman to this image. The horseman rides a white horse (in a possible parody of the first horseman of

[63] Muel 1986: 192.
[64] Morgan 1990: 186–7, tr. of *Lambeth* fo. 19ᵛ.
[65] Bauckham 1993a: 35.
[66] See Morgan 1990: 186–7.

*Angers* 1.9, also depicted as an older figure riding a white horse) from right to left as an evocation of the kings who would come from the East after the Euphrates had been dried up (Rev. 16: 12). The prospect of hostile horsemen coming over the waters must have been a particularly evocative one for Louis and his court who were embroiled in Anglo-French hostilities at the time.

Indeed there are other instances in *Angers* where certain passages from the Book of Revelation text have been 'read' and consequently visualized in a contemporary light. *Angers* 2.26, for example, depicts the myriad horsemen from Rev. 9: 16–21 (Fig. 19). The lack of vegetation or background activity means that the eye is drawn to the cluster of horsemen in the centre of the composition, who are all attired in costumes and armour similar or identical to that worn by the English armies during the fourteenth century.[67] Particularly distinctive is the pheasant's feathers worn on the helmet of the soldier near the front of the group. Pheasant feathers were worn by the English and the Scottish armies during the fourteenth and fifteenth centuries.[68] Thus a visual link is made between the demonic cavalry of Rev. 9: 16 and the contemporary English army.

This 'contemporizing' of episodes from the Book of Revelation continues with the addition of a gold sceptre with a distinctive fleur-de-lis tip to eight key scenes. Although not mentioned in the text of the Book of Revelation, the addition of the sceptre to *Angers* 3.40, 3.41, 3.42, 4.43, 4.44 (Fig. 18), 4.46, and 4.53 helps to imbue these scenes with a sense of the power struggle unfolding across the tapestry. Thus in 3.40–2, the sceptre functions as an apt symbol for the 'authority' that is passed between the three Beasts in Rev. 13. Although a sceptre with the fleur-de-lis on top appears in some of the later Anglo-Norman Book of Revelation manuscripts such as Metz–Lambeth, its appearance in *Angers* takes on a special resonance against the background of the ongoing Anglo-French hostilities.[69] The triple fleur-de-lis symbol had been adopted as the French royal coat of arms in 1376. Thus, the image of royal sceptre topped with the fleur-de-lis being passed from the Dragon to the Sea-Beast in 3.40, would have been visually arresting. On the strength of the nationalistic feeling attached to the fleur-de-lis symbol, it seems plausible that the Sea-Beast is here being depicted as an (English) stranger coming out of the sea to steal the sceptre of France. Those who are portrayed as worshipping the two Beasts under the sceptre are perhaps therefore symbolic of those who collaborated with the English during the fourteenth century and particularly after the Battle of Poitiers in 1356 which had led to the Treaty of Bretigny

[67] See Houston 1996: 122–8.
[68] Muel 1986: 148.
[69] See Metz 38 fo. 19ᵛ, for example, and note that here only the Sea-Beast has a sceptre with a fleur-de-lis on top. The Earth-Beast just has a plain sceptre.

in 1360, in which about one-quarter of France had been annexed to the English.

In 4.53 (the Harvest of the Chosen) the sceptre appears once again in the hands, this time, of the One like the Son of Man (Rev. 14: 14). However, here he is characterized as an old man, perhaps as the old King Charles V giving advice to the young King Charles VI, here depicted as the angel with the sickle of Rev. 14: 15.[70] This interpretation seems particularly apt in light of the fact that Louis I acted as Regent for the young King Charles VI from 1380 to 1382. In symbolic terms, this scene is important because it shows that the 'authority', which had been abused in Rev. 13 (*Angers* 3.40–6), has been restored to the heavenly realm.[71] The appearance of the same sceptre in the hands of the one One like the Son of Man also acts as a visual foreshadowing of the destruction of the Beasts that occurs in Rev. 20–1 (*Angers* 6.73–4).

## 2.8 CONCLUSION

This chapter has stressed the richness of the viewing experience provided by *Angers*, both in terms of the physicality of the experience and in terms of the new exegetical insights it offers. There is no doubt that it provides the viewer with a unique, visual encounter with the Book of Revelation. However, *Angers* is not unique in an idiosyncratic way, standing as it does firmly within the tradition of the thirteenth- and fourteenth-century Anglo-Norman Apocalypse manuscripts. Thus it is different enough to provide a real counterpart to the Anglo-Norman manuscript format, but similar enough to serve as an example of how the Anglo-Norman Apocalypse iconography had diversified and developed by the end of the fourteenth century.

The innovative stylistic features of *Angers*, including the *faux* architectural frames, John's shelter, and the upper and lower borders, do not all remain intact. Nevertheless, one is able to gain an idea of what the tapestry would have looked like in its entirety (see Fig. 10). The overall effect of the combination of these features, viewed in conjunction with the presence of the 'large figures' who appear at the head of each tapestry section, is to create the impression of a parallel, three-dimensional visionary world. It is also a 'world' that invites participation from the viewer, who is able to walk along the tapestry in a physical sense but who is also drawn into it on an imaginative level. In this sense, the tapestry resembles a static theatrical pageant or *tableau vivant*, a

---

[70] Muel 1996: 61.

[71] See Metz 38 fo. 26ʳ which depicts the two as an older king and as a young king but the older king is not holding the fleur-de-lis sceptre, only a sickle.

resemblance that was perhaps intentional given *Angers'* original function as a backdrop at secular events such as weddings or official meetings.

*Angers* also functions as a vehicle for the promotion of the Anjou dynasty in a much more self-conscious and overt way than any of the aforementioned manuscripts. The presence of the arms of the House of Anjou on flags, trumpets, shields, and heraldic butterflies throughout the tapestry serves to link the royal family, and specifically Louis himself, with the main themes of the Book of Revelation, in particular the notion of a grand triumph over evil which heralds the beginning of a new dispensation. The use of the Book of Revelation as a conduit for such blatant self-aggrandizement may well jar with more sensitive exegetical interpretations of the text that view it, among other things, as a critique of secular power. This issue and its exegetical implications will be returned to in Chapter 6.

Whether any contemporary viewers would have noticed the detailed exegetical innovations of *Angers*, as discussed in Section 2.7, is difficult to say, such are the problems with attempting to reconstruct when, where, and how it was displayed. However, *Angers'* determined emphasis on the figure of John was highlighted as a possible visual response to the emphasis on 'witness' in the late medieval period, as well as the increased importance of the role of John in the fourteenth-century prose gloss. Thus it is clear that more general contemporary trends within the history of interpretation of the Book of Revelation are reflected in the tapestry. The visual emphasis on the Lamb of Rev. 5 within *Angers* was also discussed in some detail and certainly anticipates the visual interest in this figure found in the two altarpieces discussed in the following chapter. Similarly the inversion of ecclesiastical imagery to evoke the implications of the reign of the triumvirate of Beasts anticipates both Dürer's and Cranach's interpretations of these characters. Thus it is clear that the designers of *Angers* not only transposed the established apocalyptic manuscript iconography into a theatrical, public, and, in some ways, secular dimension, but that they also self-consciously developed the exegetical emphases of the tapestry in order to reflect fourteenth-century concerns and innovations.

# 3

## Visualizing the Book of Revelation for the Fifteenth-Century Congregation

### The *Ghent Altarpiece* (1432) and
### The *St John Altarpiece* (1479)

### 3.1 INTRODUCTION

C. M. Kauffman has correctly remarked that while there are many examples from the late medieval era of illustrated Apocalypse manuscripts, stained glass windows, tapestries, and, towards the end of the period, woodcuts, altarpieces containing scenes from the Book of Revelation are very rare indeed.[1] One such altarpiece is the so-called *Victoria and Albert Altarpiece*, which dates from *c*.1400. The iconography of this altarpiece was derived from an illustrated manuscript version of the Franciscan Alexander Minorita's thirteenth-century, linear-historical commentary on the Book of Revelation.[2] The *Victoria and Albert Altarpiece* is thus a descendant of the German family of thirteenth-century Apocalypse illustrated manuscripts, just as *Angers* is clearly a descendant of the Anglo-Norman family. A discussion of the exegetical emphases of the former altarpiece would certainly accord with the aims of this study, as the influence of Alexander's 'historicizing', and pro-Franciscan, commentary, can also clearly be felt on the images. However, the *Victoria and Albert Altarpiece* represents, in essence, a transposition of the Apocalypse manuscript format into altarpiece format.

Since the transposition of the thirteenth-century Apocalypse manuscript format onto a different format has already been discussed at length in the previous chapter, this chapter will focus on two fifteenth-century altarpieces, which visualize the Book of Revelation in different ways. While these works

---

[1] 'Apocalypse Altarpiece' by Master Bertram, Hamburg, Germany, *c*.1400. London: Victoria and Albert Museum, no. 5940-1859. See Kauffman 1968: 1–2.
[2] Ibid. 3–13.

retain traces of the iconography of the dominant thirteenth-century Apoca-
lypse manuscripts, the visualizations of the Book of Revelation offered in Jan
and Hubert Van Eycks' *Ghent Altarpiece* (Fig. 20) and in Memling's *St John
Altarpiece* (Fig. 21) are very different with regard to their function and format,
as well as the hermeneutical strategies they espouse. While there are numerous
altarpiece representations of the Last Judgement from the fifteenth century in
Northern Europe, these are the only two altarpieces (apart from the *Victoria
and Albert Altarpiece*) that I have been able to find that engage in a sustained
way with the Book of Revelation and its developing tradition.[3]

However, despite the largely religious content of the Van Eycks' and
Memling's (surviving) works, such artists did not belong to the tranquil sphere
of the fifteenth-century *devotio moderna* of Thomas à Kempis, Denis the
Carthusian, *et al*. Not only were these devout circles not in touch with the
great artists of the time, they self-consciously chose to produce simple books
without illustrations and would probably have regarded the *Ghent Altarpiece*
as a work of pride and ostentation.[4] Thus it is possible that artists such as the
Van Eycks and Memling knew of the Book of Revelation only through the
conventional, 'popular' channels, such as *The Golden Legend* and the Liturgy
of the Feast of All Saints, as well as perhaps through Apocalypse manuscripts
such as the *Flemish Apocalypse* (*c*.1400), all of which will be discussed briefly
below. The fact that the Van Eycks and Memling may not have known of
many contemporary exegetical interpretations of the Book of Revelation must
be held in tension with another possibility: that the works they produced are a
reaction against some textual interpretations of the Book of Revelation current
in the fifteenth century.

The *Ghent Altarpiece*, produced at the request of its patron, a Gentenaar
called Jodocus Vijd, to hang above the altar in a side-chapel in what was then
known as St John's Cathedral, is by no means a comprehensive visualization of
the Book of Revelation. Articulating the overall theological programme of this,
the largest multi-panel altarpiece produced in Northern Europe in the
fifteenth century, has proved to be something of a thankless task for all
those who have attempted it. In short, however, the *Ghent Altarpiece* is a
visualization of the communion of the mystical body of the Deity and the
Church that was believed to take place during the celebration of the Eucharist.
Themes from Book of Revelation chapters 5, 7, 14, 21, and 22 and its
developing tradition are visualized in the central panel in such a way as to
illuminate the meaning and implications of the Eucharist for the fifteenth-
century viewer. Kovacs and Rowland argue that the division between heaven

---

[3] See H. Memling, *Last Judgement Triptych*, 1467–71, Gdansk: Muzeum Navodowe, and
R. Van der Weyden, *Last Judgement Altarpiece*, 1452, Beaune: Hôtel-Dieu, for examples of the
Last Judgement altarpiece genre.
[4] Huizinga 1924: 261.

and earth, transcended in Rev. 21: 1ff. with the coming of the New Jerusalem, is presented in the central panel of the *Ghent Altarpiece* as being transcended via the Eucharistic feast, here symbolized by the slaughtered Lamb of Rev. 5: 6 who here stands not in the midst of the throne but on an altar.[5] Thus the New Jerusalem, ostensibly a future event is, in line with the principles of a Tyconian reading of the Book of Revelation, here viewed as an event which could be experienced as a present reality during participation in the Mass. This 'selective' and unashamedly synchronic approach to the Book of Revelation finds a parallel in Botticelli's approach to the text, as will be discussed in Chapter 4.

Hans Memling's *St John Altarpiece* (1474–9), which also emphasizes the ritual of the Eucharist, was commissioned by four ecclesiastics associated with the St John's Hospital in Bruges to hang in the newly renovated chapel. One side panel of this triptych depicts the life of John the Baptist and the other the events of the Book of Revelation in fleeting visionary format. Like the Van Eycks, Memling also realized a synchronic approach to the Book of Revelation. While he has not adopted an overtly selective approach to the text, his painting forms a clear and important contrast with the approaches discussed in the two previous chapters. Here, the narrative of the Book of Revelation flows through the painting as a whole rather than being contained in individual scenes according to a diachronic format.

Any interpretation of fifteenth-century altarpieces must be intimately connected to their liturgical and devotional function, a function that differs markedly from the presumed function of the illuminated manuscripts and tapestries discussed hitherto. Attempts have been made recently, notably by Lane (1984) and Williamson (2004), to analyse the fifteenth-century altarpieces that have survived in terms of their original context and function and in terms of their relationship with the altar.[6] Although such studies have inevitably tended to produce varied and not entirely complementary answers, some useful, general points can still be made.

Altarpieces have been linked in origin (although not exclusively) to the confirmation of the Doctrine of Transubstantiation at Lateran IV. Their link to the Eucharistic ritual endured into the fifteenth century and beyond.[7] During this time Early Netherlandish painters imbued their altarpieces with a greater degree of realism and naturalism than had been the case before, or indeed than continued to be the case in Italy (see Giovanni di Paolo's *Madonna and Child with Angels* for an example of a 'non-naturalistic' altarpiece).[8] By visualizing well-known theological themes such as the Annunciation or

---

[5] Kovacs and Rowland 2004: 37, 74.

[6] For more information on 15th-cent. altarpieces see Williamson 2004; Lane 1984; Koerner 2004.

[7] Williamson 2004: 348.

[8] Giovanni di Paolo, *Madonna and Child with Angels*, 1426, New York: Metropolitan Museum of Art.

the Passion within the context of the worshipper's everyday experience, Early Netherlandish artists such as Van Eyck, Memling, and Rogier van der Weyden were able not only to create a new form of intimacy for the worshipper, but also to illuminate or dramatize these miracles of Church doctrine in a way accessible to most viewers.[9]

Furthermore, many fifteenth-century Northern European altarpieces are imbued with Eucharistic symbolism, symbolism that is integrated into the previously mentioned naturalistic style. Lane argues, for instance, that a significant number of altarpieces depicting the Madonna and Child from this period portray the Madonna as the altar and Christ as the host sitting on a white corporal (see, for instance, Van Eyck's *Lucca Madonna*).[10] This would have facilitated parallels being drawn between the miracle of the Incarnation (the Word becoming flesh) and the miracle of Transubstantiation (the host or bread becoming the body of Christ). Similarly, the purpose of several altarpieces depicting instances from Christ's Passion (see, for example, van der Weyden's *Crucifixion Triptych*) appears to have been to explicate the sacrifice being re-enacted through the Eucharistic ritual on the altar.[11] Both the *Ghent Altarpiece* and the *St John Altarpiece* represent attempts to dramatize the miracle of the Eucharist.

Altarpieces in side altars (like the *Ghent Altarpiece)* may also have had a particular focus on individual saints for their subject-matter, the purpose of side altars being to accommodate the extra-liturgical devotions of lay people. However, many if not most altarpieces were intended to be understood in connection both with the liturgy and theology of the Eucharist *and* with the cult of saints, the Virgin, and other figures of devotion.[12] If Mass was being celebrated in front of the altar, as was the case on a daily basis with the *Ghent Altarpiece* and we assume also the *St John Altarpiece*, any Eucharistic themes present in the altarpiece would have come to the fore.[13] Conversely, if a beholder/devotee was engaged in private devotion, the focus could shift to the particular saints depicted in an altarpiece.[14] Crossley argues that altarpieces would have been opened or closed on particular days in order to draw attention to particular saints.[15] Alternatively, the two forms of devotion with their different emphases could also take place alongside each other.[16]

---

[9] Lane 1984: 2.

[10] J. Van Eyck, *Lucca Madonna,* c.1436, Frankfurt: Städelssches Kunstinstitut. See also Lane 1984: 13–35.

[11] Van der Weyden, *Crucifixion Triptych,* c.1440, Vienna: Kunsthistorisches Museum. See also Lane 1984: 79–82.

[12] Williamson 2004: 377.

[13] Although the panels of both altarpieces may only have been opened on Sundays and Feast Days.

[14] Williamson 2004: 379.

[15] Crossley 1998: 170–2.     [16] Williamson 2004: 380.

## 3.2 THE *GHENT ALTARPIECE*

Painted by Hubert and Jan Van Eyck, according to an inscription on the original frame, and finished in 1432, the *Ghent Altarpiece* is made up of twenty-four interior and exterior panels, making it the largest surviving fifteenth-century Northern European altarpiece.[17] It stands at 375 cm × 520 cm when opened. Only Rogier van der Weyden's *Last Judgement Altarpiece* comes close in terms of scale, ambition, and patronage context.[18] While it is important to be aware of the fact that there have been many investigations into the question of whether it was in fact Hubert, who died in 1426, or Jan Van Eyck who painted most of the *Ghent Altarpiece*, this debate is tangential to the question of the Book of Revelation imagery in the altarpiece. It is probable that Hubert was only involved in the early 'design-stage'.[19] Thus, as Goodgal, author of a comprehensive unpublished dissertation on the iconography of, and textual sources for the *Ghent Altarpiece*, puts it, 'the important matter, from the vantage point of its iconography, is not so much where in its progress the altarpiece went to Jan as what happened when it did.'[20]

As well as being a visual explication of the mystery of the sacrament of the Eucharist, the *Ghent Altarpiece* can also be described as a visual unfolding of the concept of Salvation History focusing on Genesis, the Incarnation, and the Book of Revelation in particular. While whole theses could be (and indeed have been) devoted to explicating the iconography of this altarpiece, here I have included only the briefest of descriptions of the parts of the work pertinent to the present study, namely, how it represents a unique visual exegesis of the Book of Revelation.

The two Johns are depicted on the outer panels as *grisaille* statues, part of the visual prologue to the inner panels, which also includes an Annunciation scene. John the Evangelist is the author of the vision that unfolds within, while John the Baptist is quite literally the forerunner to Christ himself (see, for example, Mark 1: 6–8). Thus their inclusion here fits well with the overall schema of the altarpiece.

Turning now to the interior, the figures of Adam and Eve (situated on the top tier of the inner panels) and above them the *grisaille* figures of Cain and

---

[17] For detailed expositions of the *Ghent Altarpiece* see especially Pächt 1994; Schmidt 2001; Goodgal 1981; and Dhanens 1973. See Dhanens 1973: 26–36 and Goodgal 1981: 124–5 on the dedicatory inscription which names both painters and reads as follows: *Pictor Hubertus eeyck. maior quo nemo repertus Incepit. pondus. q[ue] Iohannes arte secundus [Frater perfecit]. Iodoci Vijd prece fretus. Versu sexta mai. vos collocat acta tueri.*

[18] Rogier van der Weyden's *Last Judgement Altarpiece*, 1452, Beaune: Hôtel-Dieu. See Lane 1984: 137–43.

[19] Goodgal 1981: 128.

[20] Ibid. 125; see also ibid. 353. See further Luber 1997; Pächt 1994: 135–70; Goodgal 1981: 122–68; Dhanens 1980; Dhanens 1973: 37–50, and Coremans 1953 on the complicated artistic relationship between Hubert and Jan Van Eyck.

Abel, represent the Fall and its consequences. This is interesting given that, while ostensibly being a work about redemption, the *Ghent Altarpiece* actually shows very little awareness of sin. The only real acknowledgement of its existence, apart from the post-Fall depictions of Adam and Eve, is via a discreet wood-carving depicting St Michael's fight against the Dragon, on the choir-stand on the second panel from the left. This *faux* wood-carving is an interesting visual reference to Rev. 12, although it is not at all prominent within the altarpiece.

In the centre of the upper tier is a Deësis group with the Deity in the centre, the Virgin to his right and John the Baptist to his left. There is little scholarly consensus as to which person or persons of the Trinity the figure of the Deity represents due to the plurality of visual attributes used in the depiction.[21] The inscription at his feet, which refers to the condition of the saved, serves to link the upper and lower tiers. The figure of the Deity also forms a vertical axis of Divine images when taken in conjunction with the Dove, the Lamb, and the fountain in the lower panel. The Deity, the Dove, and the Lamb in particular are linked via the use of the colour red. The 'Divine axis' provides a unifying arrangement across the altarpiece, joining invisible concepts into the visible sacrament.[22] Another subtle link between the two panels is made through the use of a quotation from Rev. 19: 16 ('King of Kings and Lord of Lords') on the hem of the Deity's robe.[23] This serves to link the Lamb in the lower panel (see Rev. 5: 6) with the Word of God (Rev. 19: 11–16), although the question of whether Latin inscriptions in works of art in the Middle Ages were read is a vexed one.[24] Exegetical details such as this inscription, in combination with the wide range of sources used for the inscriptions, also point to the existence of a theological adviser.[25]

The theme of redemption or salvation intimated on the exterior panels finds its expression in the central interior panel known as the *Holy Lamb of God Panel* (hereafter referred to as the central panel). Visual references to the Book of Revelation abound, including to Rev. 5, 7, 14, 21, and 22. Particularly interesting is the transformation of Rev. 7 into a scene with obvious Eucharistic connotations. The red altar on which the Lamb stands is inscribed with the words *ecce agnus dei peccator mundi* (John 1: 29), and below on the penduli are the words *Ihesus via veritas vita* (John 14: 6). The Lamb itself is surely the Lamb from Rev. 5: 6 who reappears at Rev. 7: 9–11, 14: 1, 19: 9, 21: 9, 14, 21:

---

[21] See Goodgal 1981: 278–304; Pächt 1994: 128–31, 150–1; Dhanens 1973: 76–80; Schmidt 2001: 23, and Curley 1979: 9–10 on the debate in contemporary literature.

[22] Goodgal 1981: 334.

[23] See Dhanens 1973: 76.

[24] As has been discussed in Ch. 1.

[25] Harbison 2005: 392; see also Harbison 1991: 195.

22, 22: 1–3.[26] Directly in front of the Lamb is the Fountain of the Water of Life (see Rev. 7: 17, 21: 6, 22: 1, and 22: 17). Inscribed on the Fountain are the words *Hic est Fons Aque Vite Procedens de Sede Dei + Agni*.

Groups of people process on all four diagonals towards the Lamb on the altar. These represent the innumerable multitude from Rev. 7: 9. They have, however, been interpreted here as female martyrs, confessor saints, Old Testament patriarchs and pious pagans, and apostles and Popes. Only the 'saved' are permitted to gather around the altar.[27] In the distance behind the groups are buildings that might represent the New Jerusalem (Rev. 3: 12; 21: 2). To the left of the central panel are two panels, both of which also house groups of figures processing through (quite different) landscapes towards the Lamb. These include the *Iusti iudices*, the *Cristi milites*, the *Heremite sancti*, and the *Peregrini sancti*. They are all *viatores*, representatives of the Church militant, whose destination is the central panel where they will merge with the Church triumphant. The Church militant is made up of representatives from contemporary Gentenaar society. The ruling elite appear on the left-hand side and the humble poor on the right.[28] Visser confirms that the inclusion of pilgrims in the *Ghent Altarpiece* is not surprising, as 'viatorship' was a pervasive motif in contemporary commentaries on the Book of Revelation.[29]

The iconographic detail of the *Ghent Altarpiece* has for the most part followed 'tradition'. What is so innovative about the altarpiece is the composition, the way in which the Van Eycks have put together these pictorial elements, which by themselves would not have been particularly distinctive. It is undeniable that the altarpiece as it stands today is 'top-heavy' compositionally, a fact that cannot have been an accident and which may have some theological import. While it was usual to depict heaven above earth in late medieval art, the top-heaviness of the *Ghent Altarpiece* results from the fact that Christ and/or the Father in majesty is much larger and more prominent, around ten times larger in fact, than the Eucharistic Christ, the Lamb, on the altar. The prominence and size of the large figures in the Deësis group facilitate easy viewing, whereas one has to peer much harder at the central panel to take in the details, as well as to understand the panel's intricate internal composition, which recedes to a focal point in the background. The seemingly endless composition, used to depict the usually walled, heavenly garden or New Jerusalem, was an unusual choice. The unwalled composition suggests that earth, in its transience, is receding and giving way to the top register, which is eternal. One is reminded of Giotto's *Last Judgement* of 1306

---

[26] The Brussels commission (of 1950–1) noted that there exists underneath the Lamb an earlier, less precise version of the same figure. Thus the central point, the Lamb, would originally have been larger.

[27] See Visser 1996: 152.        [28] Goodgal 1981: 347–51.        [29] Visser 1996: 154.

in which the angels at the top of the fresco roll up the sky in order to reveal the permanent Heaven behind it.[30] In the *Ghent Altarpiece*, the theological point of the top-heavy Deësis panel and the receding horizon of the central panel may have been to evoke the New Jerusalem, the eternal city, coming down from the sky as described in Rev. 21: 2, an act which can be foreshadowed on earth through the sacrament of the Eucharist, as depicted in the central panel, but not fully achieved until the eschaton.

The top-heavy nature of the *Ghent Altarpiece*, the differences in panel size, and the fact that the curved tops of the outer panels on the upper tier do not neatly cover the flat tops of the central panels on the upper tier, led Brand Philip to an altogether different conclusion regarding the Van Eycks' original intention as to how the altarpiece should function. She suggests that the altarpiece as it is displayed today in a fixed position lacks logic, balance, and harmony, and that the Vijds would not have found it acceptable.[31] The twenty-four remaining panels were in fact originally part of a simple, yet huge, mechanical device, largely reliant on a hidden network of hinges, whereby the different panels could be turned around, swapped over, or hidden.[32] Thus the configuration of the panels could easily be changed, into any of up to ninety-eight different symmetrical configurations, a number that neatly coincides with the number of festivals in the ecclesiastical year.[33] This is an interesting suggestion, the theatrical possibilities of which may go some way to explaining the uneven nature of the panels. However, it is also completely unverifiable as no trace (either tangible or documentary) of the mechanical structure survives. Thus Brand Philip's suggestions remain just that and have not been taken up by more recent Van Eyck scholars.[34] They do, however, remind us that one should not necessarily view the altarpiece as a static entity but one with further possible states than that of being merely 'open' or 'closed'.

## 3.3 THE PATRONS OF THE *GHENT ALTARPIECE*, ITS ORIGINAL LOCATION AND FUNCTION

In order to better understand how the apocalyptic imagery described above functions within the overall programme of the *Ghent Altarpiece*, the altarpiece needs to be contextualized both in terms of its patron and the intellectual and

---

[30] Giotto, *Last Judgement*, 1306, Capella degli Scrovegni, Padua, Italy.
[31] Brand Philip 1971: 5.
[32] Ibid. 31.
[33] Ibid. 32.
[34] Although Seidel (1999) relies heavily on Brand Philip in her recent exposition of the *Ghent Altarpiece*.

religious climate of Ghent in the first half of the fifteenth century. Goodgal is absolutely correct in arguing that understanding the iconography of the *Ghent Altarpiece* hinges on being able to view it as much as possible through the eyes of a contemporary Gentenaar.[35]

The patrons of the *Ghent Altarpiece*, Jodocus Vijd, a wealthy financier, and his wife Elizabeth were both parishioners at St John's Cathedral in Ghent during the first half of the fifteenth century. Jodocus Vijd is named as the patron in the aforementioned inscription (see n. 17). Both Vijd and Elizabeth are depicted on the exterior of the altarpiece kneeling at the feet of the *grisaille* figures of John the Baptist and the Evangelist. Their presence here is an affirmation of the necessity of participation in the Mass.[36]

Elements of Vijd's biography in the form of official documents concerning his possessions, religious foundations, and career are now available to us.[37] A document registered with the Ghent city council on 13 May 1435, refers to the setting up of a religious foundation on behalf of Jodocus van Vijd and Elizabeth Borluut at St John's Church.[38] Crucially, it refers to the upkeep and function of the side chapel and altar, which the *Ghent Altarpiece* was designed for and for whose restoration they had also paid.[39] The presence of the altarpiece in the 'Vijd chapel' (as it came to be known) can be verified with documentary references from 1435 onwards.[40] However, it may be fairly confidently asserted that it was hung there on its completion in 1432. The chapel window is reflected in the blue brooch of the singing angel at the front of the composition on the upper tier of the left-hand side of the altarpiece (as you face it), a sure sign that the Van Eycks were working with the chapel in mind as the site for the altarpiece. In addition, the way in which they have used light in the altarpiece also suggests that they knew that it would be hung in that particular chapel.

The second section of the foundation document refers to the purpose of the chapel.[41] It was to be used to hold a daily mass in perpetuity 'to the glory of God, his Mother, and all the saints... for the souls of themselves [the Vijds] and their forebears... in the chapel and at the altar which they had recently

[35] Goodgal 1981: 91.
[36] Lane 1984: 139.
[37] See Goodgal 1981: 103–20 for a comprehensive treatment of Vijd's biography.
[38] Dhanens 1965: 89–93. It was common for documents such as these to be registered long after the event.
[39] Nicholas Rolin also established a Mass for the salvation of his soul in the chapel in which Rogier Van der Weyden's *Last Judgement Altarpiece* hung and which he had also commissioned (Lane 1984: 142).
[40] Goodgal 1981: 100.
[41] See Goodall 2001: 5–6 and 141–53 for an interesting contemporary English parallel to the Vijds' chantry foundation. God's House at Ewelme was set up in 1437 following the establishment of a similar foundation by husband and wife William and Alice de la Pole.

erected at their own expense'.[42] It can be surmised from this that one of the aims of both the chapel and the altarpiece was the personal salvation of the patrons. However, the emphasis placed on the arrangements in the foundation document for the daily mass itself, the responsibility for which was given to two priests without prior benefices and who would receive life-long salaries, implies a deeper preoccupation with the sacrament of the Eucharist.

The existence of the foundation document of 1435 also raises the question of Vijd's involvement in the iconographical programme of the *Ghent Altarpiece*. Goodgal argues that with a commission of this size and ambition, the patron would have been involved with each step of the production process.[43] From the evidence available it may be surmised that Vijd commissioned the *Ghent Altarpiece* and probably specified its theme, that of an explication of the mystery of the Eucharist.[44] He would then have overseen the production process. Vijd's role in determining the theological programme of the *Ghent Altarpiece* is less clear. The complexity of the programme, as well as the sophistication and wide-ranging aspect of the inscriptions, point to a more formally trained theological mind than those either of Vijd or of the Van Eycks. The sources for the inscriptions range from biblical books to *The Aeneid* and from patrological and scholastic writings to liturgical books.[45] Although Jan Van Eyck did use inscriptions in other works, such as in the *Madonna of van der Paele*, they tended to be fewer and less complex than in the *Ghent Altarpiece*.[46] Goodgal also argues that there is evidence of a copying error in the under-drawing for the inscription (mentioned above) at the feet of the Deity on the upper tier of the interior panels. The inscription makes reference to the right- and left-hand sides of the Deity, but examination of the first under-drawing reveals that it originally corresponded to the right- and left-hand sides of the painter or viewer. This may indicate that the Van Eycks were merely copying the inscriptions from a list without perhaps initially grasping their theological import.[47]

Although recent scholars, such as Harbison, have been rightly critical of the overuse of the unsubstantiated notion that the fifteenth-century Northern European artists had learned advisers to assist them with the complex theological symbolism present in their paintings, there does seem to be a case for positing the involvement of such an adviser in the *Ghent Altarpiece*, as he himself admits.[48] A possible parallel can be drawn with two other roughly

[42] Goodgal 1981: 111.
[43] Ibid. 352.
[44] See also Pächt 1994: 134 and Harbison 1991: 195–7 on Vijd's possible involvement with the *Iusti Iudices* panel.
[45] See Goodgal 1981: 227–9 for a more extensive list of sources.
[46] J. Van Eyck, *Madonna of Canon van der Paele*, 1436, Bruges: Groeninge Museum.
[47] Goodgal 1981: 193.
[48] Harbison 2005: 392; see also Harbison 1991: 195.

contemporary compositions. In 1439, a payment was made to a Franciscan of Tournai for a 'life and passion of St Peter' on which Robert Campin based an image.[49] Similarly, the theological programme for Dirk Bout's *Holy Sacrament Altarpiece* of 1464 was drawn up by a group of theologians in Louvain.[50] Most *Ghent Altarpiece* scholars now agree on the existence of a theological adviser. Goodgal has argued convincingly that the theological adviser for the *Ghent Altarpiece* might have been a prior of St John's Church named Olivier de Langhe. Even if he was not directly responsible for the theological programme of the altarpiece, in 1440 he wrote a treatise on the Eucharist called the *Tractatus de corpore Christi*, which may provide the theological 'key' to many of the visual ideas found in the altarpiece, as well as to the overall 'programme'.[51]

## 3.4 THE THEOLOGICAL PROGRAMME OF THE *GHENT ALTARPIECE* AND ITS LIKELY SOURCES

Prior to Goodgal's research, there were many attempts to trace the dominant influences on the iconography found within the *Ghent Altarpiece*. Much of the iconography has roots in the Book of Revelation itself, but this was a book that did not always reach the layman unmediated. Most people would have been familiar with the Book of Revelation via the liturgy of the Feast of All Saints, when the Epistle of the Mass consisted of a number of passages from the text, all of which refer to the vision of the Lamb surrounded by worshippers (Rev. 5: 6–12, 7: 2–12, 14: 1).[52] If the iconography of the central panel was in part derived from the liturgy of the Feast of All Saints, this would explain the visual interpolation of well-known saints into the depiction of the great multitude of Rev. 7: 9–10.

Chapter 162 of *The Golden Legend*, the thirteenth-century compilation of saints' lives and events relating to liturgical feasts, edited by Jacobus de Voragine, in which the sacristan of St Peter's in Rome has a dream-vision of a throne-room scene similar to that in the central panels of the *Ghent Altarpiece*, complete with the Deësis group and the multitudes of virgins and elders, may also have informed the general composition.[53] However, despite the clear parallels between the description found in *The Golden Legend* and the composition of the *Ghent Altarpiece*, both Pächt and Dhanens are adamant that the latter is *not* a straightforward illustration of the former since the Eucharistic and 'water of life' imagery that are central to the altarpiece are

---

[49] Goodgal 1981: 194.     [50] Ibid.     [51] Ibid. 229.
[52] Dhanens 1973: 88.     [53] See De Voragine 1969: 727 f.

lacking from the description found in *The Golden Legend.* Therefore, the full 'programme' of the *Ghent Altarpiece* is not found in either *The Golden Legend* or the liturgy of the Feast of All Saints, although it seems possible that they could have served as a starting point.

That no single obvious source contains all the themes found in the *Ghent Altarpiece* has prompted scholars to look among less well-known sources. Dhanens argued that there are strong parallels between Rupert of Deutz's commentary on the Book of Revelation, *de Victoria verbi Dei*, and some of the imagery in the *Ghent Altarpiece.*[54] However, concrete evidence of a direct link between the Deutz commentary and the altarpiece is lacking. Visser's attempts to link the *Ghent Altarpiece* to late medieval versions of the Berengaudus commentary on the Book of Revelation are similarly tenuous.[55]

We thus return to the relationship between Olivier de Langhe's *Tractatus de corpore Christi* (hereafter his *Treatise*) of 1440 and the *Ghent Altarpiece.* The *Treatise* not only reflects some of the dominant visual concerns of the altarpiece, but also evokes the theological context out of which other works focusing on the Eucharist in Ghent at this time arose. Concerns about the Eucharist and the 'water of life' seem to have been part of the academic 'lifeblood' of Ghent and the Low Countries more generally at this time, a trend that has been researched by MacNamee.[56]

De Langhe was prior of the monastery of St John's in Ghent from 1417 to 1455. His *Treatise* consists of two hundred and fifteen folios of theological quotations on the subject of the Eucharistic sacrament, the union between the mystical body of Christ, and Christ, its head.[57] As was the case with de Langhe's other writings his intention was to illuminate the subject of the Eucharist for a devout yet 'popular' audience using a variety of learned sources, mainly from the thirteenth century. This preference for older sources (as opposed to the more contemporary theologians Geert Groote, Johannes Ruysbroeck, and Jean Gerson, for example) is certainly reflected in the inscriptions for the *Ghent Altarpiece*, which have been drawn from a pool of sources and authors that includes the small group of sources that de Langhe relies upon most in the *Treatise*, such as Chrysostom and Hugh of St Victor.[58] Those without a direct parallel in de Langhe's *Treatise* could easily have been collected in St Bavo's monastery library, for which there exists an inventory.[59] De Langhe would certainly have had access to this library; indeed, some of his personal books are listed in the inventory.[60] However, more than this, the *Treatise* demonstrates that de Langhe was particularly skilled in selecting, editing, and organizing theological quotations of the sort found in the *Ghent*

[54] Dhanens 1973: 92–9.    [55] Visser 1996: 153–8.
[56] MacNamee 1998: 11–91.
[57] De Langhe, *Tractatus de corpore Christi*, Lille: Bibliothèque Municipale, MS. 387.
[58] Goodgal 1981: 227–8.    [59] Ibid. 201–9.    [60] Ibid. 210–11.

*Altarpiece*. He would thus have been exactly the sort of person that Vijd might have commissioned not only to assemble the inscriptions found in the altarpiece, but also to create the overall theological programme, which, like the *Treatise*, has at its core a desire to explicate complex theological ideas about the Eucharist in an accessible but nevertheless erudite manner.

Having established a link in genre and intention between the *Ghent Altarpiece* and de Langhe's *Treatise*, the conceptual parallels can now be discussed. Goodgal argues that the inscription at the feet of the Deity[61] on the upper tier refers to the concept of the Deity as head of the mystical body of Christ or the communion, a concept to which de Langhe devotes several chapters.[62] It also serves to relate the upper tier to the lower, where Communion has been visualized.[63] Secondly, Goodgal argues that five of the six different communions affected by the sacrament, as described by de Langhe and based on Albertus Magnus, are reflected visually in the central panel of the *Ghent Altarpiece*.[64]

The communion with the saints (see *Treatise* Part I, chapter 11) envisaged by de Langhe as including the Virgin, the angels, the patriarchs, apostles, martyrs, and 'every merit of God's elect' is clearly reflected in the central panel. The inclusion of a group of prophets and patriarchs in this panel (see the left-hand corner where many of them have been depicted as Sephardic Jews) shows that the iconography cannot have been directly derived from an All Saints' Liturgy, which lacks any mention of patriarchs. The communion of the Holy Spirit (see also *Treatise* Part I, chapter 11) is represented by the dove in an aureole at the top of the central panel.

The communion with the passions of the mystical body (also described in *Treatise* Part I, chapter 11) is enacted by the sharing in Christ's Passion that follows from taking part in the sacrament of the Eucharist.[65] In the *Ghent Altarpiece*, the central image of the slaughtered Lamb from Rev. 5: 6 on the altar (i.e. instead of a throne) shedding its blood into the Eucharistic cup, whilst simultaneously surrounded by angels holding the instruments of the Passion, serves as a visual evocation of the communion of the passions of the mystical body. The presence of the angels here (as well as above in the upper tier possibly) reflects the communion with the glory of the angels described by de Langhe in Part I, chapter 11.

The composition of the central panel has been arranged entirely around the figure of the Lamb. The groups of worshippers are arranged around the Lamb on diagonal planes (although the female martyrs are almost parallel to the

---

[61] The inscription reads as follows from left to right: 'Life without death at his head; Youth without old age at his forehead; Joy without sorrow at his right; security without fear at his left.'

[62] See for instance *Treatise* Part 1, chs. 1 and 2; Part 5, chs. 15–16.

[63] Goodgal 1981: 234–9.

[64] Ibid. 240–60.     [65] *Treatise* Part I, ch. 3, trans. Goodgal 1981: 254.

picture plane). The Dove forms the upper apex and the Fountain the lower. In spite of all this, however, the Lamb constitutes a 'weak centre' on grounds of its small size and passive demeanour. It was suggested above that this weak centre forms a deliberate contrast with the Deity in the middle of the Deësis group. Nevertheless, the members of the communion represented by the different groups both inside and outside the central panel all process towards this weak yet symbolic focal point, an indication of their participation in the communion with the passions of the mystical body as well as with the glory of the angels. The two inscriptions on the altar are from John 1: 29 (which is quoted at the breaking of the Host) and John 14: 6 respectively. These quotations describe the sacrificial content of the Eucharistic sacrament, an aspect emphasized by de Langhe in the *Treatise* Part I, chapter 2, as well as in Part V, chapter 2. The Van Eycks' Lamb is a visual explication of this sacrificial theme.

The Lamb can also be interpreted in terms of Rev. 21: 3, which states that God's throne is now to be found on earth rather than in heaven, as it had been in Rev. 4: 1–11 (cf. Rev. 7: 9–17; 8: 1–5; 11: 15–19; 15: 2–8; 19: 1–6). Although it is the Lamb that stands on the altar in the central panel, the interchangeable nature of the attributes used to describe God and Christ in the Book of Revelation means that the altar in the central panel could equally be interpreted as God's throne as described in Rev. 21: 3.[66] The implication is that the division between heaven and earth, which is collapsed in Rev. 21–2, is also transcended via the Eucharistic feast, here symbolized by the Lamb.[67] The essential point of the altarpiece was therefore to evoke the present reality of the New Jerusalem experienced by the participants in the daily Mass in the Vijd chapel via participation in the sacrament of the Eucharist. However, as well as having a 'present' function, the altarpiece also evokes a future salvation, the entrance into the New Jerusalem, which was thought to follow from daily participation in the Mass. This future salvation or realm is symbolized by the upper tier of the altarpiece.

The fifth communion described by de Langhe, that of the communion with the fountain of grace, is reflected in the image of the fountain, also placed on the 'Divine axis' of the central panel. Throughout the *Treatise*, images of running water and particularly of fountains are used by de Langhe to evoke the grace that flows from God to mankind during the sacrament of the Eucharist.[68] For de Langhe then, the flowing fountain in the Eucharist is a metaphor for Christ's own actions during the sacrament itself, when he pours himself out for the nourishment of the faithful.[69] This idea is articulated in the central panel of the altarpiece via the inscription from Rev. 21: 6 and 22: 1

[66] Bauckham 1993*a*: 141–2.    [67] Kovacs and Rowland 2004: 37, 74.
[68] Goodgal 1981: 260. See de Langhe, *Treatise*, Introduction, tr. Goodgal 1981: 216.
[69] See also de Langhe, *Treatise* Part V, chs. 10, 12, and 13.

found on the fountain itself. The inscription can be translated as: 'This is the fountain of the water of life, proceeding from the seat of the Lamb and the Father.' The fountain, which according to de Langhe exists in the Eucharist, is thus here visualized and explicated via the inscription as the apocalyptic fountain of life (Rev. 21: 6) and also as the river of the water of life (Rev. 22: 1). The two concepts of a fountain and a river are both contained in the image as, although jets of water spurt up from the fountain, the water also flows in a rivulet to the bottom of the panel, down towards the altar itself, where Mass was celebrated in the Vijd chapel. The motif of the fountain of life could not, however, be included if the image of the slaughtered Lamb (Rev. 5: 6, cf. John 1: 29, 1 Corinthians 5: 7) were not also prominently visible as a reminder of the sacrifice that facilitated the transmutation of the blood of suffering to the water of life.

The image of the fountain in the central panel has striking similarities with Jan Van Eyck's earlier *Fountain of Life/Triumph of the Church over the Synagogue* (Fig. 22). The central theme of this piece is the transmutation of Christ's blood into the Water of Life via the sacrament of the Eucharist, an idea, as has been argued above, that is also taken up in the central panel of the *Ghent Altarpiece*. The compositional similarities are also striking, particularly with regard to the Deësis group and the fountain, which also connects to a rivulet.

This central theme (the transmutation of Christ's blood into water) is also found in an illustration for *De Omnibus Sanctis*, a manuscript from Ghent in which the water of redemption is seen flowing from the side of the crucified Christ into the fountain of life, around which a group of saints kneel.[70] Thus, the concept of a fountain as a metaphor for the grace that flows from Christ to the believer during the Eucharist seems to have both textual and visual roots in Ghent during the first half of the fifteenth century. It is only in the *Ghent Altarpiece*, however, that this idea is fully explicated using prominent visual imagery from the Book of Revelation in particular.

The visualization of the fountain and the New Jerusalem found in the central panel also echoes conventional exegesis of Rev. 21 and 22. John's vision of the New Jerusalem describes the return to earth of the divine glory that has been located in heaven since the Fall. This New Jerusalem (Rev. 22: 1–4) is partially described in terms of the original Garden of Eden (see Gen. 2: 9–10), complete with a life-giving river and a tree of life.[71] The serpent evoked by the images of Adam and Eve on the upper tier of the altarpiece is not found in John's vision of the New Jerusalem (see Rev. 22: 3, 'nothing accursed will be found') and, accordingly, no images of judgement or of evil intrude on the central panel. The images of Adam and Eve as well as the *grisaille* figures of

---

[70] Pächt 1994: 134.     [71] See Kovacs and Rowland 2004: 238–9.

Cain and Abel (see Gen. 4) on the upper tier and the visualizations of the Book of Revelation found in the central panel are thus synthesized in the central vision of the New Jerusalem as a new Eden.

Pächt has highlighted the problems raised for visual interpreters by the account of the New Jerusalem as a walled city in Rev. 21, followed by the account of the river of the water of life surrounded by fructifying trees in Rev. 22.[72] The two visions cannot be visualized in the same space. As has been seen in Chapters 1 and 2, in late medieval illustrations of the Book of Revelation, the New Jerusalem was usually visualized as a city coming down from the sky. This was followed by separate images of the river of the water of life (see *Angers* 6.80–4). In the central panel of the *Ghent Altarpiece*, the image of the water of life flowing from the fountain and implicitly from the throne of God and the Lamb supersedes any visualization of the New Jerusalem as a city. A small nod is given to the description of the celestial city in the detail of the gemstones that lie scattered around the fountain, since Rev. 21: 19–21 describes the foundations of the city as being adorned with 'every jewel'. The buildings visible in the background of the central panel, among which the towers of Utrecht Cathedral and of St Nicholas in Ghent can be identified, may represent the New Jerusalem (Rev. 3: 12; 21: 2). Although not obvious to the present-day viewer, it is likely that contemporary viewers would have recognized these buildings. This may have indicated to them either that paradise was present in fifteenth-century Flanders or, more likely, that these buildings too would pass away with the descent of the eternal New Jerusalem, to be replaced with the celestial city itself.

If the prominent visualization of the fountain from Rev. 21: 6 breaks with tradition, so too does this vision of Eden as an open and verdant paradise. The 'earthly paradise' was usually depicted as a *hortus conclusus* in late medieval art.[73] The garden in the central panel purposefully has no end, extending beyond the frame into limitless space. As Pächt perceptively remarks, in keeping with his predilection for realism, Van Eyck offers the viewer a vision of a 'naturalized' heaven.[74] Perhaps he is also making the theological point that the New Jerusalem can only be partially evoked with our transient visual abilities. The eternal realm represented by the Deësis group is beyond the scope of the painter and can only be hinted at. Thus the central panel is a foreshadowing of the New Jerusalem, but does not and perhaps cannot represent it in its entirety.

---

[72] Pächt 1994: 145.

[73] See Aben and de Wit 1999: 31–59 on the medieval origins and development of the idea of Eden as a *hortus conclusus*. Chaotic nature represented the Fall whereas a proportionally ordered and enclosed garden represented Eden.

[74] Pächt 1994: 148.

The interpretation of the central panel in terms of a new Eden, an earthly paradise, is supported by a chronicle description of a *tableau vivant* of the *Ghent Altarpiece* staged for Philip the Good in 1458 called the *Chorus beatorum in sacrificium Agni paschalis.*[75] In this piece, the players clearly seem to have understood the altarpiece as an explication of the sacrifice celebrated daily through the Eucharist.[76] The description also notes several inscriptions used in the *tableau vivant* that have either been erased from or were never included within the altarpiece. The chronicle notes two extra inscriptions on the fountain. In addition to the original inscription, which amalgamates Rev. 21: 6 and 22: 1, there was written: 'Our fountain will give a refreshing draught to him who seeks it', also derived from Rev. 21: 6. Similarly, the chronicle reports another inscription held by an angel.[77] This inscription read: 'A river flowed forth from the place of delight to irrigate Paradise' Gen 2. [10]. This serves to link the apocalyptic fountain with Gen. 2: 10, as is the case in conventional exegesis of the Book of Revelation.[78]

Thus, five of the six communions discussed in de Langhe's *Treatise* are visually explicated in the *Ghent Altarpiece.* However, neither does the *Treatise* provide a complete explanation of the theological programme contained within this monumental work. As Goodgal herself acknowledges, the Eucharistic theme of the *Treatise* does not yield itself easily to the painter's brush.[79] Thus while she seems correct in treating de Langhe's *Treatise* as a partial gloss on the altarpiece, it should not be focused on to the exclusion of other more immediately obvious sources, such as that of the Book of Revelation itself. For it would seem that the artists and theological minds behind the *Ghent Altarpiece* used key visual imagery from the Book of Revelation as a 'springboard' into this artistic exploration of the mysteries of the Eucharist. Goodgal, for instance, fails to suggest at any point that the compositional structure of the central panel is based around the description of the great multitude processing towards the Lamb on the throne and holding palm branches as described in Rev. 7: 9–10, despite the fact that the female martyrs and the confessor saints are clearly holding palm branches as they progress towards the Lamb. In Rev. 7: 17, the Lamb is even described as the shepherd of the multitude who 'will guide them to springs of living water', thus providing an exegetical link with the apocalyptic fountain of Rev. 21: 6 that appears on the vertical axis at the front of the central panel. The connection of the Lamb with the fountain is in some ways obvious, but a more secure link is certainly provided by Rev. 7: 17.

As mentioned above, on All Saints' Day the Epistle of the Mass consisted of a number of passages from the Book of Revelation, all of which refer to the vision of the Lamb surrounded by worshippers (Rev. 5: 6–12, 7: 2–12, 14: 1). Rev. 5: 6–12

[75] Pächt 1994: 148.     [76] Goodgal 1981: 272.     [77] Ibid. 276.
[78] See Kovacs and Rowland 2004: 238–9.
[79] Goodgal 1981: 270.

and 7: 2–12 have already been related to the altarpiece. Additionally, there is a visual detail in the central panel that strongly suggests that those responsible for the design of the panel were also familiar with Rev. 14: 1, which describes the Lamb as being worshipped on Mount Zion. Careful attention to the central panel reveals that the Lamb's altar is indeed situated on top of a hill. Similarly, in Rev. 14: 4, there is a (much discussed) reference to the virginity of the 144,000 worshippers, which may have inspired the inclusion of the group of virgin martyrs in the top right-hand corner of the central panel.[80] Such an easy familiarity with the Book of Revelation cannot be explained in relation to the Epistle of the Mass on All Saints' Day, but a theologian such as de Langhe would not have been restricted to such well-known sources and would also have had access to commentaries on the text via the library at St Bavo's, as well as to the source text itself.

## 3.5 CONCLUSION

The central panel of the *Ghent Altarpiece* functions as a visual explication of the mystery of the sacrament of the Eucharist on which Olivier de Langhe, prior of St John's, wrote a contemporary *Treatise*. What remains most striking about the piece from the point of view of the visual history of the Book of Revelation, is the way in which imagery from several chapters have been brought together in order to serve the didactic aims of the altarpiece. Elements from within the Book of Revelation have been combined and juxtaposed with other biblical and theological themes. Thus, while the Lamb of Rev. 5: 6, which also appears in Rev. 7, 14, 19, 21, and 22, does of course already have Eucharistic import, in the *Ghent Altarpiece*, his role as the sacrifice that facilitates the daily sacrament of the Eucharist is given visual prominence. The fountain of the water of life from Rev. 21–2, which has also been placed on the vertical axis in the central panel, functions both as a metaphor for the 'outpouring' of Christ during the sacrament of the Eucharist and as a symbol of the resolution that is achieved between heaven and earth during the Eucharist, when the New Jerusalem is enjoyed as a present reality.

The central panel, in its visual presentation of the Fountain of Life and of the New Jerusalem as a paradisal garden, also echoes the exegetical links that can be made between Rev. 21–2 and Gen. 2. The top-heavy compositional structure nevertheless suggests that the *eternal* New Jerusalem has yet to replace the earthly vision of paradise evoked in the central panel. This type of presentation forms a clear contrast with the earlier manuscript and tapestry visualizations of the New Jerusalem discussed in previous chapters.

---

[80] See Kovacs and Rowland 2004: 160–1 for a discussion of interpretations of the 'virgins' of Rev. 14: 1–5 ranging from Origen to the present day.

In terms of its overall hermeneutical strategy, the *Ghent Altarpiece* can also be distinguished from the examples discussed in the preceding chapters. In contrast to diachronic or chronological visualizations, the *Ghent Altarpiece* is a good example of the synchronic altarpiece format in which multiple theological ideas can be brought together in one pictorial space. Once freed from the constraints of a diachronic book-format, the artist can prioritize parts of a text, in this case the Eucharistic and celestial imagery, and leave other parts out completely. Such a theatrical, non-literal representation of themes from the Book of Revelation presents the viewer with a very different hermeneutical approach to the text from those attributed to the Anglo-Norman manuscript genre, for example. The liturgical function of the altarpiece as a backdrop to a daily Mass would also have served to illuminate both the Eucharistic themes of the altarpiece, as well as the Eucharistic relevance of the apocalyptic imagery contained therein. Thus the altarpiece and its setting serve to interpret each other, a complex example of how function can play an important role in shaping hermeneutical strategy.

## 3.6 HANS MEMLING'S *ST JOHN ALTARPIECE*

The *St John Altarpiece* (1474–9) is the second of Hans Memling's three large, extant triptychs (Fig. 21).[81] Commissioned by four ecclesiastics associated with St John's Hospital in Bruges, Jacob de Ceuninc, Antheunis Seghers, Agnes Casembrood, and Clara van Hulsen, the altarpiece was designed to hang above the new high altar in the hospital chapel.[82] Although little is known about the patrons and commissioners, they are depicted, as was traditional, along with their patron saints on the rear of the two wings of the triptych.

The central panel (173.5 cm × 173.5 cm) depicts Mary and the Christ-Child surrounded by a gathering of saints and angels. The left-hand panel (176 cm × 79 cm) depicts scenes from the life of John the Baptist, while the right-hand panel (also 176 cm × 79 cm) consists of a synchronic presentation of the Rev. 1–13. As far as is known, Memling never again produced another Apocalypse panel, although interestingly some of its scenes reappear in the right-hand panel of Memling's *Diptych for John Cellier*.[83]

The central panel has been referred to in the scholarly literature as a *sacra conversazione*, but as this is a term applied more naturally to Italian altarpieces,

---

[81]  See de Vos 1994 for the most comprehensive recent treatment of the life and works of Hans Memling. See also Lane 2009 for likely influences on Memling.

[82]  Smets 2001: 35.

[83]  Memling, *Diptyque for John Cellier*, c.1482, Paris, Museé du Louvre, inv. R.F. 309, 886.

it will be referred to throughout this chapter merely as the central panel.[84] The altarpiece as a whole was originally referred to as *The Mystic Marriage of St Catherine* on account of the ceremony that is taking place between Jesus and St Catherine in the bottom left-hand corner.[85] Although this original title fails to take into account the emphasis within the altarpiece on the two Johns, it is significant in that this was how it was perceived and defined by original viewers.

St Catherine's mystic marriage makes her in a sense a 'bride of Christ', a role which had been undertaken in reality by the two female patrons of the altarpiece when taking their vows as nuns. Her designation as a bride may also be significant in terms of the visualization offered of the Book of Revelation in the right-hand panel. Visser has persuasively suggested that the marriage scene in the central panel between St Catherine and the Christ-child may be a visual interpretation of the marriage feast of the Lamb from Rev. 19: 5–10, which is absent from the Apocalypse panel itself.[86] This idea will be explored in more detail below.

On the right of the central panel sits St Barbara, invoked when sudden death was feared, thus rendering her inclusion appropriate for an altarpiece made for a hospital. Behind the female saints stand the two Johns, the patron saints of the hospital. They personify various aspects of the Eucharist.[87] John the Baptist, accompanied by a Lamb, points to Christ in what is probably an evocation of John 1: 29. John the Evangelist, standing on Mary's left, blesses the poisoned cup, his attribute, which he is holding. The cup is a visual reference to the poisoning episode in the apocryphal Acts of John, a work that was well known by this stage thanks to its inclusion in de Voraigne's hugely 'popular', aforementioned, thirteenth-century *Golden Legend*.[88] The episode itself is depicted on the capital of one of the columns behind John, as is the scene of the raising of Drusiana, another miracle associated with this saint. Although the cup is poisoned, the sign John is making is identical to that made by a priest when blessing the chalice of wine during Mass, thus providing a clear visual link with the ritual of the Eucharist.

In addition to the scenes on the capitols of the columns, Memling has also included more tiny scenes from the lives of John the Baptist and John the Evangelist in the background of the central panel. This was not in itself an unprecedented action. Some Italian painters such as Paolo Veneziano

---

[84] See, for example, De Vos 1994: 151. See Turner (ed.) 1996: vol. 27, 494–6 for a description of the Italian *sacra conversazione*.

[85] De Vos 2002: 171. As well as the aforementioned *Diptyque for John Cellier* which depicts the mystic marriage of St Catherine and the Christ-child, among other things, Memling also depicts St Catherine's mystic marriage in his *c.*1479 *Virgin on the Throne with St Catherine, St Barbara and two angels*, New York: Metropolitan Museum of Art, inv. 14.40.643.

[86] Visser 1996: 158–60.

[87] De Vos 2002: 172.     [88] See Hennecke 1974: vol. 2, 215–59.

(d. *c*.1362) and Benezzo Gozzoli (*c*.1420/22–1497) had regularly painted small narrative scenes around larger central compositions of the Virgin and Child or collections of saints.[89] Whether Memling knew of this Italian style of painting is not clear.[90] Within his own oeuvre, however, this style of 'simultaneous painting' became well established. The life story of John the Baptist, related to the viewer via these tiny scenes, meanders back and forth between the central panel and the left-hand panel, making the narrative quite difficult to follow.[91]

John the Evangelist is depicted in the background of the central panel being tortured in a vat of oil. In the chapel at the very back of the panel, Memling has depicted John baptizing the pagan philosopher, Crato.[92] In between these two scenes, John is depicted as boarding a boat for the island of Patmos. This image provides a visual link with the Apocalypse panel on the right-hand side, which depicts John on Patmos receiving his vision. In one sense then, the entire Apocalypse panel, as well as the tiny background scenes, should be viewed as part of the widening out of John's traditional attribute, that of the poisoned cup. Interestingly, some contemporary evidence can be found to support the idea that saints' attributes were increasingly being expanded into narratives. Uccello's George and the Dragon of *c*.1470, for example, in which St George is depicted, mid-narrative, defeating the Dragon while a princess looks on, instead of merely posing with his attribute, suggests a similar interest in narrative visualizations of saints' lives rather than mere static depiction of attributes.[93]

It is worth pausing here to question the purpose of these tiny background scenes, which are significantly smaller than the main figures in the central panel. However, anyone familiar with John's *vita* would easily have been able to identify John's 'martyrdom' in oil and probably his boarding of the boat to Patmos too.[94] On an exegetical level, the depiction of episodes from John's *vita* in a synchronic fashion via these tiny scenes forms a contrast with the presentation of the same subject-matter in the Apocalypse manuscripts discussed in Chapter 1. In these manuscripts, the illustrated *vitae* were placed either at the beginning or the end of the text of the Book of Revelation and the accompanying illustrations. While it was argued that the visual presentation of John's *vita* in Lambeth in particular had been designed to inform the 'reader's'

[89] See Veneziano's *Virgin and Child* in S. Pantalon, Venice and his *Danaldo* lunette, as well as his cover for the Pala d'Oro Altarpiece (see Turner (ed.) 1996: vol. 24: 29–34).

[90] Campin and van der Weyden also included small narrative scenes within some of their larger paintings. See for instance Campin's *Virgin and Child before a firescreen c.*1425.

[91] De Vos 1994: 152.

[92] Hennecke 1974: vol. 2, 215–59.

[93] P. Uccello, *Saint George and the Dragon*, *c*.1470, London: National Gallery NG 6294; see also *The Golden Legend*, vol. III, ch. 58.

[94] The apocryphal Acts of John had been well known in Europe since the 11th cent. (see Morgan 1990: 53–5) and (as mentioned above) had been immortalized in De Voragine's *The Golden Legend*.

experience of the Book of Revelation itself and, in particular, their view of John as participant, author, and moral guide, it was physically impossible for the viewer to look at both the Apocalypse images and the *vita* images at the same time. In Memling's altarpiece, however, the attentive viewer would be able to locate John's apocalyptic visions (depicted on the right-hand panel) within his life story in one glance. Thus while the tiny scenes from John's life do not have a moralizing function as was the case with Lambeth, they help to contextualize the apocalyptic vision as a real event within John's life and perhaps, as suggested above, represent, on one level, an expansion of John's traditional attribute, the poisoned chalice.

This visual contextualization is offset by the left-hand panel, which contains scenes from the life of John the Baptist. Both outer panels include meandering stretches of water that fade into the background, drawing both the eye and the imagination with them over the horizon. While in the Apocalypse panel the chronological progression of events runs from the front of the composition to the back (decreasing in size), in the left-hand panel, the earliest event (John pointing out Jesus to his disciples on the banks of the Jordan) takes place in the far distance and the most recent event (the beheading of John the Baptist) in the foreground. The two panels thus constitute an inverse mirror of one another. It is therefore important to keep the altarpiece as a whole in mind even when focusing on the right-hand Apocalypse panel.

## 3.7 SETTING AND FUNCTION OF THE *ALTARPIECE*

In the fifteenth century St John's Hospital was less a place of medical treatment and, in keeping with contemporary norms, more a place where patients would experience a dignified, religious death and receive a proper burial.[95] Thus it was also a place of contemplation, contemplation that may have been assisted by the arrival of Memling's *St John Altarpiece* in the chapel in 1479, although it should be noted that the triptych would probably only have been opened on Sundays and feast days.[96] The choice of a partially apocalyptic subject was somewhat unusual in light of the hospital setting of the altarpiece. Traditionally, hospital altarpieces would have concentrated on such subjects as the Day of Judgement, the Weighing of Souls, and the Threat of Damnation.[97] Memling's serene composition is, in contrast, devoid of any sense of moral opprobrium, evoking not judgement but a mystical fusion of the heavenly and earthly

---

[95] Porter 1997: 110–34 on hospitals in Western Europe in the Middle Ages and their relationship with the Church.

[96] Harbison 1991: 131 in support of this suggestion.

[97] De Vos 1994: 38.

realms. In this sense, then, the *St John Altarpiece* has clear parallels with the *Ghent Altarpiece*, which visualizes aspects of the New Jerusalem with no reference to the judgement that must precede it.

Although it by no means encapsulates a simple message, Memling's triptych offers what might be described as a conciliatory view of human suffering. Human suffering, as encapsulated in the two side panels, is presented as a necessary counterbalance to the central scene where the four persecuted saints (John the Baptist, St John the Divine, St Catherine, and St Barbara) sit with the Madonna and Child in ordered tranquillity. The throne-room scene from Rev. 4–5, which is so prominently depicted at the top left-hand corner of the Apocalypse panel, and the glimpse of the Deity through the clouds at the baptism of Jesus in the left-hand panel, serve to infuse the two side panels with an air of Divine control.

What can be said about the contemporary function of the altarpiece? When opened, Memling's synchronic presentation of his subject-matter would have confronted the worshippers. It has been variously suggested that the central panel represents a vision of the afterlife, the fusion of heaven and earth that takes place during the Eucharist, as in the *Ghent Altarpiece*, or perhaps, as Visser suggests, it is a depiction of the marriage feast of the Lamb from Rev. 19.[98] Whatever the correct interpretation, and they need not be mutually exclusive, the awe-inspiring effect of the triptych would have been all the greater if, as was the case with the *Greverade Triptych*, a large triptych of the Passion painted by Memling for Lübeck Cathedral in 1491, the panels were actually opened in front of the assembled congregation.[99]

The aforementioned Eucharistic features of the central panel, as well as the throne-room scene at the top of the Apocalypse panel, would have provided a fitting backdrop to the ritual of the Eucharist, while the overarching themes relating to suffering and its heavenly reward, if this is indeed what the central panel depicts, would have provided a focus for more personal devotion.

## 3.8 MEMLING'S ICONOGRAPHIC AND TEXTUAL INFLUENCES

Little is known about Memling's theological influences and, likewise, about any theological texts or persons that he might have been influenced by while he produced the *St John Altarpiece*. Neither is there any Treatise available, such as de Langhe's, that seems to match the 'programme' of the altarpiece as was the

---

[98] See De Vos 1994: 151–6; Visser 1996: 157–64.
[99] De Vos 1994: 54. *The Greverade Triptych*, 1491, Lübeck: Sankt-Annen-Museum, inv. 1948/138.

case with the *Ghent Altarpiece*. While one should not therefore automatically posit the existence of a theological adviser, it seems likely, given the very detailed nature of the Apocalypse panel in particular, as well as some of the sophisticated interpretative ideas in evidence, that Memling consulted with someone rather than just relying on a pre-existing text or visual tradition.

Visser makes some interesting suggestions regarding specific interpretative trends relating to the exegesis of the Book of Revelation and, in particular to that of the marriage of the Lamb (Rev. 19) by which Memling may have been influenced. He also suggests a link with Thomas à Kempis' *The Imitation of Christ*.[100] These suggestions will be discussed below alongside the relevant apocalyptic imagery. Parallels can also be drawn between Memling's use of a roundel resembling an eye-ball in his depiction of the heavenly throne-room (Rev. 4–5) at the top of the Apocalypse panel and Hieronymous Bosch's use of similar roundels in his exterior for the *Scenes from the Passion* (reverse of the *St John on Patmos* panel) and, more specifically, for his *Tabletop of the Seven Deadly Sins* (Fig. 23).[101]

On a compositional level, it is my contention that a tentative case can be made for Memling having known the so-called *Flemish Apocalypse*, the first known Apocalypse manuscript to be written and illuminated in the Low Countries (*c*.1410–20).[102] Klein also argues that Memling might have been influenced by Giotto's fourteenth-century Italian fresco cycles of the Book of Revelation and their descendents. While Giotto's Naples frescoes (*c*.1328–32) are no longer extant, copies of them (*c*.1330–40) portray forty-four scenes from the Book of Revelation across two small painted panels.[103] Crucially, the crowded scenes are arranged on small, sometimes interconnecting islands, a feature that recurs in Memling's Apocalypse panel. Klein argues that this style of visualizing the Book of Revelation went on to influence both fourteenth-century Neapolitan Apocalypse manuscripts and Northern Italian wall paintings as well as the Bohemian Apocalypse frescoes of the St Mary Chapel at Karlstein Castle near Prague (*c*.1357–61).[104] It is therefore possible, but far from verifiable, that Memling could have come into contact with this style of visualization of the Book of Revelation. While the Neapolitan panel tradition does go some way towards encompassing a simultaneous depiction of the text, the crowded and over-detailed nature (in some instances compositions have merely been lifted straight from Apocalypse manuscripts), as well as the lack of perspective and realism, entail a viewing experience closer to that of *Angers* than of Memling's Apocalypse panel.

---

[100]  Visser 1996: 159–60.
[101]  See Gibson 1973: 205–26; Koerner 1998: 277; Jacobs 2000: 1028–9.
[102]  The *Flemish Apocalypse*, BN Néerl. 3, Bibliotheque Nationale, Paris and see also Van der Meer 1978: 203–36.
[103]  *Apocalypse*, after Giotto, *c*.1330–40, Panel 35.1 cm × 86.6 cm, Stuttgart: Staatsgalerie.
[104]  Klein 1992: 193–6.

Finally, on a stylistic (and possibly interpretative level), we note that the use of tiny scenes to express an overarching narrative was a technique displayed by Memling in works executed both before and after the *St John Altarpiece*. An early example is his *Scenes from the Passion of Christ*, which was painted between 1470 and 1471.[105] In it the entire story of the Passion unfolds in one continuous cycle via twenty-three tiny scenes, extending from the entry into Jerusalem to Christ appearing by the Sea of Galilee. There is an interesting possibility that the work could be based on the report of Anselm Adornes' (a friend of the patron's) trip to Jerusalem in 1470. The painting could almost be a historical reconstruction of the various holy sites described in the report. At the time, indulgences could be obtained by those making imaginary 'pilgrimages' to the Holy Land (by contemplating a painting, for example).[106] This work is important in that it represents the first large-scale example of Memling's so-called 'simultaneous painting' style. In 1480, Memling painted the *Advent and Triumph of Christ*.[107] The painting, on which Memling must have commenced work whilst finishing the *St John Altarpiece*, is two metres wide and manages to convey not only spatial but temporal movement. The temporal aspect of the painting is key, in that in the *St John Altarpiece* one also perceives that Memling is playing with the concept of time. In the *Advent and Triumph of Christ*, the viewer is once again presented with tiny depictions of episodes from the Advent to the Resurrection of Christ, scenes which De Vos describes as appearing like 'the beads of a rosary'.[108]

Thus the 'simultaneous painting' in evidence in all three panels of the *St John Altarpiece* was very much a part of Memling's style, particularly with regard to his large paintings and altarpieces. One has to 'enter' these sorts of paintings and experience them rather than try to understand them from the outside. This can only be achieved by mentally shrinking down in order to envisage stepping inside the painting so that the events visualized within might take on their true dimensions.[109] Just as rosaries and pilgrimages were supposed to lead to higher spiritual truths and discernment, so could such narrative paintings be experienced in the same way. However, it would be much easier to 'experience' a painting in such a way if it was a private work, which the former two works by Memling were and which his *St John Altarpiece* was not. Whether the whole altarpiece and the Apocalypse panel in particular could have been experienced in such a way would largely depend on how often the panels were opened and for how long, information that is not readily available to us today.[110] To be able to immerse oneself in the apocalyptic drama of the scene would also require sustained and perhaps even

---

[105] See De Vos 1994: 105–9.     [106] Ibid. 32.     [107] Ibid. 173–9.
[108] Ibid. 43.     [109] Idem 2002: 175.
[110] Although see De Vos on how the *Greverade Triptych* was opened before the congregation (De Vos: 1994: 54). Such an action may have been common practice at this time.

repeated contemplation. Such contemplation might not have been possible for the dying patients of the hospital, although it might well have been possible for some of the staff.

### 3.9 DETAILED ANALYSIS OF THE APOCALYPSE PANEL OF THE *ST JOHN ALTARPIECE*

The detail, small scale, and impressive synchronicity of Memling's Apocalypse panel mean that a detailed description of the exegetically interesting parts of the altarpiece is warranted. It would have originally sat (with the rest of the triptych) on top of the altar in the hospital church's apse, where it remained until the renovation of the building in 1637. This raised setting would have made it difficult to view all the events depicted in the Apocalypse panel. Today the panel is displayed in the Memling Museum, which is housed in what used to be St John's Hospital. It is not, however, displayed on the altar, but in front of it, about fifty centimetres from the floor, in a separate room. Even so, it is very difficult to see the tiny figures depicted in the top right-hand corner without the aid of a stepladder. De Vos and other scholars such as McFarlane have remarked upon the fact that Memling's innovative way of presenting the Book of Revelation did not have many followers.[111] It has nevertheless been suggested that Albrecht Dürer may have been influenced by Memling's inter-pretation of the Book of Revelation.[112] Although dismissed by De Vos as unlikely, there are similarities between the two throne-room scenes and the presentation of the Mighty Angel of Rev. 10, which certainly deserve further consideration.

Dürer aside, the fact remains that Memling's synchronic presentation of the Book of Revelation did not inspire any important later examples.[113] De Vos puts this down to the small scale of the various visionary scenes. The place-ment of the altarpiece on top of the altar would have meant that the tiny yet vivid scenes would have been inaccessible to many viewers. Thus, one of the most innovative representations of the Book of Revelation might literally have been overlooked by most viewers for many centuries, even though it will be argued below that Memling's presentation of the heavenly throne-room might nevertheless have influenced some later exegetes.

The small scale of many of the scenes does raise the question of what exactly Memling's, or his patrons', intention was in producing this panel. Both he and

---

[111] De Vos 1994: 156; McFarlane 1971: 39–40.       [112] Evers 1972: 21–8, 84–8.
[113] It should also be noted that in more general terms Memling was not much copied, representing as he did the end of one tradition and having exerted little tangible influence on the next generation (McFarlane 1971: 42).

his patrons knew exactly where the altarpiece would be installed. In addition to this, whether as a result of sessions with a theological adviser or not, Memling clearly knew the textual narrative of the Book of Revelation very well. Was it therefore intended that the events described therein should appear to the panel's viewers as fleeting visions, just beyond the range of normal sight, thus creating an illusion in the mind of viewers that they too (like John) were experiencing a vision? In addition to this, if one knows the Book of Revelation, the mind will compensate for what cannot be seen in the fleeting visions, allowing for a more personal viewing experience. Meaning is thus not *imposed* on the viewer in the same way as it is with the larger, more prominent imagery at the front of the panel. Alternatively, the visions and tiny scenes in the Book of Revelation and central panels may have a symbolic function rather than a practical one, in that they were intended primarily for a Divine eye rather than for mortal ones. This would certainly link with the interpretation, suggested below, of Memling's heavenly throne-room as the Divine eye.

Turning to the Apocalypse panel itself, one notes again that the Book of Revelation is not depicted in its entirety. Despite this De Vos, one of the foremost experts on Memling, still argues that: 'Memling's representation of the Apocalypse is unique in the history of painting. No other artist has ever dared depict the entire Book of Revelation in a single image.'[114] In fact, only chapters one to thirteen of the text have been visualized. Even in the illustrated chapters, Memling makes omissions. He does not represent the letters to the Seven Churches of Rev. 2–3 (as was customary in medieval depictions of the Book of Revelation) nor Rev. 7 and 11. Although these last two chapters are important in theological terms, on a compositional level it is difficult to see how they could have been integrated into Memling's panel which itself operates on three basic levels.[115]

In the foreground of the panel, John sits on Patmos receiving his visions. At the top of the composition, the heavenly throne-room is encased in a circular rainbow, separating it from the apocalyptic drama that unfolds in the centre of the panel. The apocalyptic visions centre mainly on the sequences of destruction heralded by the seven seals and the seven trumpets. Into this sequential composition Memling has integrated the Mighty Angel of Rev. 10 and the Woman Clothed with the Sun from Rev. 12. Neither the worship of the Lamb in Rev. 7, which is said to take place on Mount Zion (see the *Ghent Altarpiece*), nor Rev. 11, which takes place against the backdrop of the Temple, could readily have been integrated into the composition as it stands. The last scene depicted in the right-hand panel is the transference of power from the Dragon to the Sea-Beast (Rev. 13: 2). This is just visible on the horizon of the painting

---

[114] De Vos 1994: 38.
[115] The *Lambeth* Book of Revelation, for example, features an extended pictorial treatment of Rev. 11. See fos. 12$^v$–13$^v$.

to the left of the Mighty Angel. Despite the fact that no further episodes are visible (to the naked eye at least), the implication is that they too are continuing to unfold in John's mind.

In the foreground then, John sits, practically life-size, on what is presumably a rocky outcrop of Patmos, surrounded by the Aegean Sea. De Mirimonde notes that there is a spring coming out of the rock on which John is sitting, which may represent Christ as the source of the Gospel.[116] John's upturned, vacant eyes suggest that the visionary experience is in progress and that he is perhaps in a trance-like state (see Rev. 1: 1, 1: 10ff.). The viewer therefore views the visionary events, depicted in diminishing size across the top half of the panel, as they appeared to John himself. His right hand is dipping a pen in an ink-well, while his left appears to be writing with a stylus, or perhaps lining the page in preparation for the writing that will follow the vision. If the former, this could be an example of 'automatic writing', writing which occurs while the visionary is in an inspired state.[117] The fact that John is bathed in light also points towards divine inspiration. Van der Meer stresses John's calmness as well as his visual similarity to Memling himself.[118] While John may look calm, on another level a greater sense of realism and immediacy pervades this scene than those of the manuscript versions of the first chapter of the Book of Revelation. This is due not only to Memling's more naturalistic style but also to the fact that in Memling's panel John, the seer, occupies the same spatial plane as his visions. In contrast to the Apocalypse manuscripts, the viewer can gaze simultaneously at John on Patmos and the visions that he received there.

In the top left-hand corner, the heavenly throne-room of Rev. 4 and 5 is depicted. The throne-room is housed in a roundel, itself enclosed by an elliptical rainbow, of which only around two-thirds is visible. No explanations have been advanced as to why the throne-room is only partially visible. However, despite its incomplete shape, the throne-room is a large and dominant presence within the Apocalypse panel. The resemblance of the throne-room to an eyeball is also unmistakable. The pupil is represented by another elliptical rainbow at the centre of the throne-room, inside which the throne of God and the Lamb has been placed, and from which emanates bright, almost white light. This interpretation can be supported by the existence of two almost contemporary, similar, roundels by Hieronymous Bosch, in which the central image appears to be of God's own eye. Bosch's use of roundels in general is a peculiar feature of his work. He uses one on the exterior of *The*

---

[116]  De Mirimonde 1974: 81–2.

[117]  'Automatic writing is the process, or product, of writing material that does not come from the *conscious* thoughts of the writer. The writer's hand forms the message, and the person is unaware of what will be written.' See http://en.wikipedia.org/wiki/Automatic_writing.

[118]  Van der Meer 1978: 265.

*Garden of Earthly Delights,* on allusion to the terrestrial globe, which brings out the universal implications of the scenes depicted within.[119] Interestingly, Bosch's use of an 'eye-like' roundel in his *Scenes from the Passion* is on the reverse of the Vienna *Saint John of Patmos*.[120] Jacobs argues that here the eye-like structure functions as a spiritual mirror in which the viewer is invited to contemplate the significance of the Passion.[121]

The notion of the centre of the eye functioning as a spiritual mirror is also found in Bosch's *Tabletop of the Seven Deadly Sins, c.*1485–1500 (Fig. 23).[122] The central roundel (itself surrounded by four smaller roundels) is structured like a huge eye by using concentric circles. Christ stands in the middle (the pupil) displaying the wounds of the Passion. This is significant in that Memling has taken care to depict the Lamb at the centre of his 'eye-like' throne-room as bleeding from its neck (Rev. 5: 6), another way of visualizing the sacrifice embodied in the Crucifixion. Around the centre of Bosch's eye is written *cave, cave, dominus videt*. The sins that God sees are arranged around the outside of the eye (the cornea). Koerner, the influential art historian who specializes in the art of the Renaissance and the Reformation, argues that in structuring the panel thus, Bosch makes the painting return the gaze of the viewer, and in doing so gives us a glimpse of God's view of the world.[123] He is both the all-seeing and ever-present witness (see Ezekiel 7: 9, Job 28: 24, Amos 9: 8) and mirror of his creation.[124]

Gibson argues cogently that these two concepts of God—as ever-present witness and mirror of creation—had already been brought together in the works of Hildegard of Bingen, Jean de Meun, and Nicholas of Cusa, a fifteenth-century theologian whose work on the Divine gaze, it will be argued in Chapter 5, might also have influenced Albrecht Dürer.[125] In *De visione dei* Cusa specifically compares the Deity to a great reflecting eye.[126] Bosch's Divine eye in *The Tabletop of the Seven Deadly Sins* has an even more complex role, in that it not only functions as an ever-present witness, but also reflects the vices of mankind in general, whilst inviting the viewer to look into his own sinful soul.[127] This idea of a spiritual mirror is frequently found in medieval literature from Deguilleville to Brant.[128] Gibson argues that such

---

[119] Jacobs 2000: 1028–30.
[120] Bosch, *Saint John of Patmos,* 1490, Gemäldegalerie, Berlin.
[121] Jacobs 2000: 1030. Perhaps significantly, in *The Ascent into Heavenly Paradise (c.*1490), Bosch represents the path to Paradise as an 'eye-like' tunnel.
[122] Koerner 1998: 277; Gibson 1973: 207–8.
[123] Koerner 1998: 277.
[124] See Gibson 1973: 209–15.
[125] Ibid. 215–17.
[126] Dolan 1962: 147.
[127] Gibson 1973: 218–19.
[128] Ibid. 219, see nn. 41 and 44 for specific mirror refs to Deguilleville's *Pèlerinage de la vie humaine* (1355) and Brant's *Ship of Fools* in which the ship itself is described as a mirror 'where each his counterfeit may see'.

texts suggest the tradition that inspired Bosch to place Christ at the centre of the Divine eye.[129]

Returning to Memling's Apocalypse panel, it would seem that in his depiction of the heavenly throne-room of Rev. 4–5, Memling was drawing on some of the same ideas, a suggestion that is plausible given both the similarity of the imagery and the temporal and spatial proximity of the two artists. In representing the throne-room as a sort of Divine eye, Memling places a strong visual emphasis on the ever-present and all-seeing nature of the heavenly throne-room, something that is certainly stressed in the text itself in, for example, the description of the ceaseless praise given to God, as well as in the description of the tiny eyes covering the bodies of the four living creatures (Rev. 4: 8). This interpretation of Memling's presentation of the throne-room links well with the notion that the Apocalypse panel in its entirety was only intended to be seen and contemplated by the Divine eye, on account of its tiny yet incredibly detailed scenes. The presence of the Lamb in the middle of the Divine eye as well as the actual mirror on which the four living creatures stand (an evocation of the 'sea of glass' from Rev. 4: 6) may also have invited the sort of spiritual reflection that Gibson argues was demanded by Bosch's *Tabletop of the Seven Deadly Sins*.[130]

On a more broadly exegetical level, it would seem that Memling's eye-like heavenly throne-room conveys a sense of the Divine 'world-view', the revealing of which is at the heart of Rev. 4–5, after which it continues to be contrasted with the human world-view throughout the text. Thus, the 'eye', as well as symbolizing the Divine, may also symbolize John's visionary understanding of the Divine world-view revealed in the Book of Revelation.[131]

Enclosed in a protective rainbow, Memling's Divine eye thus does not directly reflect the sins of the world in the same way as Bosch's does.[132] The throne-room itself is reflected in the sea just above John's island, giving the ensuing visions a sense of realism and urgency. The reflections of the first two horsemen and the throne-room merge into each other, perhaps foreshadowing the mingling of heaven and earth heralded by the New Jerusalem (Rev. 21–2), as well as signifying the presence of the Divine gaze upon the world. Thus I suggest that Memling has infused his visual interpretation of the throne-room of Rev. 4–5 with contemporary ideas regarding the Divine eye,

---

[129] Gibson 1973: 221.     [130] Gibson 1973: 222.

[131] See Rowland 1982: 214–47 on the significance of the throne-room or *Merkavah* vision in the Book of Revelation and in apocalyptic literature in general.

[132] Rainbows are an important signifier in Memling's work. In his *Last Judgement Triptych* (1467–71) the rainbow on which Christ is seated separates God's Kingdom from that of the earthly one.

which functioned both as a symbol of the ever-present witness of the Deity and as a spiritual mirror for the viewer, who now gazes upon the visions that John saw, as evoked by Memling. While Memling's altarpiece could not have functioned as an aid to private meditation in the same way as Bosch's *Tabletop of the Seven Deadly Sins*, the eye-like throne-room, large enough to be visible to all viewers, could well have invited spiritual meditation.

In compositional terms, parallels can be drawn between Memling's throne-room scene and the *Flemish Apocalypse's* scenes five, six, and eight.[133] In these scenes Rev. 4, 5, and 7 are depicted respectively. Scenes five and six, in particular, focus on the throne-room scene. In each case, the mandorla that encloses God and the Lamb is set in a dark blue background. Against this dark blue background, gold crowns and musical instruments are visible, as are the lightly sketched figures of the Twenty-Four Elders. The use of the dark blue background and shadowy figures was not a common one in depictions of the apocalyptic throne-room. There is also a marked similarity between the instruments played by the Twenty-Four Elders in the *Flemish Apocalypse* and Memling's Apocalypse panel. In Rev. 5: 8, the Twenty-Four Elders are said to be playing harps. Both the artist of the *Flemish Apocalypse* and Memling himself have extended this reference to include lutes or mandolins, fiddles, portative organs, recorders, and harps.[134] There are, however, important differences. In contrast to the *Flemish Apocalypse*, in Memling's panel, the Elders are holding their instruments without playing them, perhaps evoking the cosmic silence of Rev. 8: 1.[135] Similarly, the artist of the *Flemish Apocalypse* has placed God and the Lamb in a mandorla, as was traditional in manuscript representations of this scene.[136] Memling meanwhile has placed the two Divine figures at the centre of his 'Divine-eye', sitting on a throne but not enclosed in a mandorla, which would have interfered with the overall effect.

Replacing the mandorla in the throne-room scene was not the only way in which Memling deviated from the established Apocalypse iconography that had been dictated by the Anglo-Norman family of manuscripts and their descendants. His depiction of the four horsemen is, for instance, innovative and in many ways represents a halfway point between the Anglo-Norman manuscript depictions and Dürer's groundbreaking depiction of the four horsemen all riding out together. Although all four horsemen appeared together in the ninth-century Trier Book of Revelation, since then, the vast majority of visualizations, including all the surviving Anglo-Norman Apocalypse manuscripts, had presented the four horsemen in four separate

---

[133] The *Flemish Apocalypse*, Bibliothèque Nationale, Paris, BN Néerl. 3. See also Van der Meer (1978: 203–36) for a full set of colour reproductions.

[134] Note also Visser's case for the *Ghent Altarpiece* having been influenced by the *Flemish Apocalypse* (Visser 1996: 155).

[135] Van der Meer 1978: 266.

[136] See Lambeth fo. 4, for example.

images.[137] In interpretative terms, the implication was that they represented four quite separate 'woes', a literal reading of Rev. 6: 1–8. However, Dürer's synchronic depiction of the horsemen all riding out together implies that they represent different aspects of the same tribulation.[138] Memling's visualization of the four horsemen occupies a middle ground in interpretative terms. The motion of the Lamb pulling open the first seal in the throne-room sets in motion the sequence of the seven seals (Rev. 6). The first horseman, occupying the same vertical axis as the Lamb, rides a bright, white horse across a small island protruding from the sea. As discussed in the preceding chapters, the first rider had traditionally been associated with Christ by exegetes since Victorinus, an interpretation disregarded by Dürer who emphasizes the fourth horse instead (D4, Fig. 31).[139] It is difficult to tell whether Memling attempted to imply visually this Christological interpretation. Certainly the first rider stands out from the others on account of his brilliant whiteness and also on account of the fact that he rides in the opposite direction to the other horsemen.[140] The second, third, and fourth horsemen ride in a more synchronized fashion across their individual islands, their reflections clearly visible in the sea.[141] Memling has echoed the presentation of the third rider as a jurist or doctor of the law as found in the Anglo-Norman manuscripts.[142] The deep black of the third horse also forms a contrast with the muted brown of the third horse in *Angers*, for instance, as well as providing a dark centre for the panel as a whole. Memling has also visualized the fourth rider, 'Death' (Rev. 6: 8–9), as a skeleton being pursued by a canine hell-mouth as was the case in *Angers* (1.12). Importantly, however, Memling's hell-mouth is not contained within an architectural structure as in *Angers*. Thus while Memling's horsemen do not resemble Dürer's synchronized cavalry, in his composition they are more fully integrated into the overall scheme of destruction than they had been in either *Lambeth* or *Angers*, and their 'authority over a quarter of the earth' (Rev. 6: 9) is more keenly felt.

The sense of movement, of a sequence unfolding, that is evoked by Memling's presentation of the four horsemen continues across the rest of the pictorial narrative. As intimated above, interpreters since Tyconius have been inclined to view the Book of Revelation's three cycles of seven as

---

[137] Trier Book of Revelation, Stadtbibliothek, MS 31, fo. 19ᵛ.

[138] See Rowland 2005: 308; Boxall 2006: 102–12.

[139] See Kovacs and Rowland 2004: 78–9.

[140] Boxall (2007) has suggested that Memling's first rider might be attempting a 'Parthian shot' (a backwards arrow shot favoured by the Parthians or Ancient Iranians), thus indicating a negative reading of Rev. 6: 2 in which the first rider is associated with the threat from the East (see Rev. 16: 12).

[141] See Klein 1992: 193–6 on the parallels between Memling's islands and the islands in the 14th-cent. Apocalyptic Neapolitan panel paintings after Giotto's frescoes.

[142] See, for example, Trinity Apocalypse fo. 6ʳ.

unfolding in a recapitulative, rather than a linear, sense. Memling too depicts elements of both of the first two cycles, hardly seeming to differentiate between them. For instance, the handing out of the seven trumpets to the seven angels occurs outside the top right-hand corner of the throne-room, but the breaking of the seven seals, the first sequence of seven, is not depicted. Memling also illustrates the angel described in Rev. 8: 3, who stands at the altar under the heavenly throne-room with a golden censer. He is shaking the censer over seven flaming coals, each of which (one assumes) represents one of the disasters caused by each of the trumpet blasts.

The disasters resulting from the trumpet blasts are depicted in the top half of the panel. Earlier events are represented as occurring spatially prior to later ones, thus allowing the viewer to trace the progression of events as they unfold across the canvas. Thus, before the mountain of Rev. 8: 8 even hits the water, the viewer is aware of the carnage that it will cause. The fiery red reflection of the boulder in the surface of the sea also foreshadows the turning of a third of the sea into blood, while the sinking boats represent the shipwrecks (Rev. 8: 9). The Third Trumpet blast (the falling star named Wormwood, which poisons a third of all the fresh water, Rev. 8: 10–11) is depicted by Memling on the right-hand side of the panel, behind the caves in which the victims of the opening of the Sixth Seal are sheltering. The star is suspended above a well, whilst next to the well, one of the victims of the poisoned water already lies dead. In this way Memling evokes for the viewer what it might be like to observe a synchronized vision, whilst also retaining a strong suggestion of narrative progression.

Memling's rendering of Rev. 10 is perhaps one of his most impressive. Behind the mutant cavalry of Rev. 9, Memling has painted a rocky island, probably Patmos again, in front of which stands the Mighty Angel of Rev. 10. John stands at his feet, a tiny figure in a blue gown. This is the only instance in the whole panel where John is depicted as actually participating in the action. This tiny scene would thus have provided a link for the viewer between the 'earlier' and 'later' scenes. Similarly, the islands on which the four horsemen and their horses are depicted resemble stepping-stones that the viewer could imagine stepping on, a way of providing a material link between the visions.

The last full chapter to be represented by Memling is Rev. 12, which has been broken up into three different scenes. The first scene corresponds to Rev. 12: 1–6. Directly above the fiery thundercloud of the Mighty Angel of Rev. 10 is the Woman Clothed with the Sun. To the right, at the very edge of the panel, St Michael and his angels fight the Dragon and his devils (Rev. 12: 7–9). This represents the war in heaven, the only time in Memling's panel when the heavenly realm is in danger of being encroached upon by the chaos that unfolds below it. The beginning of Rev. 13, the exchange of power between the Dragon and the Sea-Beast, is, as mentioned above, just visible on the horizon and serves to bring the action back down to the earthly realm.

This is ostensibly where Memling's depiction of the Book of Revelation ends, although the implication is that the visionary sequence of events continues to unfold over the horizon. However, as mentioned above, Visser argues that Memling, influenced by contemporary, variant depictions of the marriage of the Lamb from Rev. 19, has incorporated a subtle representation of this episode into the central panel. While the marriage of the Lamb (Rev. 19: 5–10) was traditionally depicted as a wedding banquet, as in the Trinity Apocalypse, there exist other versions where the ceremony is visualized as an exchange of rings.[143] These include Paris BN Lat. 10474, in which the Lamb and the bride exchange rings in front of an altar, and Douce 180, in which the Lamb holds up a ring for the bride, who kneels opposite him (Fig. 24).[144] The well-known themes of the mystic marriage of St Catherine and the apocalyptic marriage of the Lamb and the bride (symbol of Israel) seem then to have been brought together by Memling in the central panel of the *St John Altarpiece*.[145] Visser argues that in the central panel, John the Baptist is pointing at the ring ceremony itself rather than at Christ specifically, in what is probably an allusion to John 3: 29. A contemplative use of John 3: 29 in conjunction with Rev. 4, 7, 14, and 21 had certainly been suggested by Thomas à Kempis in his very well-known *The Imitation of Christ*, first published in 1418 and translated into German, French, and English by 1447.[146] Thus it seems likely, although not certain, that Visser is correct in arguing that there is contained within the central panel a subtle evocation of the marriage of the Lamb and the bride. Such an evocation functions effectively as a resolution to the Apocalypse panel.

## 3.10 CONCLUSION

It has been suggested that Memling's the *St John Altarpiece*, ostensibly a homage to John the Baptist and the Evangelist, functioned as the object of both devotional and Eucharistic worship at the St John's Hospital in Bruges. The devotional element is brought to the fore through the expansion of the traditional visual 'attributes' of John the Baptist and John the Evangelist, who are pictured with their traditional attributes in *grisaille* form on the outer panels, into visual explorations of their respective *vitae* in the two inner, side panels. This particular focus on the figure of John the Evangelist was attributed, in part, to the huge contemporary popularity of *The Golden Legend*, in which his *vita* appears.

---

[143] The Trinity Book of Revelation, R.16.2, fo. 22$^v$.

[144] See Douce 180, p. 79.

[145] See De Voragine tr. Stace 1998: 333–8 on St Catherine's *vita*.

[146] See Visser 1996: 159–60.

Memling's Apocalypse panel, only tangentially connected with the Judgement theme often evoked in hospital altarpieces, manages to be both serene and 'action-packed' at the same time. The top half of the panel functions as something akin to a huge 'thought-bubble' above John's head, his lurid visions before us in all their immediacy. Memling has used size and perspective to indicate the chronological progression outlined in the Book of Revelation itself, but the visions need not be viewed in chronological order by the viewer. The idea of the Book of Revelation as a chronologically unfolding textual narrative is therefore called into question through Memling's visualization, which evokes the visionary character of the text. One could almost go as far as saying that Memling's visual interpretation of the Book of Revelation, although itself an interpretation of the text, goes some way to bringing us closer to John's original visions than the text itself because of the impact of Memling's use of a visual rather than a written medium to render the events described in the text. The contemplative viewer is thus forced to consider the visionary nature of the Book of Revelation afresh. In visualizing John's visions as a series of simultaneously occurring events, Memling thus provides the viewer with a new perspective on the Book of Revelation, which could not be invoked or brought to mind, so successfully at least, by words alone. Moreover, and in contrast to all the previous examples, the subject-matter is allowed to 'come forth', unmediated by any text whatsoever.

While no direct influences have been unearthed regarding the seemingly (in the absence of other surviving examples) unique, synchronic composition of Memling's Apocalypse panel, contemporary sources have been cited in an effort to understand how the panel might have been viewed in its original setting. Firstly, the possibility that the mystic marriage of St Catherine in the central panel should be interpreted also as a reference to the marriage of the Lamb from Rev. 19: 5–10 was judged to be plausible in light of similar existing visual interpretations of this episode. Secondly, several of Bosch's eye-like roundels, and in particular *The Tabletop of the Seven Deadly Sins*, have been discussed in order to understand better the eye-like quality of Memling's heavenly throne-room scene, which dominates at least the top half of the panel, if not the entire panel itself. Conceiving of the throne-room scene as a sort of Divine eye, a concept that seems to have had contemporary currency, not only rendered the throne-room very prominent in Memling's panel, but also served to emphasize the eternal, all-seeing quality of the throne-room that is evoked in the Book of Revelation itself. As was suggested above, this interpretation of Memling's throne-room may also offer a way out of the problem of the small size of many of the scenes in the Apocalypse panel, which would have made them difficult to apprehend and, indeed, comprehend with the naked eye. If Memling's throne-room is to be interpreted as analogous in some ways to the Divine eye, the possibility that the panel itself was intended in the first instance to be seen by the Divine eye is rendered infinitely more

plausible. The intended viewer of the panel has thus been represented symbolically within it. Alternatively, it was also suggested that the roundel might symbolize John's visionary 'eyes', through which he perceives his apocalyptic visions. In this case the roundel symbolizes access to the Divine mysteries, on which the Book of Revelation offers the reader a window. Thus the two suggestions, that of the roundel symbolizing the Divine eye but also the eye of the visionary are by no means mutually exclusive.

In addition to this, despite its negligible immediate artistic influence, Memling's Apocalypse panel, with its prominent prioritization of the apocalyptic throne-room scene with the slaughtered Lamb at its centre, either implicitly influenced, or at the very least is reflected in the tendency of, exegetes over the last two or three centuries also to prioritize these same two chapters. Bauckham, writing as recently as 1993, is typical of this tradition, through both his sustained focus on Rev. 4 and 5 (perhaps at the expense of other features of the text), as well as in his assertion that the three main motifs of the text (those of messianic war, new exodus, and faithful witness) are all introduced in Rev. 5: 6–13.[147] This emphasis on the slaughtered Lamb is also reflected, on a more contemporary level, in the *Ghent Altarpiece* where the Lamb and its Eucharistic relevance is the central focus of the whole altarpiece. Thus, while in the manuscript and related diachronic interpretations of the Book of Revelation discussed in the preceding chapters, the Lamb played an important but proportional role in the images, in the two altarpieces discussed in this chapter, the Lamb of Rev. 5 has a central role, in itself a significant exegetical development facilitated in part by the synchronic altarpiece format.

Visualizing the Book of Revelation, or elements therein, in an altarpiece format certainly forms a clear contrast with the established way of visually interpreting this text in the late medieval period via illuminated manuscripts. The two altarpieces discussed are nevertheless substantially different in terms of hermeneutical strategy the *Ghent Altarpiece* is not an attempt to visualize the narrative of the Book of Revelation in synchronic, rather than diachronic, format. Although resolutely synchronic, its purpose is not to convey a visionary narrative but rather to visualize the mystery of the Eucharistic sacrament through a selective appropriation of the Eucharistic imagery present within the Book of Revelation. By contrast, while Memling's Apocalypse panel is not necessarily chronological in form, it nevertheless seeks to convey a visual narrative to the viewer, albeit one that prioritizes Rev. 4–5.

---

[147]  Bauckham 1993a: 66–76.

# 4

---

## *The Mystic Nativity*

### Botticelli and the Book of Revelation

#### 4.1 INTRODUCTION

*The Mystic Nativity* (*c*.1500) is in many ways quite unlike the other visual representations of the Book of Revelation examined in this study. On the face of it, Alessandro Botticelli's painting appears to be a Nativity scene based fairly closely on Luke 2: 1–20 (Fig. 25). However, several features of the image lead one to question this initial impression. First of all, several little devils frolic among the rocks at the bottom of the scene, seemingly speared on their own forks. Secondly, just above them, three men embrace three angels. Thirdly, the three angels on the roof of the shed where the Nativity scene is taking place are dressed in robes that correspond to the colours of the three virtues (white, red, and green): faith, charity, and hope. Above them hovers a group of angels suspended in mid-air, in defiance of the laws of perspective and gravity. None of these details appear in the Lucan account of the Nativity. Lastly, at the top of the painting is an inscription in Greek in which Botticelli not only puts his name to the work (as well as a date: 1500), but also relates it directly to the eleventh and twelfth chapters of the Book of Revelation, as well as to the current 'troubles of Italy'.[1]

Thus *The Mystic Nativity* represents an important interpretative challenge to those investigating the artistic reception of the Book of Revelation as well as forming an interesting, 'Renaissance', counterpart to the other fifteenth-century examples discussed in this study. John the seer is not present at all, for instance; neither is there is any sense of narrative, implied or otherwise, within the painting. Rather, the visualized events confront the viewer simultaneously. Crucially, the inscription also personalizes the image in an unprecedented way. In

---

[1] *The Mystic Nativity* and the illustration for Canto 28 of *Paradiso* (see Botticelli's *Drawings for Dante's Divine Comedy* in Schulze Altcappenberg (ed.) 2000: 276–7) are the only extant, signed works by Botticelli.

none of the other examples discussed in this study does an artist explain his understanding of how his image/images relate to the Book of Revelation. Secondly, and regardless of whether Botticelli did the painting for himself or someone else, the inscription implies that this painting and its subject had an important personal significance for him. Thirdly, the fact that the inscription is written in (not particularly polished) Greek gives the painting not only a personal aura, but also an esoteric one.

Thus, this chapter will first discuss the possible scope of Botticelli's personal relationship with the Book of Revelation and with apocalyptic ideas at the end of the Quattrocentro more generally. It is quite possible that Botticelli painted *The Mystic Nativity* for himself, but more interesting is the prospect that he painted it for a *piagnone* patron, colleague, or even a Savonarolan boys' group to use in their processions. Followers of Savonarola, the self-proclaimed Florentine prophet, were known as *piagnoni* (lit. weepers). A possible public, ritual function such as this would also demarcate *The Mystic Nativity* from the other visualizations of the Book of Revelation discussed herein.

In accordance with the aims of this study, the way in which the painting relates to the text of the Book of Revelation and other related texts will be the primary focus of this chapter. For instance, is *The Mystic Nativity* an illustration of one of the Dominican preacher Girolamo Savonarola's sermons on the Book of Revelation, as first suggested by Pope-Hennessy in 1947?[2] Or is it the product of a more sustained interface with texts, ideas, and images relating to a broader late fifteenth-century cultural context, and in particular the ongoing and increasingly radical *piagnone* context that Botticelli himself inhabited? With this in mind, the relationship of *The Mystic Nativity* with Botticelli's *Mystic Crucifixion* (*c*.1497, Fig. 26) will also be considered, and a closer relationship between the two paintings than has been suggested by previous commentators will be offered.

## 4.2 THE ARTIST: ALESSANDRO BOTTICELLI

Vasari's biography of Botticelli (1445–1510), as well as extant extracts from Simone Botticelli's (Alessandro's brother) diary and the various Florentine chronicles, have provided art historians with a fairly full account of Botticelli's life and career.[3] By the 1470s, Botticelli was well established as an altarpiece and fresco painter.[4] It was also around this time that he began to work for

---

[2]  Pope-Hennessy: 1947: 8.
[3]  Vasari: 1965: 147–55 and 314–15, although I am aware of the limitations and inaccuracies of Vasari's biographies of the Renaissance artists.
[4]  Lightbown 1978: 21, 37.

members of the Medici family (particularly Giuliano and Lorenzo di Pier-francesco).[5] The *Primavera* and *The Birth of Venus* were painted for Lorenzo di Pierfrancesco in the 1480s.[6] These great 'mythical' paintings are often cited as evidence of the influence of humanist ideas and poetry on Botticelli.[7] Additionally, Schulze Altcappenberg suggests that Botticelli might have consulted humanists within the circle of Lorenzo de' Medici, such as Manetti and Landino, whilst working on both his commentary on and his drawings for Dante's *Divine Comedy*.[8] This is relevant in terms of *The Mystic Nativity* as some scholars, such as Arasse, have posited the existence of a learned adviser in the execution of this project, particularly with regard to the inscription.[9]

Others have commented on Botticelli's conscious adoption of a more 'medieval' or religious style in the 1490s, the era in which *The Mystic Nativity* was painted.[10] In *The Virgin Adoring the Child* (c.1490), *The Lamentation of Christ* (c.1494–5), *The Agony in the Garden* (c.1500), and *The Mystic Nativity* itself, the key figures (Christ or the Madonna) are enlarged and accentuated out of scale for devotional purposes.[11] Zöllner also comments on the pared-down handling of space and contour and the relative 'flatness' in these paintings, as well as a perceived heightening of emotion.[12] This change in style is frequently attributed to the pietistic influence of Savonarola on the artist, with the result that Botticelli's oeuvre is often divided into pre- and post-Medicean periods, *The Mystic Nativity* (c.1500) falling into the latter period.[13] While this division is in some ways useful, Dombrowski has cautioned against a straightforward acceptance of the notion that Botticelli's style changed beyond recognition in the 1490s.[14] Botticelli's drawings for Dante's *Divine Comedy*, which span from c.1478 to c.1498, for example, are well known for their continuity of style and vision and do not show evidence of 'stylistic ruptures', despite spanning over twenty years of Botticelli's artistic career.[15] Viewing Botticelli as a straightforward visual propagandist for either the Medici or Savonarola, as has often been the case, is thus probably not the most fruitful approach.

[5] Ibid. 41–56.

[6] Ibid. 73–89.

[7] See especially Dempsey 1992, who discusses the influence of the reigning Neoplatonic humanist culture on Botticelli's 'mythical paintings', as well as Lightbown 1978: 99.

[8] Schulze Altcappenberg (ed.) 2000: 32.

[9] Arasse 2004: 270 on Botticelli's possible use of Michelle M. Tarcaniota for the inscription.

[10] See for, example, Argan 1957: 127–8.

[11] Lightbown 1978: 117–19.

[12] Zöllner 2005: 170.

[13] See for, example, Argan 1957: 127–8.

[14] Dombrowski 2000: 299. For Vasari's account of Botticelli's 'decline' into 'piagnonism' see Vasari 1965: 152–3.

[15] Ibid. 304.

## 4.3 BOTTICELLI'S CULTURAL AND INTELLECTUAL CONTEXT

In order to understand *The Mystic Nativity*, care must be taken to understand the various general and more particular contexts in which Botticelli was working. While remaining sensitive to Dombrowski's contention that Botticelli's career should not be viewed straightforwardly in terms of a Medicean and a Savonarolan period, the Savonarolan influence on Florence and, indeed, Botticelli himself in the 1490s and beyond, must be discussed. This is true not least because even if Botticelli was not a *piagnone* in any sort of formal sense, Savonarola's influence on the intensification of the Florentine identity (which certainly manifests itself in *The Mystic Crucifixion*) is crucial to understanding Botticelli's later religious works.

While it is certainly not necessary to go into Savonarola's biography in great detail, some discussion of the main themes of his ministry and their effect on the Florentine population, where discernible, is useful. With regard to *The Mystic Nativity*, of particular interest is the development of Savonarolan thought after his death in 1498, after which the *piagnone* or 'weeper' movement, as it is known, took different paths. It is possible that Botticelli could have been in touch with both the conservative and/or more radical wings of the movement.

Particularly helpful is Weinstein's book on Savonarola, which includes a thorough elucidation of Savonarola's use of the 'Florentine myth'.[16] Weinstein demonstrates how Savonarola was able to use the myth to his own advantage as his prophetic message developed after 1490.[17] Savonarola's enduring hold over Florence was due in part to his charismatic personality and diplomatic skills and in part to luck, but perhaps primarily to his intelligent handling of this Florentine myth. Since the thirteenth century, the idea that Florence had been set aside as a centre of rebirth and Christian renewal had permeated her literature and art.[18] This had developed into the 'myth of Florence', a belief that the city was destined for great future leadership in political, moral, cultural, and religious matters.[19]

During the French Invasion of 1494, Savonarola preached frequently to growing crowds in the Church of San Marco.[20] The fact that Florence emerged unscathed from the invasion, in part due to Savonarola's own role as an ambassador for the city, was interpreted by Savonarola as evidence of the elect status of the city, a message developed in his November and December

---

[16] Weinstein 1970.
[17] See Weinstein 1991: 483–503 for an overview of recent scholarship on Savonarola.
[18] Weinstein 1970: 34–5 and see 35–64 for examples of this belief.
[19] Ibid. 35.
[20] Ibid. 114.

sermons on the Old Testament prophets.[21] Following the invasion, between the years of 1494 and 1498 Savonarola's main aim was to inspire the Florentines to undertake moral reform and continue their spiritual renewal, with a more positive, millenarian message beginning to surface in his, previously pessimistic, preaching.[22] A vision for the future began to emerge in which the Divine and the human would intermingle in a new millennium of spirituality where 'the angels would come to live together with men and the Church Militant would join together with the Church Triumphant'.[23] Such sentiments may have inspired the composition in the foreground of *The Mystic Nativity* where angels embrace men, although this scene may also have been influenced by *piagnone* Pietro Bernardino's more developed ideas regarding men and angels living together.[24] Repeated talk of Florence as the New Jerusalem also seems to have influenced the composition of Botticelli's *Mystic Crucifixion* (Fig. 26).[25]

Savonarola allegedly gave forty-four, now lost, *Lezioni* on the Book of Revelation between 1490 and 1491.[26] His treatment of the Book of Revelation in his other writings and sermons is somewhat inconsistent.[27] However, he made use of the sevenfold schema used throughout the text, which he took to refer to the seven ages of history. For Savonarola, the present age corresponded to the fourth age of the Book of Revelation. This schema is exemplified in his Sermon on Haggai and the Book of Revelation from 15 December 1494. Taking the four horsemen of Rev. 6: 2–8 as his starting point, Savonarola explained that the first (white) horse corresponded to the age of the Apostles, the second (red) horse to the age of the martyrs, the third (black) horse to the age of the heretics, and the fourth (pale) horse to the present 'tepid' age. The fifth age or state would be that of Antichrist after which the Jews and infidels would convert and the Church would be renewed throughout the world.[28] The events of the last two ages were left ambiguous.[29]

On Assumption Day 1496 Savonarola preached a sermon on Psalm 32: 11, in which he also discusses Rev. 11 and 12, focusing particularly on the Woman Clothed with the Sun and the war in heaven.[30] It is possible that Botticelli heard this sermon in person or that he read it after it came out in print in 1500. Rev. 12: 10–11 was understood as applying to the near future, with Savonarola

[21] Polizzotto 1994: 3.
[22] Ibid. 159; for an example of a 'doom-filled' sermon see Savonarola's *prediche* from 11 Nov. 1494: Weinstein 1970: 66–7; see also Polizzotto 1994: 2.
[23] *Prediche italiane ai Fiorentini*, vol. III: 199; see also 67 (Weinstein 1970: 174).
[24] Hatfield 1995: 105.
[25] *Prediche sopra Aggeo*, 151: 'blessed will you be, Florence, for you will soon become that celestial Jerusalem' (Weinstein 1970: 142).
[26] For the surviving notes on these *Lezioni* see Verde 1988: 5–109.
[27] See Hatfield 1995: 101 n. 72 for information on the Sermons.
[28] Weinstein 1970: 144.
[29] Ibid. 162.
[30] *Prediche ... delle feste*, sigs. n5ʳ–o4ʳ, Romano (ed.) 1969: vol. 2, 71–108.

saying: 'Now is come the power of Christ on earth; the Dragon has lost; our brethren have won by the blood of the Lamb.'[31] Savonarola argues that this is the fourth of John's visions, which corresponds to the fourth age, that is, the current one, and accordingly the vision of the Dragon would be fulfilled soon.[32] Savonarola interprets the Dragon (actually identified as Satan in Rev. 12: 9) as Antichrist. Interestingly, later on in the sermon he also identifies the Dragon with the tribulations of the Florentines *and* with the *tiepidi* or uncommitted Florentines.[33] Savonarola connects as well the crown of twelve stars worn by Mary with the twelve 'privileges' or supplications given to Mary to pray on behalf of believers, a point that will be considered in greater detail below.[34] Finally and interestingly, Savonarola identifies himself not with the Two Witnesses of Rev. 11. 4–14 but with the thunder and hail of Rev. 11: 19.[35] Some interpreters of *The Mystic Nativity* have argued that Botticelli connected the death of the Two Witnesses in Rev. 11 with the deaths of Savonarola and Fra Domenico da Pescia in 1498, and that this constituted the second woe referred to in the painting's inscription.[36] Although Savonarola nowhere makes this exegetical connection, it is possible that Botticelli made this connection himself. Indeed, several elements of the painting seem to represent a development of the sort of Savonarolan thought espoused in this sermon.

Thus the parallels between *The Mystic Nativity* and this sermon from 1496 are striking, but at the same time it does not provide a specific textual model for the painting. There are also some parallels between the painting and the annotations made by Fra Domenico da Pescia in a printed Bible of 1491 used by Savonarola in preparation for his sermons. The annotations to Rev. 12 link the birth of the child therein with a new (as in a second) Nativity, exactly the link that is being made in *The Mystic Nativity*.[37]

Savonarola's appeal did not appear to diminish in the eyes of his supporters after his execution in May 1498. His downfall could be explained away in political terms and the confessions that he made during torture discounted.[38] His death was interpreted as an apocalyptic event by his supporters, as well as being a sign of the fulfilment of his prophecies, which had included predictions of his own martyrdom.[39] Polizzotto distinguishes between the different forms that *piagnonism* took after 1498. As well as the political branches, there

---

[31] Weinstein 1970: 77.
[32] Ibid.
[33] Ibid. 77–8.
[34] Hatfield 1995: 95, 98.
[35] Ibid. 97, Romano (ed.) 1969: vol. 2, 95.
[36] Horne 1908; Rowland 2005.
[37] Hatfield 1995: 100–1.
[38] Polizzotto 1994: 98–9.
[39] Weinstein 1991: 483. See also Weinstein 1970: 318 on Savonarola's predictions of his own martyrdom.

also existed a more mystical branch of *piagnonism*, led by Pietro Bernardino, among others, as well as a more conservative branch represented by intellectuals such as Girolamo Benivieni and Giovanfranceso Pico.[40]

By 1496 Pietro Bernardino, although only around 21 years of age, enjoyed a prominent position in three of the main boys' groups in Florence, two of which, that of the Purification of the Virgin Mary and of S. Zanobi and S. Giovanni Evangelista, were closely controlled by the church and convent of San Marco, which also ran boys' *scuole*.[41] Bernardino's tasks included preaching and leading the boys (also known as *fanciulli*) in processions.[42]

By the 1490s both the boys' groups (of which there were around ten) and ritual processions had become an integral part of Florentine life.[43] The boys' groups took part in processions, dramatic presentations, and *sacre rappresentazioni*, where they would often play the part of angels, dressed in white, a detail that will be elaborated on below in relation to *The Mystic Nativity*, where it seems that some of the angels may have been represented as boys.[44] Trexler argues that the processions were understood as ritual activities performed at certain times during the religious calendar, as well as in times of perceived threat. Often, ritual objects, such as a sacred image of the Virgin, would be paraded in these processions where it was believed they were at their most efficacious.[45] This tradition of carrying paintings and sacred objects in the processions certainly carried on into the Savonarolan period.[46]

Up until 1496, the boys' clubs and boys from the *scuole* were just one, often not particularly important, part of the Florentine procession. While there is evidence from 1455 and 1492 of boys (and girls) being used in processions to appease God, it was not until 16 February 1496 that Savonarola organized a Florentine procession made up entirely of boys. After this, the boys' clubs often led processions, such as those on Palm Sunday of 1496 (sometimes known as Olive Sunday in Florence due to the fact that Florentines carried the more seasonal olive branches instead of palms) and the Feast of Corpus Christi of 1497.

The prominence of these boys' groups in the Savonarolan processions is a symbolic indication of the fact that they were now thought, by Savonarola and his close followers, to represent the Florentine community before God.[47] Savonarola, who was at the height of his influence between 1496 and 1498, placed a special emphasis on children who had come of age during the 'new

---

[40] See Polizzotto 1994 and chs. 3 and 4 in particular.
[41] Ibid. 119–21.
[42] See P. Bernardino, *Epistula...a fanciulli*, sigs. A1$^v$–a3$^v$, b1$^v$–b2$^r$.
[43] See especially Trexler 1980; 1993: 120 ff.; 1994: 260–325.
[44] Trexler 1980: 375–6.
[45] Ibid. 63–73; Hatfield 1995: 96.
[46] See Trexler 1980: 245; Hatfield 1995: 96.
[47] Trexler 1980: 477.

dispensation' (i.e. after 1494), even going so far as to identify the New Jerusalem with the *fanciulli*.[48] However, despite their perceived future importance, he did not ultimately envisage a role for young people in the Florentine government.[49] Pietro Bernardino, on the other hand, adopted a more radical stance on the role of the boys than both Savonarola and Domenico da Pescia, his erstwhile mentor.[50] In a letter to the *fanciulli* of 1497, drawing on Matt. 18: 3, Bernardino argues that reform was not possible without them, and that they and not the clergy were the chosen instruments of reform.[51] Having escaped arrest after Savonarola's death in 1498, Bernardino adopted an increasingly radical position until his own execution in 1502.[52] In a reaction against the ecclesiastical hierarchy, Bernardino began anointing his numerous followers, acted effectively as a Pope, and claimed to have heavenly visions.[53] The name *Unti* (meaning the anointed) was given to Bernardino and his followers after claims about his anointings surfaced. There is also some evidence that, following Savonarola's belief that in the Florentine future men and angels would live together, Bernardino established an angel cult with his followers and even claimed to converse with angels.[54] This element of his thinking seems to be reflected in the actions of the group at the bottom of *The Mystic Nativity*, where angels freely embrace men. By the time he fled Florence in 1500, Bernardino and his followers had become an embarrassment to the *piagnone* movement (themselves under threat until *c*.1502), although it was Giovanfrancesco Pico, the moderate, intellectual *piagnone* who offered them refuge at Mirandola until 1502.[55]

Giovanfrancesco Pico forms an interesting counterpart to Bernardino and may represent a model for Botticelli's own relationship with the *piagnone* movement. While Pico was clearly interested in and even protective of the radical wing composed of Bernardino and the *Unti*, the *piagnone* movement remained one of only several interests for this Florentine philosopher, as it did also for Girolamo Benivieni, the intellectual, poet, and brother of Domenico Benivieni, the Savonarolan mystic and canon of the Basilica of San Lorenzo. However, neither did they ever renounce their allegiance to the movement, always remaining faithful to the reforming ideal that Savonarola, a personal friend of both men, had advocated. In 1500 Giovanfrancesco published the

[48] Trexler 1980: 317.
[49] Polizzotto 1994: 125.
[50] See Ibid. 122–4 on Bernardino's falling out with Da Pescia.
[51] *Epistola ... a fanciulli*, sigs. a5ᵛ, b1ᵛ.
[52] Information on his increasingly radical position was recorded by two chroniclers, Bartolomeo Cerretani and Piero Parenti. See Cerretani, *Istoria fiorentina*, fos. 274ᵛ–274ᵛ [bis] and Parenti, *Istorie fiorentine*, 292–3. Their claims are to an extent corroborated by Bernardino's published sermons of 1500 (see Polizzotto 1994: 129 n. 95).
[53] Weinstein 1970: 331.
[54] See Hatfield 1995: 105 nn. 99–105.
[55] Polizzotto 1994: 133–8; Weinstein 1970: 333.

*Commento dittieronymo Benivieni... sopra a più sue canzone et sonetti dello amore et della belleza divina,* a philosophical and practical (rather than mystical) exploration of the Savonarolan vision in which he discusses the intellectual tension between Neoplatonic ideals and Savonarola's pietistic vision, a tension perhaps also reflected in Botticelli's later work.[56] The *Commento* also included a selection of songs composed while Savonarola was alive, intended to be sung or recited by his followers. These songs refer to Florence as the New Jerusalem, to Mary as her only queen, and Christ her only king.[57] Thus while we may find elements of Bernardino's contemplative, almost mystical *piagnonism* in Botticelli's *Mystic Nativity,* in life Botticelli was probably nearer to the intellectual strain represented by Giovanfrancesco Pico and Girolamo Benivieni.

In practical terms, Botticelli's *piagnone* credentials cannot be satisfactorily verified, although a clear interest in the movement emerges from the available sources. His brother Simone (with whom he lived in the 1490s) was an ardent *piagnone* who was forced to leave Florence after Savonarola's death and who kept a chronicle of events in the 1490s, which serves as a useful document on the rise and fall of Savonarola.[58] Vasari described Botticelli as being 'extremely partisan to that sect' and argued that this devotion caused him to neglect his work and fall into poverty, but he may have been confusing Sandro with Simone.[59] *The Milan Lamentation* (1495–6), *The Last Communion of St Jerome* (1495–1500), and the portrait of Lorenzo di Lorenzo (1498–1500) were all commissioned by supporters of Savonarola, which also suggests that Botticelli moved in *piagnone* circles and was presumably sympathetic to their ideas.[60] A portrait of Savonarola is thought to appear in the unfinished *Adoration of the Magi* (1500–5), next to a portrait of Lorenzo dei Medici to the left of the figure of Joseph.[61] Of the twenty-one works produced by Botticelli after 1494, seven can be linked with *piagnone* patrons or ideas, a significant but not overwhelming number.

Botticelli's question to Doffo Spini, the leader of the Compagnacci, as recorded by Simone in his chronicle as to why Savonarola was put to death is also often cited as evidence of his interest in the movement.[62] However, the fact that Botticelli did not leave Florence after Savonarola's death in 1498

---

[56] Polizzotto 1994: 139–45.
[57] Hatfield 1995: 104; see also Giovanfrancesco Pico, Quetif (ed.) 1674: *Vita Reverendi Patris F. Hieronymi Savonarolae* and the Letter of Giovanfrancesco Pico to Girolamo Tornielli, 24 Dec. 1495, in Pico 1573: *Opera Omnia,* vol. 2, 1322–3.
[58] Lightbown 1978: 127.
[59] Vasari 1965: 152–3.
[60] Ibid. *The Milan Lamentation* (1495–6) was commissioned by Donato di Antonio Cioni; *The Last Communion of St Jerome* (1495–1500) was commissioned by Francesco del Pugliese (see Zöllner 2005: 255–62).
[61] Zöllner 2005: 272.
[62] See Horne 1908: 291–2.

suggests that he was not publicly connected with the movement (before Savonarola's death at least) in the way that, for example, his brother was.[63] On a more practical level, it seems that, initially at least, Botticelli would not have been a natural supporter of Savonarola's as it was almost certainly some of Botticelli's works (perhaps the *Madonna of the Magnificat* or the *Madonna of the Pomegranate*) that Savonarola criticized in a sermon, complaining that 'You have made the Virgin appear dressed as a Whore.'[64] Thus, it seems that even if Botticelli was not a committed *piagnone*, it is possible, given the available evidence, that he was seduced by elements of the *piagnone* philosophy via his patrons and through his own initiative.

But what of other influences on Botticelli that might have contributed to the apocalyptic schema of *The Mystic Nativity*? Reiss, author of a study on the Signorelli *Orvieto Frescoes*, has noted that there were remarkably few illustrations of the Book of Revelation or of related subjects, such as the Antichrist cycle, in Italy at this time.[65] He puts this down to the fact that the mystical content of the Book of Revelation held little appeal for Italian artists,[66] the exception, of course, being Signorelli's *Orvieto Frescoes*, which he was working on at the end of the fifteenth century. Chastel and, more recently, Meltzoff have argued that the *Orvieto* Antichrist figure was intended to be identified with Savonarola, an identification whose usefulness is questioned by Reiss.[67] Whether Botticelli would have seen the Signorelli frescoes is not known. Orvieto is about one hundred kilometres from Florence, but it is not documented as to whether Botticelli ever went there, although it is on the way to Rome where he did go in 1481 to 1482. Reiss suggests that the embracing angels and men in *The Mystic Nativity* are rejoicing at the defeat of Antichrist.[68]

## 4.4 PATRON, PLACE, AND PURPOSE
## OF *THE MYSTIC NATIVITY*

The internal evidence of *The Mystic Nativity* gives us few clues as to the likely patron or place of production. The inscription at the top of the painting names Botticelli as the artist and gives the date as 'the end of the year 1500'. It may reasonably be assumed that the date given refers to the Florentine calendar,

---

[63] The only time Botticelli is known to have left Florence was in July 1481–Oct. 1482 when he took part in the painting of the frescoes of the *Capella Magna* of the Vatican (Lightbown 1978: ch. 6).

[64] See the *Predica XIII sopra Amos* (6 Mar. 1496). Seward 2006: 170; Dempsey 1996: 500.

[65] Reiss 1995: 105.

[66] Ibid.

[67] Ibid. 5.

[68] Ibid. 107.

which began not on 1 January but on 25 March (Annunciation Day). Thus the end of the year 1500 would translate as approximately the first three months of 1501 in a present-day calendar.

Several scholars have argued that *The Mystic Nativity* could have been painted by Botticelli for a patron from the Aldobrandini family.[69] The painting was purchased by William Young Ottley from the Villa Aldobrandini in Rome at the end of the eighteenth century.[70] The Aldobrandini family were one of the great Florentine families who moved to Rome in the sixteenth century when one of their members became Pope Clement VIII (1536–1605). Clement's mother had been a committed *piagnona*.[71] Arasse suggests that the painting might have been displayed in a relatively private part of the Aldo-brandini Villa (or wherever it resided) and that it would have been used for personal devotional or meditative purposes. Indeed, Plazzotta and Dunkerton have observed that the combination of images and written messages (in addition to the inscription, there are also written messages on the scrolls of the angels and so forth) in *The Mystic Nativity* explicitly invite meditation.[72]

Davies argues that the Greek inscription personalizes the painting and makes it more likely that Botticelli painted it for his own devotional purposes 'or at least for someone whose views he well understood'.[73] The notion that Botticelli painted and drew fairly ambitious pieces for his own satisfaction, as did other Renaissance artists, is supported by other works. Lightbown argues, for instance, that Botticelli may well have painted the *Calumny of Apelles* (*c.*1495) for his own pleasure and then given it to a friend, Antonio Segna Guidi.[74] Similarly, Lightbown and Schulze Altcappenberg argue that Botticelli's Dante drawings, a huge project, may have been executed for his own edification (even if they were ultimately bound and given as a de luxe codex to a foreign dignitary).[75]

It is, however, possible, on the strength of the above discussion of Botticelli's intellectual context as well as the content of the painting itself, that *The Mystic Nativity* was painted for an intellectual *piagnone* patron such as Giovanfran-cesco Pico, about whom we know much more than the Aldobrandini. Such a patron would not only have been able to understand the Greek inscription, but would also have been sympathetic to the dramatic and ritual elements, as well as the meditative elements, found within the painting, so important had the processional culture been to the Savonarolan/*Piagnone* movement. It is also just possible, although unverifiable, that Pico would have allowed the painting

---

[69] This possibility is suggested by Horne (1908: 293–4) and Lightbown (1978: vol. 2, 100) and also discussed by Zöllner (2005: 266–7).

[70] Horne 1908: 293.

[71] Lightbown 1978: vol. 2, 100 who quotes R. Ridolfi 1952, vol. ii, 60; 245.

[72] Plazzotta and Dunkerton 1999 (National Gallery CD Rom).

[73] Davies 1951: 82; see also Mesnil 1938: 175.

[74] Lightbown 1978: 125. See also Meltzoff 1987 on the *Calumny of Apelles*.

[75] Lightbown 1978: 148; Schulze Altcappenberg 2000: 28–9.

to be used in illicit *piagnone* processions after Savonarola's death (any sort
of open support of Savonarola having been banned by the Republic). The
dramatic or ritualistic elements evident in *The Mystic Nativity* stem in part
from its hierarchical structure, which could have been derived from a proces-
sional float or *sacra rappresentazione*. The embracing men and angels on the
bottom tier, the presence of 'boyish-looking' angels, and the prevalence of
olive branches also recall reports of the Palm Sunday processions of 1496-7
and beyond, as well as the children's processions of February and March
1496 when, as alluded to above, many Florentine children (boys and girls)
processed through the streets, dressed in white, carrying olive branches and
singing hymns.[76] Any satisfactory explanation for the purpose of the painting
ought to take into account both the intellectual, meditative elements of the
painting *and* such ritual, dramatic elements.

The initial impetus for the suggestion that *The Mystic Nativity* could have
had a dual purpose came from Hatfield, who sets out three possible inter-
pretations of the painting at the end of his seminal article on the subject. Two
seem to presuppose either that Botticelli painted it for his own satisfaction or
alternatively for a very close *piagnone* associate, a suggestion endorsed, as has
been seen, by most other scholars. The third (and in his view least likely) is
quite different. He suggests that *The Mystic Nativity* and *The Mystic Crucifix-
ion* might have been painted as a sort of pair (despite their differing sizes) for
one of the Savonarolan boys' groups, such as the one run by Pietro Bernar-
dino. To support this interpretation, he cites the 'naïve syntax' of both paint-
ings, as well as the fact that the symbols for evil are played down and not very
frightening. He also mentions the fact that the collected works of Bernardino
are illustrated with just two pictures, one of a Nativity and one of a Crucifix-
ion, perhaps signalling a particular interest in these two images.[77]

However, the presence of the Greek inscription on *The Mystic Nativity*
seems to count against Hatfield's suggestion, as the boys would not have been
able to understand Greek. Greek was the lesser known of the two classical
languages and copies of the New Testament only became available in Greek in
Europe around 1516. Arasse remarks in connection with this that 'the choice
of Greek suggests that the picture was not displayed in a public place for the
edification of believers but in some not very accessible setting where it was
intended for a cultivated elite'.[78] Or if it was intended for a public place, it has
been suggested that Botticelli was attempting to conceal the true (and poten-
tially inflammatory) message of the painting by putting it into Greek.[79]
Hatfield argues that the inscription could have been added later to 'redefine'

[76] Goldfarb 1997: 12; Hatfield 1995: 96; Ghiglieri (ed.) 1972: vol. iii, 146.
[77] Hatfield 1995: 112.
[78] Arasse 2004: 270.
[79] Lightbown 1978: 136–8.

the painting. However, based on technical examinations that have been made of the painting this seems unlikely. The inscription was indeed painted on top of the blue sky. But a cross-section of the inscription's paint showed that there wasn't any varnish or dirt in between the blue paint of the sky and the white of the background of the inscription. This means that even if the inscription was an afterthought, it cannot have been a significantly later addition.[80]

My proposal, that the painting had a dual function, although ultimately unverifiable, avoids the problems that Hatfield's proposal runs into regarding the presence of the Greek inscription. For, if it was produced for an intellectual patron such as Giovanfrancesco Pico who was also sympathetic to the activities of the *piagnone* boys' groups, then the inscription would have served a private, meditational purpose and a different public or processional one. As Trexler points out, many of the sermons that the boys listened to were in Latin, a language that most of them would also not have understood. However, this was a time when Latin (and perhaps, one might also suggest, Greek as well) 'awed rather than bored'.[81] Thus although the Greek inscription would not have been fully understood by those in the processions, it would have added to the apocalyptic mystique of the painting.

That devotional paintings were used in Florentine processions has already been alluded to above. There exist several concrete examples to show that this tradition continued into the Savonarolan period. The first is the report by Piero Parenti of the Palm Sunday procession of 1496, which states that the boys carried a painting of *The Entry of Christ into Jerusalem*, together with two real crowns, one dedicated to Christ and the other to Mary.[82] The second is a woodcut of the Corpus Christi procession of 1497, which depicts paintings of the saints being held aloft at the front of the procession (Fig. 27).[83] Thirdly, in 1499, an image of the Virgin was used in a procession allegedly to revitalize the *piagnone* movement.[84] The interesting point about these examples is that they show that 'narrative' paintings such as *The Mystic Nativity*, as well as portraits of saints, were used in this way. As mentioned above, carrying such paintings in processions was meant to make them more efficacious in that they actually seemed to begin to embody what they represented.[85] Perhaps carrying a painting of a *Mystic Nativity* in procession, of a longed for millennial future, brought that future closer to being a reality, just as carrying a painting of Mary in procession evoked the actual Mary and thus made it more likely for people's prayers to be answered. The fact that there is written evidence of a *piagnone*

---

[80] See Plazzotta and Dunkerton 1999.

[81] Trexler 1980: 374.

[82] See Piero Parenti in Schnitzer (ed.) 1910: 112–14 and also the 'Pseudo-Burlamacchi' 1937, in P. Ginori Conti and R. Ridolfi (eds.), 127–9.

[83] Trexler 1980: 245, plate 16.

[84] Trexler 1972: 15 n. 27.

[85] Ibid. 16–17.

procession, albeit an illicit one, in 1499 also shows that such events still took place after Savonarola's death. Therefore, the suggestion that both *The Mystic Nativity* and *The Mystic Crucifixion* had a devotional as well as a processional function should be kept in mind throughout the following discussion of these works.

## 4.5 *THE MYSTIC NATIVITY*

*The Mystic Nativity* (*c*.1500, 108.5 cm × 75 cm) is painted on linen canvas prepared with a layer of gypsum and primed with oil pressed from walnuts.[86] Although most Florentine paintings from the end of the fifteenth century were painted on panel, canvas was more widely used than is sometimes supposed, particularly by Botticelli, who also painted *The Birth of Venus* on canvas.[87] This is perhaps not surprising given that canvas was both cheaper and easier to prepare.

*The Mystic Nativity* can be conceived of as occupying three realms: the heavenly, the earthly, and the demonic, with some intermingling between each of the three. The inscription at the top of the painting adds a fourth dimension to the image. The parallels with the typology of Botticelli's drawings for Dante's *Divine Comedy* should not be ignored. In these, Botticelli begins each new book with a synoptic drawing demonstrating how he envisages the realms that Dante moves through in the individual cantos. The Inferno is imagined, in cross-section, as a gradually tapering pit, made up of the nine circles of hell, which comes to an end with the devil himself.[88] The green grass at the top of the cross-section gives a sense of ordinary life continuing on top of the hellish scenes that lie below. Purgatorio is envisaged as a sort of island rising up to the sky, the inverse of the tapering cone of the Inferno.[89] Redeemed souls arrive by boat at the bottom and there is a clearly visible, meandering path leading to the top of the 'island'. Paradiso is represented by a series of concentric spheres or rings (like the orbit of the planets), which gradually get smaller the nearer they are to the Empyrean.[90] The final images in the *Paradiso* series consist of multitudes of angels, and finally Dante and Beatrice too, flying up towards the Empyrean. In *The Mystic Nativity*, the devils at the bottom of the composition seem to be being drawn down between the cracks in the rocks into the awaiting Inferno. Meanwhile, a 'zigzagging' path leads the viewer up to the Nativity scene, which is taking place in a

[86] Plazzotta and Dunkerton 1999.
[87] Ibid.
[88] See Botticelli's *Chart of Hell* in Schulze Altcappenberg (ed.) 2000: 39.
[89] Botticelli, *The Mount of Purgatory* in Schulze Altcappenberg (ed.) 2000: 137.
[90] Botticelli, *Paradiso* II in Schulze Altcappenberg (ed.) 2000: 221.

sheltered cave, the geography of which (particularly the trees in the background) bears some relation to Botticelli's design for *Purgatorio*. Meanwhile the twelve angels at the top of the painting are being drawn up into the heavenly sphere, a large opening in the sky which has the shape of an ellipse and whose presence is emphasized by the use of real gold on the canvas of this upper scene.[91] The compositional parallels with the drawings for Dante's *Divine Comedy* are thus quite striking, but as far as I know, have not been remarked upon before.

It is probably sensible to begin any discussion of *The Mystic Nativity* with the central Nativity scene, before moving onto the more complicated, apocalyptic aspects of the painting that appear in the upper and lower scenes. As mentioned above, the Nativity scene is based largely on Luke 2: 1–20. Thus, Mary and Jesus occupy the middle of the painting, Jesus lying in a makeshift manger on swaddling clothes (Luke 2: 7). Mary is the focus of the picture as she is larger than the other figures and her eyes are placed exactly at the centre of the painting (if one doesn't include the inscription).[92] This discrepancy in scale is an example of Botticelli's adoption of a more 'medieval', less realistic style of painting. Her stance, and that of the infant Jesus reaching up to her, recall Botticelli's earlier *Virgin Adoring the Child* (c.1480–90). Joseph sits to the left of the scene in a subordinated pose. He is also the oldest figure in the painting by some way, a potentially significant point, his age perhaps being contrasted with the youthful nature of the eschatological scene unfolding around him. Echoes of Jesus' subsequent life and suffering may be found in the resemblance of the swaddling clothes to a shroud and the fact that the Nativity is taking place in a cave, which may suggest his tomb (see Mark 15: 46, for example).[93] These details may offer a subtle link with *The Mystic Crucifixion*.

Interestingly, there are no iconographic details linking the Mary figure to the Woman Clothed with the Sun of Rev. 12, one of the chapters mentioned in the upper level inscription, but viewers might have made the link anyway, so established was the exegetical connection by the fifteenth century.[94] It could be argued that the twelve angels flying just below the heavenly sphere and holding hands represent the Woman Clothed with the Sun's crown of twelve stars, an idea that is taken up and significantly modified by Hatfield, as discussed below. To the left and right of the shelter are the shepherds of Luke 2: 8–19, who are being shown the Nativity scene by angels carrying

---

[91] Plazzotta and Dunkerton 1999.

[92] There is also a parallel with the representation of Beatrice in the 'Paradiso' section of Botticelli's drawings for Dante's *Divine Comedy* where she is purposely depicted as being much bigger than all the other figures.

[93] Plazzotta and Dunkerton 1999.

[94] See Kovacs and Rowland 2004: 137 for information on the interpretation of the Woman Clothed with the Sun in the late medieval period, as well as previous chapters in this study.

branches of olive. This is unusual in that in the Lucan account the angels go back up to heaven (Luke 2: 15) before the shepherds reach the Nativity scene.[95] The two angels are holding scrolls on which it has been suggested is written: 'Ecce agnus Dei qui tollit peccatum mundi' (John 1: 29) although the only letters still legible are '…nus Dei…'.[96] The shepherds themselves are crowned with wreaths of olive and there are many olive trees growing around the shelter, once again probably recalling the Palm Sunday processions.[97] The two angels have been rendered by Botticelli as very young looking boys, quite different in form and shape from the twelve angels at the top of the painting. It seems highly likely that Botticelli had been influenced by the aforementioned use of boys in Florentine processions, floats, and *sacre rappresentazioni* where they usually played angels.[98] There exists a report from the San Giovanni Ceremonies of 1454, for example, of a parade of floats in which thirty boys dressed in white represented the angels of the Nativity.[99] Although Botticelli would only have been 9 years old at the time of this particular procession, there is every indication that such dramatic spectacles were a regular occurrence at processions in Florence in general.

On top of the shelter are three angels dressed in white, red, and green robes, suggesting the virtues of faith, charity, and hope respectively. Botticelli has also depicted these angels as young boys. Although they do not hold any scrolls, the middle angel holds a book and the outer ones olive branches. They also wear crowns of olive. The presence of the olive branches in the hands of the angels, as well as functioning as a visual reminder of the Savonarolan Palm Sunday processions, also suggest an intermingling of worldly and Divine hopes, a visual reflection of Savonarola's hopes for a synthesis between the Church Triumphant and the Church Militant.[100] Savonarola made the link between the reconciliation of the heavenly virtues of mercy and truth, righteousness and peace (see Psalm 85: 10–11) and the Nativity in a sermon delivered on Christmas Eve 1493.[101] In it, he argues that mercy, truth, righteousness, and peace were the names that David applied to Christ and that they were first united through Jesus' birth. Believers must have these virtues if they are to understand the Nativity.[102] He seems to have been the first person to have made this link between the Nativity and the reconciliation of these heavenly

---

[95] *Pace* Davies (1951: 80), who comments on the remarkable proximity of the Botticelli scene to the Lucan account.

[96] Ibid. 79.

[97] Lightbown 1978: 134.

[98] See Trexler 1980: 376f. and Trexler 1994: 281–8.

[99] Trexler 1980: 376.

[100] Savonarola, *Prediche italiane ai Fiorentini*, vol. 3, 199, 67. See Weinstein 1970: 174.

[101] Savonarola, *Prediche… Quam bonus*, fos. 112ᵛ–20ᵛ but see esp. 116ʳ.

[102] Hatfield 1995: 89.

virtues, one that is seemingly reflected in *The Mystic Nativity* and then taken up later by Milton, among others.[103]

Turning now to the top tier of the painting, as noted above, this section of the painting consists of a ring of twelve angels suspended in the blue sky above the shelter and seemingly being drawn up toward the golden elliptical opening, which symbolizes heaven. The twelve angels, dressed alternately in white, red (now faded), and green (now darkened), each hold an olive branch together with the neighbouring angel.[104] From these olive branches flutter more scrolls with inscriptions on them. From the bottom of the olive branches hang crowns. In terms of the Lucan narrative, these angels seem to correspond with the 'multitude of the heavenly host praising God' in Luke 2: 13. In terms of their relationship to the inscription, these angels have been variously interpreted as making up the crown of twelve stars worn by the Woman Clothed with the Sun of Rev. 12, and also as the twelve-gated city of the New Jerusalem described in Rev. 21: 12.[105] However, there are two more complex explanations of their presence in the painting. The first, suggested by Hatfield, is based on the eight surviving inscriptions fluttering from the olive branches of the ring of twelve angels which all seem to pertain to Mary. Each inscription conforms to one of what Savonarola (in his *Compendio di revelatione*, first published 1495) refers to as the 'Twelve Privileges of the Virgin'.[106] These 'privileges' (or invocations or supplications), which first became known to Savonarola in a visionary dream, were part of an allegorical crown offered to Mary by the Florentine people in order that she might pray for them.[107] The whole crown was in effect an elaborate set of prayers to Mary. Both Savonarola and, later, Bernardino instituted the reciting of the 'Virgin's Crown' prayer in their boys' groups.[108]

In addition to the similarities between the inscriptions on the scrolls of the angels in *The Mystic Nativity* and the 'privileges of the Virgin' (described by Savonarola in his *Compendio di revelatione*), there are further correlations that can be made. For example, the crown is said to have different jewels on each tier, those of jasper, pearl, and carbuncle (i.e. green, white, and red).[109] Thus the colours of the crown also correspond to the colours of the robes worn by the angels. The second tier of the crown is decorated with ten hearts, which might correspond to the ten crowns hanging down from the angels' olive branches in *The Mystic Nativity*.[110] Interestingly, crowns also appear later in

---

[103] Ibid. 91; see also Saxl 1942: 84, Chew 1942: 64–5, and Dempsey 1996: 501 for a (not ultimately convincing) Joachite interpretation of these three angels.

[104] See Hatfield 1995: 89 n. 2 on the discolouration.

[105] Dempsey 1996: 501.

[106] Hatfield 1995: 94. See Savonarola, *Compendio di revelatione*, fos. 30$^r$–36$^v$.

[107] Hatfield 1995: 94–5.

[108] Ibid. 96.

[109] Savonarola, *Compendio di revelatione*, fos. 30$^r$–31$^r$. See also Crucitti (ed.) 1974: 74, 76–7.

[110] Ibid. Hatfield 1996: 95.

Savonarola's vision when, carrying his crown up to Mary who he describes as being 'clothed with the sun', he encounters a multitude of guardian angels also carrying crowns to which inscriptions have been attached.[111] The similarities between Savonarola's vision of the 'Virgin Crown' and the ring or crown of angels in the upper tier of *The Mystic Nativity* are indeed striking and certainly echo the established exegetical link between the Mary of the Nativity scene and the Woman Clothed with the Sun. However, Hatfield, in his eagerness to link Botticelli to as many Savonarolan sources as possible, seems to be arguing that these angels are *both* the heavenly virtues *and* the angels of the Savonarolan vision of the Virgin's Crown. As we shall see below, Hatfield is at times guilty of 'reading too much into' some of his sources and thus into *The Mystic Nativity* itself. Therefore, it is worth also considering another suggestion, incidentally one that is overlooked by Hatfield.

Olson, who has undertaken research into the *sacra rappresentazione* of Renaissance Florence, has argued that Botticelli found his source for the celestial host in the upper tier of *The Mystic Nativity* in a specific *ingegni del paradiso* created by Filippo Brunelleschi for the staging of an Annunciation play in the church of San Felice in Piazza in Florence.[112] The now lost mechanical stage set was described by Vasari and reconstructed by Arthur Blumenthal, among others.[113] In this reconstruction, one observes a device whereby the actors (normally 12-year-old boys, according to Olson) could be strapped into a wheel-like device and pulled up to the domed ceiling of the church.[114] Once elevated, the wheel could be turned to simulate the ethereal presence of the heavenly host at the Annunciation. According to Vasari's description of Brunelleschi's machinery, the three unusual elements of Botticelli's composition, the dome of heaven, the twelve angels, and the fact that they are joined together in a distinct circle by holding hands, all also occurred in Brunelleschi's *ingegni del paradiso*.[115] Brunelleschi's device was created during the 1430s and four subsequent performances have been recorded: in 1439, March 1471, November 1494 (to celebrate the victory of Charles VIII over the Medici), and 29 March 1497.[116] It is possible that Botticelli witnessed one or perhaps even all of the performances after 1471. Olson argues that the celestial vision in *The Mystic Nativity* has been designed by Botticelli so as to be reminiscent of the actual *sacra rappresentazione* itself, a reminder of his interest in theatrical devices and scenography.[117]

[111] Savonarola, *Compendio di revelatione*, fos. 36$^v$–38$^r$. See also Crucitti (ed.) 1974: 92–6; Hatfield 1995: 95–6.

[112] Olson 1981: 183.

[113] Vasari 1965: 92–3, Blumenthal 1974.

[114] I suggest that these boys might have come from the boys' clubs.

[115] Vasari 1965: 92–3, Blumenthal 1974.

[116] Olson 1981: 185.

[117] Ibid. 186–7.

One does not, however, necessarily need to choose between Olson and Hatfield. Botticelli may have read or heard about Savonarola's vision of the 'Virgin's Crown' and decided that an image of such a crown being carried up to heaven would be best captured in the form of the Brunelleschi *ingegni*. The fact that there seem to be two plausible sources, one literary and one visual, for the top tier of *The Mystic Nativity* is testament to both the complexity and the allusiveness of the imagery, as well as possibly to Botticelli's inventiveness and resourcefulness as a visual artist. This resourcefulness is manifested in Botticelli's 'borrowing' of images from the ritual life of Florence. Indeed, the composition of the painting (minus the top tier of the crown of angels) could easily have been modelled on the Nativity scenes found on the floats of Florentine ceremonial parades.[118] The ritual importance of the *fanciulli* in the Savonarolan era was linked to their perceived role in the coming of the New Jerusalem in Florence, an idea that also seems to have influenced Botticelli in painting this eschatological Nativity scene.[119] The unusual composition of *The Mystic Nativity*, which Argan describes as having a 'hierarchical order of images' that unfold 'like a ritual in defiance of the laws of perspective', as well as being derived from Florentine ritual life, may also suggest an awareness on the part of Botticelli that the painting might have a ritual function within a *piagnone* or *fanciulli* group.[120]

In the foreground of the third, bottom tier of *The Mystic Nativity* a number of little devils are falling into holes and down crevices, having been speared on their own forks. The crevices and cracks in the ground may refer to the devastating consequences of the great earthquake of Rev. 11: 13 following the death of the Two Witnesses, which is probably alluded to in the inscription. On the grass above them, three angels (again holding scrolls bearing inscriptions) embrace three men. The man nearest the reclining demon on the right is rising up from his knees while the one on the left is fully standing, perhaps signifying a gradual resurrection, or more symbolically the gradual dawn of the New Jerusalem in Florence.[121] What is the viewer to make of this strange scene? The possible explanations vary considerably. Before turning to a survey of these explanations, Botticelli's sources for this scene, both pictorial and textual, shall be considered.

There are some parallels with the devils in Botticelli's *Drawings for Dante's Divine Comedy*.[122] In the illustrations to *Inferno* cantos 8, 9, 18, 21, 22, and 28, the 'torturing devils' are depicted as hybrid creatures with bird-like feet, mammalian bodies, and wings. In *The Mystic Nativity,* all the little devils

---

[118] See Trexler 1980: 376 for description of the San Giovanni parade floats.
[119] Trexler 1994: 317.
[120] See Argan 1957: 127–8 on the 'ritual' aspects of *The Mystic Nativity*.
[121] Plazzotta and Dunkerton 1999.
[122] See Schulze Altcappenberg (ed.) 2000 for a full set of reproductions of these images.

seem to have mammalian bodies and bird feet apart from the devil on the extreme left, who has bird feet and a human body. In contrast to the *Inferno* drawings, here the little devils are portrayed as defeated rather than as the active torturers. The counterpart to the devil on the far left is the reclining devil with his hand behind his head on the far right. This devil has attracted some attention on account of its similarities with the devil in an engraving by the Master M.S. entitled *Inspiration against despair*. This devil is also lying on its front and has the same facial features (nose and eyes) and very similar horns. The image is part of a series of eleven prints illustrating the *Ars Moriendi* collection, which enjoyed great popularity across Europe in the fifteenth century.[123] The fact that Michelangelo himself famously painted a coloured copy of Martin Schongauer's engraving of the *Temptation of St Anthony* suggests that even the most famous Italian artists sometimes borrowed from, or even directly copied, their Northern counterparts.

In terms of the men and the angels, there are textual links that can be made with both Luke and the Book of Revelation itself. The inscriptions on the scrolls (where still legible) are thought to spell out Luke 2: 14 (*Gloria in altissimis Deo, et in terra pax hominibus bonae voluntatis*).[124] Botticelli may well have been depicting the 'peace among men' envisaged in this verse at the birth of Christ. However, the events of the lowest tier of *The Mystic Nativity* can also be related to Rev. 11. Rev. 11: 15 (cf. also Rev. 21: 3) suggests the intermingling of the heavenly and the earthly realms, while Rev. 11: 18 talks of how the servants of the Lord will be rewarded and the 'destroyers of the earth' destroyed. In *The Mystic Nativity*, both these themes are played out in a non-mimetic, Florentine setting. The men being embraced by the angels are presumably the 'servants', while the speared devils are being destroyed and cast down into Hell. The embracing of men by angels also suggests a realization of Savonarola and Bernardino's frequently expressed hopes for a future communion of men and angels in Florence itself.[125]

Other interpretations of the significance of the foreground scene depend on the number of devils counted by the scholar in question. Plazotta and Dunkerton, as well as Arasse, count seven devils, which seems to be correct. In addition to the devil in the left-hand corner and the reclining devil on the right, there are at least four devils in the middle area, three falling into holes at the front and one trapped in a crevice behind the central pair of angels and men. The seventh devil's head is poking out of the crevice next to the reclining devil. Plazzotta, Dunkerton, and Arasse suggest that the devils, as well as

---

[123] Eserdijan 1998: 15 (see also Huizinga 1924: 148).

[124] Davies 1951: 79.

[125] Savonarola, *Registro delle prediche del Reverendo Padre Frate Hieronymo da Ferrara facte nel Mccccclxxxxv*, sigs. a2ʳ, a3ʳ, a7ʳ. Bernardino, *Predica*, sigs. a7ʳ, b6ʳ (see Hatfield 1995: 105 nn. 98–105).

representing the 'destroyers', could also represent the seven heads of the Dragon in Rev. 12. 3 or alternatively the seven deadly sins.[126] The suggestion that the seven little devils represent the Dragon of Rev. 12 is particularly interesting. Zöllner counts only six devils and adds that they are fleeing the reign of peace that was initiated by the return of the Redeemer.[127] Lightbown, Dempsey, and Hatfield all count only five devils, their criteria for what constitutes a devil remaining unclear.[128] Hatfield then goes on to construct a spurious argument around there being only five devils, stating that they represent the five senses through which the devil could enter the body. He also quotes Savonarola twice on this theme in an attempt to strengthen his argument regarding Botticelli's reliance on Savonarolan sermons as a theological source for *The Mystic Nativity*.[129] The fact that there are clearly seven little devils visible renders this section of Hatfield's argument irrelevant, and exposes the weaknesses of his at times overly speculative approach to Botticelli's sources.

Quibbling about the number of little devils will not, however, significantly aid our understanding of *The Mystic Nativity* as a representation of the Book of Revelation, an interpretation that Botticelli claims for his own painting in the inscription on the upper tier. For, as intimated above, without the inscription, which serves as a hermeneutical 'key' to the work, the painting consists of a rather strange Nativity scene with apocalyptic and ritualistic *piagnone* elements. In the inscription, Botticelli claims that *The Mystic Nativity* is a depiction of Rev. 11 and 12, a relationship that is not initially obvious. The full inscription can be translated as follows:

> I, Alexandros, was painting this picture at the end of the year 1500 in the [troubles] of Italy in the half time after the time according to the eleventh [chapter] of St. John in the second woe of the Book of Revelation in the loosing of the devil for three and a half years. Then he will be chained in the twelfth [chapter] and we shall see him [about to be buried/trodden down] as in this picture.[130]

The inscription, in which Botticelli claims authorship of the work, represents the only instance of Botticelli either putting his name to, or giving any sort of explanation for, a work, apart from his drawing for Canto 28 of *Paradiso* of Dante's *Divine Comedy* in which a figure (perhaps the artist himself) appears holding a *cartellino* bearing his signature. This has been interpreted as a petition on behalf of Botticelli and his work.[131] Thus the inscription personalizes *The Mystic Nativity* in an almost unprecedented way, leading Zöllner to

[126] Plazzotta and Dunkerton 1999; Arasse 2004: 270.
[127] Zöllner 2005: 178.
[128] Lightbown 1978: 135; Dempsey 1996: 501; Hatfield 1995: 100.
[129] Hatfield 1995: 102.
[130] Based on Rowland's translation (2005: 310).
[131] Schulze Altcappenberg (ed.) 2000: 276-7.

speculate that, via the inscription, 'Botticelli linked both his painting and his person to the apocalyptic views of the era'.[132] It should also be reiterated that (*pace* Hatfield) based on recent technical analyses, it seems certain that the inscription was done at the same time as the rest of the painting.[133] This is important because as Hatfield rightly points out, the inscription radicalizes the painting. If it can be definitively shown that the inscription was not an afterthought, then the painting and the inscription must have been conceived as a coherent whole, the idea being that one would illuminate the other, however esoteric a pairing they might seem at first glance.

The esoteric character of the inscription stems from the fact that it is in Greek, a language that had only recently been revived by the humanists and therefore one that would exclude all but a small, very 'elite' audience. The choice of Greek as the language of the inscription may also indicate that Botticelli was worried about too openly promulgating an apocalyptic or an overtly Savonarolan message. Conversely, as suggested above, Botticelli's use of Greek may point towards an attempt to intensify the painting's mystical appeal either for its presumed *piagnone* patron or for a more public but still *piagnone* audience. With regard to the standard of the Greek, several commentators have remarked upon the fact that it is rather poor, perhaps indicating that Botticelli himself wrote it.[134] Horne remarks particularly on the inconsistency in the numerals. The numerals ΧΣΣΣΣΣ in the inscription denote the year 1500, but this is a confusing use of Greek numerals because in Greek, X is the symbol for 600 and Σ for 200, but here Botticelli seems to have used X for 1000 (Χίλιος) and Σ for the Latin C, the symbol for 100. This is all the more confusing when one considers that later on in the inscription, the correct Greek symbol for 3 (Γ) is used.[135] Similarly, the way that Botticelli has written 'the half time after the time' (Rev. 12: 14) indicates that he had in mind the Vulgate's *tempus et tempora et dimidium temporis* rather than the καιρὸν καὶ καιροὺς καὶ ἥμισυ καιροῦ of the Greek New Testament that was probably not known to him.[136] Others have suggested that he turned to a learned colleague for assistance with the inscription, even if the latter clearly had a slightly shaky grasp of Greek.[137]

In any case, the inscription is crucial in interpreting the painting *and* linking it to the situation in Florence in 1500/1. Rowland argues that *The Mystic Nativity* reflects the critical challenge facing Florence around 1500, the

---

[132] Zöllner 2005: 177.
[133] Plazzotta and Dunkerton 1999.
[134] Ibid.; Horne 1908: 295. See also Vasari 1568 (vol. 1): 474 on Botticelli's education.
[135] Horne 1908: 295.
[136] Ibid. 295
[137] Luchinat 2001: 25.

half-millennium, as understood by Botticelli.[138] As stated above, given the Florentine calendar, its reference to the end of the year 1500 can be taken to refer to January–March 1501 of the present-day calendar. The inscription states that the painting was done 'in the troubles of Italy'.[139] These 'troubles' have usually been taken to refer generally to the two French invasions of 1494–9 and to Cesare Borgia's ravaging of Italy in 1500–1.[140] By the end of 1501, it even seemed as though he would take Florence itself.[141]

Botticelli then goes on to situate the work 'in the half time *after* the time according to the eleventh of St John [i.e. according to Rev. 11] in the second woe of the Book of Revelation'. The second woe of the Book of Revelation is the earthquake that occurs in Rev. 11: 13 after the preaching, subsequent death, and resurrection of the Two Witnesses (who are also likened to two olive trees, a potentially significant detail given the prevalence of olive trees and branches in the painting). The fact that Botticelli feels himself to be living in the half time *after* the eleventh chapter implies that the Two Witnesses have already come, been killed, and been resurrected. There is, however, no perceptible reference, visual or otherwise, to the Two Witnesses in *The Mystic Nativity*. Several commentators have argued that Botticelli saw the execution of Savonarola and Fra Domenico da Pescia in May 1498 as a fulfilment of the vision of the Two Witnesses in Rev. 11.[142] If, as seems likely, he had done, then their deaths would have followed the loosing of the devil from the bottomless pit in Rev. 11: 7, which Botticelli seems to allude to in the next phrase in the inscription, the reference to the 'loosing of the devil for three and a half years'. However, according to Botticelli's own schema, this woe, the killing of the Two Witnesses, possibly envisaged by Botticelli as Savonarola and da Pescia, ended in 1498. There are then two possible explanations for the devil that Botticelli is referring to. He may be referring to the Dragon of Rev. 12 who keeps the Woman Clothed with the Sun in the wilderness for a 'time, times and a half time' (Rev. 12: 14). However, in Rev. 13 there also exists a counterpart to the 'three and a half years' described in the inscription. The Sea-Beast of Rev. 13 is said to have been given power over the earth for forty-two months (Rev. 13: 5), which works out as exactly three and a half years. It seems likely that Botticelli has conflated the two symbols for the devil, the Dragon of Rev. 12 and the Beast of Rev. 13, revealing a metaphorical, recapitulative understanding of the text whereby the Dragon and the Beast are both symbolized by the seven little devils at the bottom of the painting.

---

[138] Rowland 2005: 311.

[139] The Greek word for troubles, 'ΤΑΡΑΧΙΑΣ' is incomplete. In fact only the ΤΑΡ...is fully legible but the translation is the only one that really makes sense in the context.

[140] Plazzotta and Dunkerton 1999; Horne 1908: 296–7.

[141] Ibid.

[142] Ibid. 297; Rowland 2005: 311.

What is important is that Botticelli seems to locate himself in the period just after Rev. 11 in which the devil (in all his manifestations) has been unleashed. However, in a further interpretative twist, he also goes on to relate the subsequent chaining and 'treading down' of this devil to Rev. 12, an exegetical error, in the strictest terms, since the chaining or binding of the devil actually takes place in Rev. 20: 2, prior to the millennial reign of Christ and the final destruction of Satan and his angels in Rev. 20: 10. There are two possible explanations for this. First, and following on from Botticelli's previous conflation of the apocalyptic symbols for the devil or Satan, he may equate the casting down of the Dragon by Michael and his angels in Rev. 12: 9 with the binding and then the final defeat of Satan as described in Rev. 20: 2–10, the former being read as another symbolic manifestation of the latter. This would represent an example of an extreme 'recapitulative' reading of the Book of Revelation in the Tyconian tradition. Significantly, there also exists an extant Savonarolan sermon from Assumption Day 1496 in which he spoke of the casting out of Satan (Rev. 12) as if it were his binding (Rev. 20) and also the beginning of Christ's power on earth, suggesting that Savonarola too was amenable to such extreme recapitulative readings.[143] However, Rowland also suggests that Botticelli may be drawing on a different part of the Tyconian–Augustinian tradition, that relating to the millennium. Rowland argues that in linking the Beasts of Rev. 11, 12, and possibly 13 with the loosing of the devil and his final destruction in Rev. 20: 2–10, he might be drawing on the a-millennial Augustinian interpretation of Rev. 20: 2–10, which holds that the binding of Satan (20: 1–3) was accomplished through the birth of Christ.[144]

*The Mystic Nativity* could therefore function as a visualization of the Augustinian reading of Rev. 20: 1–3 were it not for two factors. First, the inscription refers not just to the chaining or binding of Satan, but also to his burial or 'treading down' (which we may construe as his final defeat). Secondly, in Botticelli's visual presentation of this part of the inscription, Satan (represented we presume by the seven little devils) is shown to be completely defeated and not just bound. Hatfield ventures that, since Satan was manifestly not defeated in Florence in 1501, Botticelli had interpreted the prophecy in Rev. 12, about the birth of the child of the Woman Clothed with the Sun, as a sort of new 'new Nativity', an exegetical link also made by Savonarola.[145] Several extracts from what is believed to be Savonarola's annotated Bible and two of his well-known sermons all support the idea that Christ either has been or will be born in Florence.[146] If Botticelli knew about this Savonarolan link, then *The Mystic Nativity* could indeed be an expression of his belief that a

[143] See Savonarola: *Prediche ... delle feste*, sigs. n5ʳ–o4ʳ. Also in Romano (ed.) 1969: vol. 2, 71–108.
[144] Rowland 2005: 311.
[145] Hatfield 1995: 101.
[146] Ibid. 102.

Second Nativity, the one that would herald the final defeat of Satan and that had been predicted in Rev. 12, was imminent in Florence. Into this vision of the future Botticelli had also brought allusions to the reconciliation of the heavenly virtues with one another and with mankind and the crown of Mary.[147]

Rowland seems to be largely in agreement with Hatfield when he writes that:

> [in *The Mystic Nativity*] past and present are brought together as Florence becomes the epicentre of the apocalyptic deliverance that is about to come upon the world. Like Milton after him, Botticelli interprets the first coming of Christ as itself an eschatological event, in which the powers of darkness are overcome and a new age begins.[148]

The idea of Florence as the epicentre of apocalyptic deliverance is one that was, as we have already seen, developed forcefully by Savonarola and perpetuated by *piagnoni* such as Benivieni and Bernardino after his death. Thus in *The Mystic Nativity* Botticelli has visualized the dawning of the messianic kingdom evoked in Rev. 12 and 20 not in terms of the symbolic imagery used therein but rather, in terms of the first Nativity, a real historical event. In accordance with the *piagnone* belief that some form of Second Nativity was imminent in Florence around 1500, Botticelli has infused his Nativity scene with mystical and apocalyptic detail.

In light of this interpretation of *The Mystic Nativity*, it is pertinent to end this section with a consideration of the relationship between this painting and Botticelli's *Mystic Crucifixion*. The *Mystic* (or *Fogg*) *Crucifixion* (*c.*1497) is a Crucifixion scene with (like *The Mystic Nativity*) both traditional and unexpected elements (Fig. 26).[149] At the foot of the cross, Mary Magdalene, here a symbol of Florence, lies in a penitent pose.[150] Out of her cloak runs either a wolf (symbol of the persecution of the Church) or a fox (symbol of Pisa, which had 'escaped' from Florentine domination in 1494).[151] To her right, an angel (who is reminiscent of the angels in the top tier of *The Mystic Nativity*) slays another small animal, possibly a lion, which may symbolize the sins of the city.[152] In the upper left-hand corner, God sits in a mandorla. Underneath him (and very difficult to see), white-robed angels hand roses to each other,

---

[147] Ibid. 114.

[148] Rowland 2005: 312.

[149] Weinstein dates the painting to 1502 or the beginning of 1503 and Hatfield to *c.*1500. Readers should also note that it is now very badly damaged and thus some parts of the painting are very difficult to see.

[150] Weinstein 1970: 336.

[151] Ibid.

[152] Lightbown 1978: 131; see also Johnson 2000: 55–73 on the symbolism of the Florentine lion or *marzocco*.

perhaps symbolizing the blessings or prayers of the repentant Florentines.[153] Underneath them are angels holding white shields with red crosses on them as they fight seven brown devils armed with burning faggots and torches. The right-hand side of the painting where the devils are is made up of a dark sky, probably symbolic of the black clouds of Hell that would have rolled over Florence if she had not repented. The shields of the angels bear the symbol of the *popolo*, or people, of Florence that had informally replaced the Medici arms when the Florentine Republic was established in December 1494.

The scene on the right-hand side of the painting evokes the report of the San Giovanni ceremonies in June 1454 as described by Matteo Palmieri, and thought by Trexler to be representative of the sort of dramatic presentations on show at Florentine parades throughout the fifteenth century.[154] The first float in this particular parade comprised the archangel Michael, with God above him in a cloud. This was followed by two or more fraternities of thirty angels, played by boys from the boys' groups dressed in white. The parade finished in the Piazza della Signoria where the boys staged a 'reconstruction' of the fight between Michael and his angels and Satan and his angels (Rev. 12: 7–9), in which Satan/the Dragon and his followers are eventually cast down from heaven. Once again ritual elements, well known to the Florentine population, seem to have informed Botticelli's composition.

*The Mystic Crucifixion* is also thought to relate to a sermon of Savonarola's from 11 November 1494 and a woodcut believed to illustrate another sermon, published in 1496 in Domenico Benivieni's *Tractato in defensione della doctrina et prophetia predicate da frate Hieronymo da Ferrara*. In the 1494 sermon, Savonarola had exhorted the Church to renew itself in the face of imminent woes (*gran flagello*) that were about to be visited on all of Italy. In order to support his calls for repentance, Savonarola related a 'vision' to his audience that he purported to have had a year and a half before in 1492. In his vision, he saw two crosses hanging in the sky. One, hanging over Rome, was black with the words *crux irae Dei* written on it. A massacre followed and only a few survived. Then the skies cleared and he saw a golden cross hanging over Jerusalem. This cross was called the *crux misericordiae Dei*. The light of this cross illuminated all the world,[155] and a woodcut believed to illustrate this sermon also embellishes it. The crosses themselves are missing, but the woes brought by the *crux irae Dei* are visible on the right-hand side over the city labelled 'Roma', while there is a clear sky over Jerusalem on the left echoing the illuminating effect of the *crux misericordiae Dei*. In the middle ground on the right is the city of Florence itself, no longer menaced by the storm. Zöllner

[153] Lightbown 1978: 131.
[154] Matteo Palmieri cited in Guasti 1908: 20–3.
[155] See Weinstein 1970: 72–3 and Zöllner 2005: 175–6 for a reproduction of this image.

argues that it should be regarded as the 'pendent to Jerusalem'.[156] The same themes (those of the Divine scourge, penitence, and triumph) are carried over into *The Mystic Crucifixion* where they are directly applied to Florence. Indeed, Weinstein argues that *The Mystic Crucifixion* represents Florence three times and that these correspond to the three hallmarks of the Savonarolan prophetic cycle. Thus we see Florence once under the Divine scourge, once repentant at the foot of the cross, and a third time in triumph, bathed in the light of the open book of God's revelation.[157]

The proximity of *The Mystic Crucifixion* to aspects of Savonarola's 1494 sermon and to the corresponding woodcut has led most scholars to the conclusion that, like *The Mystic Nativity*, it was painted for a follower of Savonarola.[158] The idea that *The Mystic Crucifixion* and *The Mystic Nativity* may even have been intended as counterparts to one another is significant. On a general level, both works represent the 'apocalypticization' of an earlier 'Christ-event', be it the Nativity or the Crucifixion. In the latter case this link is legitimated through Matthew 27. There are other themes both visual and contextual, which link the two works. First, the battle between the shield-carrying angels and the devils in the sky of *The Mystic Crucifixion* is, as argued above, strikingly reminiscent of the battle between Michael and his angels fighting the Dragon and his angels in Heaven from Rev. 12: 7–9. In the left-hand corner, God sits presiding over the scene, his hand raised in benediction. Thus, Botticelli has not only depicted elements of the Savonarolan sermon here, but also superimposed onto these events the battle between the angels and the devil and his angels from Rev. 12, a battle that was part of the Florentine dramatic and processional repertoire. The resolution of this battle, the final defeat of Satan in the form of those same devils being speared down into Hell, is then depicted in a separate painting, *The Mystic Nativity*.

The second theme that may link the two paintings together is the *piagnone* connection. It has often been noted that *The Mystic Nativity* lacks the Savonarolan theme of penitence.[159] If the two paintings were to be taken together, however, *The Mystic Crucifixion* could be viewed as embodying the penitential Savonarolan message of sermons such as those delivered in 1490–4, while *The Mystic Nativity* encompasses the more joyful, future-orientated side of the friar's preaching, as evidenced after 1494.[160] If *The Mystic Nativity* is to be interpreted as a 'second Nativity', then it also makes sense that this truly mystic, future, Nativity should follow the past, historical event of the Crucifixion.

---

[156] Zöllner 2005: 176.
[157] Weinstein 1970: 337.
[158] See Lightbown 1978: 130–3 or Steinberg 1977: 69–77.
[159] e.g. Rowland 2005: 311.
[160] See for example Savonarola's 1495 sermon in which he spoke of angels and men living together in Florence in peace (Savonarola, *Registro delle prediche del Reverendo Padre Frate Hieronymo da Ferrara facte nel Mcccclxxxxv*, BNCF MS Sav. 49, sigs. a2$^r$, a3$^r$, a7$^r$).

Against the idea that the two paintings were intended as a pair is the fact
that they are different sizes. *The Mystic Nativity* is 108.5 cm × 75 cm while *The
Mystic Crucifixion* is 72.3 cm × 51.3 cm. It is just possible that *The Mystic
Crucifixion* could have been cut down at some point, but this is not verifiable.
They are, however, both on canvas, a fairly unusual material at this time.
Second, there is the problem of chronology. If they were really intended to be a
pair, then why would Botticelli have produced them some four years apart? If,
however, we accept that a later dating for *The Mystic Crucifixion* is possible, as
argued by Weinstein and Hatfield (1502–3 and *c.*1500 respectively), then this
second problem is significantly diminished. Indeed, as mentioned above,
Hatfield entertains the idea that the two paintings could have been produced
together for one of the *piagnone* boys' groups, an idea that was suggested in
relation to *The Mystic Nativity*.[161] It was suggested that both paintings could
have been painted for an intellectual *piagnone* patron who also allowed them
to be used in processions, thus accounting for their devotional and their ritual
features. In a processional sense they could have been carried as a pair to
depict the development of the Florentine apocalyptic drama, the eschatologi-
cal climax of which they believed to be very close. Thus the notion that the two
paintings were intended as a complementary pair seems to be at least a
possibility, although it must be noted that any *piagnone* processions after
1498 would have to have been conducted in secret. Evidence has been found
and cited of at least one such secretive event, thus opening the possibility that
there may well have been more.[162] In any event, even if not literally intended
to be displayed or used as a pair, the two paintings are related in important
hermeneutical ways.

## 4.6 CONCLUSION

This chapter has sought to understand Botticelli's thinking about the Book of
Revelation (and, in particular, Rev. 11, 12, 20, and possibly 13) as expressed in
his *Mystic Nativity*. *The Mystic Nativity* has been shown to represent a very
different type of interpretation of the Book of Revelation from the other works
discussed in this study. The Greek inscription at the top of the painting not
only personalizes the painting (in a way that is perhaps comparable to Dürer's
monogram, as will be seen in the next chapter), but also interprets the painting
for a learned, Greek-reading viewer. This is unprecedented with regard to the
other works surveyed in this study where the viewer (although perhaps

---

[161] Hatfield 1995: 112.

[162] See Trexler 1972: 15 who cites Del Badia in *Landucci*, 193 on the probable *piagnone*
motivations behind a Marian procession in 1499 in which a painting of Mary was carried (*Fare
più risurgere la loro secta e farsi risentire*).

conditioned or manipulated towards a particular interpretation) is not explicitly alerted to the artist's own interpretation in this way.

*The Mystic Nativity* also stands out in that Botticelli is not attempting to offer a holistic, narrative, or mimetic interpretation of the Book of Revelation in any way. Having perhaps been influenced by Savonarolan and *piagnone* exegesis of the Book of Revelation (and of other biblical texts), in *The Mystic Nativity* Botticelli offers the viewer a synchronic visualization of the perceived essential subject-matter of the Book of Revelation. Thus the coming of the messianic kingdom and the final defeat of Satan evoked, in particular, in Rev. 12 and 20 are pictorialized, in non-mimetic fashion, as a Nativity scene. The eschatological appearance of Christ (Rev. 20) is visualized as a second Nativity, complete with elements of contemporary Florentine ritual. The only way to 'read' such an interpretation is synchronically. The viewer is effectively unable to separate the events in a chronological sense and thus the impression is that they are all taking place simultaneously, a mystical 'snap-shot' of the future. This synchronic approach finds a parallel in hermeneutical terms (if not in functional terms) in the *Ghent Altarpiece*, where themes from the Book of Revelation are taken out of their narrative context as part of a wider visual programme.

As has been demonstrated, Botticelli's conviction in an imminent, apocalyptic, Florentine future was expressed by drawing on a wide range of contemporary visual and textual sources. Botticelli has used images of the Nativity, the fight against Satan (in its many guises), the Florentine millennial future, and heaven itself from the rich tapestry of the contemporary Florentine ritual life of processions, floats, and *sacre rappresentazioni*, which themselves placed a particular emphasis on the young and pure. Such rituals clearly helped to inform the dramatic, but also ritualistic, compositions of both *The Mystic Nativity* and *The Mystic Crucifixion*. Through Savonarola's sermons and through more radical *piagnone* thought and woodcuts, as well as surely his own reflections on the Book of Revelation, Botticelli was able to interpret the assembled images of salvation through the lens of a very Florentine understanding of the near future. Whether *The Mystic Nativity*, itself a product of *piagnone* thought and ritual, was then used in *piagnone* boys' processions, whose ritual it reflects, or whether it had a much more private function is not verifiable. What is certain is that Botticelli's synchronic, non-mimetic visualization of the Book of Revelation, or elements therein, marks an attempt to pierce or 'translate' the symbolic language of that text in a quite unprecedented way. The hermeneutical implications of *The Mystic Nativity* will be discussed further in Chapter 6.

# 5

---

# A Time of Transition

## Visual Representations of the Book of Revelation in Germany in the Late Medieval and Early Modern Period

### 5.1 INTRODUCTION

In contrast to Botticelli's almost idiosyncratic interpretation of the Book of Revelation, the two artists featured in this chapter, Albrecht Dürer and Lucas Cranach, were part of a more 'mainstream' tradition of apocalyptic visualization. Both artists used the 'popular' format of the woodcut book for their images of the Book of Revelation, reproducing the text in its entirety as a narrative accompanied by a number of images (Dürer uses fifteen images and Cranach twenty-one). This chronological, diachronic mode of presentation stands in contrast to the various synchronic presentations offered by the Van Eycks, Memling, and Botticelli. In this sense, on a presentational level at least, Dürer and Cranach's images of the Book of Revelation have more in common with the thirteenth- and fourteenth-century Anglo-Norman Apocalypse manuscripts.

However, the reduced number of images used by Dürer and Cranach meant that important interpretative decisions had to be taken regarding which parts of the text to visualize and which to leave out. Their more naturalistic style and artistic autonomy also distinguishes these later, 'Renaissance' artists from their earlier, late medieval counterparts. As will be demonstrated, Dürer offers a more penetrating and personal exegesis of the Book of Revelation, incorporating elements of a synchronic presentation into his essentially diachronic book-format, while Cranach visualizes a 'Lutheran' interpretation, a rendering that inspired literally hundreds of imitations and succeeded in fixing a particular type of polemical, apocalyptic imagery into the public consciousness.

By the 1470s, in both Northern Europe and Italy, woodcut illustrations were increasingly popular. Thousands of blocks were being designed and cut for book printers in the German-speaking regions, France, the Netherlands, and Italy. The majority of these were scriptural and devotional books. Although

there is both a lack of information and conflict of opinion on the subject, it was almost certainly the case that woodcut illustrations were relatively cheap to buy. For example, the Strasbourg preacher Geiler von Kaisersberg is quoted in 1500 as saying that a simple image (that is, one sheet) of 'The Visitation' could be purchased for a *pfennig,* an affordable price even for a regional labourer who would have earned around 16*d.* a year, where 1*d.* was equivalent to around 240 *pfennig.*[1] The woodblocks themselves were remarkably hard-wearing, being able to produce up to 1,500 impressions of good quality before they started to crack and splinter. Thus, after the initial outlay of paying for the craftsmanship involved and the raw materials, the publisher of such woodcut illustrations could afford to print many copies and sell them quite cheaply.

For the first time, ordinary (albeit still generally 'middle-class') people were able to purchase images for devotional and/or aesthetic purposes. It was also incredibly liberating for artists, who, instead of waiting for a commission, could now produce images to be printed themselves. Some artists, such as Dürer himself, were able to purchase their own printing presses, meaning that they could control every step of the process from design to marketing.[2] The graphic media thus became a vehicle of artistic self-expression, a key element of what is now known as the 'Renaissance'.[3]

The three visualizations of the Book of Revelation discussed in this chapter represent different manifestations of the new print media. The first visualization is the work of an unknown artist who produced the woodcut illustrations for Anton Koberger's eponymous Koberger Bible of 1483 (also referred to throughout as K1–8; see Appendix 2, Table 1 for a short description of each image).[4] The eight images that he produced are crude in an artistic sense, but significant in terms of the 'compressed' visual interpretation offered of the text of the Book of Revelation, particularly when contrasted with the ninety or so images used by the earlier Anglo-Norman artists in their Apocalypse manuscripts. The second visualization analysed in this chapter is Dürer's Apocalypse Series of 1498 (also referred to throughout as D1–15; see Appendix 2, Table 2 for a short description of each image). Dürer has been widely credited as the first major artist of the 'Northern Renaissance'.[5] He was also the first artist in Europe to exploit the real possibilities of the new print media with his Apocalypse Series. In addition to this, much of the twentieth-century scholarship on Dürer's Apocalypse Series has turned on the thorny issue of whether he was in fact (due to his possibly critical portrayal of the Church in the fifteen images) a 'proto-Reformer'. He thus perfectly encapsulates this transitional

---

[1] Landau and Parshall 1994: 350, 370–1. See 347 ff. for detailed information on print prices.
[2] See Koerner 1993: 203.
[3] Panofsky 1955: 45.
[4] A full key is provided to the Koberger, Dürer, and Cranach series in Appendix 2 of this study.
[5] Panofsky 1955: 8.

time and his legacy in terms of the iconography of the Book of Revelation has been profound. In spite of, or perhaps because of, this, Dürer's Apocalypse is a work that was nevertheless probably too expensive and too intellectually sophisticated to be deemed truly 'popular'.[6] Cranach's illustrations for Martin Luther's New Testament of 1522, in contrast, may be called, and indeed were intended to be, 'popular' (also referred to throughout as C1–21; see Appendix 2, Table 3 for a short description of each image). In iconographic terms, their influence has been as, if not more, profound than Dürer's Apocalypse Series.

Throughout this chapter particular emphasis will be placed on the complicated relationship between these three different interpretations of the Book of Revelation. In keeping with the traditions of the 'Northern School', the later artists relied on the earlier ones, changing details, but not starting completely afresh. It will be demonstrated that Dürer relied heavily on the Koberger illustrations for many of his compositional and some of his interpretative ideas. Despite the fact that stylistically the two series are incomparable, fourteen of the fifteen images in the Dürer series have clear precedents in the Koberger images. Dürer has essentially taken the compositional and interpretative ideas espoused in a set of eight devotional images and recast them in his own, unique, interpretation of the same text.

While there may have been a devotional element to Dürer's Apocalypse, his images were not designed as part of a Bible, but as a stand-alone version of the Book of Revelation in which the large, full-page images jostle for precedence with the text and indeed, one could argue, ultimately overwhelm the text. This style of visualization stands in marked contrast to the Anglo-Norman manuscript style where the much smaller images were 'balanced' by the presence of both the text and commentary extracts on every page. Dürer, having embraced the artistic values of the Italian Renaissance, was the first known artist to present an Apocalypse *Series* first and foremost as a set of images. The text of the Book of Revelation is not, of course, discarded. The images and the text, set out in two columns, are on facing pages, but they do not correspond directly to each other. The impression given to the 'reader' is therefore of a dual Book of Revelations, one visual and one textual, coexisting with each other. There is, however, no sense in which the images are present as mere illustrations to the text. In this sense then, Dürer's series really has no predecessor.

Like the Koberger images, Cranach's images are part of a larger enterprise. Commissioned by Luther in 1522, Cranach's visual interpretation of the Book of Revelation represents the reformer's desire for biblical art that was literal and didactic, but not theologically innovative or properly exegetical. It is also in places deeply polemical. By increasing the number of images used to represent the Book of Revelation from Dürer's fifteen images to twenty-one

---

[6] See Landau and Parshall 1994: 352–3.

(and in the process designing six of his own compositions) in order to depict each chapter of the book, Cranach offers a visual interpretation that manages to be a more rigid and literalistic interpretation of the text on the one hand and a more polemical one on the other. Where Dürer had allowed for synchronic, nuanced, and, at times, ambiguous interpretations of the text, Cranach's illustrations generally admit only one interpretation, and one that is more or less imposed on the viewer. While Dürer's Apocalypse images thus stand at the end of one visual tradition, that of late medieval image-making, and the beginning of a new one, that of 'Art' with a capital 'A', Cranach's images are part of a wider and often more public movement, that of a new Protestant art of propaganda.

## 5.2 THE KOBERGER BIBLE

The Koberger Bible, published in Nuremberg in 1483 by Dürer's godfather, Anton Koberger, may be grouped with the Dutch Bibles of the early fifteenth century and their successors, and the early printed Bibles of the 1470s–1480s. With their small illustrations embedded in the text, they stand in contrast to the block-book Apocalypses of the mid-fifteenth century, which tended to feature a very large number of less condensed illustrations.[7]

The Koberger Bible (33.0 cm × 29.0 cm) came in two, leather-bound volumes and contained illustrations for some, though not all, of the biblical books.[8] The decision to provide illustrations or not seems to have depended largely on the subject-matter of the books. Thus Genesis, the Gospels, and the Book of Revelation all contain hand-coloured illustrations (which were inserted into the text), but the Pauline Epistles, for example, do not. The fact that the Book of Revelation was illustrated should come as no surprise. The very visual nature of the imagery found in the Book of Revelation, and the fact that this imagery is often better or at least differently expressed through images rather than through a textual commentary, is one of the fundamental claims of this study.

The Apocalypse images in The Koberger Bible consist of eight woodcut illustrations (12.0 cm × 19.0 cm), the blocks of which first appeared in the Cologne Bible, printed by Bartholomäus von Unkel and Heinrich Quentell in Dutch and Saxon editions in Cologne in c.1478. The blocks were reversed and recopied in the woodcuts for the Strasbourg Grüninger Bible of 1485, as well as

---

[7] Panofsky 1955: 51.

[8] An original 1483 version of this Bible is housed in the British Library, shelfmark C.11 d.5. I have used this British Library copy for my research and this is where my illustrations were obtained from.

in contemporary Czech and German Bibles.[9] Thus by the 1490s, these wood-cuts would have been well known in one form or an other to most people purchasing German Bibles and in this sense can be called truly 'popular'. We shall here focus only on the Koberger woodcuts as these are the ones that Dürer is most likely to have seen via his godfather, Anton Koberger himself.[10]

The Koberger illustrations are rough delineations of painted manuscript pictures. The blocks themselves are cut in a simple style, with no use of perspective, and they have been coloured in (rather carelessly) by hand in order to enhance their appearance.

In the 1483 version, the illustrations are inserted into the German text in the middle of the page (see Fig. 28: K8, for example).[11] The German text (trans-lated from the Vulgate) had first appeared in 1466 in a Bible published by Johann Mentel at Strassburg. It was revised in 1475 for Günther Zainer's Augsburg edition of the Bible and, after receiving further corrections, was adopted by Koberger in 1483. The Koberger Bible was therefore the ninth German Bible to be published.[12] It is held to be the most textually 'fluent' of all the pre-Lutheran German Bibles.[13] The fact that the text is in the vernacular and is accompanied by illustrations suggests that the Bible was probably intended for lay devotional use. Significantly, contemporary Bibles in Latin generally aimed at both a clerical and highly educated lay readership, did not include illustrations.[14] In fact, the Latin version of Dürer's Apocalypse Series and an illustrated Vulgate printed in Venice by Simon Brevilaqua, also in 1498, were the first known examples of Latin biblical texts printed with accompanying woodcut illustrations.

Koberger was first and foremost an entrepreneur who wanted to make money from the new demand for printed Bibles in Germany in the late fifteenth century. During this period, he published over twenty Latin Bibles.[15] While he probably did not intend to make profound political or theological statements with his Bible, as will be demonstrated below, he may nevertheless have been keen to reflect 'popular' political and theological sentiment. Impor-tantly, the Book of Revelation itself, with its accompanying illustrations was only a small part of this two-volume work.

In many ways the illustrations to the Book of Revelation are a rather straightforward rendition of the text, as one would expect from a lay devo-tional Bible intended for 'popular' use. As many textual details as possible have been represented in a literal manner. In K1c, for example, which depicts the vision of the seven candlesticks from Rev. 1: 12–20, the text has been

---

[9] Bartrum in Carey (ed.) 1999: 129.
[10] See below for further evidence of Dürer's reliance on the Koberger Bible as opposed to any other contemporary German Bibles.
[11] Bartrum in Carey (ed.) 1999: 129.
[12] Darlow and Moule (eds.) 1911: 481 ff.
[13] Price 2003: 34.    [14] Price 1994: 688.    [15] Price 2003: 37.

represented more faithfully than in the earlier manuscript models. It shows John praying at the feet (Rev. 1: 17) of a robed figure (Christ/One like the Son of Man) in the middle of seven lamp stands (Rev. 1: 12–13), who also has a sharp sword protruding from his mouth and seven stars in his hand (Rev. 1: 16).

This literalistic portrayal continues throughout the series. In K2, which depicts the four horsemen of Rev. 6: 1–8 all riding out together, the crowning of the first horseman as stressed in Rev. 6: 2 is clearly represented on the far right-hand side of the image. K4 depicts Rev. 7: 9–8: 13. It is the depiction of Rev. 8, in which the cycle of the seven trumpets is begun, on the right-hand side of the image that is particularly striking. God has been placed in the centre at the top of the image actually handing out the trumpets. On a very literal reading of the verse in question (Rev. 8: 2), it is just possible to assume that God himself was handing out the trumpets, although this detail is not usually part of the established iconographic schema. The presence of the heavenly altar in this image is also significant in that it appears in four out of the eight Koberger images (K3, K4, K5, K6), a fact that may be indicative of a desire to reflect the increasing interest in lay piety that was gathering strength at the end of the fifteenth century in Germany. The altars themselves are reminiscent of late medieval altars that contained relics.[16] Thus, alongside the ecclesiastical critique that will be shown to run through the Koberger images, there are also present respectful images of the Church's authority.

The literal rendition of the text of the Book of Revelation that we find in the Koberger images does on occasion break down, as in K5 where the angel from Rev. 10, who is described as having 'legs like pillars of fire' (Rev. 10: 1), is comically depicted with classicizing columns for legs. Such an image brings to mind the question raised in the Introduction regarding whether John's literary imagery should be pictorialized at all. This image seems to suggest an answer to this question, in that, when literalistic *depiction* of John's text is attempted, the results are often strained or comic. This suggests that John's imagery was not intended to be taken at face value or decoded via either textual *or* visual means. However, more metaphorical, less mimetic *visualizations*, as evidenced in the images by the Van Eycks, Memling, and Botticelli offer conceptualizations of the spirit and not the letter of the text. Thus it seems that the manner in which pictorialization (i.e. via depiction or visualization) is attempted is a determining factor in this debate.

Also noteworthy are the conflations that have occurred due to the Koberger artist's desire to condense the Book of Revelation into just eight images. This could not be achieved without some serious compositional and interpretative decisions having been taken. Although there are indeed only eight images inserted into the text, in actual fact up to twenty-five different individual

---

[16] See Price 2003: 59.

scenes have been depicted. This is a feature of the Koberger images that has been much neglected. The following statement is indicative of the cursory treatment that the Quentell–Koberger images have been given by art historians: 'with only a few exceptions, notably the *Four Horsemen*, each woodcut shows two or more scenes to represent a complete chapter of the Book of Revelation'.[17] In fact, in most of the images, much more than a chapter of text is depicted (in some cases five chapters are depicted, see K8, for example). In some, on the other hand, much less than a chapter is depicted (see K1).

While impressive on one level, the compression of twenty-five scenes into eight images means that there is often little or no correspondence between the different scenes in the cluttered images. This has a negative effect on the interpretative potential of these images, for the viewer far from using them as tools with which to elucidate the text of the Book of Revelation, would have had to dissect the different parts of them with painstaking reference to the text, as is also the case with Jean Duvet's Apocalypse images of 1561, for example, a series which is discussed further in Chapter 6.[18]

By condensing the images thus, the artist responsible for them has also taken some fairly drastic decisions in terms of the interpretation offered, with the result that the text is represented unevenly. An example of an 'even' representation, although even in this case omissions have been made, would be Cranach's Apocalypse illustrations, discussed below, in which roughly one image is allotted per chapter. In contrast, although Rev. 1: 12–17 has been depicted in the Koberger images (in K1c), Rev. 2, 3, 4, and 5 have not been illustrated at all. The omission of Rev. 4–5 is particularly glaring given the earlier emphasis on these chapters in both late medieval and early modern exegesis and artistic representations. Rev. 6–13 are then represented fairly faithfully before Rev. 14, 15, and 16 are omitted from the illustrative process. The omission of the sequence of seven bowls (Rev. 15–16) could be for interpretative reasons. Interpreters in the metaphorical, Tyconian tradition were inclined to view the three sequences of seven woes as recapitulations of the same events, which could thus be viewed synchronically.[19] Working consciously or unconsciously from this tradition, the artist of the Koberger illustrations perhaps therefore saw no need to illustrate the third as well, having already illustrated the first two. The last image in the Koberger series, K8, is a representation of Rev. 17–22 (Fig. 28).

---

[17] Bartrum 1999: 129.

[18] Ibid. 169. See Eisler 1979: 244–93 for a good reproduction of the Duvet series.

[19] This claim has also been forcefully contested due to the fact that there are important differences between the three cycles of seven woes. For instance, the last cycle brings total destruction whereas the first had brought destruction to a third of the earth and the second cycle to one half (see, for example, Bauckham 1993*a*: 40–2 or Rowland 1993: 81–8 for discussion of the cycles of seven).

However, even this is not the full picture. Details from the omitted chapters are frequently inserted into depictions of other sections of the text. So the initially omitted throne-room scene of Rev. 4–5 reappears in K4 transposed onto the representation of Rev. 7: 9–12 that occupies the left-hand side of the image. This visualization is in some ways a sophisticated interpretation of the text, which itself includes a recapitulation of the imagery used in Rev. 4 (see Rev. 7: 11–12). The somewhat 'liberal' attitude found within the Koberger images towards the chronology of the Book of Revelation text is sometimes echoed in the Dürer images. It is to these images and, in particular, to Dürer's obvious compositional reliance on the Koberger images that this chapter now turns.

## 5.3 DÜRER'S APOCALYPSE SERIES

### 5.3.1 Dürer's artistic development: preparing for the 'Apocalypse'

The 1490s were a time of great productivity and innovation in Dürer's life, one that found its climax in the Apocalypse Series on which he began work in 1495 or 1496. On his first journey to Italy, Dürer came across the work of Mantegna and Donatello, both of whom influenced him stylistically.[20] In 1494–5 Dürer returned to Venice for a second visit where he discovered the nude as an artistic genre (perhaps courtesy of Jacopo de' Barbari).[21] Whilst there, he made many drawings of people and things that interested him. Among them are several sketches that were subsequently incorporated into the Apocalypse Series. The first is a sketch of a Turk's Head, which appears in D1 (the martyrdom of St John), as well as in Dürer's *Martyrdom of St Catherine* (1498–9). The back of the head appears in D14 (the Whore of Babylon). Dürer uses the same style of turban in his depiction of Pilate in his *Large Passion* (c.1500), a woodcut series that was published in book form with the Book of Revelation Series and the *Life of Mary* after 1511.[22] Dürer's ink drawing entitled *An Oriental Ruler on his Throne* (1495) also bears more than a passing resemblance to the sultan in the martyrdom scene of D1. The second sketch that was obviously incorporated into the Apocalypse Series was a careful study of the front and back of a Venetian Courtesan, which Dürer reused in his visualization of the Whore of Babylon (D14).

[20] See Krüger 1996: 72–3.
[21] Panofsky 1955: 35. See also Bartrum 2002: 105–34 and Koerner 1993: 253 on Dürer's artistic development in Venice.
[22] Campbell Hutchison 2000: 36.

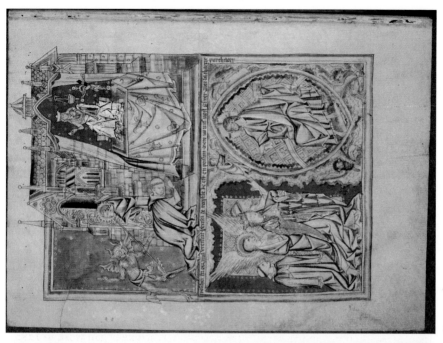

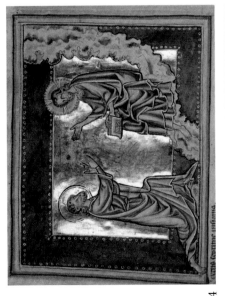

4

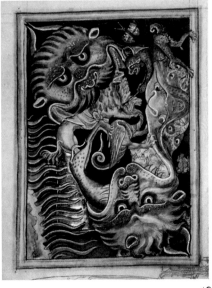

6

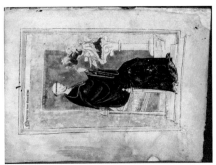

3

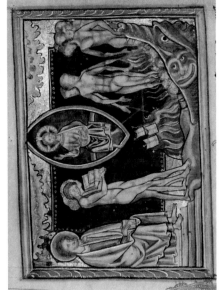

5

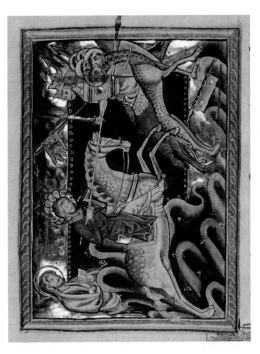

8

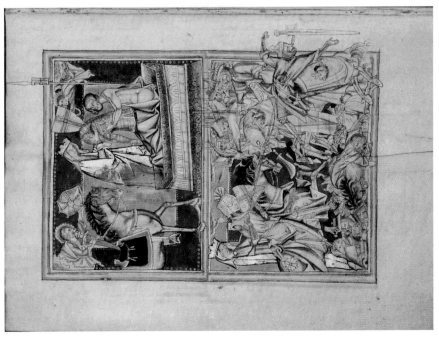

7

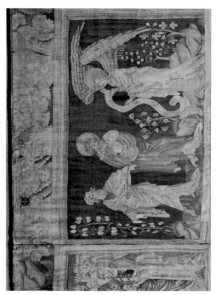

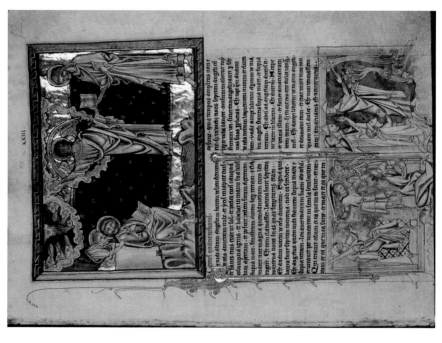

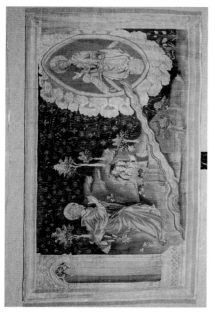

12

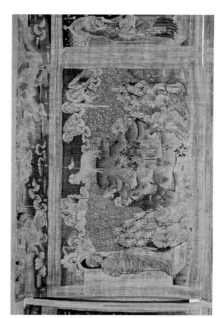

13

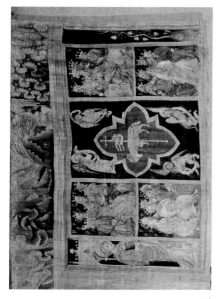

14

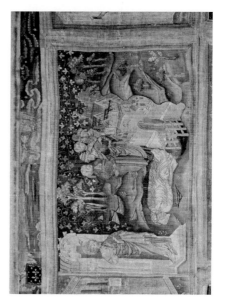

15

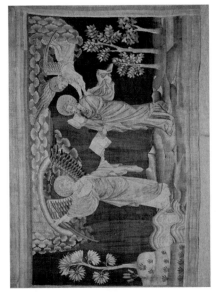

17

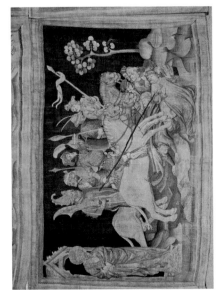

19

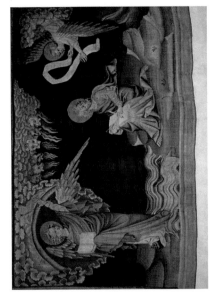

16

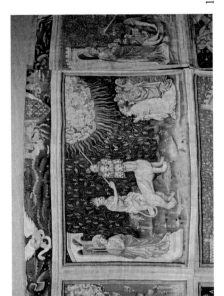

18

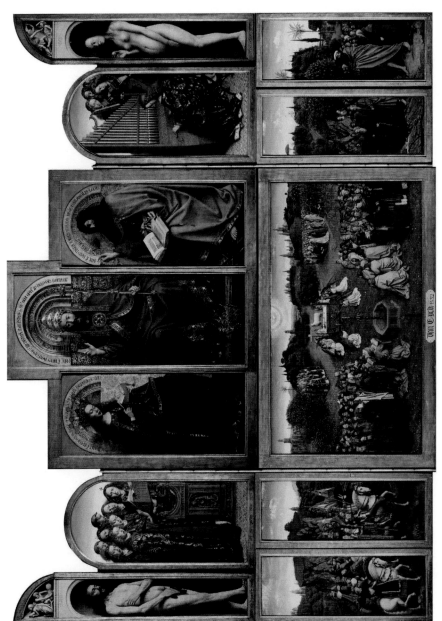

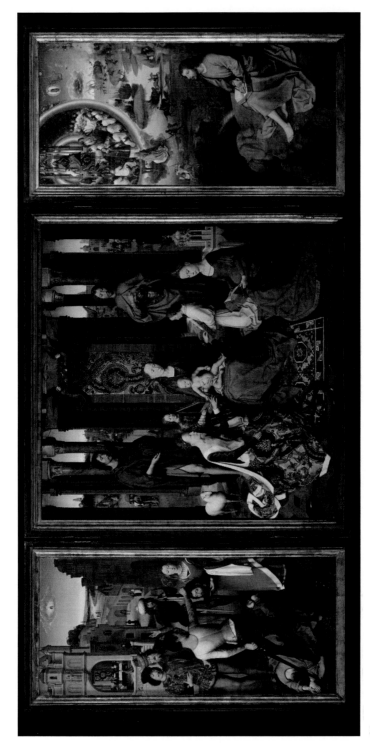

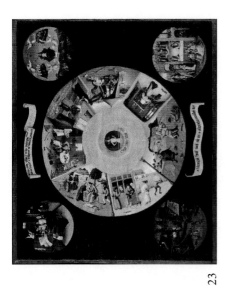

23

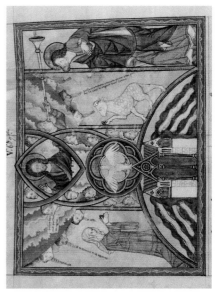

24

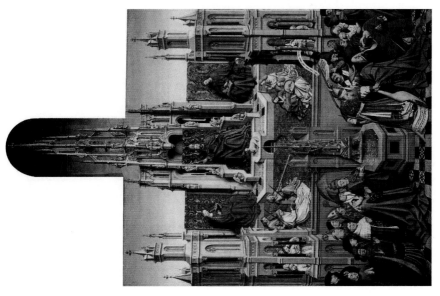

22

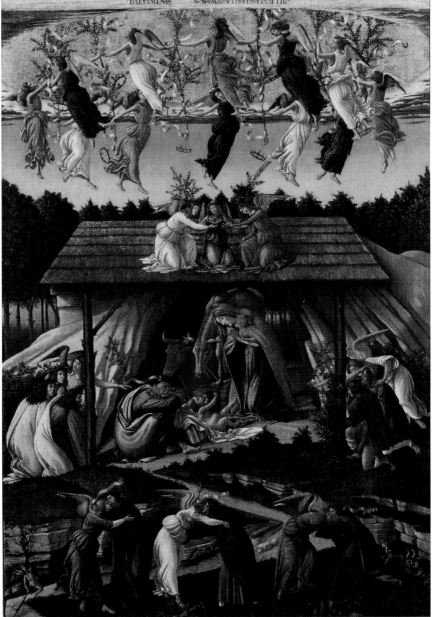

25

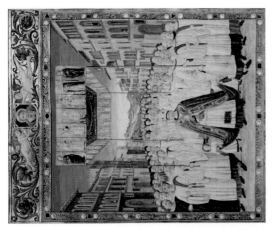

27

28

26

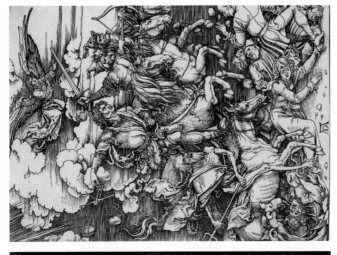

31

30

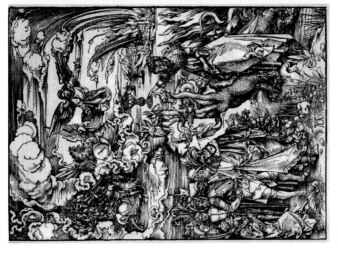

29

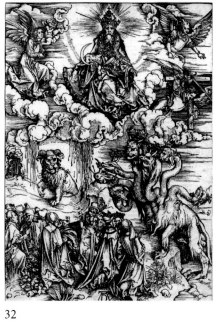

32

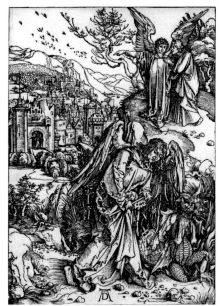

33

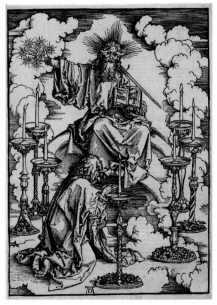

34

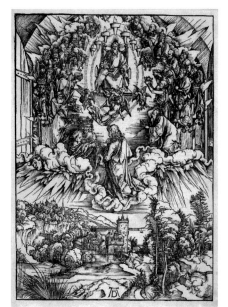

35

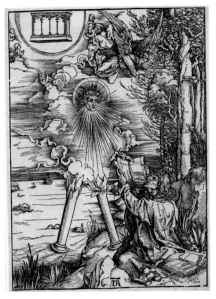

36

37

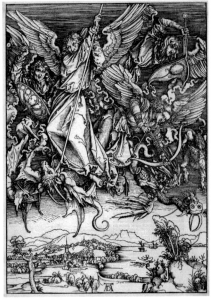

38

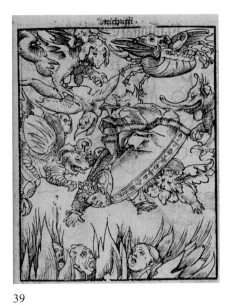

39

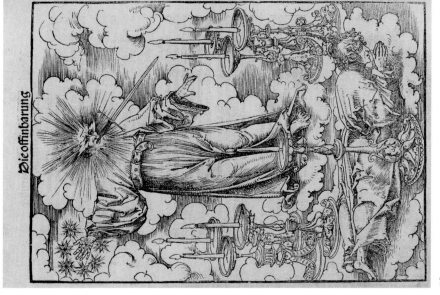

Johannis.

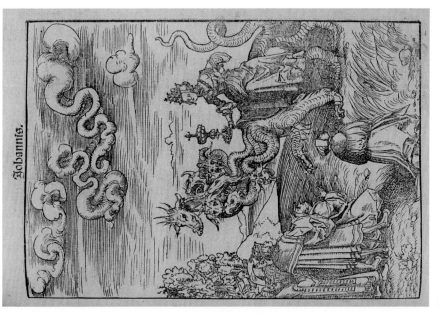

Die offinbarung

43

42

Having returned from Venice, Dürer entered one of the most productive periods of his life. Over the next five years he produced a dozen paintings (including his famous Munich self-portrait of 1500 in which he deliberately styled himself in the likeness of Christ), twenty-five engravings, seven large-sized single woodcuts, most of the *Large Passion* and the Apocalypse Series.[23] Panofsky argues that 'stylistically, these works represent a first synthesis between the Flemish and German traditions and the *maniera moderna* of the Italians and lay the foundations of the Northern Renaissance'.[24] This view is echoed by later scholars such as Koerner and Bartrum.[25]

This is also the period in which Dürer established himself primarily as an engraver and woodcut designer. The reasons behind Dürer's decision to embrace the woodcut in particular as one of his main media are worth discussion. Firstly, there were economic reasons. Woodcut prints (more so than prints from engravings) were fairly cheap to produce because they required very little outside help and not much material expense, after the initial outlay on woodblocks, paper, and ink. After setting up his Nuremberg workshop in 1495 and purchasing his printing press in 1497, Dürer was also free from the domination of both patrons and publishers. Instead of waiting for a commission, he now had the means to turn out works of his own invention, which he could then market himself.[26] For him, woodcuts (and engravings) represented both artistic autonomy and the possibility of economic prosperity, as evidenced in this quotation from one of Dürer's letters in 1509: 'assiduous, hair-splitting labour gives little in return. That's why I am going to devote myself to my engraving. And had I done so earlier, I would be today one thousand times richer.'[27] Koerner surmises that the 'hair-splitting labour' referred to by Dürer in this quotation is a reference to the large winged retable altarpieces that were among the most commonly commissioned artworks in pre-Reformation Germany. However, their production required a huge amount of work by a team of craftsmen and painters and the finished product guaranteed little exposure beyond the altarpiece's local area for the artists involved. Consequently, Dürer, one of the most famous and sought-after artists of his day, did virtually no work in this area.[28]

It also seems that by the 1490s the buying public were amenable to a certain amount of 'education' by artists. Thus, Dürer was able to make and sell prints of rarely illustrated mythological scenes such as his *Hercules and Iole* (c.1496), as well as to market his Apocalypse Series successfully, a subject that was

---

[23] See Koerner 1993: 63–186 on the 1500 Munich self-portrait.
[24] Panofsky 1955: 39.
[25] Koerner 1993: 286; Bartrum 2002: 105–6.
[26] See Koerner 1993: 207–12 on Dürer's marketing of his prints.
[27] Durer: *Schriftlicher Nachlass*, 1: 72.
[28] Koerner 1993: 206.

very rare in privately commissioned works such as altarpieces, as discussed in Chapter 3.

Dürer's command of graphic media at this time is exemplified by his distinctive 'AD' monogram, which appears in all of his prints after 1496. Referred to as his 'flag' by Panofsky, Dürer's appropriation of the German monogram tradition was significant in several ways.[29] Monograms had previously been used to link individual prints to a particular artist, shop, or publisher.[30] Dürer's use of the monogram, on all of his printed output after 1496 (and many other pieces besides) indicated not only that he was the designer of the image in question but also its publisher. Thus Dürer's monogram was the public face, as it were, of his artistic autonomy. It also became a way of identifying authentic 'Dürers', although as Pon has researched, the most sophisticated 'copyists' of Dürer's prints, such as Marcantonio Raimondi, who copied and disseminated his own version of the *Small Woodcut Passion* under Dürer's name in Venice in 1515, were able to copy the monogram convincingly as well.[31] In 1511, Dürer was able to obtain a form of copyright protection from the Emperor Maximilian for his prints, although this did not always have the desired effect, as evidenced by the Marcantonio scandal.

What is crucial in terms of this chapter is the fact that Dürer personally designed and published (albeit with the help of his godfather, Anton Koberger) his Apocalypse Series in two different versions: one in Latin and the other in German. The 'AD' monogram appears prominently on every image. Designing, printing, and distributing a series of prints signed with one's own monogram was an unprecedented move by an artist at this time. This decisive act reveals a level of personal commitment by Dürer to his visualizations of the Book of Revelation not evidenced by any of the other artists discussed in this study, apart from Botticelli. Dürer's series also clearly differs from Botticelli's in that it was immediately disseminated around a wide, paying audience, whereas any discussion of *The Mystic Nativity*'s audience remains tenuous at best. Koerner argues, in relation to Dürer's self-portraits, that his use of the 'AD' monogram 'affirms an irreducible relation between the artist and the substance of his art'.[32] I will argue below that the monogram functions in much the same way in the Apocalypse images and that, as in the Munich self-portrait, Dürer has made John (instead of Christ) in his own likeness. The effect of Dürer's interpolation of himself, via the John figure and via his strategic use of the monogram, into his Apocalypse images is somewhat

---

[29] Panofsky 1955: 46–7.
[30] See Koerner 1993: 203–7 on Dürer's use of his monogram.
[31] See Pon 2004: 39–41 on Dürer's fight against copyists.
[32] Koerner 1993: 220.

different from in the self-portraits, but the ideas behind the use of his likeness are similar.

Within the medium of woodcut, Dürer also made great advances stylistically. Previously, German woodcut artists had worked in 'descriptive' and 'optical' lines. 'Descriptive' lines were used to define the forms in the woodcut. Such lines did not contribute to the characterization of light, shade, or surface texture. 'Optical' lines (or what we might call 'hatching'), on the other hand, served mainly to suggest shade and surface texture, without contributing to the definition of form. When these two types of lines happened to coincide (in the depiction of hair or foliage, for example), the resulting lines could become rather muddled.[33] Dürer was able to overcome this problem by freeing the descriptive lines from the function of mere boundaries and by softening the optical lines. In Dürer's woodcuts, both types of lines were variable in length and width, could curve and could taper, thus expressing organic tension and relaxation. In Panofsky's words, both types of lines were subjected to the discipline of 'dynamic calligraphy'.[34]

Dürer also incorporated the 'chiaroscuro values' of the Italian Renaissance into his woodcuts. 'Chiaroscuro values' is a term used to describe an artist's use of light and dark in an image. Thus black lines and white intervals became negative and positive signs of the same entity, namely, light. Dürer tended to use these values in the following three ways. First, when a lit form had to be singled out from a blank area, he would create a boundary by placing a black line at the edge of the lighted form. Secondly, where a shaded form had to be separated from a dark environment he would replace the black contour with a white one. Thirdly, when a lit form had to stand out from a dark background, the contour was either omitted altogether, or absorbed or swallowed up by the surrounding darkness.[35]

Taking D14 (Fig. 29, The Whore of Babylon) as an example, one can clearly see Dürer's mastery of the woodcut technique at work. The Whore's sensual figure and clothes could only be achieved through use of a sophisticated mixture of curved and straight lines of varying length and width. Similarly, the 'ageing' effect that Dürer has used on the Whore's face is achieved through the positioning of tiny, curved optical lines around the eyes and mouth. Their size and subtlety allow these details to become noticeable only on closer inspection. With regard to his use of light in this image, we notice immediately that Dürer has left more blank space at the top of the picture, thus indicating the presence of light as one moves towards the heavenly realm. Meanwhile, the flames from the burning city of Babylon snake upwards towards heaven. The psychological realism of Dürer's Apocalypse Series was therefore achieved via a combination of this Italianate, naturalistic yet dramatic woodcut technique

[33] Panofsky 1955: 47–50.     [34] Ibid.     [35] Ibid. 47–50.

and Dürer's apocalyptic sensibility. This combination seemingly gave him the
confidence to represent the Book of Revelation in visual form for his own age.
It is to Dürer's apocalyptic influences, therefore, that we now turn.

### 5.3.2 Dürer's cultural context: apocalyptic speculation in the 1490s

There is little doubt among commentators that part of the success of Dürer's
series was due to the level of apocalyptic expectation among his contempor-
aries.[36] Such expectations took many forms, from simple fears about the end
of the world to the channelling of eschatological ideas into hopes for major
political and religious changes.

The millennium of Rev. 20: 1–3 had, in 'orthodox' circles, been interpreted
metaphorically since Augustine. However, Joachite exegesis of the Book of
Revelation had been used, since the twelfth century, to support hopes in a
literal millennium, as well as other, more radical, eschatological and apocalyp-
tic expectations. Several movements in the fifteenth century, such as the
Taborites in Bohemia and radical groups (often Franciscans) in Germany
and Italy, relied on eschatological ideas that can be traced back to Joachim
and Olivi.[37] However, on a more general level, in the fifteenth century, events
that were perceived as posing a threat to the status quo of western Christen-
dom or the natural order of things were often interpreted apocalyptically. It is
important to stress that apocalyptic speculation was not the preserve of radical
groups on the fringes of society, but also of educated men and women.[38] Dürer
too seems to have been profoundly affected by such speculation.

The constant (and real) threat to western Christendom from the Turks was
never far from the western European mind and was one of the main sources of
apocalyptic speculation.[39] Their almost yearly attacks were sometimes inter-
preted as a sign that God was punishing western Christendom for its im-
morality. The threat from the East is emphasized subtly but unmistakably by
Dürer in his Apocalypse Series. The decision to portray the emperor figure as a
sultan (see D1 and D14) and the Whore of Babylon as a Venetian courtesan
are but two examples of how Dürer sought to channel these contemporary
fears. Secondly, much was read into unexpected astrological signs. For in-
stance, in November 1484, Johannes Lichtenberger, the court astrologer to

---

[36] Anzelewsky 1982: 91.
[37] See Burr 1993: 118–21; Cohn 2004: 198–222; Lerner 1999: 351–4; McGinn 1987: 534;
Potesta 1999: 117–6 on 15th-century apocalyptic movements.
[38] Anzelewsky 1982: 80.
[39] See MacCulloch 2004: 53–7.

Emperor Frederick III, wrote the following after witnessing a conjunction between Jupiter and Saturn in the constellation of Scorpio: 'For when the Holy Roman Empire ceases to exist then the whole world must end too.'[40] Other natural disasters that became the subject of apocalyptic expectation included the flooding of the Tiber in December 1495 and the meteorite landing of 1492 at Ensisheim.[41] Thirdly, the spread of syphilis throughout Europe in the 1490s was interpreted apocalyptically on account of its plague-like symptoms. Dürer's woodcut of *The Syphilitic* (1496) is testament to the new-found fascination with the so-called 'French Disease'. Interestingly, Dürer clearly believed that the cause of the disease was a bad conjunction of planets (in this case, the conjunction of Saturn and Jupiter that had so alarmed Johannes Lichtenberger in 1484), as he has depicted this constellation above the man who is suffering from syphilis.[42] Finally, great importance was attached to reports of 'mutant births'. Dürer's engraving entitled *The Miraculous Pig of Landser* of 1496 was probably based on Sebastian Brant's long, moralizing poem on the subject, in which he speculated that the unfortunate pig symbolized the threat posed by the Turks and the need for the German princes to support Maximilian in order to prevent a military catastrophe.[43]

### 5.3.3 Dürer's personal and theological development, 1496–8

In light of the above, it is surely no coincidence that, by 1496, Dürer had already started work on his Apocalypse Series. *The Syphilitic*, *The Miraculous Pig of Landser*, and the Apocalypse Series itself all seem to point to the fact that apocalyptic subject-matter and its interpretation were very much on his mind. Indeed, it is Massing's belief that a sketch of a strange cosmic phenomenon on the back of a panel by Dürer depicting St Jerome in the wilderness (c.1496) is the result of an apocalyptic dream that Dürer had experienced (Fig. 30).[44] The vivid sketch of a red and yellow cosmic explosion against a night sky does not conform to a visual or literary tradition, but 'rather records a visionary experience, quickly noted down by the artist'.[45] He argues that the sketch seems to have been inspired by the image of the false prophet conjuring fire from the sky in Rev. 13: 13.[46] Bartrum also cites a similar verso painting from c.1493 on the back of the oil panel of *Christ as the Man of Sorrows*.[47] Dürer certainly went on to have well-documented 'apocalyptic dreams' later in his life, the most famous of which took place in 1525 and was so vivid that Dürer

---

[40] Quoted in Peuckert 1948: 106.     [41] See Brant 1498: no. 51.

[42] Theodoric Ulsenius had made the connection between syphilis and the planets in a broadsheet in 1496 (see Sudhoff 1912: 8–10).

[43] Brant cited in Heitz (ed.) 1915: no. 10.

[44] Massing 1986: 242–4. See also Bartrum 2002: 115–16.

[45] Massing 1986: 243.     [46] Ibid. 244.     [47] Bartrum 2002: 116.

painted a watercolour of it when he awoke.[48] The above evidence suggests that Dürer felt he was living in close proximity to his apocalyptic subject-matter and perhaps even meditating on it. It is even possible that Dürer saw himself as a latter-day John of Patmos, as will be discussed in further detail below.

Regarding Dürer's specific theological influences, we have very little information, although several suggestions have been made.[49] Both Panofsky and Campbell Hutchison, two of Dürer's most thorough biographers, cite Willibald Pirckheimer, Dürer's lifelong friend and sometime patron as a theological and general intellectual influence.[50] Campbell Hutchison also cites the humanist Konrad Keltis as an additional influence.[51] Panofsky states that Pirckheimer assisted Dürer with his study of Latin and Greek.[52] Campbell Hutchison goes somewhat further and attempts to establish a link, through Pirckheimer, from Dürer to the theology of Nicholas of Cusa (1401–64), the former Bishop of Brixen.[53] Hans Pirckheimer, Willibald's grandfather, and Thomas Pirckheimer, his great uncle, were both associates of Nicholas of Cusa. Hans went on to educate Willibald's sister, Caritas, in the theology of Nicholas of Cusa. Caritas knew Dürer personally (indeed, Dürer dedicated his *Life of the Virgin* to her) and both played an active part in Pirckheimer's group of humanist friends. Schedel, the Nuremberg humanist who printed some of Dürer's early woodcuts, owned the complete works of Cusa to which Dürer may have had access.[54]

Koerner has also written in detail on the influence of Cusa's thought (as set out in *De visione Dei sive de icon liber*, 1453, among other works) on Dürer's self-portraits in particular.[55] He argues that, even if Dürer did not know the text itself, Cusa's basic ideas regarding the purpose and implications of images of God would have been easily accessible to him. Such ideas are reflected more simply in the illustrated *Pilgrim Tract of Nicolas of Flüe* (1486–9). In short, Cusa argues in the *De visione Dei sive de icon liber* that portraits of God or Christ, which portray the Divine figure as looking straight out of the painting, thus creating an illusion of omnivoyance, are a metaphor for the relations between the individual and God. The inescapability of the gaze suggests that everything exists through the will of God. It also serves to connect our love of

---

[48] See Conway 1889: 145 for Dürer's own account of the dream in 1525.

[49] Koerner (1993: 181) also cautions against looking for specific theological sources for Dürer's works on the grounds that they cannot offer a full account of the theological nuances and contradictions being played out in the images themselves.

[50] Panofsky 1955: 46, 107–9; Campbell Hutchison 1990: 48–9.

[51] Ibid. 48–50.

[52] Panofsky 1955: 7.

[53] Juraschek (1936) argues that Dürer's Apocalypse cycle should be interpreted as an elaborate presentation of the philosophy of Cusa as set out in a sermon he (Cusa) gave on the Lord's prayer. Such a direct link has been discredited as untenable (see Bialostocki 1986: 286–9).

[54] See especially Koerner 1993: 129–30.

[55] Ibid. 127–38.

ourselves with God's love for us. The face of Christ becomes a mirror of the viewer, reflecting back the narcissistic gaze. Self-love thus becomes the starting point of devotion rather than its antithesis.[56]

Dürer's decision to depict himself as Christ in the Munich self-portrait of 1500 is therefore perhaps not as strange as it seems, when set against this Cusan analysis of omnivoyant paintings of God and Christ.[57] What is novel, according to Koerner, is the ownership of the image that Dürer claims for himself via the painted inscriptions and monograms. In doing so, he does seem to be elevating himself to the position of an *alter deus*. It is possible that this reading of Dürer's self-portraits might have some bearing on our analysis of the Apocalypse Series in which, as mentioned above and discussed in greater detail below, Dürer seems to claim St John's authority as his own, by depicting the first-century visionary after his own likeness. In these Apocalypse images, Dürer seems to be presenting himself not as an *alter deus* but as an *alter Iohannis*.

Peter Krüger has argued alternatively that Dürer was influenced by Alberti's *De Pictura*, which had existed in Nuremberg in manuscript form since 1471, as well as, more specifically, by the new Latin translation of Aristotle's *Poetics*, which had been prepared in Venice by Giorgio Valla in 1492–4.[58] Krüger highlights the emphasis on mimesis that is found in chapter 6 of the *Poetics*. Mimetic copying of actions (in tragedy and epic) have a cathartic effect, an effect deemed to be the purpose of tragedy as a genre. Krüger argues, in relation to Dürer, that his mimetic presentation of the Book of Revelation also has a cathartic effect.[59] Even more important than the production of such emotions, however, is the narrative structure of the entire series, which corresponds to Aristotle's notion of *mythos*. For Aristotle the concept of *mythos*, the key component in the genre of tragedy, represents the fusing together of events into a single coherent action. This idea, Krüger argues, is reflected in Dürer's presentation of the Book of Revelation as a cyclical, pictorial narrative ordered around a major turning point (Rev. 10). In Aristotle's terms then, the first cycle of pictures (up to the Mighty Angel of D9) can be characterized as tying together the threads of the plot. The second cycle, which follows the turning point, is the denouement and extends to the end of the cycle.[60] While both these thematic links to Aristotle's *Poetics* appear plausible, there exists no further, more concrete, evidence that Dürer knew the text. Krüger merely speculates that he may have come into contact with the Latin translation on one of his Italian journeys.

---

[56] See Hopkins 1988 tr.: 111–35.
[57] See Albrecht Dürer, *Self Portrait*, 1500, Munich: Alte Pinakothek.
[58] Krüger 1996: 101–8; Campbell Hutchison 2000: 175–6.
[59] Krüger 1996: 103.
[60] Ibid. 104–8.

### 5.3.4 Dürer's artistic influences

Both Panofsky, and later, Camille, noted that some of the compositions in Dürer's Apocalypse cycle bear more than a passing resemblance to those in the *Flemish Apocalypse* (*c.*1400).[61] In the illustration for Rev. 10, for example, the artist of the *Flemish Apocalypse* focuses on John and the angel, as Dürer does in his depiction of this scene (see D9: Fig. 36). In addition, Camille highlights the Flemish artist's use of 'Dürer-esque' lighting effects such as in the illustration to Rev. 4.[62] The text–image layout of the *Flemish Apocalypse*, whereby the Flemish text and commentary is laid out on the verso of the images, also finds an echo in Dürer's series. In both, each 'opening' of the manuscript forms a complete text–image unit, with no need for additional captions or inscriptions as in other Apocalypse illustrations of the day. This reticence to pursue a 'diagrammatic' style of illustration is compounded by the artist's decision to compress the whole set of illustrations into twenty-three miniatures, thus condensing the narrative into more complex, synchronic images. Dürer took this strategy further, managing to condense the textual narrative into just fifteen images. Whether Dürer ever saw the *Flemish Apocalypse* is not attested to in any of the extant writings on the subject. Bartrum nevertheless argues that it seems likely, based on the style of his work in this period, that Dürer travelled to the Netherlands sometime between 1490 and 1494, where he could have seen the manuscript or a copy of it.[63]

With regard to Dürer's other artistic source, the Koberger Bible, we can be more precise. It seems certain that Dürer knew the Koberger Bible of 1483 and not the earlier Quentell edition of 1478/9 that contained the same woodcuts, because the earlier Bible contains nine, rather than eight woodcuts.[64] The ninth woodcut, which is the fourth in the series, was not reused in the Koberger set. This woodcut depicts a very small section of the text (Rev. 9: 1–11) and was perhaps omitted in the Koberger version because woodcuts were comparatively expensive to reproduce vis-à-vis text and it does not cover a large section of the narrative, as is the case with the eight other images. Tellingly, Dürer does not base any of his designs on this missing woodcut and one may thus conclude that he probably only knew the Koberger version.[65]

While Dürer's Apocalypse is undoubtedly an aesthetic masterpiece and includes many of his own interpretative ideas (such as the addition of the angel actually painting the sign of the cross onto the foreheads of the martyrs

---

[61] See Ch. 3, Sect. 3.8. The *Flemish Apocalypse*, Bibliothèque Nationale, Paris, BN Néerl. 3. See also Van der Meer (1978: 203–36) for a full set of reproductions.

[62] Camille 1992: 285.

[63] Bartrum 2002: 93.

[64] See Krüger 1996: 68–71 for an earlier analysis of this relationship.

[65] Price 1994: 691 n. 20.

in D6, or the Bishop receiving the blood of the Lamb in D13), it is quite surprising how many of his compositional and thus to an extent his initial interpretative ideas came from the Koberger illustrations. Indeed, fourteen of Dürer's fifteen images have clear precedents in the Koberger images, *pace* Price, who maintains that only thirteen of them have precedents in the Koberger series. D3 (the heavenly throne-room, Fig. 35) and D13 (the adoration of the Lamb), he argues, were Dürer's own inventions.[66] However, as discussed above, iconographic elements from Rev. 4 and 5 (the throne-room scene) have been interpolated into Koberger's depiction of Rev. 7: 9–12 (K4). Thus even D2 has some precedent in the Koberger version. D13 has no precedent and does indeed seem to be Dürer's own invention. Interestingly, Panofsky criticizes this image as the weakest in the series and surmises that Dürer must have designed this image first.[67]

Dürer's seminal depiction of the four horsemen all riding out together (D4, Fig. 31), a subject that was usually divided up into four separate images, is, in compositional terms only, almost an exact copy of the Koberger version (K2). From right to left one sees in both versions the rider with the bow and crown, the rider with the sword, the rider with the balance, and the rider of Death. In the bottom left-hand corner, both artists have represented Hades (Rev. 6: 8) as a hell-mouth devouring human victims, including royal and ecclesiastical figures, an important addition to the established manuscript iconography. Strikingly, both versions give a central role to a female victim. The sense of psychological realism and urgency that pervades the Dürer version lies behind the fact that, despite the shared subject-matter and even many of the details, the two versions do not appear to be very similar at all on the first viewing.

The desire to create a more coherent and immediately striking version of the four horsemen scene may lie behind Dürer's paring down of the Koberger material. Dürer omits, for instance, the crowning angel referred to above, a detail that would have interfered with the impression that the four horsemen were galloping at full speed. Dürer replaces the scythe being brandished by the deathly fourth rider with a pitchfork, perhaps suggesting that the Koberger artist was more concerned with traditional Judgement motifs than was Dürer.[68] The Koberger and Dürer four horsemen thus both visualize a recapitulative reading of Rev. 6: 1–8. Visualizing the horsemen and their horses together, in a synchronized movement, implies that there is a recapitulative element to the woes brought by the horsemen themselves.

---

[66] Price 2003: 38 n. 16.

[67] Panofsky 1955: 58.

[68] Interestingly Baldung retains the pitchfork motif in his *Death Overtaking a Knight* (1510–11) in which Death is represented as the Fourth Rider from Dürer's Apocalypse Series (D4). See Koerner 1993: 284–8.

Similarly, Dürer's interpretation of Rev. 17–19 (D14, Fig 29) has been praised for the way in which he combines 'several incidents of the story into one pictorial representation', thus better representing the visionary character of the text than a blow-by-blow pictorial accompaniment would have.[69] Once again, many of Dürer's compositional and interpretative ideas in both D14 and D15 can be traced back to the last Koberger image, K8 (Fig. 28), which depicts five chapters of text as well as some interpolations from Rev. 14. These similarities have been given only a cursory treatment by previous scholars. Panofsky is typical in stating that: 'The general composition of the main group, the posture of the Whore, and the presence of an angel were suggested by Quentell–Koberger.'[70] K8 is not a straightforwardly synchronic visualization of the text because this would not be an appropriate reading of these chapters; Babylon's seduction of the kings of the earth has to precede her destruction, just as the binding of Satan has to precede the establishment of the New Jerusalem. What we see in this image is thus slightly different from the synchronization of the four horsemen in K2. If the image is divided down the middle, we notice the following: in each half, the earlier event is depicted as taking place in the foreground, while the later event is depicted in the background. On the left-hand side in the foreground, the Whore of Babylon first enchants and deceives the kings and assorted other people. Her subsequent destruction (Rev. 18) is represented by the destruction of the city of Babylon behind her. Similarly, on the right-hand side, Satan is bound and cast into the pit in the foreground (Rev. 20) while the New Jerusalem hovers in the top right-hand corner as if not quite established yet (Rev. 21–2). Interestingly, the small size of the New Jerusalem suggests that the future is, at this stage, being left open-ended, in much the same way as it is in Dürer's final image.

Even if the Koberger artist produced this extremely compressed representation of Rev. 17–22 as a result of economic considerations, the interpretation that is suggested by it is strangely compelling, a fact that Dürer must also have noticed. In Dürer's image (D14), the Whore enters the picture from the right (the East), where a crowd of onlookers have gathered to look at her. Babylon burns in the background and the angel with the millstone is poised above, ready to cast the stone down in judgement. In the top left-hand corner, the rider on the white horse descends from the clouds (Rev. 19: 11–16), a detail that the Koberger artist chose to omit. D15 (Fig. 33) is reminiscent of the right-hand side of the Koberger image. Satan is bound in the foreground by a winged angel with a huge key, as was traditional in medieval representations of the Book of Revelation.[71] In the Dürer schema, salvation is portrayed as

---

[69] See for example, Dvorak 1984: 59.
[70] Panofsky 1955: 54.
[71] See Lambeth fo. 35, for example.

flowing from the top to the bottom of the images rather than from left to right as in the Koberger series.

An emphasis on worldly corruption, and in particular, political and ecclesiastical corruption is also found in both sets of images. It is important to note Dürer's dependence on the Koberger illustrations in this respect, because the fact that Dürer highlights political and ecclesiastical corruption in his series is often used as evidence that he was a proto-reformer.[72] If he was merely copying such features from this well-known set of illustrations, however, then such arguments are considerably weakened. Indeed, Price has argued that the Koberger series places *more* stress on the corruption and overthrow of worldly power than the Dürer series.[73] A few examples will suffice to support this contention. In K2, K3, and K5, the destruction of members of the political and ecclesiastical hierarchy is clearly depicted. K2, for example, depicts the four horsemen and their victims who are being eaten by the monstrous head in the bottom left-hand corner. Among the victims are a king (complete with crown and sceptre) and a bishop (identifiable by his mitre). Two other images from the Koberger series portray kings and noblemen (although, significantly, not clergymen) as prominent supporters of the consortium of Beasts. In K7, all the worshippers of the seven-headed Beast have crowns, while in K8, there are clearly kings amongst those who worship the Whore of Babylon. Finally, the Dragon in K6 and the Beast in K7 are depicted as wearing crowns, which, although a traditional iconographic feature, serves, in this context, as a particularly emphatic image of worldly corruption, as does the fact that in K7 one of the heads is of a human king. In his depiction of the Beast of Rev. 13 (D12, Fig. 32) Dürer deletes the human head and replaces it with another monstrous head, which may imply that he was seeking to 'down-play' the connection between corrupt contemporary kings and the Beasts of the Book of Revelation.

A third area of comparison between the Koberger illustrations and the Dürer series relates to the depiction of the figure of John. As discussed at length in relation to *Lambeth* and *Angers*, the way in which and the frequency with which John is depicted can convey a considerable amount about how the particular artist(s) in question understood the apocalyptic visionary experience. While John is almost always present in earlier illustrations of the Book of Revelation, such as *Lambeth* and *Angers*, in the Dürer series he is only present when he plays an active role in the drama. As Panofsky notes: 'He appears not as a mere "seer" but as one who directly participates in the action.'[74]

In the Dürer cycle John appears in six of the fifteen images (D1, D2, D3, D8, D9, and D15) and in the Koberger illustrations John appears in three of the eight images (K1, K6, K8). Panofsky argues that the reason why Dürer could

---

[72] See for example Chadabra 1964.
[73] Price 1994: 691.
[74] Panofsky 1955: 53.

omit the figure of John while the earlier medieval illustrators could not was in part due to their use of a non-naturalistic style of illustration. This meant that the presence of the visionary was needed to signify that the image did, in fact, depict a vision rather than a miracle or some other event.[75] This explanation is not entirely satisfactory, not least because it does not explain why the Koberger artist, whose style is distinctly 'non-naturalistic', could afford to omit John from the majority of his illustrations. As discussed in Chapter 2, Camille suggests that the reason that John was included in nearly every illustration in the medieval period was because contemporary devotees believed that visionary perception issued from the mind of the visionary. Thus, the important point about John for the medieval viewer was not that he had written the visions down but that he had *experienced* them. By leaving John out of all but the most necessary images, according to Camille, Dürer was perhaps locating his own representations rather than John's experiences at the site of revelation.[76]

While Dürer's dependence on the Koberger images is sometimes hinted at by art historians, the full extent of the relationship between the two Apocalypse Series has not been fully explored. Thus the above survey constitutes an attempt both to uncover the interpretative nuances of the Koberger Apocalypse illustrations *in their own right* and to highlight the key areas in which Dürer is indebted to those illustrations. Despite the differences in details and, of course, the incomparable differences in style, Dürer's dependence on the Koberger illustrations is more than evident. In borrowing the compositions of the Koberger images, Dürer also inherited some of their exegetical emphases, particularly, it seems, a certain ambivalence towards the New Jerusalem, as well as towards the ecclesiastical and secular hierarchies, and an emphasis on synchronicity and a 'pared-down' approach to the figure of John. The brilliance of Dürer's series lies, then, in the way that he breathed new life into this quasi-synchronic way of interpreting the Book of Revelation with his vivid and naturalistic woodcut style. It is for these reasons that Klein wrote that 'Dürer's woodcut Apocalypse represents the exact borderline between medieval and modern illustrations of the Book of Revelation.'[77]

### 5.3.5 The layout of Dürer's Apocalypse Series

#### (a) Setting the text

In 1498 Dürer began selling his Apocalypse Series under the title of *Die heimliche Offenbarung Johannis* in German and *Apocalypsis Cum Figuris* in Latin. The series consisted of fifteen upright (as opposed to the small transverse format of the earlier Bible illustrations) images (39.4 cm × 28.3 cm) of the

---

[75] Panofsky 1955: 58     [76] Camille 1992: 287–8.     [77] Klein 1992: 199.

Book of Revelation, with the text arranged in two columns (as in the Koberger Bible) on the verso of the images. According to Parshall and Price, Dürer borrowed the German translation and typeface of the Book of Revelation that had been used in the Koberger Bible from Koberger himself. Price argues that the 'type proves that Koberger's establishment did the presswork in 1498', despite the fact that Koberger is not credited anywhere.[78] The German edition ends with the following statement:

> Here ends the book of the hidden revelation of St John, the disciple and evangelist. Printed in Nuremberg by Albrecht Dürer, painter, in the 1498th year after the birth of Christ.[79]

The fact that Koberger is not credited is not altogether surprising, given the freer attitude towards artistic 'copyright' that existed during this period, but which Dürer himself was to challenge.[80] However, while Parshall and Price may well be right in their assertions, the evidence that they cite is inconclusive. Price argues that the page designs for Dürer's work match the Koberger typographic format in earlier Bibles and that the use of full-page illustrations recalls another Koberger imprint, the *Schatzbehalter* (1491), the woodcuts for which were designed in the workshop where Dürer had completed his apprenticeship. While the format itself does look very similar, a comparison of sample passages from the two texts reveals that, although it is basically the same, there have been abbreviations and spelling and grammatical changes implemented in the Dürer version, changes that would surely have required a resetting of the text.[81]

For the Latin version, Dürer reprints the text of Jerome's Vulgate with Jerome's introduction. As indicated above, the Latin version was significant in that 'it represents the earliest extension of the illustrated format of vernacular Bibles to the printed Vulgate'.[82] The pages of Dürer's Apocalypse would have been loosely bound, but would not have been sold with a leather cover or any such protective element: that would have been up to the buyer.[83] In addition to the two Apocalypse Series that Dürer produced with text, he also produced a sizeable number of loose impressions of the Apocalypse Series to be sold without text.[84] These loose-leaf impressions represented (albeit unwittingly perhaps) the first purely visual Apocalypse Book.

---

[78] Price 2003: 36–7.
[79] Dürer, *Die heimliche Offenbarung Iohannis* (1498), fo. 15$^v$ (London, British Museum, 1895.1.22.554).
[80] See above, as well as Pon 2004: 39–41 and Koerner 1993: 208–23.
[81] Price 2003: 36–8.
[82] Ibid. 34.
[83] Personal communication from G. Bartrum, curator of Renaissance prints at the British Museum.
[84] Bartrum 2002: 124.

The issue of the arrangement of the text in both series is a vexed one. Panofsky (and all those who have followed him on the matter, including Camille) claims that Dürer allows the text of the Book of Revelation to run without interruption so that the back of the last illustration (D15: The chaining of the devil and the unveiling of the New Jerusalem, fo. 33) is blank.[85] This assertion (that the text runs without interruption) has quite profound consequences on Panofsky's interpretation of Dürer's Apocalypse:

> He [Dürer] did not want the reader to compare an individual picture with an individual passage of writing, but rather to absorb the whole text and the whole sequence of pictures as two self-contained and continuous versions of the same narrative.[86]

Price, on the other hand, argues, *pace* Panofsky, that Dürer actually arranged the text of the Book of Revelation quite carefully so as to correspond to the illustrations and that he even added in his own textual markers.[87] Krüger also comments on the fact that Panofsky was wrong to state that the text is allowed to run without interruption, emphasizing the fact that Dürer was interested in the contrast that could be attained between text and image through setting them out opposite each other.[88]

The research conducted for this book has been based on close analysis of two versions of Dürer's Apocalypse in the British Museum: the German version of 1498 and the Latin version of 1511, which also includes the *Life of the Virgin* and *The Large Passion*.[89] From this detailed study of both versions, it is clear that both Panofsky and Price are mistaken, though Price less so. The text has not been allowed to run without interruption. If this were the case, it would have run out long before the penultimate image. However, neither is there evidence that it has been carefully arranged. If the arrangement had been done carefully, then there would be far greater synthesis between the text and the images. But, *pace* Panofsky, the evidence does seem to suggest that Dürer was most concerned to link particular images to particular sections of text. Price is entirely correct to assert that Dürer has inserted formulaic textual markers at the beginning and end of each chapter of the Book of Revelation text. These markers take two forms. The first specifies the image that the chapter corresponds to and takes the form of *Item zu der...figur* in the German and *Item ad...figuram* in the Latin. In this schema, D1 (the martyrdom of St John) is not numbered as one of the 'figures'. The first 'figure' is therefore D2 (Fig. 34), 'the vision of the seven candlesticks'. So, to cite an example of how the introductory formulae work, in the Latin version before

---

[85] Panofsky 1955: 52.          [86] Ibid.
[87] See Price 1994: 689 n. 6 and 2003: 38.
[88] Krüger 1996: 42–8.
[89] *Die heimliche Offenbarung Johannis*, 1498, London, British Museum 1895, 0122. 575ff.; *Apocalypsis Cum Figuris*, 1511, London, British Museum 1895, 0122. 580 ff.

Rev. 4, *Item ad secundum figuram* is written to indicate to the reader that Rev. 4 corresponds to the second image.

The second type of marker alerts the reader to the actual image that is facing a particular chapter and takes the form of *Nachuolget die . . . figur* in the German and *Sequitur . . . figuram* in the Latin version. Thus after the text of Rev. 5, the following text-marker has been inserted: *Sequitur tertia figura*. This signals to the reader/beholder that it is the image of the four horsemen that faces these two columns of text and not the throne-room scene that they are describing. Rev. 4 and 5 are depicted in D3 (Fig. 35), which actually appears before the text of these chapters opposite the text of Rev. 3.

If we take the text of Rev. 17 as an example, we note the following idiosyncrasies. In the German version of 1498, at the top of the left-hand column of text before the chapter heading, the marker reads: *Item zu der zehenden figur*. This tells us (incorrectly) that Rev. 17 corresponds to the tenth image. At the bottom of the left-hand column of text at the end of the chapter, the marker reads: *Nachuolget die Newnt figur*. The *newnt* [ninth] *figur* is the Woman Clothed with the Sun, the image which the text of Rev. 17 faces. The second text column has been left blank. This marker is interesting in its own right for, although it reads *Item zu der zehenden figur*, this is wrong, since this would mean that the text of Rev. 17 corresponds to the image of Michael fighting the Dragon (the tenth image by Dürer's reckoning), when actually it corresponds to the thirteenth image (the Whore of Babylon). This raises the question of whether the 'text-blocks' were prepared before Dürer had finished his image blocks and not satisfactorily updated at the end of the project, or by someone other than and less meticulous than Dürer himself. In other words, was the image of the Whore of Babylon perhaps originally intended to be the tenth image and not the thirteenth? The possible order in which the images were produced will be returned to below.

In the Latin version, the text has been arranged slightly differently and the text of Rev. 17 faces the image of Michael fighting the Dragon. Thus in this version, the first marker correctly reads: *Item ad tredecimam figuram*, but the second marker reads: *Sequitur decima figura*. Again the second text column has been left blank. The image that corresponds to the text of Rev. 17, 18, and 19, the Whore of Babylon image or D14, faces the text of Rev. 21 in the German version and the text of Rev. 20 and 21 in the Latin version.

It may be concluded from the preceding discussion that Dürer (or perhaps one of Dürer's assistants on the textual side of the operation) wanted the reader to understand on some level how his images related to the text of the Book of Revelation. But there is no doubt that the images were the most important aspect of the whole production. One only has to examine the respective qualities of the text woodcuts and the image woodcuts to discern this: the quality of the woodcut lettering is vastly inferior to the quality of the woodcut lines and design. However, neither should the images be viewed as a

self-contained package distinct from the text, as this was clearly not Dürer's original aim, with regard to the bound versions at least. Whoever was responsible for inserting the textual markers discussed above (and surely Dürer must have overseen this at least to some degree) wanted the correspondence between the text and the images to be highlighted. If Panofsky had not skewed critical opinion in favour of Dürer having had an altogether more intellectual approach to the text and the images in mind, this would surely have been the common-sense scholarly view on the subject. The textual markers act as a necessary guide to the reader for, in some places, the text gets 'ahead' of the images, while on two occasions the images actually get 'ahead' of the text. For readers used to the Koberger Bible, for instance, where the illustrations were placed helpfully in the middle of the relevant section of text, this new format would have needed some explanation. Krüger seems correct in arguing that it was Dürer's original intention that the revelatory text should appear alongside its visualization.[90] However, as they actually have been laid out, it is very difficult to hold the textual and pictorial versions of the Book of Revelation in mind. Dürer's images soon took on a life of their own in both a practical and an interpretative sense. They began to be sold without the text, and, through this, their autonomy as an independent visualization of the Book of Revelation was recognized.

## (b) The order of the images

While it is fair to say that Dürer probably produced his Book of Revelation images separately and at different times from the text blocks, there is plenty of evidence to suggest that he produced the images themselves over a period of two years, namely 1496–8. There is a general consensus among Dürer scholars, firstly, that the images were not produced in the order in which they now appear and, secondly, that the date of the individual images can be deduced through stylistic analysis.[91] However, objections can be raised against the merits of a purely stylistic analysis. For instance, can it really be successfully argued that Dürer's style changed so much over a two-year period? And can the differences in style and compositional technique not be accounted for in other ways, such as whether Dürer was using different stylistic effects in order to capture particular nuances in the narrative? Thus images where many characters are involved and in which Dürer was attempting to cover a narrative full of separate events may look much more 'crowded' than images (such as that pertaining to Rev. 10) which focus on only one or two characters involved in more simple narrative developments. One should be mindful of such a possibility. Therefore, the four stylistic groups revealed by analysis of

[90] Krüger 1996: 42–8.
[91] See Panofsky 1955: 58–9; Anzelewsky 1982: 80 ff.

the series may either indicate Dürer's development as an artist or may alternatively reveal an attempt on Dürer's part to deal with the uneven nature of the textual narrative through a particular stylistic strategy.

According to the temporal hypothesis, the 'earliest' images tend to consist of crowded scenes made up of many small figures. Dürer's woodcut style is also less developed in the earlier examples. Panofsky argues that D7 (the seven trumpets) marks the 'very beginning of the whole enterprise', due to its overcrowded composition, as well as the fact that Dürer has added some text pouring out of the eagle's mouth. This textual addition (from Rev. 8: 13) marks a return to the block-book-style Bibles that often resorted to captions and text markers within the images in order to explain the (often inadequate) images themselves. D3 (the heavenly throne-room, Fig. 35) and D13 (the worship of the Lamb) also belong in this earlier category. As well as criticizing the composition of these woodcuts, Panofsky also refers to the 'fuzzy coat' of the Lamb in D13 and the 'fluffy wings' of the Eagle and the angels in D7. These details are all indicators, according to Panofsky, that Dürer was much less experienced when he designed these images. He also adds that they all show traces of the early German Wolgemut tradition, as opposed to the influence of the Italian Renaissance that one finds in the later woodcuts.[92]

The 'later' images, in contrast, depict only a few large figures engaged in simple actions. A possible parallel can be found in Michelangelo's stylistic development whilst painting the Sistine ceiling.[93] He too 'progressed' from initially more crowded scenes to grander ones with fewer and larger figures. Panofsky argues that there are three late woodcuts in the series: D9 (John devouring the Scroll, Fig. 36), D1 (the martyrdom of John), and D2 (the vision of the seven candlesticks, Fig. 34), on account of their 'grandeur of scale, concentration on essentials and graphic economy'. He also comments upon the fact that in these images, it appears that John has been transformed from a shy youth into a passionate visionary. Panofsky excludes the last image in the series, D15, the binding of Satan; and the New Jerusalem, from this group due to the fact that John still looks like a 'diffident boy'.[94] However, I would argue that D15 (Fig. 33) should definitely be included in this last group and that D1, the martyrdom scene, belongs in the 'earlier' group. Far from looking like a diffident boy in the last image, John is depicted by Dürer in the pose of a weary old man with lines around his eyes and across his brow. His hands, clasped firmly in prayer, point symbolically towards the New Jerusalem, whereas in earlier images, John is depicted with his hands held wide in a questioning pose. In addition to this, the composition as a whole is uncluttered, depicting only four fairly large and instantly identifiable figures (John, Satan, and the two

---

[92] See Panofsky 1955: 58.
[93] Wilde 1978: 66–74.
[94] Panofsky 1955: 59.

angels). D1, on the other hand, would seem to belong to a different stage in the creation of the series. The composition is crowded and somewhat unbalanced: the foreground of the image is uncluttered and there are some areas of unfilled space, while the top half of the image is almost entirely filled with figures and shading. In addition to this, and perhaps more persuasively, many of the figures in this scene also appear in D14, the Whore of Babylon, which is generally assumed to belong to the second group of images (chronologically speaking), along with D8 (the avenging angels), D10 (the Woman Clothed with the Sun), D11 (St Michael fighting the Dragon, Fig. 38), and D12 (the Two Beasts, Fig. 32).[95] The third group (again, chronologically speaking and based solely on stylistic analysis) probably consists of D4 (the four horsemen, Fig. 31), D5 (the fifth and sixth seals), and D6 (the four angels holding the winds). Table 2 in Appendix 2 sets out the four possible stages in the production of Dürer's Apocalypse images.

As the above stylistic analysis shows, there are clear compositional differences across Dürer's fifteen woodcuts. However, it is interesting to note that all the images in Panofsky's 'group four', the latest group in his opinion, are centred around compositions in which John plays a key role. As Panofsky rightly points out, these images are all uncluttered, having been pared down to their essential elements. This is especially noteworthy if D15 (Fig. 33) is added to this group, as was suggested above. Perhaps then, there were certain places in the textual narrative, always involving the John figure, with whom Dürer seems to have identified, where Dürer wished to 'slow down' the narrative through the use of such pared-down compositions. This allowed the viewer to pause over more reflective images, such as D9 (John devours the Scroll, Fig. 36), which themselves represent pictorializations of more reflective elements of the Book of Revelation text. The narrative was then resumed at its former, breathless pace in more cluttered images, such as D13 and D7. It therefore seems probable that the contrasting compositional arrangements found in Dürer's Apocalypse Series may partly be due to reasons of stylistic development but may also be due to artistic decisions taken on Dürer's part as a result of his understanding of the narrative of the Book of Revelation.

### 5.3.6 Dürer as interpreter of the Book of Revelation

Dürer's possible theological influences were discussed above. However, it is only by engaging with the images themselves that his theological nuances and sensitivities can truly be uncovered. This 'theological sensitivity' that Dürer appeared to possess found its expression in his naturalistic woodcut style.

---

[95] Panofsky 1955: 59.

Panofsky wrote of Dürer's Apocalypse; that it was successful due to the fact that Dürer 'was an accomplished master of naturalism, for only when we behold a world evidently controlled by what is known as the laws of nature can we become aware of that temporary suspension of these laws which is the essence of a miracle'.[96] It is Dürer's naturalistic style therefore that renders his Apocalypse Series both believable and effective. Dürer's figures, both human and Divine, are fully drawn and psychologically convincing human beings. Thus one is moved by the absolute fear and despair of the old man with his head in his hands, or the horrified woman with the child in the D5 as the great earthquake of Rev. 6: 12 reverberates around them. The expressive qualities of Dürer's figures are all the more impressive when compared with the Koberger artist's, and even Cranach's, comparatively inferior human representations.

While Cranach produces an illustration for each chapter in the name of literalism and clarity, Dürer condenses the twenty-two chapters into fifteen illustrations. Interestingly, this compressed style, first devised by the Koberger artist, is more successful at capturing the breathless pace and synchronicity of the events described in the Book of Revelation. Dürer also uses his own context, as a late fifteenth-century German, as the setting for many of the scenes that take place within the earthly realm. By setting the earthly scenes within his own cultural and spatial context, Dürer presents the Johannine vision in a revised but nevertheless full religious and human framework.

One of the key features of Dürer's visualization of the Book of Revelation is his handling of the compositional space. In seven of Dürer's fifteen images, he has divided the composition into a heavenly and an earthly realm, enabling him to create what we might call a 'two-world' schema. In each of these images (D3 (Fig. 35), D5, D8, D11 (Fig. 38), D12 (Fig. 32), D13, and D14 (Fig. 29) there is a complete visual dichotomy between the two worlds, which in turn suggests the gulf that exists between the perfect heavenly realm and the flawed earthly realm.[97]

This dichotomy is exactly what the reader is being presented with in the text of the Book of Revelation itself. In Rev. 1 John has a vision of Christ (Rev. 1: 17–18). This vision is followed by the letters to the seven churches of Asia, which expose an earthly reality in which there exists hatred (Rev. 2: 6), in which Satan dwells (Rev. 2: 13), where there is immorality (Rev. 2: 21), and where 'lukewarm' attitudes prevail (Rev. 3: 16). The shortcomings of the earthly realm are once again contrasted with the heavenly realm in the throne-room scene of Rev. 4 and 5 where God and the Lamb are the subjects of continuous worship. Rev. 6–19 can then be seen as a cleansing of the earthly reality of the problems that plague it through both reward and grave punishments.

---

[96] Panofsky 1955: 56.
[97] See Rowland 1982: 78–94 on how this dualistic view of heaven and earth was a common feature of apocalyptic literature by the 1st cent. CE.

A resolution between the two realities is finally achieved in the visions of the New Jerusalem in Rev. 20–2 where a 'new heaven and a new earth' replace the old versions.

The 'two-world schema' employed by Dürer in his images thus allows him to play with the contrasts between the heavenly and the earthly realm inherent in the Book of Revelation. This type of visualization had, of course, been foreshadowed in the Anglo-Norman Apocalypse manuscripts and their German descendants, as well as by *Angers*, where heaven was demarcated from earth by stylized clouds. However, Dürer's consistent use of his 'two-world' compositional device, as well as his naturalistic style, represents a new way of visualizing the two-tiered world-view of the Book of Revelation.[98] The battle between the two systems is represented throughout Dürer's series through the visual dichotomy that he creates between the two worlds, a resolution between the two finally being achieved in the last image, D15.

The most famous example of Dürer's 'two-tiered' compositions is D3, the throne-room scene (Rev. 4–5, Fig. 35). The established way of depicting this scene was to depict God and the Lamb in a central mandorla, around which the figures of the Twenty-Four Elders were arranged.[99] John traditionally stood outside the scene peering in. While the *Flemish Apocalypse* includes John in its depiction of this scene and thus foreshadows the Dürer version, heaven and earth are not strictly demarcated.[100] In Dürer's image, (D3), John is depicted as kneeling within the throne-room, whose inhabitants are engaged in the continuous worship of God and Christ. Although the scene is ordered, Dürer has also made it dramatic through the use of dense hatching on the figures of the Twenty-Four Elders and the four living creatures (Rev. 4: 6) in order to give them all different expressions and gestures, and by suspending the throne-room itself on fiery clouds. A considerable amount of blank space has been left below the throne-room, both above the scene of the countryside surrounding Nuremberg (the ordinary world, as it were) and inside the scene itself, a device used by woodcut artists to create an impression of light. The depiction of the ordinary world appears serene by comparison. However, the suggestion is that the ordinary world is oblivious to the way things should be, to the way they are in heaven.

Dürer's throne-room scene also establishes God's sovereignty and the fact that it is already fully acknowledged in heaven. The way in which Dürer has constructed the throne-room brings to mind a courtroom in which God acts as the judge (cf. Rev. 20). This may evoke the 'judicial contest' which Bauckham argues runs throughout the Book of Revelation.[101] This sense of God's

---

[98] See Rowland 1982: 78–92 on the 'two-tiered' world-view of apocalyptic literature.
[99] See Metz MS Salis 38, fo. 4$^r$, for example.
[100] See *Flemish Apocalypse* Paris: Bibliothèque Nationale, BN Néerl. 3, scene 4.
[101] Bauckham 1993a: 73.

universal sovereignty over the world, inherent in the Book of Revelation itself as well as in Dürer's images, was not captured by earlier representations of the throne-room scene, which tended to depict the heavenly realm in isolation from the earthly one. John, having been taken up to see this sphere of ultimate reality, is the link between heaven and earth. By including John within the throne-room composition, Dürer emphasizes his privileged position as the seer, a position that is emphasized throughout the text itself, which often reuses and extends motifs from earlier visions of the throne-room, such as Ezekiel 1 and Daniel 7. John's role as both seer and prophet is emphasized and reiterated in Rev. 1 (the Christophany), Rev. 10 (the devouring of the scroll), and Rev. 21–2 when John is not only shown the secrets of the New Jerusalem but also told not to conceal the things that he has seen (Rev. 22: 10–11). Dürer echoes these emphases decisively. Thus he gives great prominence to John's role in D2 (the vision of the seven candlesticks, Fig. 34), D3 (the throne-room scene, Fig. 35), D9 (John devours the scroll, Fig. 36), and D15 (John is shown the New Jerusalem, Fig. 33). In D3 and D9, John is the largest figure in the scene. In D2 and D15 he is still very prominent, as he is one of only a few figures.

This apparent fascination with the John figure, although certainly not without precedent within the history of the artistic reception of the Book of Revelation, points towards a particular hermeneutical strategy on Dürer's part. Van der Meer rightly observed that Dürer has inserted his own likeness four or possibly five times in the series (see D2, D3, D6, D9, and D15), including in the 1511 Frontispiece (Fig. 37). In all but one of these images (D6), it is the John figure that has been drawn in Dürer's likeness.[102] It is certainly true that the John figures in D2, D3, D9, and D15 recall Dürer's *Self-Portrait with Landscape* (1498) in several important ways.[103] They all share Dürer's long curly hair, which is cut shorter on top, his wiry frame and his long, thin, and rather distinctive nose. While this observation cannot of course be proved conclusively, a case can be made in favour of Dürer thinking along these lines, a case which is considerably strengthened by the fact that he added a frontispiece of John drawn in his own likeness to the 1511 edition (Fig. 37). First, Dürer gives an unprecedented amount of space in D9 to John devouring the 'little book'. As well as drawing the John figure in his own likeness in this image, Dürer's design for John's environs (the island of Patmos) bears a striking resemblance to the woodland pool on the outskirts of Nuremberg that he had painted in c.1496.[104] Finally, Dürer's monogram is particularly prominent in D9 (Fig. 36), where it is very bold, as well as in D3 (Fig. 35) and D15 (Fig. 33), where it is larger than in the other images. By emphasizing the monogram in

---

[102] Van der Meer 1978: 296, 298, 306.
[103] See *Self-Portrait with Landscape*, 1498, Madrid: Prado.
[104] *Landscape with a Woodland Pool*, c.1496 (London: British Museum, Sloane 5218-167).

these images, in which John appears in a prominent position, Dürer was emphasizing his authorship of the images on an artistic, as well as, perhaps, an experiential level.

It is interesting to note that, unlike most of his other compositions, Dürer's depiction of John devouring the scroll (D9) has no direct precursor in the Koberger series or the manuscript tradition. The Anglo-Norman manuscript illustrations and their descendants and the Koberger artist had all shied away from depicting John actually devouring the scroll, a detail that Dürer magnifies and gives great prominence to in his version.[105] This suggests that the image of the visionary imbibing the secrets of the Book of Revelation had a special meaning for Dürer. In contemporaneous commentaries on the Book of Revelation such as the one found in the Geneva Bible (*c.*1560), it was the angel (traditionally interpreted as Christ) who was the most important figure, but in Dürer's image, the angel is a shadowy configuration of pillars and clouds and it is the John/Dürer figure who stands out, as he devours the fiery-looking book.[106] Dürer has achieved a clear focus on John through the use of bold descriptive lines and dense optical hatching around the figure. John is depicted as sitting on Patmos, itself represented as a densely wooded and dark space. The angelic figure is surrounded by blank space, creating the illusion of being bathed in a powerful light, which in turn shines on John's face, providing both literal and symbolic illumination at the moment of the devouring of the book.

Dürer's emphasis on the visionary at this moment may reflect a particular exegetical strand of interest in Rev. 10: 9–11 as well as in Ezek. 3: 3, in which the prophet also consumes a book, and from which Rev. 10: 9–11 is probably derived. The twelfth-century Hugo de Folieto, for instance, in reference to these verses, speaks of how only a few are able to 'devour and digest the book, when we read the words of God', as opposed to those who read it but remain ignorant.[107] He also argues that the reason why the book initially tastes like honey but then becomes bitter, even to John, is due to the conflict humans experience over internalizing the 'word of God'.[108]

This image marks a clear turning point in the series. Up until this point, Dürer has depicted the cycles of destruction brought about by the opening of the seven seals and the seven trumpets. After D9, although he portrays the heavenly battles that are described in the Book of Revelation, he does not portray any more scenes of human destruction, choosing to omit the cycle of the seven bowls altogether. The sea-serpent edging into the frame of D9 on the left-hand side is perhaps a visual intimation of the other-worldly struggles that

---

[105] Although see detail of a frieze painted on the walls of St Mary's Chapel, Castle of Karlstejn, south of Prague (*c.*1357) (Van der Meer 1978: 173, 366) for a rare example of a representation where the angel is forcing the book down John's throat.

[106] See the Geneva Bible (1560): 117.

[107] Hugo de Folieto, *De claustro anime*, IV, 33 (PL 176, 1171D).

[108] Ibid. 1172A. See also Carruthers 1990: 167–9.

are to come. It seems that he saw the devouring of the book as the moment when the visionary himself moved from incomprehension regarding the events that he is witnessing to a newfound comprehension of the heavenly realm. Rowland remarks upon the fact that Rev. 10 is the moment at which John ceases to be a passive observer and is commanded to prophesy. He also argues that Rev. 10 represents a change in perspective from past events to present reality (i.e. to John's own situation).[109] By locating himself at the scene of this intimate revelation or unveiling, Dürer is effectively claiming great authority for his own visual interpretation of the Book of Revelation. He presents himself, through his images, as an *alter Iohannis*, experiencing the Book of Revelation anew on the eve of the half-millennium. His images thus represent a second change in perspective from John's situation to his own time.

Dürer's apocalyptic dreams and watercolours, which were discussed above, may be cited in support of his having had such an apocalyptic mentality, while his self-portraits, in which he often portrayed himself as Christ, serve as adequate evidence of the egocentric tendencies that could have led him to believe that he was indeed an *alter Iohannis*. It seems then that Dürer saw himself as the latter-day link between the two realms, the visionary who had seen the secrets of the upper realm that had yet to be successfully imposed on the lower. Dürer himself now occupies the role of guide that had befallen the medieval John figure. While the medieval John had appeared in nearly every image, thus corroborating his visionary experiences, this is not necessary in the Dürer series.[110]

By leaving John out of all but the most necessary images (i.e. those in which the text reports John's actions), Dürer was locating his own representations, as experienced and visualized by him, rather than John's experiences at the site of revelation. His more sophisticated, one might say Renaissance, understanding of the image as an extension of the self allowed him to do that.[111] The presence of Dürer's distinctive monogram in each of the fifteen images is the outward symbol of this new understanding of the image and the self. As R. Smith perceptively argues, Dürer laid claim, through his Apocalypse images, to his place alongside priests, prophets, and mystics, as one also able to mediate godly visions to an expectant audience.[112] The hermeneutical implications of Dürer's self-understanding as an *alter Iohannis* are serious. If the Book of Revelation is to be viewed as a series of words which engender pictures, a definitive visualization of that text, produced by an *alter Iohannis*, may render the text redundant. The fact that Dürer's Apocalypse images were printed and

---

[109] Rowland 1982: 420.     [110] Camille 1992: 287–8.
[111] See Koerner 1993: 220, for example, on Dürer's understanding of his art.
[112] Smith 1995: 158.

sold without accompanying text may corroborate the notion that Dürer's visual Apocalypse was viewed as a 'stand-alone' work from the outset.

Dürer's 'two-realm' schema is continued in images D5, D8, D11, D12, D13, and D14. In D11 (St Michael fighting the Dragon, Fig. 38), the heavenly realm is presented as being clothed in darkness (again through the use of very densely spaced optical lines) as the battle rages between St Michael and his angels and the Dragon, whilst the earthly realm is bathed in light and again seems oblivious to what is going on above. Here, the implication is that earthly battles with evil are prefigured by heavenly ones. It is interesting that Dürer made the decision to illustrate this scene from Rev. 12: 7–12. While it has a predecessor in Dürer's main pictorial source, the Koberger Bible, it is here presented as something of a side issue (see K7 where Michael is fighting the Dragon in the far left-hand corner of the image).[113] Although the battle had often been depicted in the Anglo-Norman iconographic tradition, rarely, if ever, was it visualized as an aerial battle taking place above a peaceful earthly landscape (see *Angers* 3.36, for example, where the battle has descended to earth). Neither was the composition taken up by Cranach or his successors.[114]

Dürer clearly saw the aesthetic possibilities of such a scene. However, it also raises an ambiguity or inconsistency that we find in the text of the Book of Revelation itself with regard to the problem of evil. The figures that are symbolic of evil in the Book of Revelation have in some ways been given their authority by God (see Rev. 13: 7 and 20: 3). Though this is mainly the case, there are certainly other examples (such as in Rev. 12) where it seems as if Satan is an autonomous being who does not derive his power from God but from another source. This ambiguity is acknowledged (we might even say emphasized) by Dürer in D11, where the battle between good and evil takes place in the heavenly realm, an acknowledgement that evil is not always confined to the earthly realm (cf. the first-century text 1 Enoch where heaven becomes infected by evil).[115]

Within Dürer's two-realm schema, and to an extent in keeping with his pictorial predecessors, one notices that Dürer has presented God and Christ as absolutely central to the events of the Book of Revelation. This idea finds its expression in the central position God and Christ occupy in ten out of the fifteen images. Thus they appear either in iconographic or symbolic form in images D2, D3, D5, D6, D7, D8, D10, D12, D13, and D14. Of the five images that they do not appear in, three of these have angels occupying a central role (D4 (Fig. 31), D9 (Fig. 36), and D11 (Fig. 38)), a feature that signifies a continued heavenly presence to the viewer. As long as a central place was given to the Divine in his compositions, Dürer's essentially 'top-down' view of

---

[113] Bartrum 2002: 124–5 argues that the design reflects elements of Schongauer's engravings of *St Michael Fighting the Dragon* and the *Temptation of St Anthony*.

[114] Ibid.

[115] See Nickelsburg tr. 2004: chs. 1–36.

salvation and of the essential differences between heaven and earth could be sustained. This view of salvation stands in contrast to Dürer's predecessors, who had tended to depict salvation as flowing across the image from left to right (see, for example, *Angers* 6.82, Fig 13). However, it accords with the doctrine of salvation found within the Book of Revelation itself, in particular the notion that the New Jerusalem would 'come down out of heaven from God...' (Rev. 21: 2).

D12 (Fig. 32) is an excellent example of Dürer's use of the Divine figure within his Apocalypse compositions. Dürer, like his predecessors, has, in this image, used billowing clouds to divide the two realms. The heavenly realm (which occupies the top third of the image) seems almost weightless. The Divine figure, the angel, and the cherub on the left hover serenely above the clouds. The two angels on the right, one of whom carries a symbolic cross, hover more aggressively in a protective stance. By leaving a large circle of space around the Divine figure free of any hatching, Dürer has created an illuminating effect. All activity seems to flow out from him (in a way somewhat analogous to the central figure in the Deësis group on the upper tier of the *Ghent Altarpiece*). This type of composition, with God or Christ occupying a central position at the top of the image, is utilized eight times by Dürer in the series. In contrast to these ethereal details, the Divine figure (possibly Christ, but I think it is God here) wears an ornate Bishop's mitre and cope (cf. the *Ghent Altarpiece* again). He also holds a sickle, a symbol of judgement, in his right-hand, as does the angel in the top right-hand corner.

Below the clouds in the earthly realm the two Beasts of Rev. 13, the Sea-Beast and the Earth-Beast rampage across the earth. The imagery here is a mixture of the prosaic and the fantastical. The shrubs, plants, and trees are typical of late fifteenth-century Nuremberg. Clear comparisons can be drawn between the buildings and foliage in D1, D3, D6, D7, D8, D9, D10, D11, D12, D13, D14, and D15 and, for example, Dürer's early watercolours of the outskirts of Nuremberg from the 1490s.[116] Similarly, the assorted worshippers and crowd members are attired in contemporary German dress (as is also the case in D1, D4, D5, D8, and D14). Examples of such contemporary fashion can be found in Dürer's own self-portraits from around this time as well as in sketches undertaken of ordinary people by Dürer in the 1490s.[117] However, this sense of normality is overturned by the presence of the two fantastical Beasts, themselves a hybrid mixture of recognizable, yet distinct animals. This in itself marks a departure from Dürer's predecessors, who had depicted the

---

[116] See for instance *Landscape with a woodland pool* (1495/6), *The Mills on the River Pegnitz* (1498), *Western Nuremberg* (undated), *The Church and the Cemetery of St John, Nuremberg* (1494), and *The Wire-Drawing Mill* (1489–94?).

[117] See *Self-Portrait with Landscape* (1498), *Nuremberg Woman in Household attire* (undated), *Rustic Couple* (c.1497).

Beasts with uniform 'dragon-like' heads (cf. *Angers* 3.35–3.40). Dürer also faithfully depicts the textual detail that the Sea-Beast had ten horns and seven heads with ten diadems upon its horns (Rev. 13: 1). Natural order is further subverted by the addition of blood pouring from the sky around the second Beast. This detail is also a slight subversion of the text, which tells of the Beast's ability to produce fire from heaven (Rev. 13: 13). It is also interesting to note that Dürer has introduced a note of ambiguity into his portrayal of the Sea-Beast in particular. Here, as well as in D10 and D14, some of the Beast's heads appear to be fighting with each other, perhaps suggesting the corrosive nature of absolute power.

By placing God (or the Divine figure) at the head of this scene, Dürer reminds us of several interrelated points. First, God's stance and his position as one who is being worshipped (albeit only by one angel here), recalls D3, which represents the heavenly reality. The earthly realm is, to recall the language of Hebrews 8, 'a copy and shadow' of the heavenly realm that has become perverted by oppressive rival forces and human fallibility. However, God, although visualized as an old man, is not presented as a passive, benign figure in D12. He holds a sickle in his hand, which suggests that he is standing in judgement over and against the events that are unfolding below in the earthly realm, thus recalling the judgement imagery perceived in D3. This in turn suggests that Dürer has interpreted Rev. 13 in light of Rev. 14. In Rev. 14: 7 the first angel warns of the need to: 'Fear God and give him glory, for the hour of his judgement has come; worship him who made heaven and earth, the sea and the fountains of water.' Later, the third angel reiterates this message even more explicitly in Rev. 14: 9–11. Rev. 14: 14–20 speaks of judgement in terms of the 'harvest of the earth', which will be gathered by the angels with sickles. The angel with the sickle in the top right-hand corner of D12 would seem to be an allusion to these verses.

The fact that God is placed at the top of this scene also recalls the statement made in Rev. 13: 7, that: 'it [the Beast] was allowed to make war upon the saints and to conquer them. And authority was given it over every tribe and people and tongue and nation.' The Beasts have not simply usurped power from God. Despite the fact that the human response to God has been inadequate, he remains at the head of the created order. The Beasts may be enjoying a temporary reign but the reader of the Book of Revelation knows they are destined for destruction (Rev. 20: 7 f.).

If the 'two-world schema' employed by Dürer throughout his Apocalypse Series allows him to play with the contrasts between the heavenly and the earthly realms, it is perhaps also the key to the over-arching theme of the whole series. This may be summarized as follows: Dürer's images, following the text of the Book of Revelation, represent the replacement of one system with a new one. The battle between the two systems is represented throughout Dürer's series through the visual dichotomy that he creates between the two

worlds. The last image (Fig. 33) with its symbolically loaded clear sky (as opposed to the other images in which the sky has been densely hatched) and peaceful atmosphere indicates to the viewer that the earthly realm has been infused with the order of the heavenly realm and that they are now in harmony (cf. Rev. 21: 3 where God is now said to be dwelling with men).

In exegetical terms, this image is interesting. In the foreground of the image, we witness the binding of the Satan figure from 20: 1–2. Behind this, an angel points at what we presume is the New Jerusalem, the city that occupies the top left-hand corner of the image. If this city is intended to be the New Jerusalem, then this is Dürer's interpretation of Rev. 21–2. In favour of this identification is the fact that there are angels visible in the three gates in accordance with Rev. 21: 12. The fact that the angel with John is pointing down at the city may also indicate that it has just descended from heaven, as predicted of the New Jerusalem in Rev. 21: 2.

However, Van der Meer and others have commented upon the fact that everything is rather commonplace in the New Jerusalem: there are no precious stones (Rev. 21: 19), no fructifying trees (Rev. 22: 2 f.), and no River of Life (Rev. 22: 1).[118] In fact, the city depicted in D15 looks very much like an idealized version of Nuremberg. This raises the question of whether Dürer was in fact depicting the New Jerusalem in this image or whether he was experimenting with the idea of there being a thousand-year messianic reign on earth prior to the final Judgement, which is outlined in Rev. 20: 4 ff. If this is a correct interpretation of Dürer's image, then he was militating against the established Augustinian position, which held that the millennium described in Rev. 20: 3 was not to be interpreted as a future event but as one which had already begun with the death and resurrection of Christ and the emergence of the Church.[119] Although the Augustinian interpretation remained normative, theologians since Olivi had entertained the possibility that there would be an actual Sabbath lasting for an extended period, possibly, as Rev. 20 suggested, for one thousand years.[120] If Dürer was indeed opposing the orthodox position, his interpretation of the Book of Revelation ends at chapter 20: 3. Perhaps he hoped that the actual conclusion to his visual Apocalypse would be revealed in the much-anticipated events of the half-millennium of 1500.

The complexity and depth of Dürer's imagery and the visual success of his 'two-level' compositions all mean that it is not an overstatement to call his Apocalypse Series an 'artistic climax'. Unlike most of his predecessors, Dürer's primary aim was not to create instructive or subordinate images whose function was to serve or illustrate or 'translate' the text.[121] In Dürer's series,

---

[118] Van der Meer 1978: 313.
[119] See Augustine, tr. H. Bettinson 1984: book 20.
[120] See Kovacs and Rowland 2004: 210.
[121] Krüger 1996: 101–8.

the text and the images serve to elucidate each other, the images perhaps ultimately even overpowering the text. This fact is especially striking if one actually handles one of the copies of the 1498 version of Dürer's Apocalypse book. The huge folio-sized images dwarf the columns of text that face them and one almost forgets that the text is there, as the images possess an inner logic and cohesion of their own.

As suggested by Krüger, Dürer's images are also, perhaps in an attempt to evoke a cathartic, Aristotelian reaction from his audience, completely mimetic. Thus, the symbolic language of the Book of Revelation is visualized in a literalistic, figurative fashion, with no attempt made on Dürer's part to tease out its metaphorical meaning for his own times. Thus he forms a hermeneutical contrast with Botticelli, who, in *The Mystic Nativity*, offers the viewer a non-mimetic metaphorical interpretation of the Book of Revelation, in which he attempts to relate the text to real, historical events. Nor does Dürer offer the viewer an interpretation of the Book of Revelation like Memling's, in which an exegetically fundamental section of the text (Rev. 4–5), is prioritized. Although Dürer 'slows down' the narrative in places, no section of the text is prioritized in the same way. Thus, Dürer's interpretation of the Book of Revelation, for which he made authoritative claims through his depictions of John in his own likeness and through his use of the 'AD' monogram, and for which he became justifiably famous, ends up, despite its artistic brilliance, being less hermeneutically ground-breaking than some of his contemporaries.

Having discussed Dürer's images on a hermeneutical level, it seems pertinent to include a discussion of their historical relevance as part of the visual history of the Book of Revelation. Dürer's naturalistic style lends his images an air of realism that has led many to speculate that his Apocalypse Series represents a critique of sections of the political and ecclesiastical hierarchy of his day.[122]

D14 (Fig. 29), the Whore of Babylon image, has remained at the centre of such discussions for more than a century. The Whore's clothing, hair, and jewellery recall those of a Venetian Courtesan that Dürer had drawn in 1495.[123] Above the Whore in the top right-hand corner flies the angel from Rev. 14: 8 and, further to the right, the city of Babylon burns spectacularly, the flames reaching up into the heavens. In the bottom left-hand corner there stands a crowd of noblemen and 'townsfolk' as well as a monk and what looks like a Sultan. They all stare at the Whore. Above the crowd in the top left-hand corner flies the angel with the millstone from Rev. 18: 21, while further to the

---

[122] See, for example, Dvořák 1921 (tr. 1984) and Chadabra 1964 for interpretations of Dürer's Book of Revelation Series as foreshadowing the Reformation. See Price 1994 and 2003 for a more measured approach.

[123] Albrecht Dürer, *Venetian Woman*, Profile and back views, c.1495, Vienna: Graphische Sammlung Albertina.

left, the rider on the white horse (Rev. 19: 11ff.), who is commonly identified with Christ in medieval commentaries, descends from the clouds with his army behind him.[124]

Much of the scholarship on this image has turned on the question of whether the Whore and the monk represent the Church or not. The monk, a non-textual addition to the scene and importantly a figure with no precedent in the Koberger images, is the only figure from the crowd to have fallen to his knees in an apparent act of worship towards the Whore. The rest of the crowd share the same nonchalant expressions as the crowd in D1, who are being forced to witness John's 'martyrdom' in boiling oil. The art historian Dvorak wrote in 1921 that Dürer's Book of Revelation was 'a revolutionary hymn, and it . . . was directed against Rome'.[125] By Rome, Dvorak meant papal Rome, the heart of the Western Church. Dvorak based his conclusions regarding Dürer's 'reforming' ambitions on several details from D14. Significantly, he notes the Venetian dress of the Whore herself, which he takes as a sign that Dürer has transformed her into the Rome of his time, contemporary Venice being practically a byword for immoral behaviour.[126] He also notes the monk and his worshipping pose, a sign of the Church's demise into immorality. In addition, Dvorak cites a diary entry that Dürer made in 1521 after hearing an erroneous report that Luther had been killed in order to support his argument. He writes that Dürer 'expressly alludes to the Book of Revelation saying that the curia murders true Christianity, sucks its blood, and is an unchristian way of life'.[127]

While Dvorak's position was interesting enough to start a wave of scholarship on the subject, his arguments do not ultimately convince. The diary evidence can largely be discounted. What Dürer felt about the Church in 1521, during the throes of the Reformation itself, has little to do with his views as a devout 25-year-old in 1497 when he designed this image. It is perhaps all too easy, in light of Cranach the Elder's Whore of Babylon of September 1522, in which the Whore wears the papal tiara, to fall into the trap of projecting later ideas back onto earlier works.[128] Indeed, one of Dvorak's disciples, Chadabra, even went as far as arguing that the three hoops of the papal tiara have in fact been thinly disguised in Dürer's image. He claims that the first can

---

[124] See Chapter 1, Sect. 1.3; Chapter 2, Sect. 2.7 for discussion of this identification with Christ.
[125] Dvorak 1984: 5.
[126] See for instance Norberg 1995: 458–9 on the rise in visible prostitution in Venice in the late 15th and early 16th cent. See also Steinberg and Wylie 1990: 82. Panofsky also comments on the fact that Dürer had been delighted by the Venetian courtesans and their costumes (Panofsky 1955: 36).
[127] Dvorak 1984: 5.
[128] See Price 1994: 688: 'the temptation to view the innovative artist of the 1490s from the perspective of post-Reformation criticism of the Church proved to be irresistible, even though it carried the obvious risk of distortion'.

be found in the Whore's crown, the second in the rim of her cup and the third in the sultan's turban.[129] This surely is a stretch too far.

Extensive research into the context behind Dürer's decision to depict the Whore as a Venetian prostitute astride the Beast suggests other motives. It is likely that in portraying the Whore thus, Dürer sought both to link her with the threat posed by the sultan and also to indicate that she posed a threat to the established order of society. With regard to the first point, one notes that the sultan who is seated in D1, and who is identifiable by the emblem on his necklace, his ornate turban, fur-collared gown, wizened hands, and high boots, is almost certainly the figure with his back to us in D14 who gestures to the Whore. His credentials as a threatening character have already been established in D1. In D14, the sultan's stance and hand gesture suggest that he is presenting or introducing the Whore to the unsuspecting crowd. The link between the two is further emphasized by the fact that they are the only two figures in 'foreign' dress. As mentioned above, Dürer made preliminary sketches for both figures on his first trip to Venice in 1494–5. The rest of the crowd, who, with the exception of the monk, seem to be viewing the Whore rather sceptically, are dressed in more contemporary German dress. The implication is that the Whore and the sultan are part of a wider, aforementioned, threat to the fabric of German society.[130]

The notion that the Whore represented a threat to society leads to a second key point. Dürer's Whore may be a sexually attractive woman, but by depicting her astride the hybrid Beast (a threat to the normal order of things in itself), he is also suggesting that there is something socially deviant about her, that she is a usurper of male power and a force to be feared.[131] Perhaps the rider on the white horse who gallops down from the clouds in the top left-hand corner of the image (i.e. diagonally placed vis-à-vis the Whore) is intended to emphasize this point. The male military saviour belongs on a powerful horse but a woman does not. This idea that the Whore has stepped outside the acceptable social norms for a woman can also be found in the text of the Book of Revelation. Rev. 18: 4ff., for instance, characterizes the Whore as a 'wanton' with royal pretensions. Tina Pippin suggests that the Whore is destroyed on account of the egotism she displays in Rev. 18: 7. Both her erotic power (as the 'mother of Whores', Rev. 17: 5) and her independence are dangerous to men.[132]

Closer inspection of the image also reveals the Whore to be only superficially beautiful. When one really gets close to the page (which owners of

---

[129]  See Bialostocki 1986: 282 ff.
[130]  See MacCulloch 2004: 53–7.
[131]  Zika 1994: 139–40; Moxey 1989: 111 (refer to both texts for many more examples of the perceived danger of women who took on traditionally male roles, as exemplified in broadsheet images from the early 16th cent.); N. Zerwin Davis (Farge and Zerwin Davis (eds.)) 1995.
[132]  Pippin 1992: 57–68.

Dürer's Apocalypse Books would have been able to do) she is actually rather haggard and ugly, an effect that Dürer was able to achieve through the use of tiny, curved optical lines around the eyes and mouth. He has arranged and shaded her dress in such a way as to suggest that she is in some way part of the Beast on which she rides. The 'reptilian' hatching at the bottom of the dress mirrors very closely the hatching on the body of the Beast itself.

With regard to the claim that the Whore was intended by Dürer to symbolize the immorality of the Church, no real evidence can been found.[133] Similarly, with regard to the monk who appears to be worshipping the Whore, several explanations can be advanced. First, Ernst Gombrich has argued that the monk is not worshipping the Whore at all but instead gazing at the angel above her. This explanation has some plausibility in that if one follows the eye-line of the monk, he does indeed appear to be looking straight up at the angel rather than across at the Whore. It also serves the dual function of preserving the monk's piety and countering what Gombrich believed to be the preposterous view that the *Zeitgeist* was already pregnant with the Reformation by 1498.[134]

However, there is perhaps a second explanation that can be offered, which can allow for the monk's indiscretion without at the same time committing Dürer to any 'proto-Reforming' tendencies. There exists a quite well-documented tradition of 'popular' drawings in Northern Europe which satirized monks for their drunkenness, gluttony, immorality, and lack of judgement.[135] *The Abbot on the Ice* is but one example from the late fifteenth century.[136] Similarly, the fact that the Koberger illustrations include evidence of clergy behaving badly, as well as clergy being amongst the first victims of the Beasts of the Book of Revelation, was stressed above. Dürer was clearly not part of a tradition that revered the Church indiscriminately. So while he might have been satirizing the ease with which this particular monk falls at the feet of a beautiful woman, this does not necessarily amount to evidence that he was attacking the Church as an institution at this point in his life.

This viewpoint is forcefully echoed by Price, who holds that there is no discernible systematic pattern to Dürer's treatment of the Church and the secular hierarchy in his Apocalypse Series.[137] He argues that Dürer's images of the Church hierarchy being destroyed were not particularly daring in light of what had preceded them and that, to a contemporary audience, the most frightening image would have been that of the sultan enthroned in Rome as the Emperor. He refers the reader back to evidence for Maximilian's

---

[133]  *Pace* Dvorak, Chadabra, *et al.*
[134]  See Bialostocki 1986: 286.
[135]  See Scribner 1981: 37–43.
[136]  Anonymous, *The Abbot on the Ice*, c.1480. Reproduced in Scribner 1981: 43.
[137]  Price 1994: 688–95.

propaganda campaign for an anti-Turkish crusade of the 1490s. Chapter ninety-nine of Sebastian Brant's *Das Narrenschiff* (1494), for example, speaks of the diminution of faith as a political catastrophe arising from the Ottoman conquests, and in a direct appeal urges German territorial princes to cooperate with Maximilian. There is even some evidence that Dürer provided the illustrations for *Das Narrenschiff*.[138] Price writes that 'it is not at all implausible that Dürer was familiar with, and conformed to, the imperial (and papal) strategy of demonising the Turks'.[139]

In addition to this, Price argues that Dürer includes positive portrayals of the Church hierarchy in his images that have no precedent in the Koberger and other contemporary illustrations. Two examples will suffice. In D12 (Fig. 32), the way that God is dressed suggests the garments of a priest, as he is wearing a pluvial, the outermost of a priest's garments. Similarly, in D13, it is a bishop in the foreground of the image who receives the blood of Christ into his Eucharistic cup. Price concludes his article on an equivocal note, arguing that Dürer has juxtaposed negative and positive images of the Church (such as its continued ability to convey sacramental grace as evidenced in D13) but crucially 'without attempting to resolve the tensions raised by such juxtapositions of despair and faith'.[140]

While Price provides a refreshing antidote to those art historians who have sought to cast Dürer as a 'proto-Reformer', and while I agree with him that there is no discernible systematic pattern to Dürer's treatment of the Church, he may be altogether too ready to emphasize the positive aspects of Dürer's portrayal of the Church. D13 does indeed seem to be a positive endorsement of the Church hierarchy. But perhaps Dürer was also, in other images, reminding the ecclesiastical hierarchy of their responsibilities to those underneath them. D12 seems to be a case in point. Price is correct to point out that God is wearing the garments of a bishop. Whether this can be said to be a positive endorsement of the Church is another matter altogether. It was argued above that Dürer's 'two-world' schema points towards the fact that he regarded the 'earthly realm' as an imperfect reflection of the heavenly one. If this logic is applied to D12 some interesting observations can be made. Working on the assumption that it is not possible to tell whether the Divine figure at the top of the image is God or Christ, we may posit for the moment that it is in fact Christ being presented as the perfect, heavenly High Priest of Hebrews (Heb. 4: 14). The heavenly High Priest is then being set over and against what is going on down below, where a bishop (again noticeable by his mitre) is actually worshipping one of the Beasts. In doing so he is falling prey to the human weakness also described in Hebrews in relation to the earthly High Priest (Heb. 5: 2). Even if Dürer was not aware of the language and

---

[138]  Price 1994: 692.      [139]  Ibid.      [140]  Ibid. 695.

imagery of Hebrews, the fact that the Divine figure at the top of the image is wearing bishop's rayments signifies a judgement on the Beast and all those who consort with him, especially members of the clergy. Thus while Dürer's Apocalypse is not an overtly political or anti-ecclesiastical work (in the sense that Dvorak and his disciples claim that it is), it certainly has more of a radical edge than Price admits. Dürer's highly contrasting 'two-tiered' images do not support the status quo. They reveal the heavenly realm to the viewer alongside the deficiencies of the earthly realm. They demand not just Church reform, but visualize the wholesale replacement of one world order with another.

## 5.4 LUCAS CRANACH AND THE BOOK OF REVELATION

Just as there is little sense in discussing Dürer's Apocalypse in isolation, neither can one discuss Cranach's Apocalypse illustrations without reference to their context, both in terms of Cranach's personal output and in terms of the religious and political context in which they were produced. The previous discussion of Dürer's Apocalypse images focused in part on their relation to the text. While it seems the case that Dürer interpreted the text from a personal viewpoint, the contemporary references and issues he includes are subtle and do not intrude on the flow of the narrative of the Book of Revelation across the images. As an interpretation of the text, Cranach's images are fairly straightforward and less subtle. He chooses to represent the narrative chapter by chapter over twenty-one illustrations, as compared to Dürer's fifteen. Crucially, however, Cranach's illustrations are part of a historically specific cultural movement, the Reformation, which purported to show, through both high and low art, as well as through sermons, books, and plays, that the Pope was the Antichrist and that allegiance to the 'Old Church' was therefore a form of false veneration.

### 5.4.1 Lucas Cranach: artist and entrepreneur

Born in 1472, only one year after Dürer, Cranach began producing both secular and religious woodcuts around 1501–2.[141] His career began in Vienna but, in 1505, he moved both his home and his workshop to Wittenberg, where he remained until his death in 1553. Having established himself in Wittenberg,

---

[141] Cranach was also a painter but this discussion will focus exclusively on his woodcuts. For further discussion of his paintings in their Reformation context see among others, Koerner 2004.

Cranach and his workshop dominated art-making in the region until around 1586, Lucas Cranach the Younger having taken over the workshop after his father's death in 1553.[142] The fact that Cranach was based in Wittenberg, the city that became the centre of the Reformation, was to prove very significant in terms of his relationship with Martin Luther, for whom he acted as a printer, artist, and sometime distributor of printed images.

Cranach's workshop in Wittenberg was a large one, famed for its rapidity of production. There exists considerably more information about Cranach's workshop than about Dürer's, the products of the former being more of a collaborative effort than in Dürer's. Ruhmer describes Cranach's large, collective workshop as functioning 'almost mechanically' by 1505.[143] The basic structure of the workshop was not dissimilar to that of a medieval workshop, which had a master at its head and a team of skilled workers below him. However, the emphases as well as the scale and quality of the output were very different, for the master of the Renaissance workshop gave the workshop its stylistic direction in a much more conscious way than had previously been the case. It was the style of the head artist that the art-loving public had begun to grow to appreciate, and it was the job of his staff to execute his orders, imitate his style, and even his handwriting if necessary when producing further works. An insight into this process is afforded by the preservation of some sketches by Cranach called *Studies of Heads*.[144] Cranach had provided these technically brilliant sketches specifically for his assistants to copy when they were carrying out commissions. Due to the hierarchical structure of this type of workshop, the assistants to the master usually remained anonymous as they were not being paid to develop their own style.[145]

Thus when talking about Cranach's Apocalypse illustrations for Luther's *September Testament* of 1522, it is important to be aware that this does not necessarily mean that they were executed or even necessarily all designed by Cranach the Elder himself. Like Dürer, Cranach did have a (constantly evolving) monogram consisting of the initials LC and sometimes also a snake. From 1506 until his death in 1525, Cranach was authorized to use his patron's coat of arms on the artistic output of his workshop, his main patron at this time being Frederick the Wise, Elector of Saxony. Thus many of the works produced during this time bear both Cranach's monogram and the Elector's arms. This arrangement can be seen particularly well in Cranach's very large (37 cm × 51 cm) prints depicting courtly subjects such as *The Stag Hunt* of

---

[142] Koerner 2004: 76.

[143] Ruhmer 1963: 10.

[144] Ibid. 13. Versions of the *Studies of Heads* can found in Reims, the Louvre, London, Berlin, and Vienna.

[145] Although, both Cranach's sons, Hans (d. 1537) and Lucas the Younger (1515–86) are known to have worked in Cranach's workshop alongside him and later developed their own reputations.

1506 and the three *Tournaments* of 1509. In *The Stag Hunt*, the Elector's coats of arms are clearly visible in the top left- and right-hand corners of the prints, while Cranach's 'LC' monogram appears more inconspicuously slightly to the right of centre at the bottom of the print.[146] It seems that, rather than ensuring that Frederick profited from the sales of the prints, the arms served as an honorific gesture, giving Cranach exclusive authorization to publish prints under Frederick's legal protection. In return for this, Frederick's superior artistic taste and generous patronage were being publicized wherever the prints were sold. Landau and Parshall argue that the commercial dissemination of works of art bearing Frederick's coat of arms was a 'major step in the aristocratic sponsorship of printmaking, a critical factor in the rising status of the woodcut at exactly this time'.[147] Thus, as Koerner argues, prints from Cranach's workshop proclaimed themselves as products both of a specific workshop (rather than Cranach himself) *and* a specific patron.[148]

While they differ with respect to their views on artistic autonomy, vis-à-vis Cranach's influences most commentators list Dürer as a very strong one.[149] Cranach's early woodcuts do indeed reflect a close familiarity with Dürer's woodcuts, including *The Temptation of St Anthony* (1507) and *St Christopher* (1506).[150] Burke also correctly notes that Cranach must have had a working knowledge (if not a copy) of Dürer's Apocalypse Series, such are the broad compositional similarities between the two, a point that will be returned to below.[151] Dürer also produced works for Frederick the Wise, and there is further evidence of a relationship in the portrait that Dürer drew of Cranach when the latter visited Nuremberg.[152] However, while Cranach continued to use the looser drawing style and rich contours that Dürer had introduced to woodcut design, there is also a slackening of intensity of contrasts in Cranach's designs.[153]

By 1528, tax records show Cranach to be the richest man in Wittenberg, with property worth over four thousand guilders.[154] Cranach was thus a very influential man in his local community by the time he produced his Apocalypse illustrations. In contrast, Dürer intended to make his name with his Apocalypse Series. It seems that Cranach's motivations were economic and political rather than personal, although as will become clear below, it is

---

[146] See also Koerner 1993: 486 n. 3.

[147] Landau and Parshall (eds.) 1994: 177.

[148] Koerner 1993: 486 n. 3.

[149] See Landau and Parshall (eds.) 1994: 176 and Ruhmer 1963: 6 ff.

[150] See Dürer's *The Hermits St Anthony and Paul* (c.1503) and his *St Christopher* (1501) by way of comparison.

[151] Burke 1936: 25–53.

[152] Ruhmer 1963: 9. The portrait is in the Museé Bonnat, Bayonne.

[153] Burke 1936: 35.

[154] Ruhmer 1963: 16 and Koerner 2004: 76–7.

extremely difficult to make concrete statements regarding Cranach's true political and ecclesiastical beliefs.

With regard to Frederick's patronage of Cranach during these years, we may also draw a contrast with Dürer's early status as an independent print-maker in the competitive and commercial centre of Nuremberg, with no such overt aristocratic patronage for his graphic output. While Cranach did not necessarily need other patrons from a financial perspective, he still took them on. Significantly, one of his most important patrons in the years 1520–7 was Cardinal Albrecht von Hohenzollern (Albrecht of Brandenberg). Albrecht of Brandenberg was at this time one of the most powerful among the German Catholic cardinals, as well as being one of Luther's most prominent German opponents. Brandenberg had become the target of some of Luther's most bitter attacks following his defence of the Dominican monk Johann Tetzel in 1517, whom Luther had attacked in his ninety-five theses for his role in the campaign to sell indulgences.[155] Cranach's relationship with the Catholic Cardinal Branden-berg has puzzled commentators due to the fact that, by the early 1520s, both Cranach's personal friendship and his working relationship with Luther had been cemented. In an obituary for Cranach written in 1556 by Matthias Gunderam, it was reported that Cranach 'was loved by Dr Luther his whole life long, and was bound to him by bands of intimate friendship and sponsorship'.[156]

The factual information that we possess regarding their friendship certainly supports this statement. In 1519, in his role as city treasurer, Cranach paid for the celebrations in honour of Luther's return from the Leipzig Disputation where he had almost been condemned for heresy. Similarly, in his role as city Councillor, Cranach approved payment for Luther's passage to the Diet of Worms. Having failed to reach an agreement at the Diet, it was Cranach to whom Luther wrote about his experiences on 18 April 1521, saying, 'I will allow myself to be taken in and concealed, I know not where'.[157] Cranach visited Luther secretly in the Wartburg and drew a picture of him disguised as Junker Jörg. This friendship and mutual respect continued for the rest of their lives, with Cranach acting as the only witness at Luther's marriage to Kather-ina von Bora in 1525. Both men acted as godfather to some of the other's children, and Luther's words of comfort on the death of Cranach's son, Hans, in 1537 are recorded in *Table Talks*.[158]

On the professional side of the relationship, in 1520 Cranach executed his first portrait of Luther.[159] The portrait was a relatively expensive engraving,

---

[155] See MacCulloch 2004: 123–6 for a lengthier discussion of Luther, Brandenberg, and Tetzel.

[156] Schuchardt 1851: vol. 1, 20.

[157] Luther, *BR* II: 305.

[158] See Koerner 2004: 77.

[159] Lucas Cranach the Elder, *Luther as Augustinian Monk*, 1520. Hamburg: Kupferstich-kabinett, Kunsthalle.

rather than a cheaper and thus more 'popular' woodcut. It emphasizes Luther's status as an Augustinian monk by drawing attention to his tonsure and cowl. It also bears an inscription in Latin. In spite of these details, namely its medium and the Latin inscription, which imply that this portrait was aimed at a comparatively 'elite' audience, Scribner holds that it may still have had a broader propagandist purpose.[160] He ventures that it may well have been composed as a reply to reports that Luther's likeness had been publicly burned in Rome. Even if Luther was to be killed, his spirit would live on in Cranach's image, an iconic sign of his immortality that also served to establish his importance.[161] Koerner also notes that some impressions of the 1520 engraving contain a small likeness of a bearded man who resembles known self-portraits of Cranach. Rays of light extending from his brow toward Luther's suggest an intimate bond between the two.[162]

This first portrait (of many) thus represents an important moment in the relationship between Cranach and Luther, the first example of their long and distinguished joint career as disseminators of the Protestant message by textual, verbal, and visual means. Only one year later, in 1521, Cranach published his Passional Christi und Antichristi (hereafter the Passional) with a commentary by Luther's disciple, Philipp Melanchthon. Cranach's Passional was the first 'popular' work conclusively to equate the Pope with the figure of the Antichrist. Luther supplied the preface for the 1522 version, in which he defended the role of the image within devotional life as a mnemonic aid, against the iconoclastic arguments of Karlstadt and his followers.[163]

Luther attempted to promote a more moderate line against Karlstadt's uncompromising stance. He argued that once the most obviously absurd (i.e. anything that promoted the cult of the saints and the pageantry of the Mass) images had been removed in a non-violent manner, sacred art could remain in churches with impunity. Indeed, those who wished to destroy it and eradicate any trace of it were implicitly admitting that the images did actually possess some sort of power and that those who still believed that sacred art was in possession of sacred powers were guilty of lapsing back into a works-based (as opposed to a faith-based) view of salvation. Thus, Luther's view on idolatry and images was quite deeply rooted in his wider theology. Luther's 'common-sense' view on the use of images can be summarized in his own words from a letter to Karlstadt: 'Zum Ansehen, zum Zeugnis, zum Gedächtnis, zum Zeichen' (to look at, to bear witness, to remind, [and] as a sign).[164]

[160] It is, however, noted that propaganda can also be aimed at a more select, even elite audience.
[161] Scribner 1981: 15.
[162] Koerner 1993: 365.
[163] See Luther, LW 10, pt. 2: 458. For Luther on images see MacCulloch 2004: 140–4; Carey (ed.) 1999: 102–6; Michalski 1993; Koerner 1993: esp. ch. 16.
[164] Luther, WA 18: 80a.

One can thus hardly imagine more partisan actions than Cranach's execution and distribution of the Luther portraits and the *Passional*. And yet, he still continued to work for Cardinal Brandenberg and other Catholic patrons. There is also, for instance, documentary evidence that Cranach sold a set of his woodcuts for Luther's December 1522 edition of the New Testament for 40 taler to Jerome Ems, agent to Duke Georg, another one of Luther's Catholic enemies who published a rival version of the New Testament in Saxony in 1523.[165]

Two explanations for his behaviour might be suggested. First of all, it would not have been clear to Cranach in the 1520s (as it is to us now, with the benefit of hindsight) that the divisions that had been caused in the Church by Luther's proclamations and challenges to the Papacy would eventually result in such a complete and final break. To Cranach in the early 1520s, therefore, Luther and Brandenberg still both belonged to the same Church: there were no Catholics and Protestants at this point, only a major disagreement within Western Christianity. Cranach visualized this disagreement in symbolic terms as a choice between two ways of life in his many versions of *The Law and the Gospel*, in which the fatalistic consequences of following the law are contrasted with the optimism of the gospel.[166] Secondly, as an artist, Cranach was comparatively free to choose his commissions: his primary motivator was economic rather than the political or religious associations of his works or, indeed, of his patrons. Ruhmer argues that as Cranach's workshop was an economic enterprise, supporting Luther and his cause through printing and illustration design did not necessarily imply any exclusive obligation.[167]

As Koerner perceptively argues, in Cranach's works for Luther, his artistic personality and interpretative instincts as an artist as well as his artistic style and shop practices are sublimated to Luther's own aims as a theologian and educator.[168] Thus in images such as *The Law and the Gospel*, for example, the figures and landscape are fairly generic and there is little spatial context. The emphasis is on legibility above all else. Koerner refers to such images as being analogous to ciphers, which once deciphered, although this may involve exegetical labour, are like solved crossword puzzles, emptied of deeper meaning.[169] In this way, as well as in others, Cranach was a different sort of artist from Dürer and Hans Baldung Grien, who represent an earlier, more self-conscious 'moment' in German Renaissance art.[170]

---

[165] Newman 1985: 110.

[166] See Cranach, *The Law and the Gospel*, c.1530, woodcut, British Museum, London; *The Law and the Gospel*, 1529, panel, Staatliches Museum, Gotha; *The Law and the Gospel*, c.1529, oil on panel, National Gallery, Prague. See Koerner 2004: 171–307.

[167] Ruhmer 1963: 25.

[168] Koerner 1993: 366.

[169] Ibid. 379–81.

[170] Ibid. ch. 16.

In accordance with his moderate position on the use of images, Luther was not primarily interested in 'great art', but rather in simple pictures with obvious symbolism that were able to function as instructional aids. In Cranach, 'Luther found a local artist capable of achieving these pedantic ends... one who learned to curtail resources specific to his medium and talent'.[171] Although presumably interested in paintings such as *The Law and the Gospel*, which espoused the Lutheran message and actively curtailed interpretative choice by presenting the dichotomy between the Law and the Gospel schematically and simply, Luther himself preferred what he refers to as penny prints or *Merckbilder*.[172] 'Popular' prints, unlike impressive paintings, did not run the risk of being viewed as agents of intercession or indulgence. Their 'sign-like' character and mimetic function as reminders of stories or theological points that people already knew rendered them 'safe' forms of visual communication.[173]

It is into this category that Cranach's woodcuts for the *Passional* of 1521 and his Apocalypse illustrations of 1522 can be placed. While undoubtedly provocative with regard to their polemical detail, on an interpretative level these images are exemplars of the Lutheran visual strategy, a strategy that was summed up in Luther's Easter sermon of 1533. In this sermon, he argues that it will always be necessary to convey 'the teachings of Divine things through crude, external images... just as Christ himself, everywhere in the Gospel, illuminates the secret of heaven through clear image and likeness'.[174] 'Art,' writes Koerner, 'it is hoped, leaves unsaid an un-exchangeable something distinct from the currency of meaning, which insures that, however much is explained, a minimum deposit will remain'.[175] The question is, do Cranach's Lutheran images empty out this reserve?

### 5.4.2 Lucas Cranach's *Passional Christi und Antichristi*

Cranach's *Passional Christi und Antichristi* was a small, illustrated pamphlet composed of twenty-six woodcuts and published in May 1521. They constitute a precursor to Cranach's Apocalypse images of the following year. Each woodcut was accompanied by Bible quotations, papal decretals, and explanatory sentences, gathered and composed by Philipp Melanchthon and the jurist Johann Schwerdtfeger, inspired in part by Luther's manifestos of 1520. While the implications of the text and, indeed, the pamphlet as a whole were

---

[171] Koerner 2004: 32.
[172] Luther, *WA* 28: 677.
[173] Koerner 1993: 381.
[174] Luther, *WA* 37: 64.
[175] Koerner 2004: 26.

theologically explosive, the central theme of the booklet itself was very simple. A *Passional* was a small picture book depicting scenes from the life of Christ or the saints for the purpose of pious meditation. All Cranach did was to adapt this idea to juxtapose the life of Christ with that of the Antichrist-as-Pope. Thus the twenty-six woodcuts have been arranged into thirteen contrasting pairs. The first in each pair depicts a scene from the life of Christ under which a scriptural passage appears. The second presents a similar scene from the life of the Antichrist-as-Pope, amplified by passages from papal decretals and comments by Melanchthon. The idea that the Pope might be identified with Antichrist is one that has a complex history, as does the figure of Antichrist itself.[176]

During the patristic era, a composite portrait of an Antichrist figure started to be fleshed out with images from 1 and 2 John, 2 Thessalonians, and the Book of Revelation (Rev. 11 and 13 especially), among other sources. Because the concept of Antichrist had been inherited from various Judaeo-Christian sources, it was a multi-dimensional concept. On the one hand it could represent a general evil presence within the world with manifestations in every age, but increasingly it began to be associated with a single character appearing at a specific moment in the programme of the last things. In the tenth century, at the behest of Queen Gerberga (sister of the future Otto I), Abbot Adso wrote the famous *De ortu et tempore Antichristi*, the first of many comprehensive 'lives' of Antichrist.[177] This particular 'life', as well as drawing on the biblical sources mentioned above, also drew on Jerome on Daniel, Haimo on 2 Thessalonians, and Bede on the Book of Revelation.

Adso presented Antichrist's life story as a black parody of Christ's. So, for instance, Antichrist's mother was said to be a Whore descended from the Tribe of Dan, his father the devil, and his birthplace Babylon ('dwelling place of demons', Rev. 18: 2).[178] By the end of the fifteenth century, the Antichrist legend had successfully permeated every area of 'popular' thought from plays to block books to 'popular' sermons and prophecies.[179] There were also nine printed editions of a Latin summary of the life of Antichrist published between 1473 and 1505. The iconography of Antichrist is similarly colourful, with the figure being represented in Apocalypse manuscripts (such as Lambeth), block-book Apocalypses, frescoes (such as Signorelli's), and, by the sixteenth century, 'popular' woodcuts.

There are also some polemical illustrations of Antichrist, although not many until Cranach's *Passional* of 1521. An important exception to this is

---

[176] On the figure of Antichrist in the Middle Ages see: Emmerson 1981: esp. ch. 4; Reeves 1984: 40–73; Muir Wright 1995.

[177] CCCM 45.20–30; For a translation see B. McGinn 1979: 81–96.

[178] Reeves 1984: 43.

[179] See Brant and Gelier von Kaiserberg for popular prophecies and Pamphilus Gengenbach's rhymed prophetic work of 1517, *The Nollhart*. See Scribner 1981: 49 f.

the Bodleian Douce Manuscript (MS 134), where Antichrist is depicted triumphantly entering a city dressed as the Pope. Similarly, J. Pelikan cites evidence of Hussite placards on which the humble entry of Christ into Jerusalem on an ass was contrasted with the pomp of a triumphal procession by which the Pope and his Cardinals entered Rome.[180] The artistic portrayals of the Antichrist tradition popularized and reinforced the theological and literary understanding of the Antichrist figure. Cranach's *Passional* was therefore almost guaranteed a receptive 'popular' audience broadly familiar with this legendary figure.

The thirteen pairs of woodcuts are a visualization of the notion that the Pope, far from opposing Antichrist, now stood at the head of his demonic church. The true Church had become invisible except for the three pillars of baptism, communion, and preaching. This viewpoint had first been formulated by Luther in 1521 in response to Ambrosius Catharinus' attacks on his work, which were not, however, published until 1524. Thus, within the *Passional*, the Pope has not merely been inserted into the role of Antichrist, as one might have expected. Rather, the thirteen images depict him as he represents himself, in ceremonies, processions, and feasts. These images are then contrasted with scenes from Christ's life. As Koerner puts it, 'Cranach assaults Rome by depicting and vilifying its visibility'.[181] This visual contrast drawn between the life of the Pope and the life of Christ is strengthened by the commentary that argues that the Pope's behaviour is anti-Christian. The visual and textual content of the thirteen pairs are briefly outlined in Table 3 in Appendix 2.[182]

To give some examples, in the second pair, Christ is crowned with thorns, while the Pope is crowned with the triple tiara. Given that, in the Gospels (see Mark 15: 17–20, for example), Christ's crowning is itself presented as a parody, this depiction exposes the worldliness of the Pope's ambitions. The papal coronation implies that he sides with Christ's tormentors and not with Christ himself. Similarly, the ninth pair depicts Christ's humble entry into Jerusalem juxtaposed with the Pope's triumphal entry in state into a city. Christ is depicted in profile riding an ass, a well-known way of depicting the scene in earlier images. The Pope, also in profile, has been cast in a grotesque parody in the opposite scene. Christ rides to the left, towards the gates of Jerusalem while the Pope rides to the right towards hell. The Pope wears his elaborate triple tiara while Christ is bare-headed. The texts beneath the images emphasize Christ's humility and the fact that he came to save and not to reign, on the one hand, and the fact that the Pope feigns kingship in order to rule improperly, on the other.

---

[180] Pelikan in Patrides and Wittreich (eds.) 1984: 83.
[181] Koerner 2004: 119.
[182] See Scribner 1981: 150–7.

The last pair of illustrations is interesting in that it is the only pair that explicitly uses iconography associated with the Antichrist figure to depict the Pope (Fig. 39). Many of the *vitae* of Antichrist in medieval art depicted his final descent into hell at the hands of St Michael. The model for the *Passional*'s illustration of the Pope can be found in one such illustration taken from Schedel's 'popular' *World Chronicle* of 1493.[183] In the Schedel illustration, it is Antichrist who grapples with the Beasts as he falls from the sky, but in Cranach's, it is clearly the Pope-as-Antichrist who falls helplessly towards the flames. In taking on the composition from an earlier, well-known depiction of Antichrist, Cranach was ensuring an identification with the papacy. Scribner argues that the success of Cranach's *Passional* was due to the way in which many similarly simple, yet effective criticisms of the papacy were brought together in an uncomplicated and undemanding visual format.[184] Certainly, one cannot overemphasize the importance of the *Passional* in iconographical terms. The one Latin and ten German editions of this work, with their visual contrast between Christ and the Pope, form an iconographic tradition that extended into the seventeenth century. This also became the basis of numerous other works of visual propaganda including, of course, the illustrations to Rev. 11 and 17 in Luther's Apocalypse illustrations of 1522, in which the Beasts are depicted as wearing the papal tiara, in a further extension of the polemical Antichrist tradition.[185]

### 5.4.3 Cranach's Book of Revelation illustrations, publication and reaction

It is certainly possible that Luther was impressed by Cranach's simple yet highly effective visual style in the *Passional* woodcuts, for, in 1522, he commissioned the Cranach workshop to provide twenty-one woodcut illustrations for his new translation of the Book of Revelation. He had translated the entire New Testament into German between December 1521 and the end of February 1522, during his confinement in the Wartburg. Melchior Lotter the Younger of Wittenberg was employed as the printer, and Cranach and Christian Döring were the publishers. The Book of Revelation was the only book to be illustrated (the reasons for which will be discussed further below) and some of these illustrations bear the Cranach monogram.[186]

---

[183] Scribner 1981: 156.        [184] Ibid. 157.

[185] See also among others: Hans Holbein the Younger, *Christ the Light of the World* (British Museum); Master MS, *Christ and the Sheepfold* (Germanisches Nationalmuseum, Nuremberg); title-page to *Verhor und Acta vor dem Byschoff von Meyssen* [J. Grunenberg, Wittenberg, 1522] (British Museum); Peter Fletner, *The New Passion of Christ* (1535); *The Pope as Bad Thief* (Germanisches Nationalmuseum, Nuremberg); Hans Sebald Behem, *The Fall of the Papacy*.

[186] Newman 1985: 106.

Surprisingly, neither the date of the publication, nor the names of the printer or translator are given in this September 1522 edition, perhaps due to a certain cautiousness regarding Luther's 'banned' status at this time, a cautiousness that does not appear to have extended to the daring images.[187] Lotter worked on three presses simultaneously in order to get three thousand copies of the first edition out in time for the Leipzig Book Fair at the end of September 1522. The fact that he published three thousand copies was unprecedented at this time and would have involved a huge capital outlay in terms of materials and time. This outlay would have been partially shared by his co-publisher, Cranach. It seems clear, therefore, that all three men were expecting the book to sell extremely well, an expectation that is reflected in the price (a reasonable one and a half gulden) and in evidence that we have from the time regarding the speed with which Luther's publications tended to sell out. For example, in 1519, a friend of Agrippa of Nettesheim wrote to him from Basel that: 'I have walked up and down throughout the whole city of Basel. Luther's works are not for sale anywhere. They have long since been sold.'[188] Similarly, Spalatin (a friend and correspondent of Luther's) had the following to report regarding the sale of Luther's works at the Frankfurt Book Fair of 1520: 'Nothing is bought more often, nothing read with more appetite.'[189]

This demand for Luther's works clearly encouraged the printers to increase the number of copies produced and, in doing so, they were prepared to go to all sorts of lengths to procure copies of the original texts. An anonymous source from Zwickau reported that: 'The whole world wants to deal in Dr Martin Luther's books and get rich doing so.'[190] Due to the fact that the first Imperial copyright was not introduced until 1530, there was little Luther could do to prevent other, unauthorized, printers from printing his works. Thus his Bible was widely plagiarized between 1522 and 1529, resulting in numerous errors being introduced into his original text when unauthorized copies were being reset.[191] Despite the fact that, in 1524, Luther introduced his 'Luther rose' mark, as well as his statement of personal copyright on versions that he had personally overseen, this had little effect in halting the production of pirated copies, as it was not legally binding. The most remarkable 'copy' of Luther's 1522 New Testament was printed at the request of Duke Georg of Saxony, an aforementioned enemy of Luther to whom Cranach had sold a set of the Apocalypse woodcuts. The text of Luther's Bible was reproduced quite faithfully in Duke Georg's edition, with the addition of a commentary by

---

[187] Luther's New Testament did not carry his name until the eighth edition, which came out in 1524.
[188] Cited in Krieg 1953: 223–4.
[189] Ibid.
[190] Ibid.
[191] Newman 1985: 109.

Jerome Ems explaining exactly why Luther's translation was so damaging.[192] This development represents an interesting example of the reception history of Cranach's illustrations, which in itself would constitute an interesting future study.

Lotter's gamble with regard to the popularity of Luther's New Testament was rewarded with significant commercial success, and in December a new edition had to be printed. There were relatively few emendations to the text itself, but the same cannot be said of the woodcuts. The September 1522 woodcuts carried at least five explicit polemical references to the papacy as outlined in Appendix 3, Table 4. In the three months prior to the December version being published, these polemical details were dampened down, or even in some cases completely eradicated.[193] Thus, the papal tiaras in illustrations C11, C16, and C17 were literally cut out of the woodcuts, leaving more innocuous single tiered crowns in their place. In the case of illustrations C11 and C17, one can clearly see the empty space above the crowns where the two further tiers had once been. This hurried move may have been a response to a ban on sales of Luther's New Testament in nearby Ducal Saxony in November 1522 by Duke Georg of Saxony. The woodcuts were particularly criticized in the ban, being referred to as 'several insulting pictures designed to ridicule and insult his Holiness . . . '.[194] So outraged was Duke Georg by the sale of these Bibles that he actually offered to buy back the offending books from those who had already purchased them but received a muted response.[195]

### 5.4.4 Luther's role in the illustrations for the Book of Revelation

Unlike Dürer, who was his own master in deciding how to depict the Book of Revelation, Cranach was clearly providing a service for Luther, as well as attempting to turn a profit for himself in his role as joint-publisher with Döring.[196] Not surprisingly, given the preceding discussion of the marginalized role of the artist in the creation of new Lutheran images, Cranach does not appear to have provided the lead with regard to how the Book of Revelation should be illustrated. There were clearly two main aims with regard to these specific illustrations. Luther's first ambition was that they should be as true to the text and as visually simple as possible. Their primary purpose was illustrative and didactic. This ambition was a direct result of Luther's rather ambiguous stance towards the Book of Revelation itself, as well as to his views

---

[192] Newman 1985: 110.       [193] String 2000: 139
[194] Reinitzer 1983: *Biblia Deutsch*, entry 108.
[195] Edwards 1983: 41–2.
[196] While Luther's exact involvement in the 1522 New Testament is not documented, his overseeing of the design for the 123 prints for his complete German Bible of 1534 is attested to (See Koerner 2004: 42).

on illustrations of biblical texts in general. The second aim of the illustrations was even simpler: to continue and extend the polemical iconographic tradition established by Cranach in his *Passional*. This aim reflects Luther's changed attitude towards the Pope and the institution of the papacy by 1522. Luther discusses his attitude to the papacy and how it changed in his 1545 preface to his Latin writings.[197] Here he describes how his early attitude of deference towards the Pope (i.e. in 1517) was slowly eroded after reading Lorenzo Valla's exposé of the *Donation of Constantine* as a forgery in 1520. This increasingly negative attitude towards the Pope was compounded by the events of 1520 during which the Pope condemned Luther with a papal Bull, the *Exsurge Domine*.[198]

Luther's ambivalent attitude towards the Book of Revelation and to apocalyptic texts in general is fairly well documented. He first touched on the issue in his *Vorrede auf die offenbarung St Johannis* in the September 1522 version of his New Testament.[199] This preface was amended and considerably extended in the 1530 version of his Bible in order to take into account his more developed, closely historical reading of the Book of Revelation. He seemingly put aside his earlier concerns regarding apostolic authorship and made correlations between characters in the Book of Revelation and actual historical figures, thus building on elements from the linear-historical method of exegesis.[200] However, in 1522, Luther did not apply this exegetical method to the Book of Revelation. Instead he compared it unfavourably with other New Testament texts.

The four main objections that he outlines in the 1522 preface may be summarized as follows. First, he maintains that on account of its visionary content (as opposed to the 'plain' words of Peter, Paul, and Christ in the Gospels), he considered it to be neither apostolic nor prophetic. The visionary content also led him to doubt whether the Holy Spirit had produced it. Secondly, he maintains that the author of the book has commended his work more highly than he should have done (cf. Rev. 1: 1–3; 22: 8 ff.). Thirdly, he cites the fact that many of the Early Church Fathers rejected the work as evidence of its inferior status. Lastly and most importantly, Luther states the following:

Christ is neither known nor taught in it [the Book of Revelation]. But to teach Christ, this is the thing which an apostle is bound above all else to do; as Christ says in Acts 1, 'You shall be my witnesses'. Therefore I stick to the books which present Christ to me clearly and purely.[201]

[197] Luther, *WA* 54: 184; *LW* 34: 334.
[198] See MacCulloch 2004: 127–8 for more information on Luther's relationship with the Pope.
[199] Luther, *WA* DB 7: 404; *LW* 35: 398–9.
[200] Luther, *WA* Bibel 7: 408. See further Krey 2002: 140; Backus 2000: 6–11.
[201] Luther, *LW* 35: 399.

In light of the views expressed by Luther on the Book of Revelation, it is perhaps surprising that he wanted it to be illustrated at all in his 1522 New Testament. Surely it would have been better to leave it unillustrated (like all the other books of the New Testament) and unnoticed at the back of the edition. However, such a solution would have failed to take into account other external factors, such as the ongoing debate with Karlstadt and Luther's resultant desire to promote the positive qualities of simple, mimetic images. Parshall argues that, 'the September Testament was a very tentative test of the propriety of making religious images, something at this stage that Luther implicitly acknowledged to be a problem'.[202] The unclear, metaphorical nature of the Book of Revelation, on which Luther had commented, meant that it was both useful and justifiable to illustrate it, in order that a 'popular' audience might understand it better and, one suspects, in order that they did not interpret it in a way that Luther would find dangerous.

### 5.4.5  Dürer's and Cranach's Apocalypse images: a comparison

Luther's reported aims seem to be reflected in Cranach's full-page illustrations, which measure 23.3 cm × 16.1 cm.[203] Although it is the view of most commentators that Cranach's illustrations would not have been possible without Dürer's, Cranach has diverged from Dürer's example in two significant ways. First, by expanding the number of illustrations from fifteen to twenty-one, Cranach had to make compositional changes, as well as inventing new compositions of his own for the extra illustrations. The insertion of six extra illustrations led to a more easily comprehensible text–image relationship. It meant that, as a general rule, and in marked contrast to Dürer's series, the illustrations appeared opposite the text of the chapter that they were depicting. In some ways, this marks a return to the ordered structure of, for instance, the Anglo-Norman Apocalypse manuscript whereby the illustrations always appeared in exactly the same place on each page, so as to perform their largely illustrative, didactic function. Second, and in line with Luther's requirements, Cranach changed small details in the Dürer compositions in order to reflect the text more accurately. The main differences between the Dürer cycle and the Cranach illustrations have been summarized in Appendix 3, Table 5.

A glance through the Cranach illustrations allows the viewer to see straight away that they offer an altogether more comprehensively literal version of the Book of Revelation. Scenes that Dürer had omitted, probably because he found them to be too repetitious, have been carefully included by Cranach. Thus, Cranach's own versions of the sixth seal: C5 (Rev. 6: 12 ff.), the fifth trumpet:

[202] Parshall 1999: 104.
[203] See *Lutherbibel* 1522, London: British Library, C. 36. g. 7 for a full set of Cranach's images.

C8 (Rev. 9: 1–6), the Two Witnesses: C11 (Rev. 11: 1–13), the harvest of the earth: C15 (Rev. 14: 14–20), the angels with the seven bowls: C16 (Rev. 15–16), the fall of Babylon: C18 (Rev. 18), and the rider on the white horse and the defeat of Satan: C19 (Rev. 19–20) all appear in his illustrations. It is worth noting that Cranach's own compositions (i.e. where he has had no lead from Dürer) tend to be much weaker, with quite a large amount of unfilled space, the only exception being his fall of Babylon (C18). The result is that Cranach's illustrations appear much calmer, less urgent, and less psychologically convincing than Dürer's.

It is also particularly noticeable that John has a different appearance in many of the images, which interferes with the overall continuity of the Cranach series. In C1 (Fig. 40), the John figure is depicted as wiry-looking with a hook-nose and quite wild curly hair. In C2, the John figure is noticeably squatter and fatter, does not have a hook-nose and has shorter hair. In C10, he is not immediately identifiable with either of the previous two Johns. The John of C21, meanwhile, is an imitation of Dürer's John in D15. Thus, while the emphases in the Dürer series had been on naturalism, psychological realism, and continuity between the images, so as to give the impression of a continuous vision, already we have a sense that in the Cranach illustrations the emphasis is on presenting the viewer with a literal, chapter by chapter digest of the Book of Revelation above all else. The lack of continuity in the way that the John figure is depicted in the Cranach images also means that Dürer's emphasis on John as an important visionary is completely lost. Perhaps Cranach's careless approach to visualizing the John figure indicates a certain sympathy with Luther's negativity towards the visionary in his 1522 preface, in which he accuses the apostle of claiming too much authority for his work.[204]

In apparently depicting John in his own likeness at crucial moments of revelation, Dürer was not only identifying himself with the recipient of the Book of Revelation, but also retaining elements of the medieval characterization of John as 'guide'. In Dürer's images, John, while not appearing in every image, as was the case with the *Angers* images, for example, appears at the beginning, middle, and end of the visionary journey. This use of the John/Dürer figure, combined with Dürer's understanding of the image as an extension of the artist, created a structure within which even the images in which John is not present function as visual revelation. Cranach, meanwhile, by including John in only four of the twenty-one images (C1, C2, C10, C21), ensures that there is no visual continuity in his portrayal. In doing so, he loses one of the overarching themes or narrative threads that had helped to hold together previous series of Apocalypse images. Nor does one get any sense that

---

[204] Luther, *LW* 35: 399.

Cranach was personally identifying with the visionary figure through the images or use of his monogram.

Cranach's handling of the final images in the series is also very different. Both the Koberger and the Dürer Apocalypse Series offer very compressed or synchronized interpretations of the closing chapters of the Book of Revelation. Dürer's final image in particular raises questions about his, possibly millenarian, interpretation of the final chapters of the Book of Revelation. By separating the illustrations to Rev. 17, 18, 19, 20, and 21 into individual images (one per chapter), Cranach evokes a more pedestrian yet more certain climax to his series of images. Having depicted the Destruction of Babylon and the Defeat of the Beast in C18 and C19, respectively, Cranach separates out Dürer's final image (D15) into two illustrations and, in doing so, radically changes the implied reading of the final chapters. Cranach, copying Dürer's figures fairly faithfully, presents the binding of Satan as taking place in C20. C21, which appears opposite the text of Rev. 21, is therefore almost certainly intended to represent the New Jerusalem. This represents a slightly strange use of Dürer's image by Cranach given that, as discussed above, Dürer's city lacks many of the celestial details described in Rev. 21–2.

Cranach's apparent reluctance towards visualizing the earthly millennial reign of Christ, as Dürer seems to have done, may reflect a Lutheran ambivalence towards millennial exegesis of Rev. 20. Certainly in his exegesis of Rev. 20 in his 1530 preface, Luther is vague regarding his understanding of the millennium. He argues, in short, that the whole period from the beginning of Christianity up until the Last Judgement corresponds (metaphorically) to Rev. 20: 3, the binding of Satan and the millennial reign of Christ. This 'millennium' was set to end in his age of renewed purity, itself the precursor to the final battle (Rev. 7–10) and the Last Judgement (Rev. 20: 11–14).[205] Thus, for Luther, and it seems for Cranach also, the millennium is almost over, while for Dürer, it lay in the future.

With regard to the Dürer illustrations that were not copied by Cranach, we can afford to be brief. Cranach does not copy Dürer's first martyrdom scene because it is apocryphal and Luther required 'only the content of the text' to be illustrated. In doing so, Cranach loses the interesting continuity that Dürer had introduced, not only regarding the John figure, but also between the crowd in his first image and the crowd in D14, which depicts the Whore of Babylon. Cranach does not copy D11, St Michael fighting the Dragon, because this scene is derived from Rev. 12: 13–17 and, accordingly, Cranach merely incorporates the fight scene into the top right-hand corner of C12, his depiction of the rest of Rev. 12.

---

[205] Luther, *WA Bibel* 7: 416; Backus 2000: 10–11.

With regard to the details that Cranach altered, we shall here focus first on those that Cranach changed in order to make his interpretations either more literal or more representative of the reforming message. Secondly, we shall look at Cranach's insertion of polemical details into his Book of Revelation Series with particular reference to C17, the Whore of Babylon.

In Dürer's version of the vision of the seven candlesticks (Fig. 34), following the illustration from the Koberger Bible, he represents the One like the Son of Man (Rev. 1: 12 ff.) as the Christ of the Last Judgement, indicated by the fact that he is holding a book and is seated on a rainbow. Neither of these details appears in the text of the Book of Revelation and so, in the Cranach version, both these interpolations are eliminated (C1, Fig. 40). The Son of Man figure is pictured as standing (Rev. 2: 1, cf. Rev. 1: 13–16), with a sword coming directly out of his mouth (a detail Dürer also includes, see Rev. 1: 16) and, unlike the Dürer Son of Man (D2), who is illuminated from behind, the Cranach figure is depicted exactly as described in the text: 'like the sun shining in full strength' (see also Rev. 1: 16). Cranach even observes the tiny detail from Rev. 1: 13 that the figure is wearing a girdle round his breast. Dürer had placed the girdle, more naturally, around the waist of his Son of Man. John's stance is also quite different from Dürer's John, who kneels at the figure's feet. Cranach's John lies prostrate at the feet of the Son of Man, with his head turned away from him in accordance with Rev. 1: 17: 'When I saw him I fell at his feet as though dead.'

Thus, while the two images are superficially similar, a considerable amount of thought must have gone into the adjustments that have been made to the Cranach version in order to make the illustration more textually accurate. With regard to C2, the throne-room of Rev. 4 and 5, Cranach has simplified Dürer's composition, with the result that the viewer sees only the heavenly realm and not the two tiers of heaven and earth as in the Dürer image (D3, Fig. 35). Cranach's composition is the poorer for this, as one loses the juxtaposition between the two realms that not only renders the Dürer image so visually arresting, but also provides the first visual key to the heaven–earth dualism that pervades the Book of Revelation itself. With regard to Cranach's observance of textual detail, he has included the 'golden vials full of odours' held by the Elders in Rev. 5: 8 that Dürer had left out altogether.

C4 and C5 represent a further 'simplification' of the Dürer programme in which D5, the opening of the fifth and sixth seals, has essentially been spilt across two different images. Superficially, it looks as though the two images have been reproduced on a larger scale. However, the fact that one's attention is totally focused on the clothing of the martyrs in C4 (in contrast to in D5, where the clothing of the martyrs takes place right at the top of the picture in miniature) is very significant. If one actually goes back to the section of text that Cranach's image represents, one sees how well Rev. 6: 9 accords with the experience of the reformers: 'I saw under the altar the souls of those who had been slain for the Word of God and for the witness they had borne.' One also

notes with reference to C4 (as well as C7 and C9) that Cranach uses very plain unadorned altars, in contrast to Dürer's much more ornate altars in D5, D7, and D8. This surely reflects the 'pared-down' style that was the hallmark of the reformers' worship.[206] In C9, for instance, the huge, bare altar dominates the composition by virtue of its size and the fact that an impression of light has been created around it through Cranach's use of blank space. Down below, Cranach has strongly emphasized the serpentine tails of the cavalry (see Rev. 9: 19), in contrast to Dürer, who depicted the demonic army in miniature near the top of D8. This may be self-referential, given that a serpent symbol often appeared in Cranach's prints by his monogram.[207] Cranach's clouds are also particularly serpentine (see C10, C17 (Fig. 41), for example), testament perhaps to the battle between good and evil that is being played out in heaven as well as on earth. Indeed, in C10 the clouds are clearly identifiable as little beasts who look as though they are fighting with each other.

In C6 Cranach may also have been playing with the tree motif that was to become so important in his many versions of *The Law and the Gospel*. Cranach divided most of his compositions of *The Law and the Gospel* into two halves, using a tall tree with full leaves on one side and bare branches on the other to signify the two opposing dispensations, between which the viewer has to decide.[208] In C6 Cranach has left out Dürer's healthy-looking tree (trees having been mentioned in Rev. 7: 1 and 7: 3) in favour of a tree that is healthy and full of leaves on top, but completely bare at the bottom. This is perhaps a vertical version of the tree motif from the *Law and the Gospel*. Here, in C6, the healthy tree represents the heavenly realm and the bare branches represent the spiritually impoverished earthly realm.

Another area in which the Cranach images differ from the Dürer images is in his treatment of the Deity. In Dürer's images, a Divine figure appears very prominently in five images. In three of these images, D7, D8, and D12, the Deity also plays a prominent role in the activity of the scene. In D7 and D8, he is actually depicted handing out the trumpets to the angels, whereas in D12 (as discussed above), he holds a sickle in his right hand in a gesture of judgement over the scene unfolding below. In Cranach's version of these images (C7, C9, and C13 respectively), in contrast, the Deity has been relegated to a fairly passive position or, in the case of C13, he has been removed from the scene completely. These amendments to Dürer's compositions may well reflect Luther's claim that 'Christ is neither known nor taught in the Book of Revelation'.[209]

---

[206]  Koerner 2004: 39–40.
[207]  See Landau and Parshall 1994: 191–3.
[208]  See especially *The Law and the Gospel* 1529, Prague.
[209]  Luther, *LW* 35: 399.

Cranach is also much more 'literal' with regard to the figures in his crowd scenes. It has been noted above that Dürer often included bishops and even Popes in scenes of destruction (see D4, D5, D8) and, in one case, one of worship (D13). Obviously, these were 'extra-textual' additions by Dürer as the text of the Book of Revelation does not refer to Popes or bishops. Thus Cranach removes Dürer's 'Popes' from C3, C5, and C8. Similarly, the bishops have been removed from C13 and C14. This is intriguing, as it has been noted in Table 4 that, on other occasions, Cranach has deliberately added anti-papal imagery. It seems that Cranach only wanted to add such polemical imagery where there was a direct correlation to be made between the Pope and Antichrist imagery. In other words, he did not want to include Popes in random scenes of destruction but only when there was a very specific identification to be made for particular propagandistic purposes.

Turning now to Cranach's handling of his visual polemic in the series, the obvious difference between the Cranach and Dürer series is the addition of the papal triple tiara to Cranach's Whore of Babylon (C17, Fig. 41), as well as to the Beasts in C11 and C16. The *Passional* of 1521 had asserted through visual means and to a 'popular' audience that the Pope was in fact Antichrist. By this time, Luther too was certain of this fact.[210] Given the exegetical links that had already been made between the Antichrist figure and the Beasts of the Book of Revelation, it is not surprising that the latter wear the triple tiara in Cranach's Apocalypse illustrations, although this would still have been extremely provocative. Rev. 19: 20–1 and 20: 10, for example, in which the Beast and the False Prophet are thrown down into the lake of fire and sulphur, were often cited in this period as the probable fate of the Antichrist.[211]

The link between the Antichrist, the Pope, and the Whore of Babylon is a little harder to follow. Scribner suggests that the equation of the papacy with the Whore may have been suggested by the legend of Pope Joan, which became popular in the late medieval era.[212] The legend told of how a woman had managed to become Pope in the ninth century, a role that she carried out successfully for two years before being exposed after unexpectedly giving birth near St John Lateran in the middle of a procession. That this legend was well known in Germany in the late fifteenth and early sixteenth centuries is attested to by the number of sources in which it appears. It is mentioned in Boccaccio's *On Famous Women*, which came out in a 'popular' German translation in 1473. Pope Joan was also the subject of a play written around 1480 in which she is called Frau Jutta, as well as appearing in two works by Thomas Murner, published in 1514 and 1517. Hans Sachs used the legend in a song of 1532 and in a broadsheet. Finally, there were at least

[210] See Luther, *WA BR* 2: 48–9 and Luther, *WA* 6: 597–612, for example.
[211] See for example the commentary to the 13th picture pair in Cranach's *Passional*.
[212] Scribner 1981: 171–3.

three broadsheets published in the 1540s that mentioned the subject, some even including woodcuts of Pope Joan giving birth in the middle of the procession.[213]

The appeal of the legend, which even the Catholic authorities accepted as historically authentic, for Protestant propagandists is evident. First it refuted the papacy's claim to an unbroken male succession. But secondly and perhaps more importantly, this 'popular' legend (whether it was in fact based on any truth or not) served to link the papacy with allegations of sexual immorality and deception. Scribner claims that the existence of the legend in 'popular' culture made the equation of the papacy with the Whore of Babylon inevitable.[214] While there is no reference to the Pope Joan legend in Cranach's Apocalypse illustrations, it is clearly alluded to in Martin Schrott's *On the Terrible Destruction and Fall of the Papacy* (*c.*1540). This work was a picture book based on the Book of Revelation, with one of the illustrations depicting the Whore in her customary pose on the Beast being worshipped by the emperor and princes. She is clearly wearing papal ceremonial garments and the triple tiara. Above her head an inscription reads: 'Agnes, a woman from England, called John VII in the year 851' (Agnes was also known as Ghiberta in some versions of the legend).[215]

Despite the fact that the papal tiaras from the September 1522 version of Cranach's Apocalypse illustrations were cut away in time for the December edition, the iconographic legacy was not eliminated. In fact, in his Apocalypse illustrations of 1523, Hans Holbein the Younger used all the papal motifs from the September 1522 edition. The Apocalypse illustrations in Luther's complete (and completely illustrated) Bible of 1534 gave the Beast and the Whore very prominent and much bigger triple tiaras than in the September 1522 version.[216] Indeed, they are so large that they render the 1522 triple tiaras positively unobtrusive. Aside from biblical illustrations, the iconographic association between the Whore of Babylon and the Pope quickly entered 'popular' culture. The title-page of a 1546 pamphlet, for instance, carries a woodcut of the Pope dressed as a warrior astride the Seven-headed Beast, accompanied by the Whore of Babylon.[217] The scene is reminiscent of the imperial motifs in Cranach's *Passional*, as the Pope is once again depicted as holding the imperial symbols, the orb and the sword of secular power. The extent to which Cranach's polemical Whore of Babylon was reproduced in representations of many varying standards over the next century and a half is testament to the power of his original image. Although a pale imitation in stylistic terms of Dürer's Whore of Babylon, in just a few woodcut lines Cranach designed something lasting and iconic. However, simultaneously,

---

[213] Scribner 1981: 171–3.        [214] Ibid. 172.        [215] Ibid. 173.        [216] String 2000: 140.
[217] View the illustration in *Des Bapsts und der Pfaffen Badstub* (J. Cammerlander, Strassburg, 1546).

he also served to limit the interpretative potential of the Whore of Babylon. For once one has seen the Whore in the triple tiara, it must have been difficult to think of her in any other way, with the subtlety of Dürer's interpretation now superseded by an image from the propaganda machine of the Protestant movement.

On an interpretative level, however, there is also a sense in which Cranach's polemical representations of Rev. 11, 16, and 17 (C11, C16, and C17) are actually *more* and not less faithful to the spirit of the Book of Revelation than those by Dürer. For it can be argued that Dürer's less explicitly political reading misses something that is crucial to a text such as the Book of Revelation, where the political element is very much to the fore.[218] Brook and Gwyther sum up the contemporary 'political' appeal of the Book of Revelation thus:

> Revelation spared nothing in its critique of empire. In being faithful to John and his vision, we must submit ourselves to the same no-holds-barred critique. Revelation does not lend itself to neutrality. The passion with which Revelation was so obviously written either repulses or engages readers.[219]

Cranach's polemical 'reading' of the text successfully engages with the original polemical passion to which Brook and Gwyther are referring. This in itself raises an interesting question regarding the type of visual exegesis in which Cranach was engaging, with both the Apocalypse illustrations of 1522 and, to a certain extent, the illustrations for the *Passional*. For the polemical details prevent his 'reading' of the text from being straightforwardly literal. Rather, he was 'actualizing' the text for a particular purpose.

Emmerson argues that Cranach's polemical insertions resemble, in purpose and effect, contemporary Protestant exegesis, such as that found in the Geneva Bible.[220] Alongside the exegetical points made regarding the text of the Book of Revelation in the Geneva Bible (first published in London in 1560), there are also many polemical identifications made between the Beasts of the Book of Revelation and the papacy. These points serve the anti-papal Reformist agenda and are examples of this agenda being projected onto the text (eisgesis). To Rev. 17: 3–4, which comes from the description of the Whore of Babylon, the following note has been attached: 'The Beast signifies the ancient Rome: the woman that sitteth thereon, the new Rome, which is the Papistrie, whose cruelty and bloodshedding is declared by scarlet . . . This woman is the Antichrist, that is, the Pope with the whole body of his filthy creatures . . . '.[221]

---

[218] Brook and Gwyther 1990: xxiv; Rowland 1993: 37–53.
[219] Brook and Gwyther 1990: xxiv.
[220] Emmerson 1981: 222.
[221] The Geneva Bible 1560: 120.

This type of polemic is also evident in the marginal notes that begin with an exegetical emphasis such as in this note to Rev. 9: 3 (the locust army): 'The Locusts are false teachers, heretics and worldly Prelats, Monks, friars, Cardinals, Patriarchs, Archbishops, Bishops, doctors, bachelors and masters which forsake Christ to maintain false Doctrine, false and deceivable doctrine which is pleasant to the flesh.'[222] In this instance, the exegetical slant to the note breaks down into anti-ecclesiastical polemic. The ease with which the distinction between the two can be collapsed suggests that it is very simple for authors of such texts to move from one genre of interpretation to another. It seems, on the evidence of Cranach's Apocalypse woodcuts at least, that it was equally easy for Protestant artists to move between the two modes of hermeneutical approach. Emmerson sums it up thus:

> Although Protestants emphasised literal readings of scripture, they were not averse to directing the reader to their particular interpretation. The Apocalypse illustrations must have been particularly repugnant to Catholics on the one hand, and must have greatly influenced the growth of anti-Catholicism among Protestants on the other hand.[223]

## 5.5 CONCLUSION

This chapter has concentrated on visual interpretations of the Book of Revelation from the late fifteenth century to the early sixteenth century, with particular reference to the Koberger Bible of 1483, Dürer's Apocalypse Series of 1498/1511, and Cranach's illustrations for Luther's New Testament of 1522. Each of these three examples represented a different type of biblical illustration: the Koberger illustrations were primarily for devotional use, Dürer's Apocalypse Series was primarily an aesthetic enterprise, and Cranach's Apocalypse illustrations were both instructive and polemical. All three examples, in contrast to those discussed in the previous two chapters, utilize a book-format in which the images are juxtaposed with the text of the Book of Revelation. In comparison to the Anglo-Norman manuscripts considered in Chapter 1, comparatively few images are used in these later visualizations of the Book of Revelation.

In historical terms Dürer and Cranach's images are particularly interesting. Dürer's Apocalypse woodcuts represent his entry into the sphere of the Renaissance 'super-artist', whilst at the same time remaining late medieval in their religious outlook.[224] Cranach's images, meanwhile, whilst capturing

---

[222] The Geneva Bible 1560: 118.     [223] Emmerson 1981: 223.
[224] Koerner 1993: 204–5. See Kemp 1989: 32–53 on the artist as 'super-genius' in the 16th cent.

the spirit of Reformation exegesis of the Book of Revelation, remain late medieval in their artistic scope. The two sets of images, both woodcut series of the Book of Revelation made within twenty-three years of each other, thus exemplify different visual and religious approaches to the same text.

In hermeneutical terms, Dürer's reliance on the Koberger images for many of his compositions implies a desire to express the entire narrative with only a few images, rather than to give visual priority to certain parts of the text, as Memling had done. This compressed style of visualization is both dramatic and effective. Using his sophisticated and naturalistic woodcut style, he evokes the two-tiered thought-world of the apocalyptic text powerfully, through the use of his two-level schema, for example. In places, he also suggests a radical interpretation of the text. Additionally, Dürer inserts himself into the narrative through his depictions of John in his own likeness and through the strategic use of his monogram. While the text remained an important part of the Dürer publication (initially at least), the authoritative claims that Dürer makes on behalf of his images suggest that the text is being overthrown, or perhaps even rendered redundant. Dürer's desire to create the 'definitive' visual Apocalypse may also have prevented him from engaging more deeply with the textual symbolism of the book. At times therefore, in hermeneutical terms, though not in aesthetic ones, one is frustrated by the straightforward literalism with which he has depicted the text, especially due to the fact that in other places he demonstrates an impressive textual sensitivity.

Cranach's images meanwhile are unashamedly literalistic. Compositional subtlety, compressed visualizations, and Dürer's 'two-level' schema are all sacrificed in the name of comprehensibility. Unlike Dürer's images, Cranach's all appear opposite the chapter of text that they depict. The 'point' of the Cranach images can be grasped on the first viewing, after which they serve as elucidatory memory aids to the section of text that they illustrate, just as Luther had intended.[225] However, it was also suggested that in some ways, the polemical details, such as the papal triple tiara worn by the Whore of Babylon in C17 (Fig. 41), reveal an exegetical sympathy with the polemical passion of the source text.

---

[225] Luther, *WA* 18: 80a.

# 6

## Hermeneutical Reflections
## and Visual Exegesis

### 6.1 INTRODUCTION

As stressed in the Introduction, on one level the seven case studies that comprise the body of this study are an end in themselves. They represent an attempt to engage with important strands of the visual reception history of the text of the Book of Revelation in the late medieval and early modern period. Each of the seven carefully chosen visualizations were considered from art historical, historical, and theological points of view in order to uncover the specific cultural, artistic, and theological context of each work, as well as its likely original function. The case studies therefore represent a contribution to the history of the interpretation of the Book of Revelation.

However, this study has another important focus, that of making a contribution to the discussion of visual exegesis more generally, which has begun to be considered in the fields of art history and biblical theology.[1] This contribution falls into two distinct yet interrelated parts. In the first part of this chapter, the different (visual) hermeneutical strategies employed by the various artists in question towards the Book of Revelation will be isolated, discussed, and analysed. The tools for discerning a visual hermeneutical strategy are as yet underdeveloped when compared with those for discerning textual hermeneutics. Thus it is only now, at the end of the project, and, crucially, in light of the historical and art historical work that has been done on each of the seven main works of art under consideration, that these different visual strategies can be drawn together with greater clarity. That is not to say that visual hermeneutical strategies are less precise or illuminating than those found in textual hermeneutics, far from it, but rather that while some emerged immediately, others were not so easy to articulate until they had been set against other visualizations, as well as against textual interpretations and a language developed for expressing the various strategies at work. These tasks having been

---

[1] See particularly Berdini 1997: 1–35 and O'Kane 2005: 337–73 and 2007.

carried out, several contrasting and important hermeneutical strategies have clearly emerged from within the visual case studies. This to an extent mirrors the experience of biblical exegetes working in the history of interpretation of the Book of Revelation as well as other biblical texts.[2]

These hermeneutical reflections, and the second-order reflection that takes place on them in Section 6.4 below, will, it is hoped, lead to an appreciation of an important strand of visual exegesis whereby images function as ways of expressing the subject-matter of the text and possibly, in the process, as offering a critique of elements of the text. Rather than attempting to illuminate the minutiae of the text, many of the late medieval and early modern examples discussed in this study represent an attempt to evoke via visual means what they or their patrons believed the essence or *Sache selbst* of the Book of Revelation to be. Images by their very nature cannot offer a detailed dissection of a biblical text. Those that attempt this, such as *Lambeth* or *Angers* quickly become repetitive, confusing even. Other images are, however, able to bring together the perceived fundamental elements of the text via one synchronic image or a short series of images. Artists, such as Memling, Botticelli, or Dürer, who have achieved this, are not exegetes in the narrow sense of the word but if exegesis is to be thought of as an illumination of the very essence of a text, as proponents of *Sachexegese* have done, then there are important comparisons that can and shall be made.[3] This section will end with a consideration of a recent series of images of the Book of Revelation by Kip Gresham. While Gresham falls well outside the historical parameters of this study, it is felt that his series of images embodies a crystallization of the type of artistic *Sachexegese* witnessed in the work of Memling, Dürer, *et al.*

A second, complementary strand of visual exegesis emerges in the second part of this chapter, whereby images are presented as a more appropriate medium for expressing the *character* of a text such as the Book of Revelation, which is itself dependent on 'something seen'. It has already been observed that all of the artists featured in this study have offered distinctive (and sometimes contrasting) interpretations of the *visionary* character of the Book of Revelation. This visionary character, an important topic in its own right, is explored at greater length in Appendix 1. For the medieval and early moderns however, visionary experience was accepted as a legitimate means of divine communication.[4] This is reflected in all of the seven case studies that have been discussed in this study, whereby the visionary character of the source text is emphasized and explored, usually but not always, via the figure

---

[2] See McGinn 1987; Luz 1994; Kovacs and Rowland 2004; Gillingham 2007: among others.

[3] See Rowland 2011: chs. 2 and 3 on *Sachexegese*.

[4] See, for example, Richard of St Victor's commentary on the Book of Revelation in which he discusses the four 'modes' of visionary experience: two physical and two spiritual (PL 196: 686 ff). See also Dronke 1984: 144–201.

of John. In such artistic examples, the perceived visionary character of the text is sometimes emphasized over and above its subject-matter or *Sache selbst*. While the visionary character of the Book of Revelation was emphasized in some important contemporary commentaries, such as that of Richard of St Victor's, it was played down in others, such as the influential Berengaudus commentary, which read John's visions, for the most part, as symbolic representations of the history of the Church and presents John as a minor figure in the narrative.[5]

While many textual exegetes, such as Berengaudus, were indeed more preoccupied with offering their interpretation of the *content* of the text, rather than engaging with or evoking its form, it cannot be denied that the overwhelming nature of the visionary experience is more powerfully captured via an image than via a textual description. This comparison may even be extended to John's textual descriptions of his visions. Compare, for example, Dürer's cowering John figure in D2 (Fig. 34) with the corresponding verses in the Book of Revelation (see Rev. 1: 9–20). The verses *describe* the visionary experience whereas the Dürer image *evokes* it for the viewer in a more direct way. Following on from this, it would seem that artists have more in common with John's attempts to articulate his actual (or contrived) visionary experiences in words, than do biblical exegetes. For the medieval and early modern artist, John had sought either to capture *or* to describe something experienced viscerally, visually, and audibly that *could* not be captured adequately with words, hence his use of 'like language' and strange literary images and metaphors. Such artists, in attempting to visualize his words were consciously or unconsciously trying to 'get at' the vision(s) they believe to lie behind the words, using a medium closer to the 'original' experience, something the artists discussed in this study seem to have implicitly or, in some cases, explicitly recognized.

These claims, regarding what one might call 'visionary' visual exegesis will be articulated with reference to some of the preceding case studies, and in particular the examples from Memling and Dürer, as well as some works by Bosch, Duvet, and Velázquez. Reference will also be made to William Blake, himself a self-proclaimed visionary, who attempted to engage with the visual aspect of the visionary experience via his art and writings. The overall conclusion to this study will relate these two strands of visual exegesis, particularly to images of the Book of Revelation, to current work being undertaken on visual exegesis by biblical scholars and art historians.

---

[5] Richard of St Victor: PL 196: 686 ff. On Berengaudus see Nolan 1977: 9–12, 68–83.

## 6.2 PART ONE: VISUAL EXEGESIS AS *SACHEXEGESE*: A CRITICAL SUMMARY OF THE MAIN FINDINGS

The various approaches illustrated by the examples discussed in the preceding seven case-studies will first be summarized and then drawn together, with a particular emphasis on the role played by 'context' on the development of visual hermeneutical strategy. 'Context' is defined here as the circumstances (historical and material) that form the setting for an event, statement, idea, or image and in terms of which it can begin to be understood. It will have become apparent that in each case, the images in question are inextricably linked with a context, whether it be a textual, a liturgical, a meditative, or a polemical one. In many ways, this is the defining feature of late medieval and early modern art.

*Lambeth* and *Angers* represent a chronological, narrative approach to the visualization of the Book of Revelation. Both stand within the dominant Anglo-Norman iconographic tradition. A large number of images are used in both cases to render an episodic, literalistic, and comprehensible approach to the text. Both works place a strong visual emphasis on the John figure who appears in most of the images as the visionary percipient. While one could argue that the images in both *Lambeth* and *Angers* perform an illustrative, rather than properly interpretative function, this is to miss several points. According to Berdini, *illustrations* are images that have been 'anchored to the literal, narrative base' of the text, whereas *images* that break free of the label of illustration are freer, perhaps unbound by chronological or narrative concerns, preoccupied not with the letter but with the spirit of the source-text.[6] While one cannot deny that formally, both *Lambeth* and *Angers* images follow the narrative of the Book of Revelation fairly literally, it has been demonstrated above that not only do both works offer some new interpretative insights into the text, but also, and more importantly, that they offer the reader/viewer the possibility of a form of imaginative engagement with the source-text.

In theory, in the case of *Lambeth*, the 'reader' would have engaged with the text–commentary–image package that appears on each page, each serving to illuminate the others. However, research into the patronage context of Lambeth and other similar manuscripts has shown it to be more likely that the images performed a meditative function for readers unable to understand the Latin text. Thus the images functioned as a gateway or vehicle that would transport the viewer to another, perhaps imaginative or visionary realm. This function is evoked by the *Lambeth* images themselves, which open with an image of John with closed eyes (fo. 1, Fig. 1) and end with him receiving an unmediated vision of Christ (fo. 39ᵛ, Fig. 4). The images thus evoke the notion of a visionary journey and of the possibility of personal transformation,

---

[6] See Berdini 1997: 9.

experiences that contact with the images may also have facilitated in the reader/viewer.

With regards to *Angers* (see Figs. 10–19), its secular, public, and ceremonial function led to the integration of heraldry and symbols from the Anjou dynasty, as well as political and historical details, into its visual narrative of the Book of Revelation, the hermeneutical politics of which will be discussed below. The grandiose aims of Louis I of Anjou also led to the transposition of an iconographic schema, lifted for the most part from Anglo-Norman Apocalypse manuscripts, onto a huge and very physical scale. Thus the transformative experience offered by Lambeth in a private, devotional context was also captured by *Angers*, but in a much larger, more all-consuming, public dimension.

The two fifteenth-century altarpieces by the Van Eycks and Memling espouse a completely different relationship with the text of the Book of Revelation. The aim of the two altarpieces was not to visualize the text in a chronological and comprehensive manner, or even in its entirety. Rather, both, inspired by elements of the source-text, have integrated apocalyptic imagery into their respective visualizations that also address more general issues. Both altarpieces were intended to function within a liturgical (as well as possibly a devotional) context. Within the altarpiece format, a greater degree of synchronicity is possible, indeed is necessary, if several ideas or images are to be brought together and successfully depicted, and therefore the constraints of the diachronic 'book-format' used by both Lambeth and *Angers* are dispensed with. While the Latin text of Lambeth and the huge size of *Angers* might have been intended to create 'awe' in their audiences, the dramatic, synchronic, and colourful qualities of both the *Ghent Altarpiece* and the *St John Altarpiece* were also intended to awe the expectant congregation when the panels were opened for services. The functional, Eucharistic setting of the altarpieces may also have played an important role in the way in which the hermeneutical strategies at work affected the viewer.

Thus, the central panel of the *Ghent Altarpiece* (Fig. 20) visualizes the Lamb of Rev. 5 at the centre of the New Jerusalem, itself characterized by the image of the Fountain of Life from Rev. 21–2. The martyrs described in Rev. 7 and 14 process towards the Lamb and the Fountain on diagonal axes. This imagery, inspired by the narrative of the Book of Revelation (and seemingly with a clear understanding of the text as a totality), but presented synchronically, also functions in combination with other elements of the altarpiece as a visual explication of the resolution achieved between heaven and earth during the sacrament of the Eucharist, a sacrament that took place on a daily basis in the Vijd Chapel for which the altarpiece was created.[7]

---

[7] Goodgal 1981: 111.

Likewise, Memling evokes chapters 1–13 of John's visions, not as they are reported in the source-text as occurring chronologically and one after the other (as suggested also by the Anglo-Norman iconography) but as taking place simultaneously within the same visual plane in the right-hand wing of the *St John Altarpiece* (Fig. 21). His Apocalypse panel represents the first known attempt at a synchronic presentation of the Book of Revelation, a brilliant visual exemplification of Lessing's well-known arguments on the differences between text and image.[8] Lessing argued that painting deals in bodies and space while poetry (or text more generally) describes actions and chronologically occurring events, thus questioning the notion of *ut pictura poesis*, which had enjoyed a revival in the eighteenth century. Lessing argued, as a result of the space–time dialectic, that the two genres of poetry and painting should be viewed as quite distinct and that this distinction should be emphasized and maintained. For Lessing, then, 'immediacy, vividness, presence, illusion, and a certain interpretative character give images a strange power, a power that threatens to defy natural law and usurp the domain of poetry'.[9] The validity of this distinction has of course been challenged, notably in recent years by W. J. T. Mitchell, who argues that although text and images are undoubtedly distinct, the rigid characterization of text as a temporal form and image as a spatial one has been unhelpful.[10] Thus although Lessing's distinction need not (and perhaps should not) be thought of as a universal one, there are undoubtedly images which exemplify what he was driving at. Memling's Apocalypse panel is one of them. His single image of the Book of Revelation, chapters 1–13 emphasizes not only the rich synchronic potential of the image but also the interpretative possibilities of a purely spatial medium.

In Memling's panel, John sits in the foreground, his visions depicted above him as if appearing in a huge 'thought-bubble'. Crucially, and in contrast to the book-format examples discussed in this study, the viewer *sees* John's visions instead of *reading* about them. What it means to have a vision and what form it might take is suggested to the viewer by this image, thus putting him/her in touch, on an imaginative level, with the experiences on which John's text might be based. Memling's image evokes the visionary experience in an unprecedented way. Additionally, by visually emphasizing the vision of the heavenly throne-room (Rev. 4 and 5) in the top left-hand corner of the panel and enclosing it within an eye-like roundel, Memling not only discloses his interpretative bias with regard to the Book of Revelation, but also shapes the experience of the viewer.[11] In this case, the eye-like roundel functions not

---

[8] Lessing 1766, tr. E. A. McCormick 1984: 7–158.
[9] Ibid. 108.
[10] Mitchell 1986: 95–115.
[11] On contemporary usage of 'eye-like' roundels see Gibson 1973: 205–26; Koerner 1998: 277; Jacobs 2000: 1028–9.

as a visual explication of the Mass (as in the Van Eycks' altarpiece), but as a 'copy' of the Divine eye looking down on worshippers as they participate in the Mass. John's visions, while depicted synchronically, are not therefore presented as equally important, thus rendering Memling's composition an important part of his overall hermeneutical strategy.

Botticelli's *The Mystic Nativity* (Fig. 25) espouses quite a different hermeneutical approach. His painting is an attempt to relate the events described in the Book of Revelation (and especially in Rev. 11, 12, and 20) to the real world rather than to the symbolic world evoked in the text. Like Savonarola before him (and as in 1 John 2:17 ff. and Matt. 25: 31–45), for Botticelli the events described in the Book of Revelation can only be understood through ordinary human experience. Thus, the dawning of the messianic kingdom evoked in Rev. 12 and 20–2 is visualized in terms of the first Nativity, believed to be a real historical event, whilst the woes described in Rev. 11 are related, in the inscription, to Botticelli's own time, specifically the year 1500. Thus *The Mystic Nativity* is the strongest example of an *actualizing* interpretation amongst the case studies presented here. By adding the inscription, Botticelli self-consciously advertised his 'actualizing' intentions to viewers (albeit perhaps only a small group of viewers who could read Greek) whilst at the same time providing them with a sort of hermeneutical key to the painting.

With Dürer's and Cranach's respective Apocalypse Series one sees a return to a book-format in which images and text jostle for position. Unlike their earlier manuscript predecessors, however, Dürer and Cranach worked with far fewer images and in the much more 'popular' woodcut medium. Additionally, and in stark contrast to the largely unknown artists who produced the Anglo-Norman illustrated version of the Book of Revelation, Dürer was his own master, in economic and artistic as well as interpretative terms. Cranach, meanwhile, in producing these and other images for Luther, was clearly (on the strength of his prolific 'Protestant' output) a willing participant in the Reformation 'propaganda machine', as opposed to being a career artist working strictly to the demands of a 'generic' patron. Thus although Dürer and Cranach were working in a format with clear links with that of their manuscript antecedents, the result, from a hermeneutical perspective, was quite different.

Dürer's series (see Figs. 29–38) can be seen, like Botticelli's *The Mystic Nativity*, to represent something of a hermeneutical (as well as an artistic) climax in terms of apocalyptic imagery in late medieval and early modern art. In his desire to create an economically viable version of the Book of Revelation which would also showcase his artistic genius, Dürer had condensed the text into fifteen images of great technical skill. In doing so, he produced a visual version of the Book of Revelation that exhibits a detailed and sympathetic grasp of the text, as witnessed particularly in his visual evocation of the 'double-decker' world-view so integral to this apocalyptic work. Dürer's

deeper exegetical motivations are, it has been argued, revealed in his approach to the depiction of the John figure with whom he clearly identified and who, as a result, he drew in his own likeness. It is as if Dürer had seen John's visions anew and, like Memling, was attempting to visualize them, and not the text of the Book of Revelation for the viewer. The images were then *juxtaposed* with John's text but in such a way as to suggest that they represented a definitive replacement *or* at the very least a necessary counterpart to it. In support of the former suggestion, there is documentary evidence that shows that by the early sixteenth century, editions of Dürer's Apocalypse images were being sold without any text at all.[12] However, in all probability this was due to the fact that these images were now seen as 'works of art' in their own right, rather than for deeper interpretative or religious reasons. It thus seems more pertinent to focus on the latter suggestion, that Dürer's images were originally intended as a necessary counterpart to the source-text. It has been shown that Blake purposefully juxtaposed text and image in order to make complex interpretative points, and it seems likely that Dürer was doing the same, forcefully exposing the inadequacies of prose text at capturing the character of a visionary text like the Book of Revelation.[13]

Cranach expanded Dürer's series to twenty-one images and set them opposite each corresponding chapter of text and significantly pared down his compositions (see Figs. 40–1). He thus exemplifies, for the most part, an illustrative more than a truly interpretative hermeneutical strategy. However, the immediate context of the images as part of Luther's first translation of the New Testament of 1522 gave them a simultaneously polemical function not hitherto witnessed in late medieval representations of the Book of Revelation. Thus, Cranach's images, whilst remaining on the one hand straightforwardly literal, on the other, typify a very specific visual strategy, and moreover one which was to be extremely successful. Like his various versions of *The Law and the Gospel*, Cranach's Apocalypse images send out an urgent summons to the viewer to decide between right and wrong, old and new, Luther and the Pope. It was also argued that Cranach's particular visual hermeneutical strategy had much in common with those of the early Reformation exegetes.

As summarized above and as stressed throughout this study, it is clear that the immediate context, intended function, and chosen medium of the work in question had a considerable effect on the hermeneutical strategy adopted by the artist. Although in a more modern artistic context an artist would most likely choose a medium that suited the hermeneutical strategy he or she wished to pursue, within the late medieval and early modern context, the medium was largely decided by the patron, the exceptions being Dürer and Botticelli. In Dürer's case, as his own publisher and agent, he could theoretically

---

[12] See Bartrum 2002: 124.
[13] See Mitchell 1978: 33–4.

have chosen to depict the Book of Revelation in a different medium but, as emphasized in Chapter 5, he was well aware of both the economic rewards and artistic fame that a well-marketed woodcut series could bring him. Botticelli, in contrast, seemingly *chose* to realize his interpretation of the Book of Revelation (and of his own Florentine situation) as a painting. Thus it would seem that the Renaissance, in facilitating greater artistic freedom, also enabled greater interpretative freedom when it came to the visualization of biblical texts.

## 6.3 TEXT–IMAGE ISSUES

We turn now to a discussion of the text–image relationship in the seven case studies. This relationship is also dependent on context and function, and can either be dictated by or help to dictate hermeneutical strategy. Although the images in both *Lambeth* and *Angers* are inextricably linked to the text of the Book of Revelation by virtue not only of its physical presence in the case of *Lambeth*, but also by virtue of their diachronic and thus chronologically unfolding format, both works go some way towards the diminishing prominence of the text arguably seen in the Dürer series. Within the 'reading' scenario suggested in Chapter 1 in relation to *Lambeth*, the images serve to problematize the text. For, while the person using the manuscript would (probably) have relied on an adviser to read and explain the words to him or her, he or she would have engaged with the images directly. Within this unsupervised, more meditative context there would have been no obvious control over the kind of imaginative engagement that occurred between the viewer and the images. The images could potentially unlock all kinds of mental activity of the sort envisaged by Carruthers, activity perhaps entirely unrelated to the standard exegetical readings of the Book of Revelation of the sort embodied by the Berengaudus commentary.[14] The images would then serve as a mnemonic device during subsequent meditative sessions. For a 'reader' in this situation, such as Eleanor de Quincy or Margaret Ferrers, the possible owners of *Lambeth*, one could quite easily envisage a situation whereby the Latin text and commentary were not only relativized by the accompanying images but perhaps even rendered redundant. Although it would have been highly unlikely that this was the original intention either of those involved in producing the manuscripts or the patrons, it is surely noteworthy that this visionary text was probably largely accessed via images rather than via reading the text itself. Could this constitute a subconscious or even a tacit recognition

---

[14] Carruthers 1990: 122–88.

that John's visionary experiences are best articulated with images rather than with words?

*Angers*, which apparently lacked any substantial accompanying text at all (the legibility of the original 'text-panel' being questionable), represents a further move towards de-emphasizing the text of the Book of Revelation on a material, as well as perhaps on a deeper level. Like looking at a stained glass window of the Book of Revelation, such as the thirteenth-century Apocalypse window in the Saint-Chapelle in Paris or the East Window in York Minster, which also lack accompanying texts, viewing *Angers* helped to condition the viewer into understanding the Book of Revelation as a visual rather than a textual entity.[15] Indeed, as was the case with most biblical and devotional texts at this time, many more people would have been in contact with visual representations of the Book of Revelation, such as Church art, stained glass windows, and other visual artefacts, than with textual ones. Visualizations such as *Angers*, which encouraged the viewer to look at the events described in the Book of Revelation as John had done, rather than to read or hear about them, also served to remind the viewer of the essentially visionary aspects of the text itself, a theme which will be explored in greater detail in the second part of this chapter.

However, while in some important senses they laid the foundations for later visualizations such as Dürer's, in neither the Lambeth nor the *Angers* images is there ever an *explicit* sense that they are offering the viewer a replacement for, or at the very least a necessary counterpart to, the text, perhaps due to their thorough and very literal relationship with the content of the text. This, arguably, is what Dürer sought to achieve with his Apocalypse Series of 1498. As discussed in Chapter 5 and above, Dürer chose to visualize the Book of Revelation within a fairly traditional book-format, within which, despite the presence of the full text as well as text markers linking the relevant sections of text to the relevant images, the relatively large images came to dominate. The dominance of Dürer's images alone would not, however, imply that the text has been downgraded in importance. In Cranach's Apocalypse, for instance, the images are still large and occupy a full page opposite each chapter of the Book of Revelation. One never senses that Cranach's images are threatening the primacy of the text, however. This is firstly due to the fact that his images perform a largely illustrative function (each image has been placed next to the relevant, corresponding chapter), as well as because Cranach (understandably in light of his Lutheran context) makes no special claims for the authority of his images in the way that Dürer does through interpolating

---

[15] Rose Window, 15th cent., Upper Chapel, Paris: Sainte Chapelle; The Great East Window, *c.*1408, York: York Minster. Note that *Angers* is much more accessible than either of these two windows, the full detail of which has only been discerned with the advent of long-range photography.

both his own likeness and his monogram into the images. The function of the Cranach images meanwhile is to visualize a particular 'Protestant' reading of this difficult, potentially dangerous text. Luther's fears, vocalized in his two Prefaces to the Book of Revelation published in 1522 and 1530, indicate that, in his eyes, it was a text that needed hermeneutical parameters.[16] Thus Cranach's images are an important aid to the text, but in no sense do they function as a replacement.

Dürer's somewhat different claim regarding his images is related to his identification with the visionary figure of John, as well as perhaps his more general pretensions to Divine inspiration as discussed by Koerner.[17] His visualizations are thus presented as an authoritative interpretation of the Book of Revelation, perhaps even, in engaging with its 'original' visionary format, negating the need for the text itself. Dürer's unique (for his time at least) approach to the task of visual exegesis will be returned to below.

The fifteenth-century altarpieces of Van Eyck and Memling, whilst almost entirely visual in format, do not (on the face of it at least) supersede the text in the way that Dürer's interpretation appears to. Both artists certainly challenge the applicability of a more diachronic approach to the Book of Revelation by depicting various elements from the narrative synchronically. Both also offer visual material for meditative contemplation unmediated by any text. However, precisely because of the fact that the images within the two altarpieces are not juxtaposed with a version of the source-text, as they are in *Lambeth* and the Dürer series, there is no perceived competition between the two. Still, interpretations of the Memling altarpiece, such as my own, which emphasize the aptness of Memling's use of a pictorial format to evoke John's visionary experiences, may well introduce a serious element of competition, whether this was Memling's intention or not. On the other hand, there may well be a sense conveyed by the text itself (via the frequent use of ὡς for example) that it was meant to be seen 'again'.[18] In this case, Memling's re-envisaging of the vision would sit well with the spirit of the source-text.

The text–image relationship in *The Mystic Nativity* is different once again. Here, Botticelli has used an inscription, which explains in words, it has been argued, his visual interpretation of the Book of Revelation via chapters 11, 12, and 20, as well as his understanding of his own situation in Florence c.1500. It has also been argued that *The Mystic Nativity* engages in some way with the essence of the Book of Revelation via his non-mimetic attempt to work out the mysterious, fantastical events described therein in 'ordinary' terms. However, there are no claims to definitiveness in this painting. Essentially, Botticelli is

---

[16] See Luther, *WA DB* 7: 404; *LW* 35: 398–9 for the 1522 Preface and see Luther, *WA Bibel* 7: 408 for the 1530 Preface.

[17] See esp. Koerner 1993: 127–38.

[18] See Rev. 13: 2, for example.

acknowledging the allusive nature of the text and offering one, very personal, response to it. But this response neither claims to nor does it actually empty out the interpretative possibilities of the text.

Thus the visual examples which make up the seven case studies exemplify a spectrum of different approaches to the text–image problem. In no case is the relationship a completely uncomplicated one. However, the approaches range from a fairly straightforward one in which the relevant section of text appears opposite a very literal (although sometimes polemical) image to a situation provoked by the Memling and Dürer images, in which, as a result of their powerful visualizations of John's visionary experience, the viewer might begin to question the validity and success of the source-text as an evocation of the visionary experience.

## 6.4 VISUALIZING JOHN'S VISIONS

One of the easiest ways to assess how an artist has dealt with the visionary nature of a text like the Book of Revelation is to examine how he or she has dealt with the figure of John. In short, has the artist depicted the visions described in Rev. 1: 10–20 and 4–22: 7 as he/she imagines John himself saw them or is the viewer looking at John receiving the visions (i.e. almost from a third perspective)? In the former, while a depiction of John may appear within the image(s) in question, there is a clear sense in which the viewer sees the events depicted from his perspective. To put it another way, the viewer is given a window into what the artist imagined was taking place in John's imagination. In the latter case, John is depicted as physically following the visions around, perhaps in heaven itself. In these images, John was clearly thought to have an important role as witness to and physical participant in the visions, a role which surpasses an emphasis on his own perspective on the experience.

This latter understanding of John's role is clearly prevalent in the thirteenth- and fourteenth-century images. *Lambeth* and *Angers* depict John in the vast majority of their images. In *Lambeth*, John appears in around two-thirds of the images. In many of the visualizations, he is depicted as part of the image or as peering into it, almost as a voyeur. In these instances, he appears to function as a 'stand-in' for the viewer, who is also encouraged to identify with John through various visual strategies. In *Angers*, John appears, often in a carefully designed viewing 'shelter', in all of the images, bar none. His frequent presence through-out both series gives the impression that the apocalyptic visions depicted within the images depend on John for their existence and veracity. In accordance with this, the images progress diachronically, following the text, rather than envis-aging a more synchronic or spontaneous visionary experience. In line with the increased scholarly interest in visionary experience that occurred in the late

medieval era, John's role as a percipient of the visions thus surpasses his role even as their author or recorder.[19] It was his physical, verificatory role that was now regarded as important. In the *Lambeth* and *Angers* and related images therefore the presence of the visionary functioned within the image as proof that that image did, in fact, depict a visionary episode from the Book of Revelation rather than some other miraculous event or just an ordinary event.[20]

This thirteenth- and fourteenth-century visual emphasis on John as visionary had become more muted by the fifteenth century, with some exceptions. In Memling's Apocalypse panel, for example, John is very prominent and thus his role as an active and interactive interpreter of the visions is emphasized. Although he appears for a second time near the back of the panel receiving the scroll from the Mighty Angel in Rev. 10, the image of him in the foreground of the panel in a visionary trance is far more prominent. When looking at the panel, the viewer may very likely feel as if he/she is seeing the visions as John himself saw them, as they passed through his mind in a contemporaneous, synchronic onslaught, and not as they are set out for the reader of the text of the Book of Revelation in a chronological, ordered format. The relationship between the 'eye-like roundel' in the top left-hand corner of the panel and the depicted visionary events also raises interesting questions. Does this ultimately represent the Divine eye or the eye of the Divinely inspired visionary who, as Blake argued, is able to see through the eye rather than with it?[21] Thus Memling, through his depiction of John, the heavenly eye, and the unfolding visions of Rev. 6–13, hints at the fact (whether consciously or not) that visions such as John's may be better communicated visually and thus synchronically than textually and diachronically. The inability of John's text to express his visions as he experienced them becomes a serious issue that must now be considered afresh.

The John figure plays a prominent role in the Dürer series, but in a way that differs from both the Anglo-Norman manuscript iconography, as well as from Memling's visualization. Both the earlier Koberger images and Dürer and Cranach's images, in a break from the earlier depictions espoused by *Lambeth* and *Angers*, only depict the John figure where he has a specific part to play in the narrative. This is in part due to the demands of their compressed style of visualization. Thus, most of the images present the visions from John's perspective. In the other five images (D1, D2, D3, D9, D15) John appears both as a seer, and as one who participates in the action directly. The medieval tradition of him appearing in every image had been negated by a combination

---

[19] See Dronke 1984: 144–201 on visions in the late medieval era, particularly those of Hildegard of Bingen.

[20] Panofsky 1955: 58; Camille 1992: 287–8.

[21] See Blake 1810: *A Vision of the Last Judgement*, page 95, reproduced in Erdman (ed.) 1988: 566.

of Dürer's more naturalistic style of illustration (which allowed him to distinguish in his images between fantastical visionary events and 'normal' events) as well as his claim to be actually recreating or re-presenting the Johannine visions through his own visualizations.[22] If Dürer's images are definitive, then John's role as the constant percipient is negated, his presence literally replaced by the presence of the prominent 'AD' monogram on each image.

In Cranach's series, John appears in only four of the twenty-one images. Neither is there any effort on his part to achieve any artistic continuity regarding the John figure across the images in which he does appear. As stressed in Chapter 5, he has quite a different appearance in several of the images and Cranach has definitely not drawn him in his own likeness. For Cranach, John appears as a mere 'cipher', the role assigned to him in the earlier Berengaudus commentary, and perhaps in the earlier medieval images too. This may also reflect Luther's disdain for John as someone who 'commended his work more highly than he ought to have done' (cf. Rev. 1: 1–3; 22: 8ff.).[23]

John does not appear at all in either the *Ghent Altarpiece* or Botticelli's *The Mystic Nativity*. In the former, there is certainly a sense that we, the viewers, are privy to a re-imagining of John's vision as he saw it, but that this is now to be perceived within the context of a much larger and more complete vision of the Church past, present, and future. In the latter, John is clearly invoked by the inscription that refers to the 'eleventh [chapter] of St John'. In this way, Botticelli seems to attest to the historical existence of the visionary author of the mysterious book whose metaphors he is attempting to unravel visually.[24] Thus, the way in which John has been depicted by the various artists discussed in this study suggests that, in many ways, John has functioned as a blank canvas on which hermeneutical strategy and visionary politics could be worked out.

### 6.5 SECOND-ORDER REFLECTION

It is worth pausing briefly to consider whether the contrasting hermeneutical strategies isolated above can be categorized further. One way in which this might be achieved is through the application of two, established methods of classification to the above observations. I therefore propose first to consider the visual strategies through the lens of the *Darstellung* versus *Vorstellung*

---

[22] See D11 (Fig. 38) for an example of how Dürer juxtaposes the 'natural world' below with the 'battle in heaven' (Rev. 12: 13–17) through judicious use of a naturalistic German landscape below, versus a dark, cloud-encased heaven above. The dichotomy between the real and the fantastical is clear, on the strength of his artistry alone.

[23] Luther, *WA DB* 7: 404; *LW* 35: 398–9.

[24] See also his *St John on Patmos*, 1490–2, Florence: Uffizi Gallery.

distinction as first conceived by Gadamer and as more recently developed by Davies and O'Kane. Secondly, the strategies will be plotted on the interpretative grid developed by Kovacs and Rowland, in their 2004 Blackwell commentary on the reception history of the Book of Revelation. The application of these lenses will help to illuminate the first strand of visual exegesis highlighted in the introduction to this chapter, whereby images function as ways of expressing the subject-matter or *Sache selbst* of a text.

## 6.5.1 *Darstellung* versus *Vorstellung*

The distinction between *Vorstellung* and *Darstellung* was coined by Gadamer and developed by Davey.[25] For Gadamer and Davey then, the 'depth' of a visual interpretation can be analysed in terms of the extent to which it successfully 'brings forth' or 'gets at' the essential subject-matter or *Sache selbst* of the text that it is interpreting. *Sache selbst* is understood to refer, in this context, to the essence or essential subject-matter of a text. Thus an image or series of images which bring forth the *Sache selbst* of a text will not be a literal representation of the text but rather will evoke some of its essential qualities or features, perhaps not necessarily in a closely representational or literalistic way at all. Some visualizations of texts, whilst evoking the subject of the source-text in question through visual re-presentation, do not engage at a deep level with its subject-matter or *Sache selbst*. This process may be defined as *Vorstellung* or literalistic representation. Davey offers the case of Dutch maritime painting as a clear example of *Vorstellung*, as it is a genre that invokes the literal 're-presentation' of a subject.[26]

*Darstellung*, in contrast, involves viewing the work of art as something which facilitates the coming forth or 'bringing to mind' of the *Sache selbst* of the text that it is visualizing.[27] In line with the understanding of *Sache selbst* proposed above, Gadamer argues that *Darstellung* is not 'merely a copied repetition, but a recognition of the essence'.[28] Because *Darstellung* involves 'bringing forth' the essence of something (in our case the biblical text), the spectator is necessarily involved in the process.[29] Davey summarizes and builds upon Gadamer's concept of *Darstellung* thus:

> The invocation of the notion of subject-matter (*die Sache selbst*) . . . offers a way of conceptualising what an art-work 'gets at', what it strives to *show* or lead us to. It offers a criterion whereby a work can be assessed in terms of whether it successfully

---

[25] Gadamer 1989: 93–103; Davey 1999: 3–26. See also Schweiker 1987: 791–810.
[26] Davey 1999: 19.
[27] Ibid.
[28] Gadamer 1987: 103.
[29] Ibid. 103.

brings forth its subject-matter . . . However it is in the doctrine of *Darstellung* that the notion of the *Sache selbst* attains its greatest significance . . . it proclaims art as that which 'raises reality to its truth'.[30]

Thus the notion of *Darstellung* encapsulates the 'presentation' or coming forth of a subject in a work of art in an illuminating but not necessarily straightforward or 'one-to-one representational' way.

The artistic notion of *Darstellung* might fruitfully be compared with the aforementioned notion of *Sachexegese* within biblical exegesis. Indeed *Sachexegese* can be defined in similar terms to *Darstellung*, as a process which engages with a (biblical) text and then seeks to express its character. This process may be further developed into *Sachkritik*, an exegetical process during which the exegete engages in criticism 'of the formulation of the text in the light of what [he thinks] the subject-matter [*Sache selbst*] to be'.[31] In short, 'criticism of what is said by what is meant'.[32] Discerning the *Sache selbst* of a text (*Sachexegese*) may lead to a critique of discrete elements of that text, which point in different directions, in light of the perceived *Sache selbst* (*Sachkritik*). Thus, for example, if the *Sache selbst* of the Pauline interpretation of the gospel was perceived via a process of *Sachexegese* to be summed up by the statement that Christ unifies humanity, then this might also enable a critique of Paul's condemnation of homosexuality in Romans 1 on the basis that this conflicted with the aforementioned, overarching *Sache selbst* of his writings. The relationship between *Sachexegese*, *Sachkritik*, and visualizations of the Book of Revelation discussed in this study and beyond, will be returned to below.

To speak in more concrete terms, however, regarding *Darstellung* and visualizations of the Book of Revelation, one might say that visualizations which engage with the *Sache selbst* of the Book of Revelation via a process of *Darstellung* might evoke its visionary origins, its apocalyptic world-view, and will also offer elucidation of the textual symbols used to describe John's original vision either via juxtaposition with a historical context or with another set of imaginative symbols. Crucially, they will also embody an attempt to get to the 'heart' of the content of the text, via a single image or theme, an action which, in line with other forms of *Sachexegese*, may take the viewer to a higher appreciation of the text as a whole.

The *contrast* between *Darstellung* and *Vorstellung* that underlies any attempt to apply these terms to actual works of art is summed up well by William Blake in some remarks made in his Descriptive Catalogue of 1809. Here he gives a context to the distinction when he castigates those (such as Rubens) who merely represent what is 'out there' with their art, producing

---

[30] Davey 1999: 23.
[31] R. Morgan 1973: 42.
[32] Ibid.

what Blake describes as 'facsimiles' as opposed to his own work which is an attempt to visualize things seen vividly and clearly via the imagination.[33] In terms of how the hermeneutical distinction might be applied to the examples discussed in this study, it perhaps should first be stressed that none of them are completely straightforward examples of re-presentation or *Vorstellung* in the same way that Dutch maritime painting might be said to be. They all have their complexities in terms of how they relate to the source-text, as has been stressed throughout. It seems, however, that the *Lambeth*, *Angers*, and Cranach images tend towards *Vorstellung* in that they re-present the subject of the text without attempting to engage with it on a deeper interpretative level.

Nevertheless, there are two further points that can be made in relation to these examples, when viewed through this particular interpretative perspective. With regard to *Angers*, one could argue that the way in which the source-text of the Book of Revelation is used as the basis for what was essentially an exercise in visual self-aggrandizement for Louis I, the patron, actually militates against the *Sache selbst* of the source-text. The Book of Revelation is not a neutral text, but rather one that offers a powerful critique of empire as an oppressive force.[34] The aberrations of secular and religious power are forcefully contrasted with the eternal equilibrium of Divine rule. Thus, *Angers* represents, in some ways, a *mis*understanding, a subversion even, of the *Sache selbst* of this text. Cranach, in contrast, while offering a visualization that encapsulates the hermeneutical force of the concept of *Vorstellung*, successfully captures in his anti-papal images something of the polemical force of the Book of Revelation. This passion, a factor that perhaps accounts for the repeated actualizations of the text throughout history, could therefore be said to be part of the *Sache selbst* of the text. Finally, the way in which both *Angers* and *Lambeth* appear to have functioned historically as visual springboards for the imagination, implies that even though the images themselves espouse the principles of *Vortsellung*, they might nevertheless have served to lead the imaginative viewer into a more engaged relationship with the text whereby something akin to *Sachexegese* could have taken place.

At the other end of the hermeneutical spectrum, the *Ghent Altarpiece*, Memling's Book of Revelation panel, Dürer's Book of Revelation series, and Botticelli's *Mystic Nativity* all appear to tend towards *Darstellung*, although in very different ways.

Taking the two altarpieces first, we note that the *Ghent Altarpiece* appears to have gone beyond the symbolic detail of the text in order to allow its *Sache selbst* to come forth in a less literal, less closely representational setting than any of its predecessors. Elements from the Book of Revelation have been

---

[33] Blake, *A Descriptive Catalogue of Pictures, Poetical and Historical Inventions*, pages 35–7. Reproduced in Erdman (ed.) 1988: 540–1.

[34] See Rowland 1982: 423–37; Brook and Gwyther 1990: xxiv; Boxall 2002: 27–47.

juxtaposed with other biblical and mythological imagery in a monumental overall explication of the ceremony of the Eucharist and its past, present, and future relevance in the life of the Church. In keeping with a Tyconian interpretation the Book of Revelation, whereby eschatological passages were applied to the present life of the Church, the eschatological New Jerusalem is presented as attainable now within the context of the Mass. Thus, in this altarpiece, an important strand or subject from the Book of Revelation has been given an illuminating but far from straightforward visual treatment.

Memling, meanwhile, with his synchronic depiction of the text in one panel, brilliantly evokes the visionary origins of the Book of Revelation. In so doing he connects the viewer with the visionary experience that is essential to understanding the text. In this sense, then, Memling's image, with its unique composition, is an important example of *Darstellung*, one that allows the viewer to engage with the apocalyptic content of the source-text.

It may of course be objected first that within this innovative compositional structure, the details of the visualization are fairly representational. The visionary events evoked symbolically by the text of the Book of Revelation are depicted as described. Secondly, Memling's depiction ends, as far as we can see, for no good interpretative reason at Rev. 13, thus leaving his visualization without a resolution. In these senses is not Memling closer to *Vorstellung*, to re-presentation? In response to the second objection, the reader is referred to the preceding discussion regarding the likelihood of the central panel of the triptych representing the visual resolution to the Apocalypse panel. If this is indeed the case, if the mystic marriage of St Catherine is intended also to evoke the marriage of the Lamb and Israel in Rev. 19 that in turn facilitates the inauguration of the New Jerusalem, then the triptych as a whole could be viewed as an example of *Darstellung*. When viewed as a unity the two panels constitute a synchronic presentation of the essential subject-matter of the Book of Revelation in a Tyconian form of interpretation, that of a period of divine judgement followed by a union or intermingling of the human with the divine.

With regard to the former objection, one would have to agree that Memling's depictions of the various episodes are indeed literalistic or figurative in their execution. Thus the four living creatures of Rev. 4–5 are depicted replete with many small eyes covering their bodies and the Woman Clothed with the Sun of Rev. 12 is indeed depicted at the centre of a sun. If the preceding discussion is correct in its intuitions, Memling was thus in touch with the essence of the text on some levels but on others has taken its symbols at face value and depicted them accordingly, with notable precision. Explanations as to why he did so will necessarily be speculative. Perhaps the patrons of the altarpiece were very strict in their specifications that the content of the visions be depicted as closely as possible? Memling would therefore not have been free to speculate visually on the wider significance of the textual symbols of the

Book of Revelation. Or perhaps like Blake, Memling believed that visionaries were able not only to comprehend their visions with great clarity but also to record them with the same precision?[35] Thus John's text was a precise record of what he had perceived and should be visualized accordingly, giving visual form to the strange textual descriptions. Or perhaps, finally, we should reflect again on Memling's visual prioritization of Rev. 4–5 as a large, eye-like roundel at the top left-hand corner of the panel. In doing so did he intend to make this passage the hermeneutical key to the whole book? The Eucharistic setting of the altarpiece would also have served to emphasize this section of the painting. Thus, the literal nature of Memling's depictions of the various visionary episodes stand relativized as compared to this bold hermeneutical move. For these reasons, Memling's Apocalypse panel remains, predominantly, in my opinion, an example of *Darstellung*.

Just as Memling's image proves somewhat problematic to classify, so do Dürer's. At first glance, Dürer's cycle seems to be a clear example of *Darstellung*. So brilliantly does he evoke the Book of Revelation, its nuances and complexities, its clearly drawn, intrinsic dichotomy between heaven and earth, as well as its recapitulative possibilities, that not only have his images caused me to look at parts of the text in a new way but, in addition, his images are often the images that pervade my imagination when I read the text, as he himself seems to have intended. Further to this he has understood and communicated the visionary basis for the text in a hitherto unseen way. He locates himself at the site of the revelatory visions or at least at the site of their re-visioning, as a sort of *alter-Iohannis*. The reader/viewer of his resulting Apocalypse book is left in no doubt that images and not words are the appropriate vehicle for conveying/communicating such heavenly visions, the huge images serving to dwarf the closely packed text.

However, as an exegete of symbolic language, Dürer, like Memling, lacks the sophistication of someone like Botticelli. To use Davey's language, Botticelli's visualization, *The Mystic Nativity*, attempts to *lead* the viewer to an understanding of the text as a whole through visual means.[36] While Botticelli offers a visual evocation of the *spirit* of the text in which he relates it to real circumstances, Dürer is still preoccupied with its 'letters', with its fantastical symbols and its breathless, chronological order. In his visual claims to be offering a definitive version of the text, he also perhaps reveals the extent to which he has missed the point, as it were, that the symbols that make up the text actually have *multiple* possible meanings and applications rather than just the one that

---

[35] See Blake 1809: *A Descriptive Catalogue of Pictures, Poetical and Historical Inventions*, pages 35–8. Reproduced in Erdman (ed.) 1988: 540–1. Here he argues that things seen in the imagination are perceived in a 'stronger and better light' than things perceived with the 'perishing mortal eye' and thus should be visualized clearly and in an organized way.

[36] Davey 1999: 22.

he has visualized. In claiming a definitive status for his images, Dürer reveals the limitations of a visual exegesis which closes down the open-ended textual symbol.

## 6.5.2 Decoding versus actualizing visualizations

In their Blackwell Bible commentary on the reception history of the Book of Revelation, Kovacs and Rowland distinguish between 'actualizing' and 'decoding' interpretations of the text.[37] As noted in Chapter 1, the 'actualizing' mode of interpretation can be traced back at least as far as Tyconius and may embrace a recapitulative reading of the source-text and will also use contemporary events to illuminate the text or vice versa. Interpreters read the Book of Revelation less as an eschatological map and more as a cyclical presentation of visions recapitulating the history of the Church and its struggle against the world.[38] Decoding interpretations, by contrast, attempt to 'work out' the symbolic language of the Book of Revelation with reference to specific events or persons, be they past, present, or future. Thus Kovacs and Rowland also consider the temporal focus of the interpretations they assess. Does the particular interpretation or 'reading' relate the text primarily to events in the past, the present, or the future? In short they found that actualizing interpreters tend to relate the source-text to current events in order to better understand both it and their own situation whilst decoding interpreters tend to focus primarily either on the past or the future application of the text. In order to compare different interpretations Kovacs and Rowland devised a grid on which they might be plotted. The temporal axis runs vertically and the actualizing/decoding axis horizontally. While not all the visual examples discussed in this study can be plotted straightforwardly on such a grid, it is illuminating to consider how they might be arranged. Integrating the visual interpretations into Kovacs and Rowland's system also serves to demonstrate how visual interpretations of biblical texts might fruitfully be compared and contrasted with examples from its textual history of interpretation (see Appendix 3, Graph 1).

The *Lambeth, Angers,* and the Cranach series can all be classified as examples of decoding visualizations, although for slightly different reasons. *Lambeth* and *Angers* offer a literal decoding of the text by breaking the text down into visual episodic fragments in order for the 'reader'/viewer to understand the narrative step by step. John appears at every stage to guide the viewer didactically. The images may open the way to a more imaginative engagement with the text, but this was certainly not their primary intention. In the main

---

[37] Kovacs and Rowland 2004: 7–11.
[38] McGinn 1987: 534.

the images tend to relegate John's visions to the status of historical events, events that have already taken place, albeit ones that make predictions about the future. However, even here there are a few instances where visual links have been made with present events. Thus some of *Lambeth's* images identify the Beast's followers as Jews, for example, a detail that reflects the contemporary, thirteenth-century hostility towards the Jewish faith.[39] Similarly, some of the *Angers* images, namely those that visualize the malevolent characters as 'English' or, conversely, those that associate the Lamb of Rev. 5, 7, and 14 with the Franciscans, for example, are also evidence of present identification.[40]

Cranach's images also offer an admittedly pared down, but fairly comprehensive, summary of the Book of Revelation. They are sufficiently detailed to evoke both the textual narrative and the main theological points found therein. In line with his patron Luther's specifications, Cranach is primarily a 'simplifier' of the source-text. However, (also at Luther's behest, it may be assumed) he also actualizes the Book of Revelation through the use of polemical imagery in five of his Apocalypse images. By including these polemical images, Cranach echoes the work of Luther and other contemporary textual exegetes such as Melanchthon and, later, Nicholas Ridley, as previously discussed. Thus, the office of the papacy becomes not just a possible manifestation of the Whore of Babylon and the Beasts of Rev. 11 and 13, but synonymous with them. In Protestant circles during the sixteenth century, aspects of the Book of Revelation were therefore not only being read as allegories for the evils of the papacy but being visualized as such as well. Thus while *Lambeth* and *Angers* would have to be plotted at the decoding end of the horizontal axis and at the past end of the vertical axis, Cranach's images oscillate between decoding/past and decoding/ present, making them more difficult to plot definitively on the graph.

The Van Eycks and Botticelli have not offered in their visualizations, it seems, anything approaching a decoding reading. No attempt is made, in either case, to break the text down into images for didactic or polemical purposes. Rather, it seems the text of the Book of Revelation has been approached in a more metaphorical way.

Botticelli 'actualises' the text, to use Kovacs and Rowland's term, by juxtaposing it with his own personal and historical circumstances in order to better understand it. However, while *The Mystic Nativity* is a visual explication of how Botticelli had come to understand the text, the mystical element of the painting is an indication that Botticelli was acknowledging the open-ended, mysterious nature of the source-text, even if the description seems to suggest a more precise, present application. In terms of the grid, *The Mystic Nativity* would have to be placed at the actualizing end of the horizontal axis and the present intersection of the vertical axis.

---

[39] See *Lambeth* fo. 18$^V$ and fo. 20$^V$, for example.
[40] See *Angers* 2.26 and 4.47, for example.

The Van Eycks, by contrast, have neither decoded nor actualized the text it would seem. This is due to the fact that their visual explication of the Eucharist is set not in historical time but in mythical or eternal time.[41] The visions incorporated from the Book of Revelation contribute to this overall explication. Thus it has an application in the past, present, and future life of the Church. This makes it rather difficult to plot on a grid with temporal variants. Perhaps it would be best placed nearer the actualizing end of the horizontal axis and in the centre of the vertical axis, its function as an altarpiece and thus as a backdrop to the celebration of the Eucharist, serving to give the work a contemporary actualizing application during such ceremonial moments.

Memling's Apocalypse panel, while not making any clearly defined decoding points, is superficially not properly 'actualizing' in tone either. As discussed above, his rendering of the symbolic descriptions found in the Book of Revelation is closely representational and literalistic. His own circumstances do not therefore seem to have influenced his visual interpretation of the text and the events depicted appear to be past events. However, once again, the Eucharistic setting of the altarpiece may constitute a sophisticated form of actualization. By juxtaposing his comprehensive (up to Rev. 13) visualization of the Book of Revelation with the celebration of the Mass, Memling enabled the viewer to reflect on both, the one unfolding beside the other. In addition, by prioritizing Rev. 4–5 (the apocalyptic throne-room), Memling has given the viewer a hermeneutical key to both the altarpiece and its ultimate function. Memling's prioritization of Rev. 4–5, chapters that refer explicitly to the blood of the Lamb, which lies at the heart of the Eucharistic ceremony, also foreshadows the great exegetical emphases on these verses in modern times.[42] Unlike the *Ghent Altarpiece*, in which the Eucharistic import of the altarpiece is self-evident, the viewer has to work a little harder, in exegetical terms, to grasp Memling's context-dependent actualizing 'reading' of the text. Thus Memling's Apocalypse panel should be placed on the actualizing end of the horizontal axis and between the past and the present markers on the vertical axis.

Dürer's images are different again. In one sense, he takes an actualizing approach to the text, claiming it as his own and imbuing it with an artistic and theological significance informed directly by his specific temporal context as a visionary artist at the peak of the Renaissance. However, in his claims to definitiveness, to have created the ultimate version or at least the ultimate *visual* version of the Book of Revelation, one might also sense an element of decoding in his visualization. In terms of the Kovacs–Rowland grid he seems best placed towards the actualizing end of the horizontal axis and somewhere

---

[41] Drury 2002: 93
[42] See, for example, Aune 1997: 266–374; Bauckham 1993*a*: 31–84; Boxall 2006: 79–102; Schüssler-Fiorenza 1993: 58–62.

between the past and present ends of the vertical axis, but nearer the present end.

## 6.6 HERMENEUTICAL CONCLUSIONS AND A CONTEMPORARY EXAMPLE OF *SACHEXEGESE*

The first part of this chapter has analysed the differences and similarities between the seven late medieval and early modern visualizations based on or inspired by the Book of Revelation, as discussed in the first five chapters of this study. Different media have been shown, on the whole, to engender different interpretative approaches, although similarities have also been perceived across examples from different media. Different relationships with the source-text have also been highlighted, both in a physical and an interpretative sense. Whilst some of the images function primarily as illustrations to the source-text, others threaten to depose it altogether or alternatively serve to undermine the efficacy of the text at capturing the visions that the Book of Revelation purports to be based on. The portrayal of the figure of John in the images in question has also been shown to be significant. Some of the images offer the viewer a perspective on John's visions from the point of view of the visionary himself whilst others offer the viewer a more removed window on John receiving his visions.

The attempt to classify the interpretations has proved illuminating but not always straightforward. With regard to the *Darstellung/Vorstellung* distinction, *Lambeth*, *Angers*, and the Cranach images were found to verge on the whole towards *Vorstellung*. This is not intended as a criticism. They are realizations of the intentions of their patrons. Luther for example, who commissioned the Cranach images, would have fiercely resisted the notion of images which facilitated *Darstellung*, such was his commitment to the primacy of the word. Cranach's images thus represent a particular way of visualizing a biblical text. The *Ghent Altarpiece*, Memling's Apocalypse panel, and Botticelli and Dürer's images, on the other hand, were held to be examples, in fairly distinct ways, of *Darstellung*, of images which brought forth the *Sache selbst* of the source-text in a less literal manner. These latter examples, perhaps by virtue of being examples of *Darstellung*, use the synchronic format of the image to bring forth the essence of the source-text, thus highlighting the interpretative scope of the image.

With regard to the Kovacs–Rowland grid, it was suggested that, in line with their observations regarding textual interpretations, more actualizing interpretations tended to focus on the present or ongoing application of the source-text whilst more decoding interpretations evoked the precise past or, in one

case, the precise present application. Thus, the interpretative outlook of the artist or patron can be seen to influence his/her relationship with the symbolic language used to describe John's visions and whether this should be more properly seen as fixed, open-ended, or even as deficient for describing with clarity what had been perceived.

Both the actualizing visualizations and visualizations which engaged in *Darstellung*, such as those by Memling, Botticelli, and Dürer, were found to have striking parallels with the already established technique (within biblical studies) of *Sachexegese*. As mentioned above, there exists a series of images of the Book of Revelation, produced in 1993, which helps to illuminate this process further, as well as perhaps functioning as an example of artistic *Sachkritik*, something that Memling and perhaps Dürer tend towards but perhaps do not quite reach.

In 1993 Kip Gresham developed a series of black and white pictograms to accompany Rowland's Epworth Commentary on the Book of Revelation. Originally intended as a counterpart to the chapter by chapter exposition of the text, in the end, only four of the twenty-one images were included in the Epworth Commentary, in a plate section in the middle of the text. The series is characterized by the use of simple images and symbols as a way of expressing the essence of the text of the Book of Revelation. While the images make up a series, the series does not progress diachronically and certain images and symbols are recapitulated. John, for example, is depicted throughout as a white, androgynous, outline perhaps intended to denote a sort of visual 'everyman'. Conversely the 'One like the Son of Man' figure is depicted using different figures in images 2 and 20. The images included in the Epworth commentary were those evoking Rev. 6, 12, 17, and 21 respectively. While the other images still exist, more detailed comments will be restricted to these four printed images, which were made publicly available. This will be followed by a discussion of the exegetical effects of the series as a whole.

In the sixth image which evokes Rev. 6, one white horse and rider symbolize the four described in Rev. 6: 2–8, while the darkened sun of Rev. 6: 12 evokes the destruction that they cause. Visual echoes of the other four horses and riders can perhaps be discerned behind the main symbol. In interpretative terms, this would represent a fascinating evocation of the recapitulative reading of this passage, which views the four horsemen as different incarnations of one woe.[43] Alternatively, the one, white horse could be intended to evoke the first horse (Rev. 6: 2), who was sometimes associated with Christ, or alternatively the fourth, pale horse (Rev. 6: 8), who has so fascinated artists from Dürer onwards. Whether Gresham had either of these readings in mind is not important. Rather, it is clear that with one symbolic representation of a

[43] See Boxall 2006: 102–5 on different interpretations of Rev. 6: 1–8. See also Aune 1997: xc–xcv.

horse and its rider, the four horsemen of the Book of Revelation and both their destructive and redemptive qualities have been suggested. This emphasis on the symbolic and the essential is continued in image 16 (Fig. 42) where the Whore of Babylon of Rev. 17 is evoked via a ghostly skeleton pulling a boat across the sea. John looks on at the scene, his back to the viewer and hence his expression disguised. Once again this is an image that illuminates some of the central issues surrounding Rev. 17. The ugly nature of the Whore of Babylon, the abominations that fill her 'cup' (Rev. 17: 3–4) are suggested by her skeletal appearance. Unlike other artists, however, Gresham has not used misogynistic, sexualized imagery to denote these negative qualities.[44] Similarly the fact that the viewer cannot see John's frightened face (as is the case in many other visualizations of this scene, such as in Lambeth fo. 30, for example) places the onus on the viewer in terms of reaction. The other major female character in the Book of Revelation, the Woman Clothed with the Sun of Rev. 12, receives a similarly innovative treatment in the eleventh image in the series. She is depicted as a black silhouette and not, as had been established by the iconography of the medieval era, as the Virgin Mary, or at least as a virginal figure. The Dragon who harasses her has been transmuted into a serpent, the universal symbol of evil. Along the bottom of the image crawls the locust army of Rev. 9, a reminder that the text's symbols are themselves different ways of expressing evil (and good). Thus the Dragon of Rev. 12 and the locust army of Rev. 9 are both manifestations of the same satanic forces.

Perhaps most interesting of all, in terms of the published images, is the depiction of the figure on the throne in image 20 (Fig. 43), which evokes elements of Rev. 20, 21, and 22. The figure sits upon a throne in the middle of what is perhaps the waters of the River of Life (Rev. 22). John peers in from outside, his huge features visible through one of the archways that make up the palace of the New Jerusalem. The image bears little resemblance to the description of the palace in Rev. 21 but the peaceful landscape in the top right-hand corner evokes a sense of the paradise that the New Jerusalem embodies. It is the essence and not the detail of the place that is being evoked for the viewer. The figure himself, perhaps the Christ figure from the Last Judgement of Rev. 20: 11–15, or more likely the 'One like the Son of Man' of Rev. 1: 16, has a sword not coming out of his mouth but going into it. This suggests a subtle form of *Sachkritik* of the source-text, whereby Gresham is suggesting that the 'One like the Son of Man' sits not in judgement in the New Jerusalem but rather is the one judged. Christ (or 'One like the Son of Man') should be viewed as one who bears the judgement rather than as its perpetrator, in accordance with Rev. 5. That this critique of one part of the text in light of its overall *Sache selbst*, is what Gresham had in mind here, is supported by his evocation of Rev. 5 via an image

---

[44] See O'Hear 2009: 327–38 for a survey of misogynistic depictions of the Whore of Babylon.

of an ordinary lamb on its own (image 5). Just as John was expecting to see a 'lion of the tribe of Judah, offspring of David' (Rev. 5: 5), so here the viewer is surprised by this seemingly 'ordinary' symbol, which nevertheless evokes something extraordinary. This solitary lamb is recalled via the image of the 'One like the Son of Man' turning the sword of judgement on himself in image 20.

I have been fortunate enough to speak with Gresham regarding this series.[45] He has acknowledged that, in his images, he attempted to do something very different from the Dürer series, which, for many represents the definitive artistic interpretation of the Book of Revelation. He also argues that his images were intended not as illustrations but as 'associated ideas', and also cited the influence of Jung, and his attachment to ritual, on his own ideas and on his work. It is this notion of ritual, pattern, and structure that underpins Gresham's interpretation of the text of the Book of Revelation. He is not reducing the text to symbols but rather evoking John's visions for the viewer via images and universally understood symbols. He makes them particular to John's vision by retaining enough of the detail of John's textual description to trigger associations and recognition in the viewer, but not so much as to be didactic or prescriptive. The *Sache selbst* or essence is evoked, as are various possible interpretations but it is up to the viewer to give these associations concrete form.

In this way, Gresham perhaps gives an answer via his images to a question posed in the Introduction and that has remained in the background of the seven case studies, namely: are the imagery and metaphors that John used to describe his experiences primarily literal rather than visual and if so were they ever intended to be depicted visually? While the examples discussed in this study would suggest that the text does lend itself to, and even perhaps demands, visual expression, this is certainly a question that has been raised by some commentators, including for example, Schüssler-Fiorenza, and as such should be discussed openly. Schüssler-Fiorenza argues that the overtly literary character of the Book of Revelation is exemplified best in the 'call vision' of Rev. 1: 10–20. She writes that, 'it is impossible to picture or draw this vision, for its images and symbols function more like words and sentences in a composition.'[46] Quite apart from the supposedly literary character of the text, others have remarked more prosaically upon the potentially farcical outcomes of attempting to visualize some of John's imagery, such as the impossible dimensions of the New Jerusalem (huge buildings juxtaposed with tiny surrounding walls (Rev. 21: 15–18) or the strange descriptive details of the call vision (Rev. 1: 9–20), which Cranach faithfully realizes in C1, leading them to conclude that the imagery was intended to be imagined rather than physically depicted.[47] Cranach's almost farcically literal depiction of Rev. 1: 2–20 (C1,

---

[45] These conversations and email dialogues took place between May and August 2009.
[46] Schüssler-Fiorenza 1993: 29, 51.
[47] See Boxall 2006: 303–5 on the descriptive detail of the New Jerusalem in Rev. 21.

Fig. 40) is perhaps a case in point. Gresham's images meanwhile, along with others discussed in this study, show that while the imagery was probably *not* meant to be *depicted* in a literalistic sense, it was intended to be *visualized*, first in the imagination, and then perhaps via non-representational, non-sequential imagery. Gresham, perhaps like Botticelli also, has managed to stay true to the undeniably visual nature of the text *not* via replication but via a process of *Sachexegese* whereby he has expressed what he feels the text to be getting at via a set of non-representational images.

While Gresham offers, via his images, incisive and sophisticated comment on the text as it stands, he has not engaged in a process of visionary visual exegesis, there is not a sense in which he has sought to re-envision the text afresh. Other artists, such as Memling and Durer have engaged in what has been called above a form of 'visionary' visual exegesis or re-envisioning and it is to this second strand of visual interpretation that this chapter now turns.

## 6.7 PART TWO: RE-ENVISIONING THE BOOK OF REVELATION

The appropriateness of a 'visionary' visual exegesis as a way of engaging with the Book of Revelation depends in part on one's view of the character of that text, which was explored in brief in the Introduction. There, it was argued that it is a highly allusive text replete with dream-like passages, such as the vision of the heavenly throne-room in Rev. 4, the presence of which endorses John's claims (Rev. 1: 1–3; 1: 9–11; 4: 1–2) about his own visionary experiences. However, these passages need to be viewed against the self-consciously apocalyptic and prophetic nature of the text, its sophisticated literary structure, and repeated allusion to both the Hebrew Bible (e.g. Daniel, Ezekiel, and Isaiah) and, to a lesser extent, the Jesus tradition (e.g. Mark 13).[48] While the presence of these other literary elements should caution interpreters against being uncritical about John's claims to be reporting real visionary experiences, nor should they, it is maintained, be dismissed out of hand.[49] In Appendix 1 it is argued that it is a plausible hypothesis, based on both the evidence of the text of the Book of Revelation itself as well as aspects of its reception history that real visionary experiences lie behind this text. John, the recipient of these visual, auditory, and visceral visions, had then struggled to find a way to articulate them, in a written text.

---

[48] Boxall 2002: 29; See also Aune 1997: cxxvi, cxxxii–cxxxiv.
[49] Boxall 2002: 30; Rowland 1982: 214–40.

The number of artists from the medieval period onwards who have attempted to engage not only with the Book of Revelation but in particular with John's so-called 'call vision' (when John receives the first vision in Rev. 1: 10–20), from Lambeth to Memling to Dürer to Bosch to Duvet to Velázquez, indicates that it *is* perhaps visual artists, rather than textual exegetes, who may be most receptive to the visionary nature of the text. As a result, many have sought to re-envision the experiences that might lie behind this strange text, and in doing so raise the possibility, as I have been suggesting, that John's text is an imperfect external signifier for an ultimately verbally inexpressible original experience. Thus images of the text may offer a particular insight that a text either has not or cannot.

In order to assess this, what follows represents a consideration of how artists, both those covered in this present study and beyond, can and have used the visual medium to connect their viewer to the visionary essence of the Book of Revelation.[50] While the hermeneutical and indeed the exegetical insights that examples from the seven case studies (and beyond) offer into the Book of Revelation have already been discussed, these insights usually function, on the whole, as a complement to existing textual exegesis. However, the ability of images to connect the viewer with the visionary essence of the Book of Revelation, and in doing so mirror John's own intermediary role, seems to be a distinct exegetical contribution that has no textual counterpart. Images which exercise this ability may be deemed to be examples of *visionary visual exegesis*, rather than merely visual *interpretations* (be that *Darstellung*, *Sachexegese*, or *Sachkritik*). In this understanding of visual exegesis, I therefore build upon, but also depart from, the work done by Berdini and O'Kane on the concept, something that will be discussed in the Conclusion.

In what follows it will be argued that artists, in the seven case studies considered here, as well as in other times and places, who have attempted to engage with the visionary nature of the Book of Revelation, were engaging with what they believed to be an important part of its *character*, in doing so, performing a re-envisioning of the experiences that they perceived to lie behind the text. Such re-envisioning is not open to the textual commentator because of the difference of medium. For while exegetes such as Boxall and Rowland can suggest that the text is based in real visionary experiences, they cannot evoke the form that that experience might have taken in the same way that an artist, by virtue of working in a synchronic medium, can.[51] The artist can re-envision John's vision for the viewer and some, such as Dürer and Blake, have produced images that suggest that they are not only re-creating the vision but seeing it anew, perhaps, as suggested above, in the tradition of the apocalyptic seers and later visionaries. In this section I will therefore look at the artists in this study who have engaged in visual exegesis of this specific kind.

---

[50] See Kovacs and Rowland 2004: 12–13 on the visionary character of the Book of Revelation.
[51] Boxall 2006: 3–5; Rowland 1982: 214–47; Kovacs and Rowland 2004: 12–14.

First, then, it seems that Lambeth offers us a fairly sophisticated visual exegesis of both the concept and the content of the apocalyptic visions recorded in the Book of Revelation. This is done via the juxtaposition of fo. 1, the first image in the series, which depicts John sleeping on Patmos, with fo. 39ᵛ, the final miniature in which John has an unmediated vision of Christ (Rev. 22: 10–21), a moment which represents both the end-point and the climax of his visionary journey (Figs. 1 and 4). As discussed in Chapter 1, the unmediated view of Christ that John is here privy to was a seemingly new addition to the Anglo-Norman iconography, not attested to before Lambeth. This image is followed in fo. 53ᵛ with the last image in the whole manuscript, that of a 'Veronica portrait'. Here too Christ's face appears, this time to the 'reader', unmediated and striking. I argue these three images represent a visual expression or summary of John's visionary experience, as described in the Book of Revelation. The visions described therein transform John from being a faithful Christian to a privileged seer via several visions of Christ himself (see Rev. 1: 10–20; 5; 19: 11–21; 21–2), which in turn serve to legitimate the content of the other visionary material and predictions.

The three Lambeth images thus summarize this transformation from possessing only human wisdom (symbolized by John's closed eyes in fo. 1) to possessing knowledge of the divine in fo. 39ᵛ, something that is promised as eventually being possible for all mankind via the New Jerusalem (cf. Rev. 22: 3–4: 'Nothing accursed will be found there any more. But the throne of God and the Lamb will be in it, and his servants shall worship him; they will see his face, and his name will be on their foreheads'). That this is a correct understanding of these images is supported by the presence of the peacock on fo. 1, a bird which symbolized immortality and resurrection in late medieval iconography and was also used as a symbol for Christ himself.[52] Thus the final images (fo. 39ᵛ and fo. 53ᵛ), which themselves symbolize knowledge of the heavenly mysteries via a vision of Christ, are anticipated in the first image in the series proper. The seventy-eight images in-between fo. 1 and fo. 39ᵛ thus serve not only as an illustration to the text of the Book of Revelation, but on another level as an evocation of the visionary journey that must necessarily precede this culminating, unmediated vision of Christ. The analysis of Lambeth as a manuscript which would primarily have been looked at rather than read, as well as the general emphasis on the visual (both in the mind and on the page) within biblical interpretation in the late medieval era, also serve to support this interpretation of these images as a visual exegesis of the nature and purpose of John's vision as set out in the Book of Revelation.[53]

---

[52] Apostolos-Cappadona 1994: 274.
[53] See, for example, Carruthers 1998: 116–70 on cognitive images and visual ornaments within medieval texts.

While *Angers* has much to offer on a more broadly interpretative level, as discussed in Part One of this chapter, I am unsure as to how much it speaks to the particular aspect of visual exegesis that is now under discussion. In other words, does it offer a visual perspective on the visionary nature of the Book of Revelation? Indeed, is there any evidence, as I think there is in *Lambeth*, that Jean de Bondol and those responsible for the iconography and its realization, even understood the text in this way? To the extent that the iconography is based on the established Anglo-Norman iconography, elements of which, Lambeth being one of them, were seemingly in touch with this visionary dimension, then they probably did. Indeed, as stressed above, the notion of visionary experience was so embedded in the medieval psyche that there would not have been the same resistance to this idea that one finds in a post-Enlightenment context. However, whether this aspect of the text has been emphasized is not entirely clear. The sheer, all-consuming size of the work may go some way to evoking the nature of the visionary journey for the viewer, and to be sure the series also ends with an unmediated vision of God and the Lamb. But beyond this rather general comment, it is difficult to give specific examples of this particular type of visual exegesis with reference to *Angers*.

The same might be said of Botticelli's *Mystic Nativity* and Lucas Cranach's Apocalypse Series. While Botticelli's painting may have a visionary feel to it, overall the painting represents an attempt to show how the message of the Book of Revelation might be applied to his own time rather than representing an attempt to guide the viewer to an understanding of John's own visionary process. Cranach's images, on the other hand, whilst engaging with the polemical passion of the text of the Book of Revelation, do little to evoke its visionary nature. Indeed so low a priority is the visionary nature of the text for the artist that there is not even continuity between the depictions of the John figure across the series.

As stressed throughout this study, the *Ghent Altarpiece* and Memling's Apocalypse panel are examples of a very different visual medium, that of the altarpiece. With regard to the particular dimension of visual exegesis under discussion, however, the altarpiece format appears particularly suited to capturing the visionary dimension of a text such as the Book of Revelation. Taking the *Ghent Altarpiece* first, the visionary window being offered here is not just one on the Book of Revelation, but on biblical history throughout all times and places. So it is an expression both of elements of John's vision, but also of a wider visionary perspective. It is as if we, the viewers, are privy to the heavenly perspective on all time. If one could sit opposite the central throne of the upper tier (as described in Rev. 4–5, for example), the Van Eycks seem to suggest, this is what one would see, a synchronic vision of Adam and Eve through to the Book of Revelation. And the promise of Rev. 22: 3–4, that one day God and the Lamb shall dwell amongst their creation and that all shall see Christ's face, is implied not only in the composition of the central panel but also in the

top-heavy composition of the whole altarpiece, which suggests that the upper tier, where God sits, will one day subside or merge into the lower. Thus the *Ghent Altarpiece* functions not only as a visual exegesis of Rev. 22: 3–4 but also of the heavenly perspective evoked, not just by the Book of Revelation but by Judaeo-Christian visionary texts more generally.

Memling's evocation of the visionary aspects of the Book of Revelation has already been discussed at some length. However, there are certainly elements of the preceding discussion which can now be brought to bear on this examination of a visual exegesis that focuses on the visionary nature of the text that it is visualizing. First, and unlike the *Ghent Altarpiece*, Memling's panel offers the viewer a visionary perspective from the point of view, not from the heavenly throne-room, but from that of the seer himself. This is a visualization of a specific visionary experience, that recorded in the Book of Revelation. The perspective of the seer, it was argued, is most likely evoked via the use of the eye-like roundel enclosing the heavenly-throne room in the top left-hand corner of the panel.[54] This seems to evoke the Blakean notion of the visionary who has learned to 'see' *through* his eyes and thus use his imagination rather than just *with* them (as is the case with ordinary sense perception).[55] Secondly, Memling, in his attempt to visualize the entirety of John's vision (up to Rev. 13 at least and perhaps even further if we admit of the possibility that the mystic marriage in the central panel represents also the marriage of the Lamb and the Bride of Rev. 19: 5–10), raises the possibility, via a visual and not a textual presentation, that John, far from being the author of these events, is just the recipient, and that the text of the Book of Revelation was thus an imperfect witness to these visual, visceral visions that he describes therein. In interpretative terms then, the artists, if they were able to conceive of the 'original' visions via meditation on the text, could suggest, via their own images, the true form that these visions might have taken.

While it is unclear whether Memling would have intended his Apocalypse panel to make such a radical comment, we can perhaps be more concrete regarding Dürer's intentions. For he seems to infuse his Apocalypse series with several intimations that he himself had been cast in the role of an *alter-Iohannis*. Thus, John is depicted in Dürer's own image on five occasions (D2 (Fig. 34), D3 (Fig. 35), D6, D9 (Fig. 36), and D15 (Fig. 33)), and later in the 1511 frontispiece (Fig. 37), which depicts John in a seated, writing position gazing at a luminous vision of the Woman Clothed with the Sun. The prominent AD monogram serves to reassert Dürer's presence in the images where

---

[54] See Gibson 1973: 205–26; Koerner 1998: 277; Jacobs 2000: 1028–9 on Memling, Bosch, and 'eye-like' roundels.

[55] See Blake 1810: *A Vision of the Last Judgement*, page 95, reproduced in Erdman (ed.) 1988: 566. See also A. O'Hear 1984: 44–6 on the idea of an 'extra' religious sense or heightened sense of imagination to which we may all have access.

John does not appear. Dürer's own visionary dreams and experiences are fairly well documented, as are his Christ-like tendencies, so in all it seems both plausible and fitting that he saw his artistic talent as the cipher through which the Book of Revelation could be re-visioned for a sixteenth-century European audience. However, whilst if this argument is accepted, his images represent the epitome of a visual exegesis that puts the viewer in touch with the Book of Revelation's visionary and apocalyptic character, on another level, the series, in its claims to definitiveness frustrates its own ambitions.[56] For, surely, all visionary record or interpretation, be it textual or visual, is ultimately partial and imperfect, a human attempt to articulate heavenly secrets. While a visual interpretation may be better at putting the viewer in touch with the original form or character, it can never exclude other visual interpretations, precisely because this apocalyptic text is so allusive.

As mentioned above, Jean Duvet, almost certainly inspired by Dürer, produced a series of images closely based on Dürer's Apocalypse in 1555, in which he also identifies himself on the frontispiece in both text and image with the figure of John.[57] However, in contrast to Dürer's youthful John, a reflection of his 27-year-old self, Duvet's is an older figure, surrounded by emblems of death and bent double over his writing/engraving desk. The image is replete with inscriptions. On the copper plate in front of the John figure can clearly be read, 'John Duvet, goldsmith of Langres, aged seventy has completed these histories in 1555'. In the lower left-hand corner, another inscription reads: 'the sacred mysteries contained in this and the other following tablets are derived from the divine revelation of John and are closely adapted to the true letter of the text with the judgement of more learned men brought to bear'.[58] This inscription is key to understanding Duvet's interpretative process for he seems to allow that although the text *contains* divine revelation, it is open to interpretation. Thus his images, what he elsewhere in the frontispiece calls his 'great work', represent an attempt to take the viewer, via his images, past the text and back to the initial Divine revelation. Indeed, the style of the eighteen images, which Bartrum states are typical of Duvet's eclectic style, 'characterised by a lack of interest in perspective, an obsession with background pattern and detail', could be intended to evoke the visionary experience itself.[59] They represent a cluttered, overbearing assault on the eye, certainly one possible interpretation of both the visionary experience itself and how this might be filtered through the imagination.

---

[56] Although note that Rev. 22: 18 makes its own implicit claim to definitiveness with its command not to add to or take anything away from the text.

[57] Duvet, *Frontispiece of the Apocalypse: Jean Duvet as John the Evangelist*, 1555. London: British Museum. See Carey (ed.) 1999: 169 for a good reproduction of this image.

[58] The inscriptions are cited in Carey (ed.) 1999: 169.

[59] Ibid.

Possibly inspired by the Dürer series and in particular his frontispiece of 1511, which in combination with images such as Schongauer's engraving of *St John on Patmos*, c.1480–5, had helped to establish a tradition of 'John on Patmos' images, both Bosch (1450–1516) and later Velázquez (1599–1660), produced paintings of John on Patmos in which elements of his visionary experience are also evoked.[60] As had become almost standard, both depict John on a rocky outcrop next to or near a tree, in some sort of visionary state, pen in hand, accompanied by an eagle. The object of the visionary gaze is the Woman Clothed with the Sun of Rev. 12. However, beyond this, the images depict different aspects of the visionary experience.

Bosch's image of 1504–5 depicts an adolescent-looking John sitting in profile in an 'early-Netherlandish' landscape and gazing up at a vision of the Woman Clothed with the Sun in the top left-hand corner. In the middle of the image balanced on a small hill is a statuette or *grisaille* image of an angel, the link between the heavenly and the earthly realm. Rowland has also located tiny depictions of some of the destruction scenes from Rev. 8 (and particularly Rev. 8: 8) in the background of the image, although these are very difficult to see.[61] John's visions are not only evoked but also presented for the viewer in a prioritized format, thus representing a condensed exegesis of the Book of Revelation. The apocalyptic nature of the work is captured, as in the Dürer images, through a visual contrast between the illuminated heavenly realm and the darker earthly realm, in which a little devil or imp also lurks (bottom right-hand corner). Rowland speculates that the fact that this little imp is wearing spectacles may be intended to evoke the air of a sceptical observer questioning the veracity of the vision.[62] Thus this image, as well as overtly engaging with the visionary nature of the Book of Revelation, may also evoke, or even represent a visual answer to, textual exegesis of the source-text of the sort that would be articulated forcefully by Luther in his *Preface* of 1522.[63]

Velázquez's image (*St John the Evangelist on the Island of Patmos*) of 1618 is one of a pair of paintings commissioned by the Shod Carmelites in Seville. Originally commissioned to paint the Immaculate Conception, by this time often represented as an event taking place in heaven in the guise of the Woman Clothed with the Sun from Rev. 12, Velázquez develops the Rev. 12 connection across not one but two images.[64] In the first image he depicts John receiving his visions (here depicted exclusively as Rev. 12) and in the other the Immaculate Conception with Mary as the Woman Clothed with the Sun. *St John the*

---

[60] Bosch, *St John the Evangelist on Patmos*, 1504–5, Berlin: Gemaldegalerie; Velázquez, *St John the Evangelist on the Island of Patmos* and *The Immaculate Conception*, 1618, London: National Gallery.

[61] Rowland 2005: 305.

[62] Ibid. 306.

[63] See Ch. 5 of this study.

[64] Drury 2002: 170–1.

*Evangelist on the Island of Patmos* is striking for its strong focus on the seer. The figure of John fills most of the image and is also heavily illuminated, thus distinguishing him from the dark background, in which a shadowy tree and the eagle have been placed. Both Drury and Rowland comment on the solid muscularity of the Johannine figure.[65] There is certainly nothing ethereal about him despite the fact that his wild, white eyes indicate that he is in some sort of ecstatic state. He appears to be gazing at the Woman Clothed with the Sun as she is menaced by the Dragon (Rev 12: 3–4), although in comparison to his size, this depiction is very small. Thus, the emphasis is very much on the earthly seer and his important role as recipient of visions. The books at his feet may either indicate the visionary process itself, one that was initiated by meditation on older biblical texts, or conversely, they could have been included to suggest the superiority of John's divinely inspired revelation over older texts.[66] Either way, the viewer is confronted with a raw, ecstatic, visionary experience, the associated implications of which may also be suggested. It is in this image, over and above any of the others so far discussed, that a particular exegesis of Rev. 4: 1–2, of being 'in the spirit' (cf. 17: 3, 21: 10), may be offered. For Velázquez, being 'in the spirit' clearly did not entail literally ascending to another dimension but rather entering this other dimension *through* the mind, or better the imagination alone. Being 'in the spirit' thus denotes an imaginative or spiritual journey and not a physical one. The seer remains physically in this realm, as we can see in Velázquez's earthy painting of John on Patmos. It is as if the vision in the top left-hand corner has been included for the benefit of the viewer, thus providing a much needed window on the visionary experience, which, it is implied, is internal and personal. This may also suggest a reply to Aune's criticism of the changes in 'perspective' throughout the text of the Book of Revelation, which suggest to him that this is a composite literary work.[67] If the heavenly dimension and its secrets are accessed through the imagination, then a change of perspective presents no problem and could be carried out, one imagines, from moment to moment, if desired.

If *St John the Evangelist on the Island of Patmos* represents the earthly perspective on the visionary experience, Velázquez's companion piece, *The Immaculate Conception*, symbolizes the heavenly, although it is notable that even here Mary is depicted as a simple girl with no hauteur or adornment. The division of the subject into two separate paintings suggests that the unification of the two realms promised by Rev. 22: 3–4 was not envisaged by Velázquez as being a present possibility, except perhaps in the mind of the privileged seer himself.[68]

---

[65] Drury 2002: 171–5; Rowland 2005: 306–7.
[66] Ibid. 307.
[67] See Aune 1997: cxviii–cxxxiv. See also further discussion of this in Appendix 1.
[68] Drury 2002: 175.

## 6.8 BLAKE'S RE-ENVISIONING OF BIBLICAL TEXTS

William Blake (1757–1827) conceived of himself as having a prophetic minis-
try which was intimately linked with his heightened visionary awareness. In
the *Marriage of Heaven and Hell*, for example, Blake imagines himself sitting
with Ezekiel and asking questions regarding his prophetic ministry.[69] Ezekiel
was a particularly important figure for Blake and in that sense can be seen as
standing in a long line of apocalyptic seers, like John of Patmos himself, for
whom Ezekiel and his *Merkavah* or throne-room vision were also crucial in
terms of their visionary experience and its articulation.[70] Thus, Blake, like
Gresham in the previous section in relation to the first strand of visual
exegesis, represents a crystallization of the re-envisioning strand of visual
exegesis whereby images are presented as a more appropriate medium for
conveying or 'getting behind' the character of a visionary biblical text such as
the Book of Revelation. While, as discussed below, Blake did produce images
of this text it is in his series of images of Job that his re-envisaging of a biblical
text finds its fullest expression.

Blake's conception of what visionary sight consists of is encapsulated in the
following quotation from 1810:

> What it will be Questioned When the Sun rises do you not see a round Disk of fire
> somewhat like a Guinea O no no I see an Innumerable company of the Heavenly
> host crying Holy Holy Holy is the Lord God Almighty I question not my
> Corporeal or Vegetative Eye any more than I would Question a Window
> concerning a sight I look thro it and not with it.[71]

In other words, Blake believed that all humans have the capacity to see not
only with their eyes, in the sense of ordinary sensory perception but also with
their imagination, not to another realm or dimension but to a reality which
exists already, but for the most part lies unnoticed. With regard to his process
of visual exegesis, the important point is that Blake believed *himself* to be in
working possession of this faculty of 'imaginative sight' and furthermore, that
his art and poetry flowed from this faculty. This relationship was not always a
straightforward one, however, a fact that is borne out via the complex rela-
tionship between word and image in his books.[72] Perhaps unlike John and the
early apocalypticists, Blake did not consider himself only as a vessel of higher

---

[69] Rowland 2007: 10; see also 21.

[70] See Appendix 1.

[71] See Blake 1810: *A Vision of the Last Judgement*, page 95, reproduced in Erdman (ed.) 1988:
566.

[72] See Mitchell 1978: 3–38, who argues that the unity in Blake's art arises from a complicated
juxtaposition and eventual convergence of text and image 'upon the goal of affirming the
centrality of the human form in the structure of reality'.

truths and expected the reader/viewer to participate in the interpretative process in which he himself was also engaged.[73]

Thus, for Blake, there was no definitive explanation of his visions and certainly no 'code' or key, an understanding of the visionary process that is forcefully endorsed by the twentieth-century 'visionary' artist and admirer, disciple even, of Blake, Cecil Collins.[74] Collins, like Blake, saw his art as a necessary expression of his inner visionary experiences.[75] Despite the fact that Collins' paintings may appear superficially simple or 'open', they have been likened to visual poetry in that, like Blake's, they require interpretative work. One's understanding of them also develops and deepens over time.[76] Thus, his pictorial language, based on universally understood or archetypal images such as the Fool and the Angel, is not, however, a language that could be 'decoded' or interpreted allegorically. Collins' reflections and his art function as a useful comment on Blake and also on the process of re-envisioning now under discussion.

While Blake did paint several watercolours of the Book of Revelation, such as his *Death on a Pale Horse* of c.1800, which offers a distinctive interpretation of Rev. 6: 2–8, it is perhaps in his Job engravings of the 1820s that his particular method of visual exegesis or re-envisioning finds its fullest exploration.[77] Rowland argues that the engravings (which combine images and biblical quotations) act as a guide to Blake's understanding of the Bible and his hermeneutics more generally.[78] In essence, Blake's Job series can be (according to Rowland) summarized thus:

> The framing idea is that seeing God face to face and recognising the divine in the human (Job 42.5) causes Job to turn from a religion based on text and sacrifice to one based on the immediacy of vision. The past is taken up and read differently in light of an apocalyptic vision.[79]

Thus, in the images themselves, we see a transition, rather like in the Dürer Apocalypse images, from a reality in which the divine and the human are juxtaposed and kept separate (see plates 2, 3, and 9, in particular) to one in which there is no longer a divide between man and God. This will come as no surprise to those familiar with Blake and his resistance to the idea of divine

---

[73] Rowland 2007: 18.

[74] See 'Letter to Trusler', Blake, *Complete Writings*, 1966: 793–4. Collins cited in J. Collins 1989: 37.

[75] See Rowe (ed.) 2008: 24–8; 242–4 for more on Collins' visionary experiences and how these were expressed through his art.

[76] Ibid. 22.

[77] See, for example, William Blake, *Death on a Pale Horse*, c.1800, Cambridge: Fitzwilliam Museum; *The Four and Twenty Elders Casting their crowns before the Divine Throne*, c.1803–5, London: Tate Gallery; *The Whore of Babylon*, c.1809, London: British Museum.

[78] Rowland 2011: ch. 2.

[79] Ibid.

transcendence.[80] So in plates 13 and 17, for example, Job and his wife are depicted as sharing the same space as God (i.e. not one divided by a symbolic barrier of clouds, as in the earlier images) and also as bathed in his light or aura. This transition is a direct result of Job's acceptance of the Divine vision (Job 42: 5) and the change in ethic and theological outlook that this inspires in him (see plate 18 where Job prays for his friends in an act of unconditional forgiveness).[81]

Thus recognition of the vision both as the primary medium of divine revelation *and* as an agent of change lies at the heart of Blake's Job series. So while his method of visual exegesis goes beyond a recognition of and an attempt to communicate the importance of the visionary nature of the text of Job, it undoubtedly also encompasses it. Furthermore, Blake's application of visual exegesis has been shown to spring from his understanding of himself as a visionary and prophet whose role it was not only to inform (albeit implicitly) but also to challenge his readers/viewers. While the note of challenge is no doubt a real one, evidenced in his juxtaposition of different mediums, often with no accompanying explanation, on the other hand, Blake also sought clarity of form. Thus in his commentary of 1809 on *The Spiritual Form of Nelson* and *The Spiritual Form of Pitt*, Blake argues that they are exercises in 'clearness and precision', inspired by his visions of the ancient world and captured not with cloying oils but with clear watercolours.[82] This serves to emphasize the fact that a visual exegesis or a visual exploration of a vision, contrary to expectation perhaps, can be precise in form, even if one has to work at the meaning.

In short, Blake devised a religious, mythical, artistic, idiosyncratic language with which to express himself and his visions and which also helps to illuminate the re-envisioning of the Book of Revelation that was undertaken by the earlier artists discussed in this study. In making the concept of vision and its visual expression the hermeneutical key of his Job engravings, Blake not only provides an intentional example of how a biblical text might be re-envisioned but also engages, via the re-envisioning process, Rowland argues, in an early form of *Sachkritik* of the text of Job. Blake looked at the text as a whole and then, via his images and choice of biblical inscriptions, and in the face of more conventional biblical criticism, tells the viewer what it is *really* about, in a similar way to Gresham.[83] Indeed, Rowland argues that Paulson's conviction that 'Blake exposes the errors of the actual verbal and visual text of the Bible while preserving their truths' is simply another way of expressing that Blake

[80] Rowland 2007: 36. Plate references are to the Blake Job series: *Illustrations of the Book of Job*, *c.*1823–6 (present location Collection of Robert N. Essick, Altadena, Calif.)
[81] Rowland 2011: ch. 2.
[82] Blake 2009: 44.
[83] Rowland 2011: ch. 3.

was engaged in *Sachkritik*.[84] The notion that Blake was in some sense critiquing the text of Job in light of his own interpretation of its *Sache selbst*, whilst simultaneously engaging in a re-envisioning of this text shows that the two strands of visual exegesis highlighted in this conclusion are indeed complementary. Whilst they need not, indeed cannot, always be at work within the same image, both aim to express something fundamental of the source-text, be that its *Sache selbst* or its character. Thus it is natural that in some visual interpretations of biblical texts, such as Memling's, Dürer's, or Blake's, something of the text's subject-matter *and* its visionary character are evoked.

---

[84] Rowland 2011: ch. 3; Paulson 1982: 121.

# Conclusion

Chapter 6 functions as an attempt to highlight and reflect upon the main hermeneutical trends that emerged from the seven case studies undertaken above. Amongst the different interpretative strategies espoused by the images in question, some patterns emerged. These patterns were analysed via the *Darstellung/Vorstellung* lens and via the Kovacs–Rowland-inspired interpretative grid. Amidst the hermeneutical trends (i.e. did the image exhibit *Darstellung* or *Vorstellung* or was a more 'decoding' or a more 'actualizing' interpretation suggested by it?), it was also possible to discern a strand of visual exegesis at work in some of the images whereby the image functioned as a way of expressing the subject-matter or *Sache selbst* of the Book of Revelation. This is comparable to the critical discipline of *Sachexegese*.

A second strand of visual exegesis was also discerned, one that focused on the *character* of the Book of Revelation as a visionary text, itself dependent on 'something seen'. This character, it has been argued, is more effectively evoked by an image than by a text, something that was also recognized, it would seem, by many of the featured artists. Thus the visionary claims made by the text of the Book of Revelation have been communicated and given intelligible form by visual artists such as the *Lambeth* illustrators, the Van Eycks, Memling, and Dürer, in what could be described as examples of (visionary) visual exegesis or re-envisioning. This tradition was taken up by Bosch, Duvet, and later Velázquez, among others. Further to this, it may also be argued that Dürer and Duvet, as well as being visual exegetes, also saw themselves like John as visionaries. Their images of the Book of Revelation are not only interpretations of the text and of its visionary nature but also records of visions, thereby giving them a real affinity with the visionary as well as the recording process that John himself undertook. Images, unlike textual interpretations, by their nature can bring many ideas together in one (pictorial) space, as occurs within the human imagination, and also, one presumes, in visions.

But what of the relationship between these two strands of visual exegesis and biblical exegesis in general and also other recent theories of visual exegesis? With regard to visual exegesis, one welcomes the work of Berdini and O'Kane, who have both written extensively on the issue. Under their conception of

visual exegesis, as alluded to in the Introduction, the artist is understood to be visualizing not a text but a *reading* of the text, which will be influenced by his or her immediate context.[1] Recognizing the artist as a reader of the biblical text in his or her own right who comes up with his or her own expanded notion of the text (which may encompass contemporary textual exegesis of the text as well as 'actualizing' detail) is an important part of Berdini and O'Kane's understanding of visual exegesis. Indeed, Berdini describes visual exegesis as 'the dialectic between textual meaning and the reader's existence'.[2] Visual exegesis is also intended to affect or modify the beholder in some way. O'Kane sums up his understanding of visual exegesis as encompassing 'the new encounter with the text made possible by the image'.[3]

However, it remains unclear whether this definition of visual exegesis as posited by Berdini and O'Kane serves to render it subordinate to textual exegesis *as well as* failing to capture its distinctive properties.[4] The subordination of visual exegesis to textual exegesis that appears to occur in Berdini and O'Kane's work may be the result of a reverence for the historical-critical method of biblical interpretation that has been pervasive within the theological academy.[5] This method privileges critical, supposedly 'scientific' and objective, often verse-by-verse explanations of biblical texts, which tend to have an almost exclusive focus on their contemporary setting and application, as this is viewed as the key to their 'meaning'.[6] That any interpretation can be properly scientific and objective has been shown to be false. Every interpreter of every text, image, piece of music or dance, brings with them certain presuppositions and a personal context, whether they are aware of this or not. There is therefore no such thing as a scientific explanation of a biblical, or any other text, as the two-hundred-year-long Quest for the Historical Jesus has demonstrated in its inability to derive any mutually satisfactory picture of Jesus from the Gospels and related texts.[7]

Even if it were possible to perform a perfectly scientific analysis of a biblical text, this would not expose a fixed 'original' meaning of that text. This is largely because there is no such easily recoverable thing as an 'original', fixed meaning when it comes to biblical or, for that matter, many other texts.[8] As

---

[1]  Berdini 1997: 14–35; O'Kane 2005: 348.

[2]  Berdini 1997: 5.

[3]  O'Kane 2005: 346.

[4]  For Berdini on textual and visual exegesis see Berdini 1997: xi–xii; 14–35. He argues that they are both intended to have a specific effect on the beholder but is less clear about whether the two are analogous in terms of their hermeneutical relationship with the source-text.

[5]  See Houlden (ed.) 1995; Fitzmyer 2008.

[6]  Fee 1983: 27–8.

[7]  Schweitzer 1906, tr. Montgomery 2005: 1–12; 294–329; 398–403. See also Luz 1994: 1–22. See also Wright 1992: 796–802 and Stanton 2002: 139–270 on the problems with the Quest for the Historical Jesus.

[8]  Luz 1994: 17.

Luz argues, biblical texts are not like reservoirs containing fixed amounts of water that can be measured exactly. Rather, they are like a natural water source from which new water constantly emerges.[9] And this 'new water', to use Luz's analogy, emerges via the interaction of new interpreters with the text in question, be they textual *or* visual exegetes. This goes against the second main contention of historical-critical scholarship: that a biblical text can only be properly understood when viewed against its immediate historical context and in terms of how it would have been received by its immediate readers/hearers. For if there is no 'original' meaning in the sense posited by the historical-critical method, then surely other receptions of the text in question from different times and places also have interpretative weight? A historical-critical reading of a biblical text becomes but one interpretation among many. The recent popularity of other sorts of interpretations of biblical texts, such as literary criticism and reception history, certainly supports this idea.[10]

If textual exegesis, of the historical-critical and indeed any other variety, is to be understood not as the revelation of the true or original meaning of a biblical text but rather as a, possibly very insightful or influential but nevertheless, subjective *interpretation* of that text then I maintain that, in terms of the 'exegetical result', visual exegesis actually is closer to textual exegesis than O'Kane and Berdini allow. Both forms of exegesis can produce an interpretation of the source-text that can evoke the essential subject-matter (*Sache selbst*) or character of the source-text for the reader/viewer. One does this diachronically, with words, and the other synchronically, with images. The difference between the two methods can therefore be located in the form used to express the interpreter's understanding of the source-text. While the choice of exegetical 'form' (i.e. whether a textual or a visual form of exegesis is applied) is crucial when interpreting a text such as the Book of Revelation, which may find its fullest expression in a visual interpretation, it does not seem at all clear that one has to accept, as Berdini and O'Kane appear to, that visual exegesis is one step further removed from the source-text than textual exegesis. Both a textual exegete and a visual exegete will first form an interpretation of the text in the mind or imagination, which, as Berdini and O'Kane argue, will be influenced by their immediate context. In both cases, this may then be worked out via juxtaposition and/or harmonization with other interpretations either textual or visual. That visual interpretations may be influenced by textual interpretations or by the demands of patrons does not seem to me any different from a textual interpretation that has been influenced (as it no doubt will have been) by another textual interpretation or via discussions

[9] Ibid. 19.
[10] On recent reception history of biblical texts see: Luz 1994; Beuken and Freyne 1995; Müller and Tronier 2002; Kovacs and Rowland 2004; Nicholls 2005; Sawyer 2006. See also the entire Blackwell Bible Commentary Series.

with other scholars, or indeed literary patrons. The dialectic that Berdini describes as existing between textual meaning and the reader's existence thus holds as much for textual exegesis as it does for visual exegesis. Furthermore it seems inconsistent that O'Kane uses the notion of *Darstellung* in his work as a way of explaining what takes place in some visual interpretations of biblical text (i.e. the subject-matter is brought forth) whilst at the same time maintaining that visual exegetes are somehow engaged in a different process from textual exegetes.

While it seems to me then, having examined to the best of my abilities the exegetical processes of the artists discussed in this study, that these two types of exegesis proceed according to a similar rationale, they are not, however, to be thought of simply as alternatives to each other. Indeed, it has been argued throughout this study that, in some cases, visual exegesis may illuminate facets of the source-text (related either its subject-matter or its character) in ways that a textual interpretation is less successful at doing. Thus to use O'Kane's phraseology, in the case of the second strand of visual exegesis described in Chapter 6, some images render possible a form of engagement or a 'new encounter' with the visions purported to lie *behind* the source-text of the Book of Revelation. Davey encapsulates this idea when he says of images that 'words can name and clarify confused feelings while images allow us to see visual likenesses of what we may feel but blindly'.[11] In the case of the Book of Revelation we may therefore, on the basis of the claims, format, and content of the written text, have some sense of its visionary character. However, it takes an image such as Memling's to give that 'sense' a spatial form.

Furthermore, as stressed above, contact with a number of images which give spatial form and content to the visionary character of the Book of Revelation may also cause the viewer to reflect again upon aspects of the text, both in terms of its character and subject-matter, in what might be described as a process of second-order reflection. Interaction of this sort between the source-text and a visual interpretation of that source-text need not therefore be mono-directional but rather reflexive, ongoing, and mutually illuminating. For this kind of relationship to take place, however, there needs to be a beholder, an observation that seems perfectly obvious but can sometimes get overlooked in discussions of how images might 'dialogue' with texts and vice versa. The text and the image, once produced, are (within reason) fixed entities and it is the beholder who has the power to relate the two and in the process come up with a new interpretation, which may remain personal to them or may in turn be expressed via an appropriate (according to them) medium. Thus Berdini and O'Kane are quite right to stress the role of the beholder as instrumental to our perception of how an image functions as an interpretation

---

[11] Davey 1999: 21.

after the artist has produced it. Like a textual commentary or piece of exegesis, an image can only function as an affective interpretation at this secondary level given an active beholder.

Returning finally to the primary level of reflection, it has already been suggested that within biblical exegesis there already exists a particular form of exegesis in which the role of the *interpreter* (as opposed to the reader/ beholder) is emphasized as opposed to de-emphasized (as in historical-critical exegesis): that of *Sachexegese*. This is a process whereby the exegete conveys to the reader their understanding of the *Sache selbst* of the text in question. Furthermore, this may form the closest parallel to the first strand of visual exegesis that has been traced throughout the study and discussed formally in Chapter 6, and which found its fullest expression in the work of Gresham, whose images were, via a process of *Sachexegese*, seen to subtly engage with and provide an answer to, the interesting question raised in the Introduction regarding whether the Book of Revelation succeeds as visual imagery and thus whether it should be visualized at all. Gresham's artistic *Sachexegese* showed, in keeping with the evidence provided via the seven case studies, that this text, while difficult to *depict* as such may be *visualized* on a more metaphorical level powerfully and incisively. Thus, it would seem that if *Sachexegese* is an accepted process within biblical interpretation, then a visual counterpart, as exemplified by many of the examples discussed in this study, also has a place. Not only does it have a place, but on occasion, as has been seen throughout this study, and as will be further demonstrated via intended future projects, it can fulfil an interpretative role that a textual interpretation cannot, as was also the case with those images which sought to re-envision John's original text.[12] However, whether these sorts of visual exegesis will be accepted by the biblical academy as something to be taught in universities alongside textual exegesis is a question that cannot be answered in this study, but one that I hope will be played out in theology faculties over the years to come.

---

[12] See O'Hear 2009 on the visual history of the Whore of Babylon, for example.

# APPENDIX 1

# The Book of Revelation: A Visionary Text?

While there are notable commentators who are supportive of the suggestion that the Book of Revelation is based wholly or in part on visionary experiences (see Boxall, Brook and Gwyther, and Kovacs and Rowland for example), there are others who maintain, perhaps influenced by the sense of discomfort with the concept of visionary experience that has been felt since the Enlightenment, that the Book of Revelation is a sophisticated literary construct which has self-consciously used the apocalyptic visionary genre in order to give authority to its message.[1] Prior to this the possibility of visionary experience was accepted almost without question. Indeed in the later Middle Ages, different types of visionary experience were categorized and labelled, so prevalent were they purported to be.[2] For many post-Enlightenment scholars, however, the symbolism and metaphors found in the text of the Book of Revelation are of an inherently literary variety and not, as I have suggested above and in the Introduction, the result of John's attempts to evoke his initially visionary, visual experiences with words. A text made up of such literary symbols, so the argument runs, does not therefore lend itself to visual interpretation, indeed may even resist it. Aune and Schüssler-Fiorenza are some of the most strident proponents of the hypothesis that the Book of Revelation is very much a 'literary vision'.[3]

Aune argues that the literary structure of the Book of Revelation is so complex as to suggest that it was written and compiled, not as a relatively straightforward attempt to record one or more visionary experiences, but over a period of twenty or thirty years.[4] He divides the history of the text's composition into two major stages. The 'first edition' consisted approximately of Rev. 1: 7–12a and 4: 1–22: 5, while the 'second edition' added Rev. 1: 1–3, 1: 4–6, 1: 12b–3: 22 and 22: 6–21. Within the first edition exist, according to Aune, twelve 'relatively independent textual units that have little to do with their immediate contexts or indeed with the macro-narrative of Revelation'.[5] These are Rev. 7: 1–17 (the sealing of the 144,000); 10: 1–11 (the Mighty Angel); 11: 1–13 (the Two Witnesses); 12: 1–18 (the Woman Clothed with the Sun and the Dragon); 13: 1–18 (the two Beasts); 14: 1–20 (the Lamb and the 144,000; three angelic revelations); 17: 1–18 (the Whore of Babylon); 18: 1–24 (the fall of Babylon); 19: 11–16 (the rider on the white horse); 20: 1–10 (the final defeat of Satan); 20: 11–15 (the judgement of the dead); 21: 9–22: 5 (the New Jerusalem). The apparent internal coherence of these twelve passages in combination with their lack of continuity with each other and the rest of the narrative (the lack of continuity between the different characters in these passages being just one example) leads Aune to suggest that they

---

[1]  See Boxall 2002, 2006; Brook and Gwyther 1999: 137; Kovacs and Rowland 2004; Rowland 1982.

[2]  See Dronke 1984: 144–6; Voaden 1999: 10–12.

[3]  Aune 1997; Schüssler-Fiorenza 1993.

[4]  See Aune 1997: cxviii–cxxxiv.     [5]  Ibid. cxix.

were composed over a relatively extensive period of time, in different contexts and for different purposes. The 'macro-narrative' (comprising the initial throne-room scene (Rev. 4–5) and the three sequences of seven (Rev. 6: 1–8: 1; 8: 2–9: 21, 11: 15–19; 15–16)) was then composed as a frame into which these twelve passages could be inserted, accustomed as apocalyptic authors were to 'marshaling [*sic*] an extensive array of apocalyptic themes and motifs, placing them within a framework of traditional eschatological scenarios, and show[ing] little hesitation to use and revise existing material (whether in oral or written form) in the process of composition'.[6] The first edition having been completed sometime around 70 CE, the second edition was completed in the 90s, and exhibits a much higher, or more 'developed' Christology.[7]

In addition to his complicated literary analysis of the narrative of the Book of Revelation, Aune also suggests that the journey motif running through the text is the result of a premeditated decision to create an apocalyptic work.[8] He argues that despite the fact that Rev. 4: 1–22: 9 is construed as a report of a single vision, the perspective changes unpredictably between heaven and earth. So for instance, while Rev. 4: 1–9: 21 is presented from a heavenly perspective, Rev. 10: 1–11, 11: 1–13, and 12: 1–6 etc. are presented from an earthly one, but with no explanation as to how John, the seer, has returned to earth. He also comments upon the frequency of John's first-person references to receiving the visions (there are nearly forty uses of the phrase καὶ εἶδον) throughout the text, as well as the emphasis placed on the descriptions of John's reactions (see Rev. 1: 9–20 where John faints or Rev. 5: 4–5 where he weeps, for example), the insinuation being that these have been inserted to lend a touch of realism to the visionary claims, as well as a sense of cohesion to the narrative as a whole.[9]

Schüssler-Fiorenza meanwhile, whilst arguing for the same general conclusion, that of the Book of Revelation being a sophisticated literary construct, does not propose a stage-by-stage evolution but rather a conscious, overarching attempt by John to make sense of his own situation via contemporary apocalyptic and mythological symbols.[10] She suggests that John has searched Hebrew Scripture and Graeco-Roman mythology 'for typologies and exemplary figures to serve as paradigms for his rhetorical composition and as rhetorical proofs for Revelation's world of vision. For instance John's depiction of God's judgement on those who oppress God's people in the seven trumpet and bowl series is modelled after the Exodus narrative and its reception in the Wisdom of Solomon.'[11] Thus he is not inventing the symbols found within his text but recasting ancient ones in imaginative ways. Neither does John use direct quotations, preferring rather to allude to connections. His choice of a Hebraizing idiom helps to strengthen these allusions, giving, as it does, the text a hieratic, traditional character.[12] Overall, John's deployment of this sophisticated apocalyptic-type genre and structure gives his injunctions and admonitions a plausibility that they would otherwise lack.[13]

If the Book of Revelation was indeed written according to the model suggested by Schüssler-Fiorenza, then she is right in calling it a 'literary vision'. She feels that this literary character is exemplified best in the 'call vision' of Rev. 1: 10–20. She writes that,

---

[6] Aune 1997: cxxiii.  [7] Ibid. cxxxii–cxxxiv.  [8] Ibid. lxxxii.
[9] Ibid. cxxvi. Against this see Rowland 1982: 232.
[10] Schüssler-Fiorenza 1993: 26–7.
[11] Ibid. 27.
[12] See, for example, John's use of the Hebrew idiom εἶδον καὶ ἰδον (Rev. 6: 2, 5. 8), meaning 'I had a vision of'. See also his use of μία as an ordinal (e.g. Rev. 6: 1), also a Semitism.
[13] Schüssler-Fiorenza 1993: 27.

'it is impossible to picture or draw this vision, for its images and symbols function more like words and sentences in a composition'.[14] By this presumably she means that the vision develops diachronically, as events happening one after the other, succeeding each other, rather than occurring synchronically as in an image. She may also be implying that later events cannot be understood without earlier ones, that there is a linear progression to the passage, which again would be difficult to capture in an image. In addition to this, it is true that the actual symbolism used here, and elsewhere, is difficult to visualize, *as it is written*. How to visualize the sword coming out of the mouth of the One like the Son of Man (Rev. 1: 16), for example, is a problem that has, on the whole, confounded artists who have attempted to visualize this passage, often with unintentionally comic or awkward results (see, for example C1 of the Cranach series). However, such visualizations rest on a rigidly literal understanding of a text whose imagery Schüssler-Fiorenza herself, although admittedly for different reasons, approaches for the most part as symbolic. Thus just because we cannot visualize this vision literally *as it is written*, does not seem, by itself, a good argument in favour of accepting that the Book of Revelation is a purely literary vision. For this could just as well point to the fact that the text is an inadequate rendering of some underlying visionary experience(s), experiences which John has been unable to capture accurately with words, but has nevertheless resonated with artists and visionaries ever since.

The wider hypothesis, espoused by Aune and Schüssler-Fiorenza, among others, that the Book of Revelation is primarily a literary composition in the prophetic/ apocalyptic genre, whilst not falsifiable, given our temporal distance from the source-text, can nevertheless be shown to be overstated for several reasons. On an argumentative level, one can see weaknesses in Aune's hypothesis. He argues, on the one hand, that there are twelve independent textual units in what he terms the 'first edition' of the Book of Revelation. He deems them independent because they 'have little to do with ... the macro-narrative of Revelation'.[15] However, a little later, he argues that the author had made these textual units the 'focal set pieces ... of the larger narrative structure'.[16] There seems to be a contradiction here in that either these twelve passages stand out for their distinctiveness or they do not. If the narrative has been carefully crafted to accommodate them, then surely they lose their distinctiveness and thus the argument that they must belong to a different *Sitz im Leben* is significantly weakened. And if the macro-narrative has not in fact been carefully crafted to accommodate them, thus preserving their distinctiveness, and they do stand out, then the notion that this is a very sophisticated literary work (as opposed to a more chaotic vision report) is likewise weakened.[17] Similarly, Aune seems to be at pains to show how, on the one hand, the author of the Book of Revelation has contrived to write his text almost slavishly in the apocalyptic genre (cf. the use of the phrase καὶ εἶδον and references to John's participation in the visions), while, on the other, that he has shown blatant inconsistency in his organization of the vision reports (cf. the discrepancies regarding whether they are being presented from a heavenly or an earthly perspective). Once again it seems that Aune is attempting to present conflicting

---

[14] Ibid. 29.    [15] Aune 1997: cxix.    [16] Ibid. cxxiii.

[17] I also maintain that, on a thematic level, the passages that Aune has picked out do have overlaps with the rest of the macro-narrative, if that macro-narrative is accepted as describing, above all else, the victory of the Lamb and the execution of divine judgement.

arguments in support of his hypothesis: that the text is contrived but at the same time chaotic or inconsistent.

That there are undoubtedly discrepancies in the style of the 'macro-narrative' of the Book of Revelation (as well as in other places) may further weaken Aune's argument that it is a sophisticated literary construct. Conversely, it may help to strengthen the alternative analysis of the text that I maintain is the more plausible one, that underlying the text are real visionary experiences. Gruenwald, Rowland, and Morray-Jones, with reference to the medieval *Hekhalot* literature (3rd–11th centuries) in particular, have shown that sophisticated literary structure and even exegesis can and has been combined, in the same text, with reports of genuine visionary experience.[18] So for instance in the *Hekhalot* text, HekhR, an account of a heavenly journey is combined with three long collections of hymns as well as with *midrash*.[19] Williams too comments upon the fact that what distinguishes Teresa of Avila's visionary writings from those of some of her fellow pre-modern visionaries, such as Hildegard of Bingen or Julian of Norwich, is not only that she reflected on her visions but also 'set them on a map of Christian life designed to be of more than individual or anecdotal rest'.[20] Thus her visions formed part of an overall argument or thesis, a fact which, in itself, does nothing to detract from the veracity of her visions.

Thus the fact that the Book of Revelation contains evidence of later interpretation or reflective material (see Rev. 17: 7–18; and cf. Rev. 1: 1–3, 1: 4–6, 1: 12b–3: 22, and 22: 6–21) alongside more fluid material, in which the visionary perspective seems to alternate between heaven and earth (Rev. 4–5 versus Rev. 10–12), is not in itself evidence that the more fluid material is not based on real visionary experience. The two genres are not mutually exclusive and thus evidence of a sophisticated literary structure (such as the Book of Revelation's sequences of seven), later reflection, and/or a refined Christology are not, as stated above, necessarily evidence that a work is not based in visionary experience.

Further to this, striking parallels can be demonstrated between apocalyptic literature in general, and the Book of Revelation in particular, and other reports of supposedly genuine, widely accepted, visionary experiences. Such parallels can be found in Jewish apocalyptic literature from the Exile (*c.*586 BCE) to the first century CE, the works of the *Merkavah* mystics, such as Ezekiel, Hildegard of Bingen (1098–1179), Bridget of Sweden (1303–73), Teresa of Avila (1515–82), William Blake (1757–1827), and more recently the visionary artist Cecil Collins (1908–89), as well as in reports issuing from Shamanistic and Inuit cultures.[21] This survey of visionary texts from at least four different historical eras and a variety of cultures has been collated intentionally, in order to illuminate the close similarities between such historically and geographically diverse material. Therefore, while this cannot and does not claim to be a comprehensive survey of the possible characteristics of visionary

---

[18]  Gruenwald 1980; Rowland and Morray-Jones 2009: 228–64; Rowland 1982: 16, 22, 342–7.

[19]  Morray Jones and Rowland 2009: 240–3.

[20]  Williams 2003: 188–9.

[21]  On Jewish apocalyptic literature (Daniel, I Enoch, 4 Ezra, etc.) see Collins 1998, Rowland 1982; on *Merkavah* mysticism see Gruenwald 1980, Halperin 1980 and 1988, Rowland and Morray-Jones 2009; on Hildegard of Bingen see Hart, Bishop, and Newman 1990; on Bridget of Sweden see Voaden 1999; on Teresa of Avila see Williams 2003; on Blake see Bentley 1969, 2004, Myrone 2009, Rowland 2007, 2010; on Collins see Anderson 1988, J. Collins 1989, Rowe (ed.) 2009; on Shamanistic, Inuit, and tribal visionaries see Eliade 1964, Niditch 1980.

literature, what follows is a summary of some key recurrent features.[22] We shall argue that the Book of Revelation shares enough of these features for the claim that it too is based in visionary experience to be taken seriously. It should be stressed that I am not entering into a philosophical debate regarding whether religious or visionary experiences actually have a divine cause (although I will make tangential references to this longstanding debate below), but rather I am arguing that all of the figures referenced above *believed* themselves to have had visionary experiences, then recorded them, and that there are many similarities between these reports. It is possible to argue inductively towards a divine (or at least an external) cause from these striking agreements (i.e. as opposed to them being simply random), as William James did in his *Varieties of Religious Experience*, but this is not a necessary step in my argument regarding the appropriateness of visual interpretations of visionary texts.[23]

Turning to these similarities, we note first that, in visionary texts, there is usually an emphasis on the visionary him/herself, the privileged seer, and possibly the circumstances which prompted his or her visions. In the case of the Jewish apocalyptic material, the visionary was always described in pseudonymous terms (see Daniel or 1 Enoch, for example). Later visionaries tend to be more open about their identity, although they may still occupy a position on the fringes of society or as a religious devotee. Hildegard of Bingen, Bridget of Sweden, and Teresa of Avila were all nuns, but of an unconventional variety. They all faced opposition to and criticism of their visionary activity.[24] Blake, although not religious in an orthodox sense, was, by his own admission and volition, deeply counter-cultural.[25]

Visionaries may also have undergone a personal crisis or trauma prior to receiving the visions, the most common of which is serious illness. The prophet Ezekiel is described as an exile when he receives his first visions by the Chebar (Ezek. 1: 1–3). Daniel is also described as an exile (Dan 1: 1–7; 7: 1). Bridget of Sweden received her commissioning vision after her husband died and she went to a convent at Alvastra in 1344.[26] Teresa of Avila, meanwhile, attributes the *loss* of her visionary powers, which she had possessed since she was a teenager, to serious illness, powers which returned in 1554 with something akin to a reconversion.[27] Interestingly, the mathematical philosopher Pascal also experienced a *nuit de feu* on 23 November 1654. This visionary experience, which followed a period of confusion, ill health, and suffering, led to a change of life (conversion to a Jansenist spirituality) and a dispelling of doubts. He recorded his thoughts on the experience in the *Pensées* 913 (The Memorial Document) and kept a personal version of this text sewn into his coat.[28]

There is certainly a focus on the figure John in the Book of Revelation, and no hint of pseudonymity either. The text is narrated from John's perspective, and as will be analysed below, his reactions are also documented throughout. This focus on John is

---

[22] This list has been compiled based on the work of Boxall 2002: 27–47; Niditch 1980; Rowland 1982: 214–47.

[23] See James 1902 (1985 edn.): 382–405.

[24] Williams 2003: 58, 144; Voaden 1999: 77.

[25] See Blake 2009: 32 (cites Blake's 'venomous statements' re the state of current art-marginalia of Reynolds' *Discourses* and his own draft lecture, *Public Address*), 43–7. See also Rowland 2007: 10 on Blake's view that it was important to 'speak out' against injustice and oppression.

[26] Voaden 1999: 75.

[27] Williams 2003: 1–14.

[28] See A. O'Hear 2007: 371–2.

taken up and expanded in the illustrated *vitae* of John that were often attached to illustrated manuscripts of the Book of Revelation (see Lambeth, fos. 40ᵛ–45 for example). Much subsequent speculation has also taken place on the circumstances of John's finding himself on Patmos due to 'persecution' (Rev. 1: 9).[29] In the second-century Acts of St John, this was certainly attributed to being exiled there by Domitian, an event which could and probably should be described under the heading of a traumatic personal experience.[30] His counter-cultural credentials are provided by the actual content of his visions, which present a paradoxical world-view in which earthly power is shown to be ultimately hollow and humility and faith the keys to the New Jerusalem (see Rev. 17: 16–18; 20: 10; 21: 27). Although of course the issue of authorial intention becomes more complicated if one maintains that the Book of Revelation is based in visionary experience.

Second, many, if not all, of the visionaries under discussion detail the execution of various ascetic practices prior to visionary experience. In Ezekiel 2: 8–3: 3, for example, Ezekiel tells how the angel orders him to eat a scroll, which tastes 'as sweet as honey' before receiving his second vision. Conversely, in Daniel 10: 2, Daniel tells how he fasted for three weeks before receiving the ensuing vision. In 1 Enoch 13: 8–9, Enoch speaks of how he prayed, fell asleep, and then received visions in his dreams. Likewise, both Bridget of Sweden and Teresa of Avila detail the various prayer practices that they undertook prior to undergoing visionary experiences. Teresa talks of the private prayer and also the use of books that help to focus her mind in readiness for a vision of Christ.[31] In *Life* 11–17 she famously likens the various stages of preparation or readiness for visionary experience to that of the different ways of watering a garden.[32] The fourth and highest stage, likened to the God-given method of watering, namely, rain, is precipitated by a special type of prayer in which self-awareness is completely suspended in recognition of the omnipresence of the Divine.[33] Once this state of passivity is attained, union with the Divine becomes possible, provided God wishes to bestow it, one presumes. While it is certainly possible, likely even, that Blake meditated on Ezekiel, this cannot be proved, although Ezekiel 1 certainly seems to have inspired Blake's Four Zoas.[34] Another mode of accessing visionary experience is expressed in Coleridge's note on the writing of Kubla Khan:

> This fragment with a good deal more, not recoverable, composed in a sort of Reverie, brought on by two grains of Opium, taken to check a dysentery, at a Farm House between Porlock and Linton, a quarter of a mile from Culborne Church, in the fall of the year, 1791.[35]

The parallels between these descriptions and the description of John's preparations are clear. In Rev. 1: 10 he speaks of being 'in the spirit on the Lord's day', when he received his first vision, probably a reference to Sunday worship (either public or

---

[29] Boxall 2006: 10–11, 39.
[30] See Hennecke 1974: vol. 2, 188–259.
[31] See Williams 2003: 66.
[32] Ibid. 86–7.
[33] Ibid. See Dronke 1984: 144–6 and Voaden 1999: 10–11 on the categorization of mystical experiences in the medieval era.
[34] See Rowland 2007: 22.
[35] Reproduced in Schneider 1945: 784–5.

private).[36] There is also a reference to imbibing a little scroll that 'was as sweet as honey' at the behest of the Mighty Angel in Rev. 10: 8–10. The parallels with Ezekiel 2: 8–3: 3 are clear. Such overlap raises the possibility that John was merely imitating passages from Hebrew Scripture and apocalyptic literature in order to evoke the apocalyptic or prophetic genre. This is a possibility that has to be considered by a proponent of a hypothesis such as mine regarding the origins of the text of the Book of Revelation. However, Rowland has convincingly shown, based on detailed analysis of Ezekiel 1 and Rev. 4 (the *Merkavah* or heavenly throne-room vision), that far from mimicking Ezekiel, the Book of Revelation represents a meditation on and a re-visioning of the earlier text, in which 'the order and details of the original have been left behind in favour of a more elaborate view of the nature of God's dwelling in heaven'.[37] Thus, if one allows that John has undergone real visionary experiences, it is feasible that he sees again and experiences again (cf. the scroll) in general terms, what Ezekiel saw and experienced by the banks of the Chebar. That there are small and important differences in the way the material has been recorded, and later interpreted, is to be expected, given the different temporal and social contexts of the two visionaries.

It is surely noteworthy, as has been commented upon already and will be discussed further below, that both the 'call vision' of Rev. 1 and the imbibing of the scroll in Rev. 10 have received particular attention from late medieval and early modern artists from Lambeth to Dürer (and beyond). This not only indicates that such artists have taken the claims to visionary preparation seriously but also that they believed that they led to real experiences. Certainly, within the context of the late medieval era, such an understanding of these sections of the text would have been perfectly legitimate.[38]

Ascetic practices undertaken in readiness for visionary experience can lead to physical and emotional sensations, sensations which either accompany the visions or signal their beginning or end. Such physical sensations can take the form of feeling hot and/or cold, having contact with angels, hearing things, feeling ecstatic or feeling scared, and in some cases feeling despondent at the end of the vision. Thus in the heavenly vision of 1 Enoch 14: 13 ff., Enoch describes heaven as being simultaneously as hot as fire and as cold as ice. He also describes feelings of fear. In I Enoch 71, he describes being physically taken by the hand by an angel. Similarly, in another first-century apocalyptic text, 4 Ezra 10, Ezra falls at the feet of the angel Uriel. Hildegard of Bingen, meanwhile, describes the vivid physical sensations that accompanied her visions. These included flashes of light (illuminations) and other aura (such as scintillating scotoma), now often associated with migraines.[39] Bridget of Sweden meanwhile, records aural phenomena as accompanying her visions, such as the singing of angels, Teresa of Avila describes physical sensations of coldness (*Life* 20), as well as feelings of weightless-ness and finally feelings of misery at the end of the visions.[40] In a much referenced vision Teresa also speaks of having a pseudo-physical encounter with a seraph (angel):

> I saw in his hand a long spear of gold, and at the iron's point there seemed to be a little fire. He appeared to me to be thrusting it at times into my heart, and to pierce my very entrails; when he drew it out, he seemed to draw them out also, and to leave me all on fire

[36] Boxall 2006: 40.
[37] Rowland 1982: 226.
[38] See Dronke 1984: 144–6.
[39] Ibid. 147.
[40] Bridget: Schiller: 78; Teresa: Williams 2003: 88.

with a great love of God. The pain was so great, that it made me moan; and yet so surpassing was the sweetness of this excessive pain, that I could not wish to be rid of it.[41]

Once again, there are parallels to be found with John's experiences in the Book of Revelation. In Rev. 1: 17, John falls at the feet of the One like the Son of Man as though dead. We would probably describe this as a fainting action. In Rev. 4: 1–2, John is said to ascend to the heavenly throne-room. In Rev. 17: 3 and 21: 10, once again he is taken by an angel. In Rev. 5: 4 John weeps when no one is found worthy to open the scroll, in Rev. 7: 14 he speaks to the angel and in Rev. 10: 10, as discussed above, he imbibes the scroll given to him by the Mighty Angel. Rowland highlights this chapter as particularly significant as this is the moment at which John ceases to be a passive observer of the visions and is commanded directly to prophesy. His personal involvement in the visions gives them a new relevance, which up until this point they had lacked.[42] In Rev. 11: 1 he is given the rod with which to measure the Temple. In Rev. 17: 6b John expresses amazement at the figure of the Whore of Babylon, a reaction that is followed by a rare interpretative section. While proponents of Aune's position dismiss these references as apocalyptic artifice, as attempts to add realism to the text, the points of overlap with other records of visionary experience, namely those regarding contact with angels and emotional reactions to the visions, could equally point to 'real' experiences.

A distinction might also be made here, indeed has been made, between vision reports which speak of visionary travel and those which take place on a more cerebral level, as if the vision is accessed via the imagination. Thus with the apocalyptic authors, there is a great emphasis on actual heavenly travel (see 1 Enoch 14: 8 which talks of him flying through the sky; or the *Hekhalot* author who talks of having a ladder in his house whereby he could ascend to the world above), something which is toned down by the medieval era when different levels of visionary experience had begun to be articulated.[43] Thus Bridget seems to talk of visions being brought to her in prayer and Teresa praises the 'intellectual vision' as the highest and most desirable form of vision.[44] In these the visionary moves beyond even comprehension with the inner eye to a merely intellectual awareness of Christ (*Life* VI.8.3).[45] Cecil Collins, the twentieth-century visionary artist, also talks of visions arriving before him, precipitated by the act of painting. He continues to paint whilst receiving the visions and is often surprised at the results, so consuming is the experience:

> I realise that all these pictures are already inside of me in the form of seeds, as in a garden, and the action of moving the paint, or some circumstance that's conducive, will make these seeds open inside of me and reveal themselves to me. The whole of the picture is a mystery to me, it unfolds under my very fingers, it surprises me. I must have that surprise; that surprise is to me the authentic note of a vision. Then I know that I didn't invent it, that it was born.[46]

Blake talks openly and in a very detailed way of:

---

[41] Teresa, *Life* 29.13.
[42] Rowland 1982: 428–9.
[43] Ibid. 22; Richard of St Victor PL 196: 686 ff.
[44] Voaden 1999: 103–8.
[45] Williams 2003: 172.
[46] Rowe 2008: 242.

having been taken in vision to the ancient republics, monarchies, and patriarchates of Asia, has seen those wonderful originals called in the Sacred Scriptures the Cherubim, which were sculpted and painted on walls of Temples, Towers, Cities, Palaces, and erected in the highly cultivated states of Egypt, Moab, Edom, Aram, among the rivers of Paradise, being originals from which the Greeks and Heturians copied Hercules, Farnese, Venus of Medicis, Apollo Belvidere, and all the grand works of ancient art.[47]

Thus, for him the visionary journey was still something that could be experienced in a visceral way albeit via the window of one's imagination.

In the Book of Revelation it seems that we have a mixture of visionary experience, in that sometimes John *appears* to have travelled physically, but this side of his experience is not emphasized as it is in the Jewish apocalyptic texts such 1 Enoch. Possible instances of the heavenly journey are spoken of more euphemistically as being 'in the spirit'. The fact that artists have engaged with both possible dimensions of John's visionary experience was discussed in Section 6.4 above. Thus some visualizations (such as Lambeth and *Angers*) depict John as physically following the visions. Others, meanwhile, such as Memling's and Dürer's visualizations, focus more on John's internal perspective on the visions, his visionary eye, as it were.

To return to areas of similarity between different vision reports, it is undoubtedly true that there are also correlations to be made across the actual *content* of the visionary reports that we have been assessing. In the most fundamental sense, the vision reports under discussion are all concerned with articulating truths about the human condition *not* seemingly accessible through ordinary rational channels. Rowland refers to this, via the words of Hengel, as the 'quest for higher wisdom through revelation'.[48] The heavenly journey motif is a key theme, as is the notion of seeing God/Christ face to face, possibly in a throne-room setting. The original throne-room or *Merkavah* vision is found in Ezekiel 1, in which he has a vision of the 'four living creatures' (Ezek. 1: 4–25) and then finally one 'with what seemed like a human form' seated on the throne in their midst (Ezek. 1: 26–8). There are also several references to fiery phenomena such as burning coals (Ezek. 1: 13) and enclosed fire (Ezek. 1: 27). These phenomena, and particularly the idea of the heavenly throne-room itself, are recapitulated and expanded upon in Dan. 7: 9–10 and 1 Enoch 14: 9ff., where many different heavens are referred to. Interestingly, Teresa of Avila also speaks of her visionary experience in terms of a transparent castle made of diamond and glass, whose rooms must be travelled through in order to attain union with God/Christ.[49] While this is a metaphor, it is interesting that she mirrors the language of the apocalypticists, and particularly that of 1 Enoch, to articulate the visionary process.[50]

John too articulates visions of the heavenly throne-room in Rev. 4–5, where the imagery of the Four Living Creatures and the figure on the throne (here described in terms of precious jewels rather than anthropomorphically) as well as references to flaming torches and a sea of glass, 'like crystal' (Rev. 4: 5–6), are recapitulated.

The similarities of content and focus in the visionary material surveyed could of course be dismissed as evidence of copying or contrivance. However, Niditch argues

[47] Blake 2009: 44.
[48] Rowland 1982: 21.
[49] Williams 2003: 146–55.
[50] See 1 Enoch 14: 8 ff. where Enoch flies up to heaven and sees a wall of crystal surrounded by tongues of fire; God's throne is also made of crystal.

that visionaries in general seem to have interiorized a certain mythology or cosmology and that 'features of this mythology then become the itinerary for [their] ecstatic journeys'.[51] This is a very important point. Supporters of the possibility of visionary experience have broadly two ways of articulating what takes place during these experiences. Either visions are not cast in terms of any definite images and it is then left to the visionary to articulate what he or she has seen in terms familiar to them from his or her own tradition. Thus John had recourse to imagery from Ezekiel, for example. Or alternatively the visions were made up of images and these images were broadly the same sorts of images as those seen by one's visionary predecessors. The second explanation seems more intelligible, although some visionary texts, such as Teresa's *Life*, for example, with its description of a purely intellectual awareness of Christ, may imply the former is more accurate. Either way, what is expressed will necessarily be expressed in terms of the visionary's own familiar traditions. This is an accepted fact in the philosophical literature on religious experience and goes some way to confounding the objection that similarity of theme and content in visionary literature must necessarily imply literary artifice.[52]

Thus, finally, it is possible to articulate some of the characteristics that one might expect from a report of genuine visionary experience. Lindblom suggests the following useful criteria:

Authentic reports of visions should exhibit:

1. Spontaneity
2. A concise format
3. A dreamlike character (it may be clear in its detail but as a whole has an unreal and fantastic quality)
4. Fresh, unsophisticated form and content
5. A concern for matters on an otherworldly plane
6. Evidence of some difficulty in expressing the visionary experience in words
7. Emotional side-effects
8. Mention of date and place of vision.[53]

Rowland, in his assessment of these criteria, takes issue with characteristics 1 and 5. To number 1 he (correctly, in my opinion, and in light of the above discussion) objects that there is ample evidence of preparation (e.g. prayer, fasting, etc.) being an important, if not an intrinsic, part of the visionary experience. With reference to point 5, he argues that visions that discuss predominantly ordinary images should not be dismissed.[54] He also suggests that one should ask the following of the material in question:

1. Is there evidence in the vision to suggest that the way in which hitherto familiar images are used moves away from the original, resulting in new combinations of ideas, as well as the inclusion of new elements?
2. If yes, is the juxtaposition of the various elements free from signs of exegetical activity? If yes again, then this is probably visionary experience.[55]

[51] Niditch 1980: 162.
[52] James 1902: 399–400 on how there is a common nucleus to the reports of 'genuine religious experiences' despite the contextual variations. See also Smart 1964: 127–8.
[53] Lindblom 1968: 218 ff.
[54] Rowland 1982: 236–7.     [55] Ibid.

Lindblom argues that the following passages from the Book of Revelation should, on balance, be viewed as having originated from actual visionary experience: Rev. 1: 9–20 (the call vision); 4: 1–5 (the heavenly throne-room); 8 (silence in heaven, the angel with the censer (representing both faithful prayer and later judgement), the first four trumpets in the seven-trumpet sequence); 11: 19 (God's temple in heaven opened, accompanied by flashes of lightning, voices, peals of thunder, an earthquake, and heavy hail; note the almost exact parallel with Rev. 8: 5); 12: 13–18 (the Woman Clothed with the Sun's battle on earth with the Dragon); 15: 1–4 (another portent in heaven, the seven angels with seven plagues); 5: 2 (John sees the martyrs/saints standing on the sea of glass mixed with fire, with harps of God in their hands, singing the song of Moses); 15: 5–8 (the temple of the tent of witness in heaven is opened, the angels with the seven bowls full of wrath of glory of God come out; note the parallel with 11: 19); 19: 9–10 (the angel tells John to write: 'Blessed are those who are invited to the marriage supper of the Lamb'; John tries to worship him and is reprimanded); 19: 11–16 (the vision of the rider on the white horse); 19: 17–18 (the great supper of God is a feast of flesh); 22: 8–9 (John's claim to have seen all these visions).[56]

While it could be argued that this is a rather conservative estimate, the purpose of this section is not to perform a literary or source-critical analysis of the Book of Revelation, but rather to demonstrate that it is reasonable to claim that the visionary nature that has been recognized, expressed, and expanded upon by so many visual artists, is attested to by the text itself. And that more than this, when an artist attempts to express, and even develop or get 'behind' the visionary nature of the text, he or she is standing within a tradition that John himself was a part of. That is to say, John is part of a visionary tradition in which visionaries seem to 'see' some of the same things and articulate them, in part, in the same sorts of terms as their predecessors, due to their familiarity, and perhaps even meditation on, the texts of these predecessors.[57] Other parts of the account will be articulated and developed via images and language appropriate to their own particular context. Artists visualizing John's text (or, indeed, other visionary texts) are part of this same enterprise, whether consciously claiming to have re-experienced John's vision, like Dürer, or whether coming at the task from a seemingly more cerebral angle, like Lambeth or Memling.

---

[56] Lindblom 1968: 218 ff.     [57] Halperin 1988: 71; Boxall 2002: 46.

APPENDIX 2

# Brief Descriptions of the Koberger, Dürer, and Cranach Apocalypse Images

**1.** Brief description of the Koberger Apocalypse images (London: British Library C.11.d.5)

| Image | Corresponding section of the Book of Revelation | Brief description |
|---|---|---|
| K1a | — | The Martyrdom of St John in oil |
| K1b | Rev. 1: 1 | The Commission of St John on Patmos |
| K1c | Rev. 1: 12–20 | The Vision of the Seven Candlesticks |
| K2 | Rev. 6: 2–8 | The Four Horsemen ride out together from the left to right of the image; their victims depicted in the left-hand corner |
| K3 | Rev. 6: 9–7: 8 | From left to right: the fifth seal (the souls of the martyrs under the altar); the sixth seal (the great earthquake); the four avenging angels protecting the army of the servants of God |
| K4 | Rev. 7: 9–8: 13 and 14: 1–5 | From left to right: the adoration of God and the Lamb; the handing out of the Seven Trumpets and their consequences |
| K5 | Rev. 9: 13–19 and Rev. 10 | The avenging angels fight mankind with the myriad horsemen; right-hand side of image: John with the Mighty Angel of Rev. 10 about to imbibe the book |
| K6 | Rev. 11–12: 6 | From left to right: the measuring of the Temple; the Two Witnesses; the Woman Clothed with the Sun attacked by the Dragon |
| K7 | Rev. 12: 7–13: 18 | From left to right: St Michael fights the Dragon; the two Beasts rampage over the earth |
| K8 | Rev. 17–21 and Rev. 14: 14–20 | From left to right: the worship of the Whore of Babylon; the destruction of Babylon; the binding of Satan; the harvest of the earth (Rev. 14); the coming of the New Jerusalem (depicted as a very small city in the top right-hand corner) |

**2.** Brief description of the Dürer Apocalypse images (London: British Museum)

| Image | Corresponding section of the Book of Revelation | Brief description |
|---|---|---|
| D1 | — | The Martyrdom of St John in oil watched by crowds in contemporary dress and presided over by Domitian dressed as an Oriental Sultan |
| D2 | Rev. 1: 12–20 | The Vision of the Seven Candlesticks; John kneels with his back to the viewer at the feet of the One like the Son of Man, identifiable by his illuminated face and the sword protruding from his mouth |
| D3 | Rev. 4–5 | The Heavenly Throne-Room; a two-tiered image depicting Nuremberg in the bottom half and the heavenly throne-room complete with God, Christ, and the Twenty-Four Elders at the top; John kneels at the edge of the throne-room, itself demarcated via fiery clouds |
| D4 | Rev. 6: 2–8 | The Four Horsemen ride out together from the left to right of the image; their victims depicted in the lower left-hand corner |
| D5 | Rev. 6: 9–17 | The fifth seal (the clothing of the martyrs under the altar) is depicted at the top of the image while the sixth seal (the great earthquake) and its consequences and victims is depicted below |
| D6 | Rev. 7: 1–17 | The four angels with the winds are depicted on the left-hand side of the image, while the 144,000 receive the seal upon their foreheads on the right-hand side of the image |
| D7 | Rev. 8: 1–9: 6 | The seven trumpets are handed out at the top of the image in heaven; the consequences of the trumpet blasts are depicted in the lower half |
| D8 | Rev. 9: 13–19 | The four avenging angels fight against mankind with the myriad army; amongst their victims can clearly be seen kings and even a Pope; at the top of the image God presides over the scene |
| D9 | Rev. 10: 1–11 | In the bottom left-hand corner John imbibes the book given to him by the Mighty Angel, a shadowy figure depicted in the centre of the image |
| D10 | Rev. 12: 1–6 | God presides from the top centre of the image as the Woman Clothed with the Sun is menaced by the Dragon; in the centre of the image her child is carried to safety in heaven (Rev. 12: 5) |
| D11 | Rev. 12: 7–9 | St Michael and his angels fight the Dragon and his army in heaven; the bottom third of the image depicts a peaceful scene from contemporary Nuremberg |
| D12 | Rev. 13 | God presides over the image from heaven wearing a bishop's cope and holding a sickle; the Sea-Beast presides over a crowd of contemporary worshippers on the right-hand side while the Earth-Beast emerges from the left-hand side of the image |
| D13 | Rev. 14: 1–5 | John kneels at the bottom of the image as above him the adoration of the Lamb of Rev. 14 takes place; the Lamb (top centre) bleeds into a Eucharistic cup |
| D14 | Rev. 17: 1–19: 16 | The Whore of Babylon rides the Beast into the foreground of the image; behind her Babylon burns, its fate heralded by the angel with the millstone (Rev. 18) and the Rider on the White Horse (Rev. 19) rides down from the top left-hand corner. |
| D15 | Rev. 20: 1–21: 27? | In the foreground of the image an angel binds Satan; behind them another angel (who is with John) points to the city depicted on the left-hand side of the image, probably intended to be the New Jerusalem |

**3.** Brief description of the Cranach Apocalypse images (London: British Library, C.36.g.7)

| Image | Corresponding section of the Book of Revelation | Brief description |
|-------|-----------------------------------|-------------------|
| C1 | Rev. 1: 12–20 | The Vision of the Seven Candlesticks; John lies prostrate at the feet of the One like the Son of Man, identifiable by his illuminated face and the sword protruding from his mouth |
| C2 | Rev. 4–5 | The Heavenly Throne-Room takes up the whole image; John kneels at the bottom of the throne-room |
| C3 | Rev. 6: 2–8 | The Four Horsemen ride out together from the left to right of the image; their victims depicted in the lower left-right corner |
| C4 | Rev. 6: 9–11 | The fifth seal (the clothing of the martyrs under the altar) is depicted in this image; the altar is prominent in the centre of the image |
| C5 | Rev. 6: 12–17 | The sixth seal, the earthquake, is depicted; the human victims shelter in the bottom right-hand corner of the image |
| C6 | Rev. 7: 1–17 | The four angels hold the winds in the right-hand side of the image; on the left the angel seals the foreheads of the 144,000 |
| C7 | Rev. 8 | The seven trumpets are handed out at the top of the image in heaven and the consequences depicted below |
| C8 | Rev. 9: 1–6 | The fifth trumpet: the locust army and their victims are depicted around a well |
| C9 | Rev. 9: 13–19 | God presides from the top centre of the image as the four avenging angels and the myriad horsemen kill their victims below |
| C10 | Rev. 10 | John devours the book in the bottom right-hand corner of the image; the Mighty Angel stands in the centre of the image |
| C11 | Rev. 11 | The Beast from the bottomless pit (wearing the papal tiara) menaces the Two Witnesses in the foreground of the image whilst John measures the Temple in the background |
| C12 | Rev. 12 | The Woman Clothed with the Sun is attacked by the Dragon in the foreground of the image; on the upper left-hand side her baby is carried up to heaven and on the right St Michael's angels fight the Dragon; God presides at the top of the scene |
| C13 | Rev. 13 | The Sea-Beast is worshipped by contemporary worshippers in the foreground of the image; in the background the Earth-Beast walks into the image wearing a monk's cowl |
| C14 | Rev. 14: 1–5 | In the bottom half of the image Babylon is destroyed; in the top half the Lamb is worshipped in heaven |
| C15 | Rev. 14: 14–20 | God presides in heaven over the harvest of the earth taking place below |
| C16 | Rev. 16 | The Seven bowls are emptied out onto the earth from heaven; in the foreground one of the Beasts, wearing a papal tiara and sitting on the papal throne, belches out frogs (Rev. 16: 13) |
| C17 | Rev. 17 | The Whore of Babylon rides from the right to the left of the image, wearing the papal tiara; contemporary worshippers kneel and stand in the bottom left-hand corner of the image |
| C18 | Rev. 18 | Onlookers watch in horror as Babylon (depicted here as Rome) burns in front of them; the angel with the millstone flies in from the top right-hand corner |

*Continued*

**3.** Continued

| Image | Corresponding section of the Book of Revelation | Brief description |
|---|---|---|
| C19 | Rev. 19–20 | The Rider on the White Horse rides down from the clouds with his army as the Beast is thrown into the lake of fire and sulphur in the foreground (Rev. 20: 10) |
| C20 | Rev. 20: 1–3 | Satan is bound by an angel in the foreground of the image |
| C21 | Rev. 21–2 | An angel shows John the New Jerusalem |

# Tables 1–5; Graph 1

**Table 1.** Description of the illustrations comprising John's *vita* in the *Lambeth Apocalypse* MS 209, fos. 40ᵛ–45

| Folio Reference | Brief description of John's actions |
| --- | --- |
| 40ᵛ top | John preaches to three converts while Drusiana listens |
| 40ᵛ bottom | Drusiana is baptized by John inside a church while armed pagans peer in |
| 41 top | John brought before the proconsul at Ephesus |
| 41 bottom | John put on a boat to be sent to the Emperor Domitian |
| 41ᵛ top | John brought before Domitian |
| 41ᵛ bottom | Two attendants roughly handle John while Domitian sits with his hand on his sword indicating judgement |
| 42 top | John tortured in a cauldron of boiling oil with Domitian presiding |
| 42 bottom | John emerges unharmed from the torture and Domitian orders him to be taken away into exile |
| 42ᵛ top | John taken off to Patmos on a boat |
| 42ᵛ bottom | John arrives back in Ephesus and is greeted by a group of figures who inform him of Drusiana's death |
| 43 top | Raising of Drusiana by John |
| 43 bottom | Atticus and Eugenius (converts) complain to John that they are sick of being dressed in rags; John turns their sticks into gems |
| 43ᵛ top | John rebukes Atticus and Eugenius; now they are rich again they will succumb to the evil consequences of wealth |
| 43ᵛ bottom | The people try to make John sacrifice to Diana; John prays for the temple to be destroyed which it is and the people become converts |
| 44 top | John challenged to drink poison by proconsul. Power of poison demonstrated by testing it on two criminals who collapse |
| 44 bottom | John drinks from the poisoned cup and is unharmed |
| 44ᵛ top | Aristodemus takes John's cloak on the orders of the proconsul |
| 44ᵛ bottom | Aristodemus raises the two criminals to life by touching them with John's cloak |
| 45 top | Last mass celebrated by John |
| 45 bottom | John lies in his tomb while his soul is carried up to heaven by angels |

**Table 2.** Possible order in which the images for Dürer's Apocalypse Series of 1498 were produced

| Actual order in Dürer's Apocalypse Series of 1498 | Possible order of production based on analysis undertaken in Chapter 5 |
| --- | --- |
| D1. The Martyrdom of St John | D7. The Seven Trumpets (Rev. 8, 9) |
| D2. The Vision of the Seven Candlesticks (Rev. 1: 12–20) | D13. The Worship of the Lamb (Rev. 14: 1–5) |
| D3. St John and the Twenty-Four Elders (Rev. 4, 5) | D3. St John and the Twenty-Four Elders (Rev. 4, 5) |
| D4. The Four Horsemen (Rev. 6: 2–8) | **D14. The Whore of Babylon (Rev. 17–19)** |
| D5. The Opening of the Fifth and Sixth Seals (Rev. 6: 9–17) | **D10. The Apocalyptic Woman (Rev. 12: 1–6)** |
| D6. The Four Angels Holding the Winds (Rev. 7: 1–12) | **D8. The Four Avenging Angels (Rev. 9: 13 ff.)** |
| D7. The Seven Trumpets (Rev. 8: 1– 9: 12) | **D11. St Michael Fighting the Dragon (Rev. 12: 7–9)** |
| D8. The Four Avenging Angels (Rev. 9: 13–19) | **D12. The Two Beasts (Rev. 13)** |
| D9. St John Devouring the Book (Rev. 10: 1–11) | **D1. The Martyrdom of St John** |
| D10. The Woman Clothed with the Sun (Rev. 12: 1–6) | *D4. The Four Horsemen (Rev. 6: 2–8)* |
| D11. St Michael Fighting the Dragon (Rev. 12: 7–9) | *D5. The Opening of the Fifth and Sixth Seals (Rev. 6: 9–17)* |
| D12. The Two Beasts (Rev. 13) | *D6. The Four Angels Holding the Winds (Rev. 7: 1 ff.)* |
| D13. The Worship of the Lamb (Rev. 14: 1–5) | <u>D15. The Binding of Satan and the New Jerusalem (Rev. 20: 1–3; 21–2)</u> |
| D14. The Whore of Babylon (Rev. 17–19) | <u>D9. St John Devouring the Book (Rev. 10: 1–11)</u> |
| D15. The Binding of Satan and the New Jerusalem (Rev. 20: 1–3; 21–2) | <u>D2. The Vision of the Seven Candlesticks (Rev. 1: 12–20)</u> |

Notes: First Stage: D7, D13, D3.
Second Stage: **D14, D10, D8, D11, D12, D1**.
Third Stage: *D4, D5, D6*.
<u>Fourth Stage: D15, D9, D2.</u>

**Table 3.** Summary of the visual and textual content of Cranach's *Passional Christi und Antichristi* of 1522

| Image pair | Life of Christ (brief description of image) | Life of the Antichrist-as-Pope (brief description of image) | Commentary |
|---|---|---|---|
| 1 | Christ fleeing the Jews as they attempt to make him king | The Pope shown defending his claims to secular rule with canon and sword | Melanchthon cites the forged Donation of Constantine |
| 2 | Christ crowned with thorns | Pope crowned with triple tiara | — |
| 3 | Christ washes feet of disciples | Pope presents his foot for kings and princes to kiss | Rev. 13: 15 cited: Pope compared with the Beast of Rev. 13 |
| 4 | Christ pays authorities their dues | Pope demands exemption for his followers | — |
| 5 | Christ among the poor and lame | Pope presides over a tournament | — |
| 6 | Christ tells followers to take up their crosses | Pope depicted being carried in a sedan chair | Melanchthon says (ironically) that this is the Pope taking up his cross of adversity |
| 7 | Christ preaching the Kingdom of God | The Pope feasting in a royal manner | — |
| 8 | Christ's birth: the humble nativity scene | The Pope depicted armed and ready to wage war | The Pope willing to spill Christian blood in order to ensure clerical possession of property |
| 9 | Christ's peaceful entry into Jerusalem on an ass | Pope riding in state on a military steed flanked by soldiers | — |
| 10 | Christ tells his disciples that they should go to the poor | Contrasted with the papal command that no bishop should preside over anything but a great town | — |
| 11 | Christ's disciples reprimanded for eating with unclean hands; Christ says that it is not observance of external laws that matters | The Pope shown seated on his throne issuing commands about such external laws | Papal law wholly concerned with external signs of religious observance |
| 12 | Christ drives the money changers from the Temple | The Pope presides over a sale of indulgences within a church | Citation: 2 Thess. 2: 4 which says that the 'man of sin' sits in God's Temple displaying himself as God |
| 13 | Christ's Ascension | The Pope is dispatched downwards to hell | Citations: 2 Thess. 2: 8 and Rev. 19: 20–1 (The Beast is thrown in the Lake of Sulphur) |

**Table 4.** A Summary of the main polemical details in Cranach's Apocalypse illustrations for Luther's New Testament of September 1522

| Image Number | Chapter | Polemical Details |
|---|---|---|
| C11 | Rev.11: 1–8: The Beast devours the Two Witnesses | The Beast wears the papal triple tiara |
| C13 | Rev. 13: The Two Beasts, one from the land, the other from the sea | The Sea-Beast is wearing a monk's cowl |
| C16 | Rev. 15–16: The Bowls of wrath emptied, one of them over the Dragon | The Dragon wears the papal triple tiara |
| C17 | Rev. 17: The Whore of Babylon | The Whore of Babylon wears the papal triple tiara |
| C18 | Rev. 18: The Destruction of Babylon | 'Babylon' is clearly recognizable as Rome and those who lament her fall are depicted as canonists and benefice-holders |

**Table 5.** A Comparison of Dürer's and Cranach's Apocalypse Series

| Dürer's Apocalypse 1498/1511 | Cranach's Apocalypse illustrations, 1522 | Book of Revelation chapter reference |
|---|---|---|
| *D1. The Martyrdom of St John* | — | — |
|  | **(Small woodcut of John receiving his vision from the angel)** | 1: 1 |
| D2. The Vision of the Seven Candlesticks | C1. The Vision of the Seven Candlesticks | 1: 12–20 |
| D3. St John and the Twenty-Four Elders | C2. St John and the Twenty-Four Elders | 4–5 |
| D4. The Four Horsemen | C3. The Four Horsemen | 6: 2–8 |
| D5. The Opening of the Fifth and Sixth Seals | C4. The Opening of the Fifth Seal | 6: 9–17 |
|  | **C5. The Opening of the Sixth Seal: The Great Earthquake and the Day of Wrath** | 6: 12–17 |
| D6. The Four Angels Holding the Winds | C6. The Four Angels Holding the Winds | 7: 1–12 |
| D7. The Seven Trumpets | C7. The Seven Trumpets | 8: 1–9: 12 (Last trumpet blown in 11: 15) |
|  | **C8. The Fifth Trumpet, Plague of Locusts** | 9: 1–6 |
| D8. The Four Avenging Angels | C9. The Four Avenging Angels (Sixth Trumpet) | 9: 13–19 |
| D9. St John Devouring the Book | C10. St John Devouring the Book | 10: 1–11 |
|  | **C11. The Two Witnesses** | 11: 1–13 |
| D10. The Apocalyptic Woman | C12. The Apocalyptic Woman | 12: 1–6 |
| *D11. St Michael Fighting the Dragon* |  | 12: 7–9 |
| D12. The Two Beasts | C13. The Two Beasts | 13 |
| D13. The Worship of the Lamb | C14. The Worship of the Lamb | 14: 1–5 |
|  | **C15. The Harvest of the Earth** | 14: 14–20 |
|  | **C16. The Angels with the Seven Bowls** | 15–16 |
| D14. The Whore of Babylon | C17. The Whore of Babylon | 17 |
|  | **C18. The Fall of Babylon** | 18 |
|  | **C19. The Rider on the White Horse and the Defeat of Satan** | 19–20 |
| D15. The Binding of Satan and the New Jerusalem | C20. The Binding of Satan | 20: 1–3; 21–2? |
|  | **C21. The New Jerusalem** | 21–2 |

Notes:
**Bold Font**: appears in the Cranach series only.
*Italic Font*: appears in the Dürer series only.

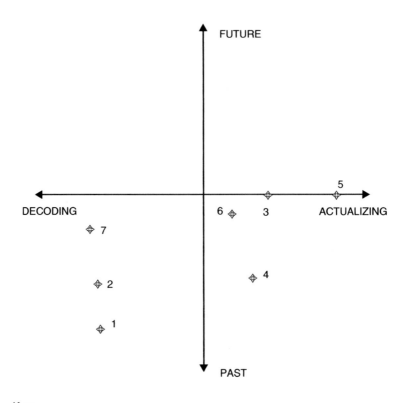

FUTURE

DECODING ←————————————————————→ ACTUALIZING

5

6 ✧   3

✧ 7

✧ 2

✧ 4

✧ 1

PAST

Key:
1 The *Lambeth Apocalypse*
2 The *Angers Apocalypse Tapestry*
3 The *Ghent Altarpiece* (The Van Eycks)
4 The *St John Altarpiece* (Memling)
5 *The Mystic Nativity* (Botticelli)
6 Dürer's *Apocalypse* Series
7 Cranach's *Apocalypse* Series

**Graph 1.** The Seven Case Studies plotted on the Kovacs/Rowland Grid

# Bibliography

## Manuscripts Cited

Abingdon Apocalypse: British Library, MS Add. 42555.
Bodleian Apocalypse: Bodleian Auct. D. 4.17.
Burckhardt-Wildt Apocalypse: see *Catalogue of Single Leaves and miniatures from Western Illuminated Manuscripts*, Sotherby's Sale: Monday 25 Apr. 1983: 35–121.
Cambrai Apocalypse: Bibliothèque Municipale 422.
Canonici Apocalypse: Bodleian Canonici Bibl. 62.
Douce Apocalypse: Oxford: Bodleian, MS Douce 180.
Eton Apocalypse: College Library 177.
Flemish Apocalypse: Paris: Bibliothèque Nationale, BN Néerl. 3.
Gulbenkian Apocalypse: Lisbon: Museu Calouste Gulbenkian, MS L. 139.
Lambeth Apocalypse: Lambeth Palace Library, MS 209.
London Apocalypses: British Library, Add. 35166, British Library, MS Royal 6. E. VI.
Metz Apocalypse: Bibliothèque Municipale, Salis 38 (now destroyed).
Paris Apocalypse: Bibliothèque Nationale fr. 403.
Paris Apocalypse: Bibliothèque Nationale, Lat. 14410.
Paris Apocalypse: Paris: Bibliothèque Nationale, BN 10474.
Pierpoint Morgan Apocalypse: Pierpoint Morgan Library, New York, M. 524.
Trier Apocalypse: Trier: Stadtbibliothek, MS 31.
Trinity Apocalypse: Cambridge, Trinity College, Trinity R. 16.2.

## Primary Sources

Abbot Adso 1954: *De ortu et tempore Antichristi*. In Corpus Christianorum Continuatio Medievalis, Turnhout: Brepols, vol. 45.20–30.
Alexander Minorita, tr. A. Wachtel 1955: *Expositio in Apocalypsim*. Weimar: H. Böhlaus Nachfolger.
Aquinas 1882–1947: *Summa Theologiae in S. Thomae Aquinatis opera omnia*. Rome.
Augustine, tr. H. Bettinson 1984: *The City of God against the Pagans*. Harmondsworth: Penguin.
Aureol, Peter, 1319: *Compendium sensus litteralis totius divinae scripturae*, ed. P. Seeboeck. Quaracchi, 1896.
Berengaudus 1879: *Expositio super septem visiones libri Apocalypsis*. In J.-P. Migne (ed.), *Patrologia Latina* 17: 843–1058. Paris: Garnier fraters et J.-P. Migne.
Bernardino, P. 1500: 'Epistola di Bernardino de' Fanciulli della citta di Firenze mandata a *epsi fanciulli el di Sancto Bernaba Apostolo a di Xi giugno* mcccc/xxxxvii'. Florence: Biblioteca Nazionale, Magl. L 6 N 22.
—— 1500: 'Predica di Pietro Bernardo da Firenze inutile servulo di Iesù Christo, et di tutti li fanciulli di [buona] voluntà. Facta a Spugnole di Mugello, loco di Giovanni

Pepi. Adí ii di marzo mcccc/xxxxix', in *Prediche*, Florence (Bartolomeo de' Libri) 1500 (copy in BNCF: Magl. L. 6. 22, sig. e6$^v$).

Blake, W. 1966: *The Complete Writings of William Blake*, ed. G. Keynes, Oxford: Oxford University Press. 1988: *The Complete Poetry and Prose of William Blake*, ed. D. Erdman, New York: Doubleday.

Brant, S. 1498: *Varia Carmina*. Basel: Johann Bergmann.

Cerretani, B.: Istoria fiorentina, in J. Schnitzer (ed.) 1904: *Quellen und Forschungen zur Geschichte Savonarolas*, vol. 4. Munich.

Charles V: Library Inventory, 1373: Bibliothèque Nationale, Paris: MS fr. 2700.

Cusa, N. *De Visione Dei*. tr. J. P. Dolan 1962: in *Unity and Reform, Selected Writings of Nicholas de Cusa*. South Bend, Ind.

De Langhe, O., *Tractatus de corpore Christi*. Lille: Bibliothèque Municipale, MS 387.

De Voragine, J. 1969: *The Golden Legend*, tr. G. Ryan and H. Rippenberger. New York.

—— 1998: *The Golden Legend*, tr. C. Stace. London: Penguin.

Dürer, A. 1498, 1511: *Apocalypsis Cum Figuris*. London, British Museum, 1895.1.22.580 ff.

—— 1498: *Die heimliche Offenbarung Iohannis*. London: British Museum, 1895.1.22.554.

—— 1956–69: *Schriftlicher Nachlass*. 3 vols. Deutscher Verein für Kunstwissenschaft.

Foxe, J., in G. Townsend (ed.) 1843–9: *Actes and Monuments of Matters Most Speciall and Memorable*, 8 vols. London.

Gautier de Coinci 1955–70: *Les Miracles de Nostre Dame*, 4 vols. ed. V. F. Frederick König. Geneva–Lille: Droz.

Giovanfrancesco Pico della Mirandola, ed. J. Quetif 1674: *Vita Reverendi Patris F. Hieronymi Savonarolae*. Paris.

Giovanfrancesco Pico 1573: Letter to Girolamo Tornielli, 24 Dec. 1495. *Opera Omnia*, vol. 2, 1322–3. Hildesheim (1969).

Hart, C., and Bishop, J. (trans.) 1990: Scivias, *Hildegard of Bingen*, with introd. by Barbara Newman. New York: Paulist Press.

Hugo de Folieto 1844–55: *De claustro anime*. In J.-P. Migne (ed.) *Patrologia Latina* 176. 1017–1184. London: Chadwick–Healey Publishing.

Krey, D. W. (ed.) 1997: *Nicholas of Lyra's Apocalypse Commentary*. Kalamazoo: Medieval Institute Publications.

Luther, M. 1883–1993: *D. Martin Luthers Werke: Kritische Gesamtausgaber [Schriften]*, 65 vols. Weimar: Hermann Böhlaus Nachfolger.

—— 1930–85: *D. Martin Luthers Werke: Kritische Gesamtausgabe, Briefwechsel*, 18 vols. Weimar: Hermann Böhlaus Nachfolger.

—— 1958–86: *Luther's Works*, American Edition, 55 vols. St Louis and Philadelphia: Concordia and Fortress Press.

Matthew Paris 1872–4: *Chronica majora*, 7 vols. ed. H. R. Luard. London: Rolls Series.

Palmieri, M., in C. Guasti (ed.) 1908: *Le feste di San Giovanni a Firenze*, 20–3. Florence.

Piero Parenti: 'Istorie fiorentine'. In J. Schnitzer (ed.) 1910: *Quellen und Forschungen zur Geschichte Savonarolas*, vol. 4. Leipzig.

'Pseudo-Burlamacchi' 1937: La vita del beato Jeronimo Savonarola scritta da un anonimo del secolo XVI e già attribuita a fra Pacifico Burlamacchi. In P. Ginori

Conti and R. Ridolfi (eds.), *Il vetro per ottica in Italia e l'Istituto del Boro-silicio in Firenze.*

Rupert of Deutz, Commentary on the Apocalypse. In J.-P. Migne (ed.) 1854, *Patrologia Latina* 167–70. Paris: Garnier fraters et J.-P. Migne.

Savonarola, G. 1496: *Compendio di revelatione.* Florence: Francesco Bonaccorsi.

—— 1497: *Predica dell'arte del ben morire.* Florence: Bartolommeo de Libri.

—— 1528: *Prediche nuovamente venute in luce del reverendo Padre Fra Girolamo Savonarola da Ferrara ... sopra il Salmo 'Quam Israel Deus' predicate in Firenze in santa Maria del Fiore in uno Advento nel mccccxciii ...* Venice: Agostino de Zanni.

—— 1539: *Prediche quadragesimali del reverendo Frate Ieronimo Savonarola da Ferrara sopra Amos propheta, sopra Zacharia propheta, et parte etiam sopra li Evangelii occorrenti et molti Psalmi di David.* Venice: Octavianus Scotus. Also in P. Ghiglieri (ed.) 1972: *Prediche sopra Amos e Zaccaria,* 3 vols. Rome.

—— 1544: *Prediche del Rev P. F. Hieronymo Savonarola ... sopra alquanti salmi et sopra Aggeo Profeta fatte del mese di Novembre et Dicembre l'anno mcccclxxxxiiii raccolte dalla sua viva voce.* Venice: Bernardino Bindoni.

—— 1930–5: *Prediche italiane ai Fiorentini.* In R. Palmarocchi and F. Cognasso (eds.), vol. 3. Florence: La Nuova Italia.

—— c.1500: *Prediche del reverendo padre frate Hieronymo da Ferrara facte l'anno 1496 ne' giorni delle feste ...* Florence: Antonio Tubini, Lorenzo d'Alopa, and Andrea Ghirlandi.

—— *Registro delle prediche del Reverendo Padre Frate Hieronymo da Ferrara facte nel mccccxxxxv.* Florence: Biblioteca Nazionale Centrale, MS Sav. 49.

The Geneva Bible, 1560, 1589, London: British Library, Rare BS170 1589.

The Koberger Bible, 1483, Nuremberg. London: British Library, C.11 d.5.

Trésorie du duc d'Anjou, aux Archives Nationales, Paris, KK. 242.

Tyconius 1989: *The Book of Rules,* tr. W. S. Babcock. Atlanta, Ga.: Scholars Press.

Vasari 1568: *Le Vite delle più eccellenti pittori, scultori, ed architettori.* Florence: T. Giunti.

—— 1906: *Stories of the Italian Artists from Vasari,* tr. E. L. Seeley. London: Chatto and Windus.

—— 1965: *The Lives of the Artists,* tr. G. Bull. London: Allen Lane.

## Secondary Sources

Aben, R., and de Wit, S. 1999: *The Enclosed Garden: History and Development of the Hortus Conclusus and its Reintroduction into the Present-Day Urban Landscape.* Rotterdam: 010 Publishers.

Ackerman, P. 1933: *Tapestry: the Mirror of Civilisation.* New York, London, Toronto: Oxford University Press.

Ainsworth, M. W., and Christiansen, K. (eds.) 1999: *From Van Eyck to Bruegel: Early Netherlandish Painting in the MMA.* New York: MMA.

Anderson, W. 1988: *Cecil Collins: The Quest for the Great Happiness.* London: Barrie and Jenkins.

Anzelewsky, F. 1982: *Dürer, his Art and Life.* London: Gordon Fraser Gallery Limited.

Apostolos-Cappadona, D. 1994: *Dictionary of Christian Art.* New York: Continuum.

Arasse, D. 2004: *Botticelli e Filippino. L'inquietudine e la grazia nella pittura fiorentina del Quattrocento*. Milan: Skira.

Argan, G. C. 1957: *Botticelli*. New York: Skira.

Auerbach, E. tr. R. Manheim 1965: *Literary Language and its Public in Late Latin Antiquity in the Middle Ages*. New York: Pantheon.

Aune, D. 1997–9: *Word Biblical Commentary: Revelation*, 3 vols. Dallas: Word, 1997, and Nashville: Thomas Nelson, 1999.

Avril, F. 1982: *Les Fastes du Gothique, le siècle de Charles V*. Paris: Réunion des Musées Nationaux.

Backus, I. 2000: *Reformation Readings of the Book of Revelation: Geneva, Zurich and Wittenberg*. Oxford: Oxford University Press.

Baron, S. W. 1965 (2nd rev. edn.): *A Social and Religious History of the Jews*, 10 vols. New York: Columbia University Press.

Bartrum, G. 1999: 'The Vision of the Apocalypse in the Fifteenth Century' and 'The Vision of the Apocalypse in the Sixteenth and Seventeenth Centuries' (Catalogue entries). In F. Carey (ed.), *The Book of Revelation and the Shape of Things to Come*. London: British Museum Press, 125–207.

—— 2002: *Albrecht Dürer and his Legacy*. London: British Museum Press.

Bauckham, R. 1978: *Tudor Apocalypse*. Appleford: Sutton Courtenay Press.

—— 1993a: *The Theology of the Book of Revelation*. Cambridge: Cambridge University Press.

—— 1993b: *The Climax of Prophecy: Studies in the Book of Revelation*. Edinburgh: T. & T. Clark.

Begbie, J. 1991: *Voicing Creation's Praise*. Edinburgh: T. & T. Clark.

Bentley, G. E. (ed.) 1969, 2004: *Blake Records*. Oxford: Clarendon Press.

Berdini, P. 1997: *The Religious Art of Jacopo Bassano: Painting as Visual Exegesis*. (Cambridge Studies in New Art History and Criticism). Cambridge: Cambridge University Press.

Beuken, W., and Freyne, S. 1995: *The Bible and Cultural Heritage*. London: SCM Press.

Bialostocki, J. 1986: *Dürer and his Critics*. Saecula Spiritalia 7. Baden-Baden: Valentin Koener.

Binon, S. 1937: *Essai sur le cycle de saint Mercure, martyr de Dèce et mercurier de l'empereur Julien*. Paris: Leroux.

Blake, W. 2009: *Seen in my Visions: A Descriptive Catalogue of Pictures*. London: Tate Publishing.

Blumenthal, A. 1966–7: 'A Newly Identified Drawing of Brunelleschi's Stage Machinery', in *Marsyas* xiii, 24.

Boesak, A. 1987: *Comfort and Protest: The Book of Revelation from a South African Perspective*. Philadelphia: Westminster John Knox Press.

Boxall, I. 2002: *Revelation: Vision and Insight*. London: SPCK.

—— 2006: *The Revelation of St. John*. London: Continuum.

—— 2007: 'Who Rides the White Horse? Truth and Deception in The Book of Revelation', unpublished talk to the Oxford Senior Theology Seminar, 8 Mar. 2007.

Brand Philip, L. 1971: *The Ghent Altarpiece and the Art of Jan Van Eyck*. Princeton: Princeton University Press.

Brook, W. H., and Gwyther, A. 1999: *Unveiling Empire: Reading Revelation Then and Now*. New York: Orbis.

Brownrigg, L. L. (ed.) 1990: *Medieval Book Production: Assessing the Evidence*. Los Altos Hills, Calif.: Anderson-Lovelace.

Bruce, J. D. 1928: *The Evolution of the Arthurian Romance from the Beginnings down to the Year 1300*. Baltimore: Johns Hopkins University Press; Göttingen: Vandenhoeck and Ruprecht.

Bruyn, J. 1957: *Van Eyck Problemen*. Utrecht: Kunsthistorisches Institut.

Burke, W. L. M. 1936: 'Lucas Cranach the Elder'. *The Art Bulletin*, vol. 18, no. 1 (Mar. 1936), 25–53.

Burr, D. 1993: *Olivi's Peaceable Kingdom: A Reading of the Book of Revelation Commentary*. Philadelphia: University of Pennsylvania Press.

Caird, G. B. 1966: *The Revelation of St. John the Divine*. London: A. & C. Black.

Camille, M. 1992: 'Visionary Perception and Images of the Apocalypse in the Later Middle Ages'. In R. Emmerson and B. McGinn (eds.), *The Book of Revelation in the Middle Ages*, New York: Cornell University Press, 276–92.

Campbell Hutchison, J. 1990: *Albrecht Dürer: A Biography*. Princeton: Princeton University Press.

—— 2000: *Albrecht Dürer: A Guide to Research*. New York: Routledge.

Carey, F. (ed.) 1999: *The Book of Revelation and the Shape of Things to Come*. London: British Museum Press.

Carmi Parsons, J. 1996: 'Of Queens, Courts and Books: Reflections on the Literary Patronage of Thirteenth-Century Plantagenet Queens'. In J. McCash (ed.), *The Cultural Patronage of Medieval Women*. Athens and London: University of Georgia Press, 175–201.

Carruthers, M. 1990: *The Book of Memory: A Study of Memory in Medieval Culture*. Cambridge: Cambridge University Press.

—— 1998: *The Craft of Thought: Meditation, Rhetoric and the Making of Images, 400–1200*. Cambridge: Cambridge University Press.

Chadabra, R. 1964: *Dürer's Apokalypse: Eine ikonologische Deutung*. Prague.

Charbonneau-Lassay, L. 1940: *Le Bestiaire du Christ*. Bruges: Desclée de Brouwer (repr. Milan: Archè, 1974).

Cheetham, F. 1984: *English Medieval Alabasters*. Oxford: Oxford University Press.

Chew, S. 1942: *The Virtues Reconciled: An Iconographic Study*. Toronto: University of Toronto Press.

Chipps Smith, J. 1985: *New Perspectives on the Art of Renaissance Nuremberg*. Texas: University of Texas Press.

Christie, Y. 1992: 'The Apocalypse in the Monumental Art of the Eleventh through Thirteenth Centuries'. In R. Emmerson and B. McGinn (eds.), *The Book of Revelation in the Middle Ages*. New York: Cornell University Press, 234–58.

Cohn, N. 2004: *The Pursuit of the Millennium: Revolutionary Millenarians and Mystical Anarchists of the Middle Ages*. Oxford, London: Oxford University Press.

Collins, J. 1989: *Cecil Collins: A Retrospective Exhibition*. Millbank, London: Tate Gallery Publications.

Collins J. 1998: *The Apocalyptic Imagination: An Introduction to Jewish Apocalyptic Literature*. Grand Rapids and Cambridge: Eerdmans.

Conway, W. M. 1889: *The Literary Remains of Albrecht Dürer*. Cambridge, Mass.: Harvard University Press.

Coremans, P., and others 1953: *L'Agneau Mystique au laboratoire: Examen et traite-ment.* Antwerp: Les Primitifs Flamands, III, Contributions à l'étude des Primitifs Flamands, 11. Antwerps De Sikkel.

Costen, M. D., and Oakes, C. 2000: *Romanesque Churches of the Loire and Western France.* Gloucestershire: Tempus Publishing Ltd.

Crossley, P. 1998: 'The Man from Inner Space: Architecture and Meditation in the Choir of St. Lawrence in Nuremberg'. In G. R. Owen-Crocker and T. Graham (eds.), *Medieval Art: Recent Perspectives: A Memorial Tribute to C. R. Dodwell.* Manchester: Manchester University Press, 165–82.

Crucitti, A. (ed.) 1974: *Compendio di Rivelazioni.* Rome: A. Berlardetti.

Curley, M. tr. 1979: *Physiologus.* Austin and London: University of Texas Press.

Daniel, E. R. 1992: 'Joachim of Fiore: Patterns of History in the Apocalypse'. In R. K. Emmerson and B. McGinn (eds.). *The Apocalypse in the Middle Ages.* New York: Cornell University Press, 72–88.

Darlow, T., and Moule, H. (eds.) 1911: *Holy Scripture in the Library of the British and Foreign Bible Society.* London.

Davey, N. 1999: 'The Hermeneutics of Seeing'. In I. Heywood and B. Sandywell (eds.), *Interpreting Visual Culture: Exploration in the Hermeneutics of the Visual.* New York: Routledge, 3–30.

Davies, M. 1951: *The Earlier Italian Schools.* London: National Gallery Catalogues.

De Baets, J. 1961: 'De Gewijde teksten van het "Lamb Gods" kritisch onderzocht'. *Koninklijke Vlaamse Academie voor Taal en Letterkunde, Verslagen en Mededelingen,* 531–614.

De La Marche, L. 1892: *Les Relations politiques de la France avec le royaume de Majorque.*

De Merindol, C. 1987: *Le Roi René et la seconde maison d'Anjou. Emblématique, art, histoire.* Paris: Le Léopard d'Or.

De Mirimonde, A. P. 1974: 'Le Symbolisme du rocher et de la source chez Joos van Cleve, Dirck Bouts, Memling, Paternier, C. van der Broech, Sustris et Paul Bril'. *Jaarboek 1974. Koninklijk Museum voor Schone Kunsten Antwerpen,* 73–100.

De Vos, D. 1994: *Hans Memling: The Complete Works.* London: Thames and Hudson.

—— 2002: *The Flemish Primitives: The Masterpieces.* Princeton: Princeton University Press.

Dehaisnes, C. 1886: *Documents et extraits divers concernant l'histoire de l'art dans la Flandre, L'Artois et le Hainaut avant le Xve siècle,* 2 vols. Lille.

Delachenal, R. 1910: *Chronique des regnes de Jean II et Charles V.* Paris.

Delisle, L. 1907: *Recherches sur la librairie de Charles V,* 2 vols. Paris.

—— and Meyer P. 1908: *L'Apocalypse en fran çais au XIIIe siècle* (Paris MS fr. 403), 2 vols. Paris.

Dempsey, C. 1992: *The Portrayal of Love: Botticelli's Primavera and Humanist Culture at the time of Lorenzo the Magnificent.* Princeton: Princeton University Press.

—— 1996: 'Botticelli'. In J. Turner (ed.), *The Grove Dictionary of Art.* Oxford: Oxford University Press, vol. 4, 493–504.

Denzinger, H. 1965: *Enchiridion Symbolorum.* Freiburg: Herder.

Deonna, W. 1920: 'Le Papillon et la tête de mort'. *Revue d'ethnographie et de traditions populaires,* 1: 250–2.

—— 1954: 'The Crab and the Butterfly'. *Journal of the Warburg and Courtauld Institutes*, 17: 47–86.

Dhanens, E. 1965: *Het Retabel van het Lam Gods in de Sint-Baafskathedraal te Gent*. Ghent: Inventaris van het Kunstpatrimonium van Oost-Vlaanderen, VI.

—— 1973: *Van Eyck: The Ghent Altarpiece*. London: Allen Lane.

—— 1980: *Hubert and Jan Van Eyck*. Paris: Albin Michel.

Dombrowski, D. 2000: 'The Dante Drawings and the Limitations of Cultural History'. In H. Schulze Altcappenberg (ed.), *Sandro Botticelli: The Drawings for Dante's Divine Comedy*. London: Royal Academy of Arts, 298–305.

Dronke, P. 1984: *Women Writers of the Middle Ages: A Critical Study of Texts from Perpetua to Marguerite Porete*. Cambridge: Cambridge University Press.

Drury, J. 2002: *Painting the Word: Christian Pictures and their Meanings*. New Haven and London: Yale University Press.

Dvorak, M. 1921 (Eng. tr. J. Hardy 1984): *The History of Art as the History of Ideas*. London: Routledge & Kegan Paul.

Edwards, M. 1983: *Luther's Last Battles: Politics and Polemics, 1531–46*. New York: Ithaca.

Eichberger, D., and Zika, C. (eds.) 1994: *Dürer and his Culture*. Cambridge: Cambridge University Press.

Eisler, C. 1979: *The Master of the Unicorn: The Life and Work of Jean Duvet*. New York: Abaris Books.

Ekserdijan, D. 1998: 'A Print Source for Botticelli: A Devil by the Master E.S'. *Apollo: International Magazine for the Arts*, vol. CXLVIII, no. 441, 15–16.

Elek, P. 1946: *French Tapestry*. Paris: Les Éditions du Chêne.

Eliade, M. 1964: *Shamanism: Archaic Techniques of Ecstasy*, trans. from French by Willard R. Trask. London: Routledge & Kegan Paul.

Emmerson, R. 1981: *Antichrist in the Middle Ages*. Seattle: University of Washington Press.

—— and McGinn, B. (eds.) 1992: *The Apocalypse in the Middle Ages*. New York: Cornell University Press.

Erlande-Brandenberg, A. 1986: 'Hommage à Jean de Bruges'. In F. Muel (ed.), *La Tenture de l'Apocalypse d'Angers*, Cahiers de l'Inventaire 4, Pays de Loire: Association pour le développement de l'Inventaire Général des Monuments et des Richesses Artistiques en Région des Pays de Loire, 283–9.

Evans, J. D. 1986: 'Episodes in Analysis of Medieval Narrative'. *Style* 20, 126–41.

Evers, H. G. 1972: *Dürer bei Memling*. Munich: Verlag Wilhelm Fink.

Farge, A., and Zerwin Davis, N. (eds.) 1995: *A History of Women in the West*, vol. III, *Renaissance and Enlightenment Paradoxes*, Cambridge, Mass.: Harvard University Press.

Fee, G. D. 1983: *New Testament Exgesis: A Hardbook for Students and Pastors*. Philadelphia: Westminster Press.

Fitzmyer, J. 2008: *The Interpretation of Scripture: In Defense of the Historical-Critical Method*. New Jersey: Paulist Press.

Freyham, R. 1955: 'Joachism and the English Apocalypse'. *Journal of the Warburg and Courtauld Institutes*, 18, 211–44.

Fris, V. 1907: 'Josse Vyt, le donateur de l'Adoration de l'Agneau mystique'. *Chronique des arts et de la curiosité*, 61–2.

Fryer, A. C. 1935: 'Theophilus, the Penitent, as Represented in Art'. *Archaeology XCII*, 287–311.

Gaborit-Chopin, D. 1985: 'Le Croix d'Anjou'. *Cahiers d'archeologie Picard*, no. 33, 157–78.

Gadamer, H.-G. 1989: *Truth and Method*. New York: Continuum.

Ghiglieri, P. (ed.) 1972: *Prediche sopra Amos e Zaccaria*, 3 vols. Rome: A. Berlardetti.

Gibson, W. S. 1973: 'Hieronymous Bosch and the Mirror of Man: Authorship and Iconography of the *Tabletop of the Seven Deadly Sins*'. *Oud Holland*, vol. 87, no. 4, 205–26.

Gillingham, S. 2007: *Psalms through the Centuries*. Blackwell Bible Commentaries. Oxford: Blackwell.

Ginori Conti, P., and Ridolfi, R. (eds.) 1937: *Il vetro per ottica in Italia e l'Istituto del Boro-silicio in Firenze*. Florence.

Godard-Faultrier, V. 1866: *Le Château d'Angers au temps du Roi René*. Angers: P. Lachèse et Dolbeau.

Goldfarb, H. T. 1997: 'Sandro Botticelli as Artist and Witness: An Overview'. In L. Kanter, H. Goldfarb, and J. Hankins (eds.), *Botticelli's Witness: Changing Style in a Changing Florence*. Boston: Trustees of the Isabella Stewart Gardner Museum, 3–12.

Goodall, J. 2001: *God's House at Ewelme: Life, Devotion and Architecture in a Fifteenth-Century Almshouse*. Hampshire: Ashgate Publishing Ltd.

Goodgal, E. 1981: 'The Iconography of the Ghent Altarpiece'. Ph.D. Study, University of Pennsylvania.

Graham, R. 1947: 'The Apocalypse Tapestries from Angers'. *The Burlington Magazine*, vol. 89.

Gruenwald, I. 1980: *Apocalyptic and Merkavah Mysticism*. Leiden: Brill.

Halperin, E. 1980: *The Merkavah in Rabbinic Literature*. New Haven: American Oriental Society.

—— 1988: *The Faces of the Chariot: Early Jewish Responses to Ezekiel's Vision*. Tübingen: Mohr.

Hamburger, J: *St. John the Divine: The Deified Evangelist in Medieval Art and Theology*. Berkeley and Los Angeles, London: University of California Press.

Harbison, C. 1991: *Jan Van Eyck: The Play of Realism*. London: Reaktion Books Ltd.

—— 1995: *The Mirror of the Artist: Northern Renaissance Art in its Historical Context*. New York: Abrams Perspectives.

—— 2005: 'Iconography and Iconology'. In H. Van Veem and B. Ridderbos (eds.), *Early Netherlandish Paintings: Rediscovery, Reception and Research*. Amsterdam University Press, 378–406.

Hatfield, R. 1995: 'Botticelli's *Mystic Nativity*, Savonarola and the Millennium'. *Journal of the Warburg and Courtauld Institutes*, 58, 89–114.

Hedley, D. 1998: 'Coleridge's Intellectual Intuition, the Vision of God, and the Walled Garden of "Kubla Khan" '. *Journal of the History of Ideas*, vol. 59, no. 1, 115–34.

Heitz, P. (ed.) 1915: *Flugblatter des Sebastian Brant*. Strasbourg: Heitz & Mündel.

Henderson, G. 1967: 'Studies in English Manuscript Illumination, Part II: The English Apocalypse; I'. *Journal of the Warburg and Courtauld Institutes*, 30, 104–37.

—— 1968: 'Studies in English Manuscript Illumination, Part III: The English Apocalypse; II'. *Journal of the Warburg and Courtauld Institutes*, 31, 103–47.

—— 1985: 'The Manuscript Model of the Angers "Apocalypse" Tapestries'. *The Burlington Magazine*, vol. 127, no. 985, 209–18.

—— 1992: Review of Nigel Morgan, *The Lambeth Book of Revelation, Manuscript 209 in Lambeth Palace Library: A Critical Study* (London: Harvey Miller Publishers). *The Burlington Magazine*, vol. 134, no. 1073, 528–9.

Hennecke, E. 1974: *New Testament Apocrypha*, vol. 2, London: Lutterworth Press.

Hopkins, J. 1988 tr.: *Nicholas of Cusa, Nicholas of Cusa's Dialectical Mysticism*. Minneapolis: Arthur J. Banning Press.

Horne, H. P. 1908: *Botticelli: Painter of Florence*. Princeton: Princeton University Press.

Houlden, J. L. (ed.) 1995: *The Interpretation of the Bible in the Church*. London: SCM Press.

Houston, M. G. 1996: *Medieval Costume in England and France*. New York: Dover Publications Inc.

Howell Jolly, P. 1998: 'Jan Van Eyck's Italian Pilgrimage: A Miraculous Florentine Annunciation and the Ghent Altarpiece'. *Zeitschrift für Kunstgeschichte*, Bd. 61, H. 3, 369–94.

Huizinga, J. 1924: *The Waning of the Middle Ages*. London: Arnold.

Hull, V. J. 1981: *Hans Memling's Painting for the Hospital of St. John in Bruges*. New York.

—— 1988: 'Devotional Aspects of Hans Memlinc's Paintings'. *Southeastern College of Art Conference Review* II, 207–13.

Jacobs, L. F. 2000: 'The Triptychs of Hieronymous Bosch'. *Sixteenth Century Journal*, vol. 31, no. 4, 1009–41.

Jambeck, K. 1996: 'Patterns of Women's Literary Patronage: England 1200–c.1475'. In J. McCash (ed.), *The Cultural Patronage of Medieval Women*. Athens and London: University of Georgia Press, 228–65.

James, M. R. 1903: *The Ancient Libraries of Canterbury and Dover*. Cambridge: Cambridge University Press.

—— 1924: *The Apocryphal New Testament*. Oxford: Clarendon Press.

—— 1927: *The Book of Revelation in Latin, MS 10 in the Collection of C. W. Dyson Perrins*. Oxford: Clarendon Press.

James, W. 1902 and 1985: *The Varieties of Religious Experience: A Study in Human Nature*. London: Longmans and Cambridge, Mass.: Harvard University Press.

Johnson, G. 2000: 'The Lion on the Piazza: Patrician Politics and Public Statuary in Central Florence'. In T. Frangenberg and P. Linley (eds.), *Secular Sculpture 1300–1550*. Stanford: Shain Tyas Press, 55–73.

Joubert, F. 1981: 'L'Apocalypse d'Angers et les débuts de la tapisserie historiée'. *Bulletin Monumental*, 139, 125–40.

Juraschek, F. 1936: *Albrecht Dürer. Gemälde, Kupferstiche, Holzschnitte, Handzeichnungen*. Vienna: Krystall-Verlag.

Kauffmann, C. M. 1968: *An Altarpiece of the Book of Revelation from Master Bertram's Workshop in Hamburg*. London: HMSO, Victoria and Albert Museum. Museum Monograph, no. 25.

Kemp, M. 1989: 'The "Super-Artist" as Genius: The Sixteenth-Century View'. In P. Murray (ed.), *Genius: The History of an Idea*. Oxford: Blackwell, 32–53.

King, D. 1977: 'How many Apocalypse Tapestries?' In V. Gevers (ed.), *Studies in Textile History in Memory of Harold B. Burnham*. Toronto: Royal Ontarion Museum, 160–7.

Klein, P. K. 1983: *Endzeiterwartung und Ritterideologie: Die englischen Bilderapokalypsen der Frühgotik und MS. Douce 180.* Graz: Akodemische Druck- u. Verlagsanstalt.

—— 1992: 'The Apocalypse in Medieval Art'. In R. Emmerson and B. McGinn (eds.), *The Book of Revelation in the Middle Ages.* New York: Cornell University Press, 159–99.

Koerner, J. 1993: *The Moment of Self-Portraiture in German Renaissance Art.* Chicago: University of Chicago Press.

—— 1998: 'Bosch's Contingency'. In V. Gerhart, V. Graevenitz, and O. Marquad (eds.), *Kontingenz, Poetik und Hermeneutic XVII.* Munich: Fink, 245–84.

—— 2004: *The Reformation of the Image.* London and Chicago: Reaktion Books.

Kovacs, J. J. and Rowland, C. 2004: *Revelation.* Oxford: Blackwell.

Krey, P. 1995: 'Many Readers but Few Followers: The Fate of Nicholas of Lyra's "Apocalypse Commentary" in the Hands of his Late-Medieval Admirers'. *Church History*, vol. 64, no. 2, 185–201.

—— 2002: 'Luther's Apocalyptic'. In C. Braaten and R. W. Jensen (eds.), *The Last Things: Biblical and Theological Perspectives on Eschatology.* Grand Rapids and Cambridge: Eerdmans, 135–45.

Krieg, W. 1953: *Materialien zu einer Entwicklungsgeschichte der Bücher-Preise und des Autoren Honorars von 15. Bis zum 20. Jahrhundert.* Vienna and Zurich: Herbert Stubenrauch.

Krüger, P. 1996: *Dürers 'Apokalypse': Zur poetischen Struktur einer Bilderzählung der Renaissance.* Bamberger Schriften zur Renaissanceforschung 28. Wiesbaden: Harrassowitz.

Landau, D., and Parshall, P. 1994: *The Renaissance Print 1470–1550.* Yale: Yale University Press.

Lane, B. 1984: *The Altar and the Altarpiece: Sacramental Themes in Early Netherlandish Painting.* New York: Harper and Row.

—— 2009: *Hans Memlings Master Painter in Fifteenth-Century Bruges.* Studies in Medieval and Early Renaissance Art History. London: Harvey Miller Publishers.

Lawrence, D. H. 1931, 1995: *Apocalypse.* London: Penguin.

Leclerq-Marx, J. 1997: 'Les œuvres romanes accompagnées d'une inscription: Le Cas particulier des monstres'. *Cahiers de Civilization Médiévale*, 40: 91–102.

Lerner, R. 1999: 'Millenialism'. In B. McGinn (ed.), *The Encyclopedia of Apocalypticism*, vol. 2, New York: Continuum, 326–60.

Lessing, G. 1766: tr. E. A. McCormick 1984: *Laocoön: An Essay on the Limits of Poetry and Painting.* Baltimore: Johns Hopkins University Press.

Lestocquoy, J. 1978: *Deux siècles de l'histoire de la tapisserie: 1300–1500.* Mémoires de la Commission départementale des monuments historiques du Pas-de-Calais, ed. 19.

Lewis, S. 1992: 'Exegesis and Illustration in Thirteenth Century English Apocalypses'. In R. Emmerson and B. McGinn (eds.), *The Book of Revelation in the Middle Ages.* New York: Cornell University Press, 259–75.

—— 1995: *Reading Images: Narrative Discourse and Reception in the Thirteenth-Century Illuminated Book of Revelation.* Cambridge: Cambridge University Press.

Lightbown, R. 1978: *Sandro Botticelli*, 2 vols. London: Paul Elek.

Lindblom, J. 1968: *Gesichte und Offenbarungen* Lund: CWK Gleerup.

Lindsey, H. 1973: *The Late Great Planet Earth.* London: Lakeland.

Lobelle-Caluwé, H. 1997: 'Hans Memling: A Self-Portrait?' In H. Verougstraete, R. Van Schoute, M. Smeyers (eds.), *Memling Studies, Proceedings of the International Colloquium (Bruges, 10–12 November 1994)*. Uitgeverij: Peeters Löwen, 43–52.

Lobrichon, G. 1988: 'L'Ordre de ce temps et les désordres de la Fin: Apocalypse et Société du IXe à la fin du XIIe siècle'. In W. Verbeke (ed.), *The Use and Abuse of Eschatology in the Midlle Ages*, Mediaevalia Lovaniensia, 15: 221–41.

Longnon, J., and Cazelles, R. (eds.) 1989: *Les Très Riches Heures du Duc de Berry*. London: Thames and Hudson.

Luber, K. C. 1997: 'Annotated Bibliography'. In J. R. J. Van Asperen de Boer *et al. Jan Van Eyck: The Two Paintings of 'Saint Francis Receiving the Stigmata'*, Philadelphia: Philadelphia Museum of Art, 97–108.

Luchinat, C. A., and Menegaux, O. 2001: *Les Allégories mythologiques*. Paris: Gallimard.

Luz, U. 1994: *Matthew in History: Interpretation, Influence and Effects*. Augsberg: Fortress.

McCash, J. (ed.) 1996: *The Cultural Patronage of Medieval Women*. Athens and London: University of Georgia Press.

MacCulloch, D. 2004: *Reformation Europe's House Divided 1490–1700*. London: Penguin Books.

McFarlane, K. 1971: *Hans Memling*. Oxford: Clarendon Press.

McGinn, B. 1979: *Apocalyptic Spirituality*. New Jersey: Paulist Press.

—— 1987: 'Revelation'. In R. Alter and F. Kermode (eds.), *The Literary Guide to the Bible*. Cambridge, Mass.: Harvard University Press, 523–41.

—— and Meyendorff, J. (eds.) 1985: *Christian Spirituality*. I: *Origins to the Twelfth Century*. New York: Crossroad/Herder & Herder.

McGuckin, J. A. 2002: 'The Book of Revelation and the Orthodox Eschatology: The Theodrama of Judgement'. In C. Braaten and R. W. Jenson (eds.), *The Last Things: Biblical and Theological Perspectives on Eschatology*. Grand Rapids: Eerdmans, 113–37.

McKitterick, D. 2005: *The Trinity Book of Revelation*. London: The British Library.

MacNamee, M. 1998: *Vested Angels: Eucharistic Allusions in Early Netherlandish Paintings*. Uitgeverij: Peeters.

Mâle, E. 2000: *Religious Art in France in the Thirteenth Century*. Toronto: Dover Publications.

Marciari, J. 2000: 'Review of Paolo Berdini, *The Religious Art of Jacopo Bassano: Painting as Visual Exegesis*', *Speculum* 75, 440–1.

Massing, J. M. 1986: 'Dürer's Dreams'. *Journal of the Warburg and Courtauld Institutes*, 49, 238–44.

Meltzoff, S. 1987: *Botticelli, Signorelli and Savonarola*. Florence: L. S. Olschki.

Mesnil, J. 1938: *Botticelli*. Paris: Albin Michel.

Michalski, S. 1993: *The Reformation and the Visual Arts: The Protestant Image Question in Western and Eastern Europe*. London: Routledge.

Michel, J. 1959: *Le Mystère de la Passion (Angers 1486)*, ed. Omer Jodogne. Belgium.

Mitchell, W. J. T. 1978: *Blake's Composite Art*. Princeton: Princeton University Press.

—— 1986: *Iconology: Image, Text, Ideology*. Chicago: University of Chicago Press.

Moorman, J. H. 1946: *Church Life in England in the Thirteenth Century*. Cambridge: Cambridge University Press.

Morgan, N. 1982–8: *Early Gothic Manuscripts*, 2 vols. *A Survey of Manuscripts Illuminated in the British Isles*. London: Harvey Miller.

—— 1990: *The Lambeth Book of Revelation, Manuscript 209 in Lambeth Palace Library: A Critical Study*. London: Harvey Miller Publishers.

—— 2005a: 'Illustrated Apocalypses of Mid-Thirteenth-Century England: Historical Context, Patronage and Readership'. In D. McKittrick (ed.), *The Trinity Apocalypse*. London: The British Library, 3–22.

——2005b: 'The Trinity Apocalypse: Style, Dating and Place of Production'. In D. McKitterick (ed.), *The Trinity Apocalypse*. London: The British Library, 23–33.

Morgan, R. (ed.) 1973: *The Nature of New Testament Theology: The Contribution of William Wrede and Adolf Schlatter*. Studies in Biblical Theology, 2nd ser., vol. 25. London: SCM.

Moxey, K. 1989: *Peasants, Warriors and Wives: Popular Imagery of the Reformation*. Chicago: University of Chicago Press.

Muel, F. (ed.) 1986: *La Tenture de l'Apocalypse of Revelation d'Angers*, Cahiers de l'Inventaire 4, Pays de Loire: Association pour le développement de l'Inventaire Général des Monuments et des Richesses Artistiques en Région des Pays de Loire, 19–30, 53–86, and 87–282, 290–8.

—— 1990: *L'Envers et L'Endroit*. Pays de Loire: Images du Patrimoine.

—— 1996: *The Tapestry of the Book of Revelation at Angers, Front and Back*. Pays de Loire: Images du Patrimoine.

Muir Wright, R. 1995: *Art and Antichrist in Medieval Europe*. Manchester and New York: Manchester University Press.

Müller, M., and Tronier, H. 2002: *The New Testament as Reception*. Sheffield: Sheffield Academic Press.

Mussafia, A. 1886: 'Studien zu den mittelalterlichen Marienlegenden'. *Sitzungsberichte der Kaiserlichen Akademie der Wissenschaften, Wien*. Philosophisch-historiche Klass 113.

Myrone, M. 2007: *The Blake Book*. London: Tate.

Newman, J. 1985: 'The Word Made Print: Luther's 1522 New Testament in an Age of Mechanical Reproduction'. *Representations* 11, 95–133.

Nicholls, R. 2005: *Is Wirkungsgeschichte (or Reception History) a Kind of Intellectual Parkour (or Freerunning)?* http://www.bibcomm.net/news/nicholls.pdf

Nichols, S. G. 1996: 'Foreword'. In J. McCash (ed.), *The Cultural Patronage of Medieval Women*. Athens and London: University of Georgia Press, xi–xix.

Nickelsburg, G. W. E. tr. 2004: *1 Enoch: A New Translation*. Augsberg: Fortress Press.

Niditch, S. 1980: 'The Visionary'. In J. J. Collins (ed.), *Ideal Figures in Ancient Judaism: Profiles and Paradigms*. Atlanta: Scholars Press, 153–79.

Nolan, B. 1977: *The Gothic Visionary Perspective*. Princeton: Princeton University Press.

Norberg, K. 1995: 'Prostitutes'. In N. Zerwin Davis and A. Farge (eds.), *A History of Women in the West*, vol. III, *Renaissance and Enlightenment Paradoxes*. Cambridge, Mass.: Harvard University Press, 458–74.

Oakes, C. 1997: 'An Iconographic Study of the Virgin as Intercessor, Mediator and Purveyor of Mercy in Western Understanding from the Twelfth to the Fifteenth Century'. Doctoral study, Bristol University.

O'Hear, A. 1984: *Experience, Explanation and Faith: An Introduction to the Philosophy of Religion*. London: Routledge & Kegan Paul.

—— *The Great Books: From the Iliad and the Odyssey to Goethe's Faust: A Journey through 2,500 Years of the West's Classic Literature*. Thriplow: Icon Books.

O'Hear, N. 2009: 'Images of Babylon: A Visual History of the Whore in Late Medieval and Early Modern Art'. In C. Joynes (ed.), *From the Margins II: Women of the New Testament and their Afterlives*. Sheffield: Sheffield Phoenix Press, 316–41.

O'Kane, M. 2005: 'The Artist as Reader of the Bible: Visual Exegesis and the Adoration of the Magi'. *Biblical Interpretation*, vol. 13, no. 4, 337–73.

—— 2007: *Painting the Text: The Artist as Biblical Interpreter*. Sheffield: Sheffield Phoenix Press.

Olson, R. J. M. 1981: 'Brunelleschi's Machines of Paradise and Botticelli's Mystic Nativity'. *Gazette des Beaux-Arts*, May/June, vol. 17, 183–8.

Pächt, O. 1994: *Van Eyck and the Founders of Early Netherlandish Painting*. London: Harvey Miller Publishers.

Panofsky, E. 1953: *Early Netherlandish Painting*. Cambridge, Mass.: Harvard University Press.

—— 1955: *The Life and Art of Albrecht Dürer*. Princeton: Princeton University Press.

Parshall, P. 1999: 'The Vision of the Apocalypse in the Sixteenth and Seventeenth Centuries'. In F. Carey (ed.), *The Book of Revelation and the Shape of Things to Come*. London: British Museum Press.

Pattison, S. 2007: *Seeing Things: Deepening Relations with Visual Artefacts*. London: SCM Press.

Paulson, R. 1982: *Book and Painting: Shakespeare, Milton, and the Bible. Literary Texts and the Emergence of English Painting*. Knoxville: University of Tennessee Press.

Pelikan, J. 1984: 'Some Uses of Apocalypse in the Magisterial Reformers'. In C. A. Patrides and J. Wittreich (eds.), *The Book of Revelation in English Renaissance Thought and Literature: Patterns, Antecedents, and Repercussions*. Manchester: Manchester University Press, 74–92.

Peuckert, W. 1948: *Die große Werde: Das apohcalyptische Saeculum und Luther Geistesgeschichte and Volkskunde*. Hamburg: Claassen & Goverts.

Pippin, T. 1992: *Death and Desire: The Rhetoric of Gender in the Book of Revelation of John*. Louisville, Ky.: Westminster/John Knox Press.

Planchenault, R. 1941: 'A propos d'un transport en Provence de l'Apocalypse d'Angers'. *Bulletin de la Société Nationale des Antiquaires de France*, 136–7.

—— 1954: *Les Tapisseries d'Angers*. Paris: Caisse Nationale des Monuments Historiques.

—— 1966: *L'Apocalypse d'Angers*. Paris: Caisse Nationale des Monuments Historiques.

Plazzotta, C., and Dunkerton, J. 1999: *The Mystic Nativity*. National Gallery CD ROM.

Polizzotto, L. 1994: *The Elect Nation: The Savonarolan Movement in Florence*. Oxford: Clarendon Press.

Pon, L. 2004: *Raphael, Dürer and Marcantonio Raimondi: Copying and the Italian Renaissance Print*. New Haven and London: Yale University Press.

Pope-Hennessy, J. 1947: *Sandro Botticelli: The Nativity in the National Gallery*. London: The Gallery Books, xv.

Porter, R. 1997: *The Greatest Benefit to Mankind: A Medical History from Antiquity to the Present.* London: Harper Collins.

Potesta, G. 1999: 'Radical Apocalyptic Movements in the Late Middle Ages'. In B. McGinn (ed.), *The Encyclopedia of Apocalypticism,* vol. 2, New York: Continuum, 110–42.

Powicke, F. M., and Cheney, C. R. 1964: *Councils and Synods and Other Documents Relating to the English Church A.D. 1205–1313.* Oxford: Clarendon Press.

Price, D. 1994: 'Albrecht Dürer's Representations of Faith: The Church, Lay Devotion and Veneration in the "Apocalypse" (1498)'. *Zeitschrift für Kunstgeschichte* 57.4, 688–96.

—— 2003: *Albrecht Dürer's Renaissance: Humanism, Reformation and the Art of Faith.* Michigan: University of Michigan Press.

Reeves, M. 1969: *The Influence of Prophecy in the Later Middle Ages: A Study of Joachimism.* Oxford: Clarendon Press.

—— 1984: 'The Development of Apocalyptic Thought: Medieval Attitudes'. In C. A. Patrides and J. Wittreich (eds.), *The Book of Revelation in English Renaissance Thought and Literature: Patterns, Antecedents, and Repercussions.* Manchester: Manchester University Press, 40–73.

Reinitzer, H. 1983: *Biblia Deutsch: Luthers Bibelübersetzung und ihre Tradition.* Wolfenbüttel: Herzog August Bibliothek.

Reiss, J. 1995: *The Renaissance Antichrist: Luca Signorelli's Orvieto Frescoes.* Princeton: PUP.

Ridolfi, R. 1952: *Vita di Girolamo Savonarola,* 2 vols. Rome: A. Berlardetti.

Romano, V. (ed.) 1969: *Prediche sopra I Salmi,* 2 vols. Rome: A. Berlardetti.

Rothwell, W. 1975–6: 'The Role of French in Thirteenth Century England'. *Bulletin of the John Rylands Library,* 58: 445–66.

—— 1978: 'A quelle époque a-t-on cessée de parler français en Angleterre?' *Mélanges offerts à Charles Camproux* II, Montpelier: 1075–89.

Rowe, N. (ed.) 2008: *In Celebration of Cecil Collins: Visionary Artist and Educator.* London: Tate.

Rowland, C. 1982: *The Open Heaven.* London: SPCK.

—— 1993: *Revelation.* London: Epworth Press.

—— 2005: 'Imagining the Apocalypse'. *New Testament Studies* 51, Cambridge University Press, 303–27.

—— 2007: *'Wheels within Wheels': William Blake and the Ezekiel's Merkabah in Text and Image.* Milwaukee: Marquette University Press.

—— 2011: *Blake and the Bible.* London: Yale University Press.

—— and Morray-Jones, C. R. 2009: *The Mystery of God: Early Jewish Mysticism and the New Testament.* Compendia Rerum Iudaicarum Ad Novum Testamentum. Leiden: Brill.

Ruais, A. 1986: 'Jalons pour l'histoire de la tenture'. In F. Muel (ed.), *La Tenture de l'Apocalypse d'Angers,* Cahiers de l'Inventaire 4, Pays de Loire: Association pour le développement de l'Inventaire Général des Monuments et des Richesses Artistiques en Région des Pays de Loire, 31–42.

Ruhmer, E. 1963: *Lucas Cranach.* London: Phaidon Books.

Runciman, S. 1955: 'The Decline of the Crusading Idea'. *Relazioni del X Congresso internazionale de scienze storiche*, III: 637–52. Florence: Sansoni.

Salter, E. 1988: *English and International Studies in the Literature, Art and Patronage of Medieval England*. Cambridge: Cambridge University Press.

Sawyer, J. F. 2006: *The Blackwell Companion to Bible and Culture*. Oxford: Blackwell.

Saxl, F. 1942: 'A Spiritual Encyclopedia of the Later Middle Age'. *Journal of the Warburg and Courtauld Institutes*, vol. 5.

Schmidt, P. 1962: *Die Illustrationen der Lutherbibel*. Bern: Verlag Friedrich Reinhard.

Schmidt, P. 2001: *The Ghent Altarpiece*. Ghent–Amsterdam: Ludion Guides.

Schneider, E. 1945: 'The Dream of Kubla Khan'. *PMLA* vol. 60, no. 3 (Sept.), 784–801.

Schnitzer, G. 1904–10: *Quellen und Forschungen zur Geschichte Savonarolas*, vol. iv. Munich.

Schuchardt, C. 1851–70: *Lucas Cranachs des Älteren Leben und Werke*, 3 vols. Leipzig.

Schulze Altcappenberg, H. (ed.) 2000: *Sandro Botticelli: The Drawings for Dante's Divine Comedy*. London: Royal Academy of Arts.

Schüssler-Fiorenza, E. 1993: *Revelation: Vision of a Just World*. Edinburgh: T. & T. Clark.

Schweiker, W. 1987: 'Sacrifice, Interpretation, and the Sacred: The Import of Gadamer and Girard for Religious Studies'. *Journal of the American Academy of Religion*, vol. 55, no. 4, 791–810.

Schweitzer, A. 1906: tr. N. Montgomery 2005: *The Quest for the Historical Jesus: A Critical Study of its Progress from Reimarus to Wrede*. New York: Dover Publications.

Scott, M. 2000: 'Dress in Van Eyck's paintings'. In S. Forster, S. Jones, and D. Cool (eds.), *Investigating Van Eyck*. Turnhout: Brepols, 131–45.

Scribner, R. 1981: *For the Sake of Simple Folk: Popular Propaganda for the German Reformation*. Cambridge: Cambridge University Press.

—— 1994: 'Ways of Seeing in the Age of Dürer'. In D. Eichberger and C. Zika (eds.), *Dürer and his Culture*. Cambridge: Cambridge University Press, 93–117.

Seidel, L. 1999: 'Apocalypse and Apocalypticism in Western Medieval Art'. In B. McGinn (ed.), *The Encyclopaedia of Apocalypticism*. New York: Continuum, vol. II, 467–506.

Seward, D. 2006: *The Burning of the Vanities: Savonarola and the Borgia Pope*. Stroud: Sutton Publishing Ltd.

Shahar, S. 1983 (repr. 2003): *The Fourth Estate: A History of Women in the Middle Ages*. Oxford: Routledge.

Smart, N. 1964: *Philosophers and Religious Truth*. London: SCM Press.

Smets, I. 2001: *The Memling Museum: St. John's Hospital Bruges*. Bruges: Ludion Guides.

Smith, R. 1995: 'Albrecht Dürer's New Jerusalem, Rev. 21–22'. *Word and World*, XV, no. 2, 151–8.

Snyder, J. 1976: 'Jan Van Eyck and Adam's Apple'. *Art Bulletin* 58, 511–15.

Southern, R. W. 1986: *Robert Grosseteste: The Growth of an English Mind in Medieval Europe*. Oxford: Clarendon.

Stanton, G. 2002 (2nd edn.): *The Gospels and Jesus*. Oxford: Oxford University Press.

Steinberg, R. M. 1977: *Fra Girolamo Savonarola, Florentine Art, and Renaissance Historiography*. Athens, Oh.: Ohio University Press.

Steinberg, A., and Wylie, J. 1990: 'Counterfeiting Nature: Artistic Innovation and Cultural Crisis in Renaissance Venice'. *Comparative Studies in Society and History*, vol. 32, no. 1, 54–88.

String, T. 2000: 'Politics and Polemics in English and German Bible Illustrations'. In O. O'Sullivan (ed.), *The Bible as Book*, Vol. 3: *The Reformation*. London: British Library Publishing Division, 137–43.

Stringfellow, W. 1973: *An Ethic for Christians and other Aliens in a Strange Land*. Waco, Tex.: Word Incorporated.

Sudhoff, K. 1912: *Graphische und Typographische Erstlinge der Syphilisliteratur aus den Jahren 1495 und 1496*. Munich, 8–10.

Taburet-Delahaye, E. (ed.) 2004: *Paris 1400: Les Arts sous Charles VI*. Paris: Fayard.

Tcherikover, A. 1997: *High Romanesque Sculpture in the Duchy of Aquitaine c.1070–1140*. Oxford: Clarendon Press.

Thompson, L. 1990: *Apocalypse and Empire*. New York: Oxford University Press.

Throop, P. 1940: *A Criticism of the Crusade: A Study of Public Opinion and Crusade Propaganda*. Amsterdam: Swets and Zeitlinger.

Trexler, R. 1972: 'Florentine Religious Experience: The Sacred Image'. *Studies in the Renaissance*, 19, 7–41.

—— 1980: *Public Life in Renaissance Florence*. New York: Academic Press.

—— 1993: *Power & Dependence in Renaissance Florence*, 3 vols. Binghamton, NY: Medieval and Renaissance Texts and Studies.

—— 1994: *Dependence in Context in Renaissance Florence*. Binghamton, NY: Medieval and Renaissance Texts & Studies.

Turner, J. (ed.) 1996: *The Grove Dictionary of Art*. London: Macmillan.

Van der Meer, F. 1978: *Book of Revelation: Visions from the Book of Revelation in Western Art*. London: Thames and Hudson.

Verde, A. F. 1988: *Le Lezioni o I sermoni sull'Apocalisse di Girolamo Savonarola* (1490) 'Nova dicere et novo modo'. *Imagine e parola retorica filologica-retorica predicatoria Valla e Savonarola, Memorie Domenicane*. Pistoia, 5–109.

Visser, D. 1996: *Book of Revelation as Utopian Expectation (800–1500): The Book of Revelation Commentary of Berengaudus of Ferrières and the Relationship between Exegesis, Liturgy, and Iconography*. Leiden and New York: E. J. Brill.

Voaden, R. 1999: *God's Words, Women's Voices: The Discernment of Spirits in the Writing of Late-Medieval Women Visionaries*. York: York Medieval Press.

Warner, G. F. 1885: *Miracles de Nostre Dame collected by Jean Mielot*. Roxburghe Club.

Watt, J. A. 1988: 'The English Episcopate, the State and the Jews: The Evidence of the Thirteenth-Century Conciliar Decrees'. In P. R. Coss and S. D. Lloyd (eds.), *Proceedings of the Newcastle upon Tyne Conference 1987*, Woodbridge: Boydell, 137–47.

Weigert, L. 2004: *Weaving Sacred Stories: French Choir Tapestries and the Performance of Clerical Identity*. Ithaca, NY, and London: Cornell University Press.

Weinstein, D. 1970: *Savonarola and Florence: Prophecy and Patriotism in the Renaissance*. Princeton: Princeton University Press.

—— 1991: 'Hagiography, Demonology, Biography: Savonarola Studies Today'. *Journal of Modern History*, 63, 483–503.

Wilde, J. 1978: *Michelangelo*. Oxford: Clarendon Press.

Williams, R. 2003: *Teresa of Avila*. London: Continuum.

Williamson, B. 2004: 'Altarpieces, Liturgy and Devotion'. *Speculum* 79, 341–406.

Wilson, R. M. 1942: 'English and French in England 1100–1300'. *History*, 27: 37–60.

Wogan-Browne, J. 1993: ' "Clerc u lai, muine u dame": Women and Anglo-Norman Hagiography in the Twelfth and Thirteenth Centuries'. In C. Meale (ed.), *Women and Literature in Britain 1150–1500*. Cambridge: Cambridge University Press, 61–87.

Wright, N. T. 1992: 'Quest for the Historical Jesuss. In D. N. Freedman (ed.), *The Anchor Bible Dictionary*, 6 vols. Yale: Yale University Press, 796–802.

Zika, C. 1994: 'Dürer's Witch, Riding Women and Moral Order'. In D. Eichberger and C. Zika (eds.), *Dürer and his Culture*. Cambridge: Cambridge University Press, 118–40.

Zöllner, F. tr. I. Flett 2005: *Botticelli*. Munich, Berlin, London, New York: Prestel Verlag.

**Websites**

http://www.franciscanfriarstor.com/stfrancis/stf_the_tau_cross.htm
http://en.wikipedia.org/wiki/Automatic_writing
http://www.johannesoffenbarung.ch/bilderzyklen/angers.php

# Index